FLORA

AN ILLUSTRATED HISTORY OF THE GARDEN FLOWER

A FIREFLY BOOK

Published by Firefly books Ltd., 2001

First Printing

National Library of Canada Cataloguing in Publication Data

Elliott, W. B.
 Flora : an illustrated history of the garden flower
Includes index.
ISBN 1-55209-604-1
1. Botanical illustration – History. I. Title.
QK98.15.E44 2001 582.13'022'2 C2001-930407-2

U.S. Cataloging-in-Publication Data
 (Library of Congress Standards)

Elliott, W.B.
 Flora : an illustrated history of the garden flower / W.B. Elliott. – 1st ed.
[336] p. ; col. ill. : cm.
Includes index.
Summary : History of botanical illustration accompanied by 300 color illustrations, and
biographies of their illustrators.
ISBN: 1-55209-604-1
1. Flowers – Pictorial works. 2. Botanical illustration – History. 3. Botanical artists –
Biography. I. Title.
581.022/ 2 21 2001

Published in Canada in 2001 by
Firefly Books Ltd.
3680 Victoria Park Avenue
Willowdale, Ontario
M2H 3K1

Published in the United States in 2001 by
Firefly Books (U.S.) Inc.
P.O. Box 1338, Ellicott Station
Buffalo, New York 14205

First published by Scriptum-Cartago
in association with The Royal Horticultural Society.

Printed and bound in Italy, at Officine Grafiche De Agostini.

FLORA

AN ILLUSTRATED HISTORY OF THE GARDEN FLOWER

WRITTEN BY BRENT ELLIOTT

WITH A PREFACE BY SIR SIMON HORNBY

FIREFLY BOOKS

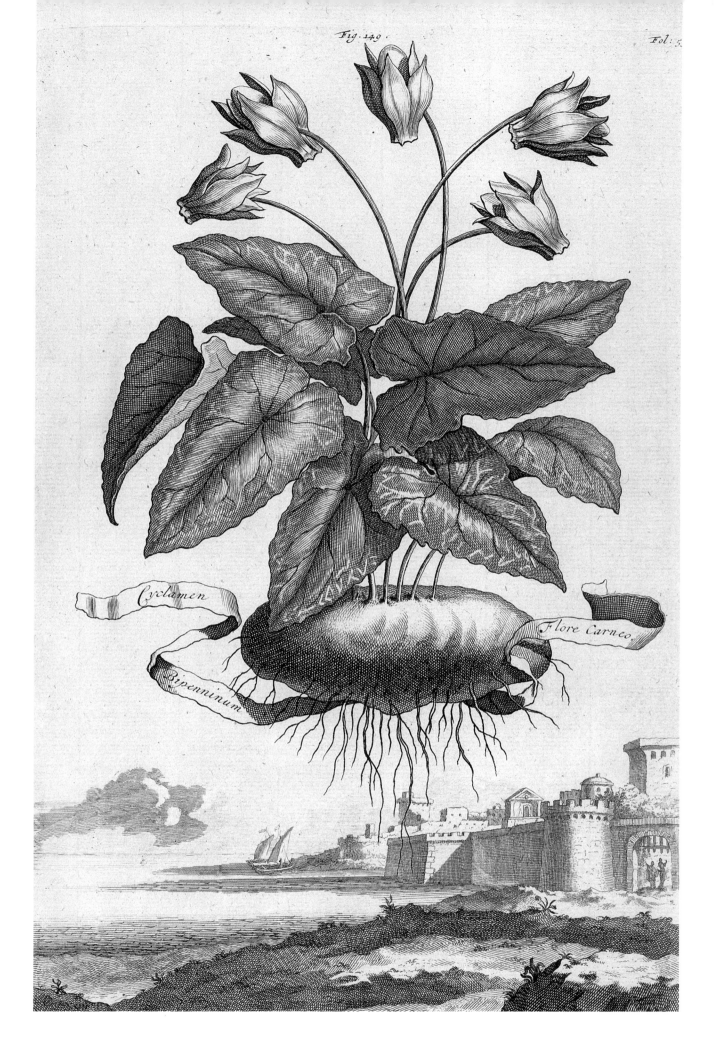

Cyclamen, from Abraham Munting's *Phytographia Curiosa* (1704).

CONTENTS

PREFACE

BY SIR SIMON HORNBY

PRESIDENT OF THE ROYAL HORTICULTURAL SOCIETY

The passion for plant hunting, while never reaching the scale of the Gold Rush in California, has engendered manic characteristics among botanists over centuries. There have been distinct breeds of botanical adventurers: true botanists spurred on by scholarship, the thrill of the chase and breathtaking delight in the beauty of their discoveries; collectors, particularly the orchid hunters, driven by rivalry and the desire to claim a new species before anyone else; and commercial exploiters whose motive was greed – to make money by introducing new plants to an enthusiastic and increasing band of amateur gardeners all over Europe.

Books have already been written about the plant hunters – for much of the time operating in very tough and difficult conditions – yet this story is about the plants they brought to Europe. It is a story not only of plant discovery but also of the changing fashions in gardening that drove the demand for new introductions. From the early nineteenth-century onwards, the successful breeding of hybrids in large quantities by commercial growers added still further to the increasing number of new plants. Over the years, too, many plants have been lost in cultivation as the drive to gain commercial advantage from new introductions has intensified. Today, a study of the *RHS Plant Finder* shows how out of hand this drive has become with some genera, but it is symptomatic of an obsession that has existed for hundreds of years.

The art of botanical drawing has a tradition of minute accuracy combined with freshness, portraying the beauty of nature in the colour and form of its plants. New introductions have been recorded with superb skill and artistry over the centuries, creating a significant historical record. That tradition continues today, as all over the world artists of outstanding ability record the introductions of plant breeders as well as species. In *Flora*, Brent Elliott uses illustrations from collections in the RHS Lindley Library to trace the introduction of plants over four and a half centuries. The combination of outstanding illustrations and fascinating text has produced a book of beauty and considerable horticultural significance.

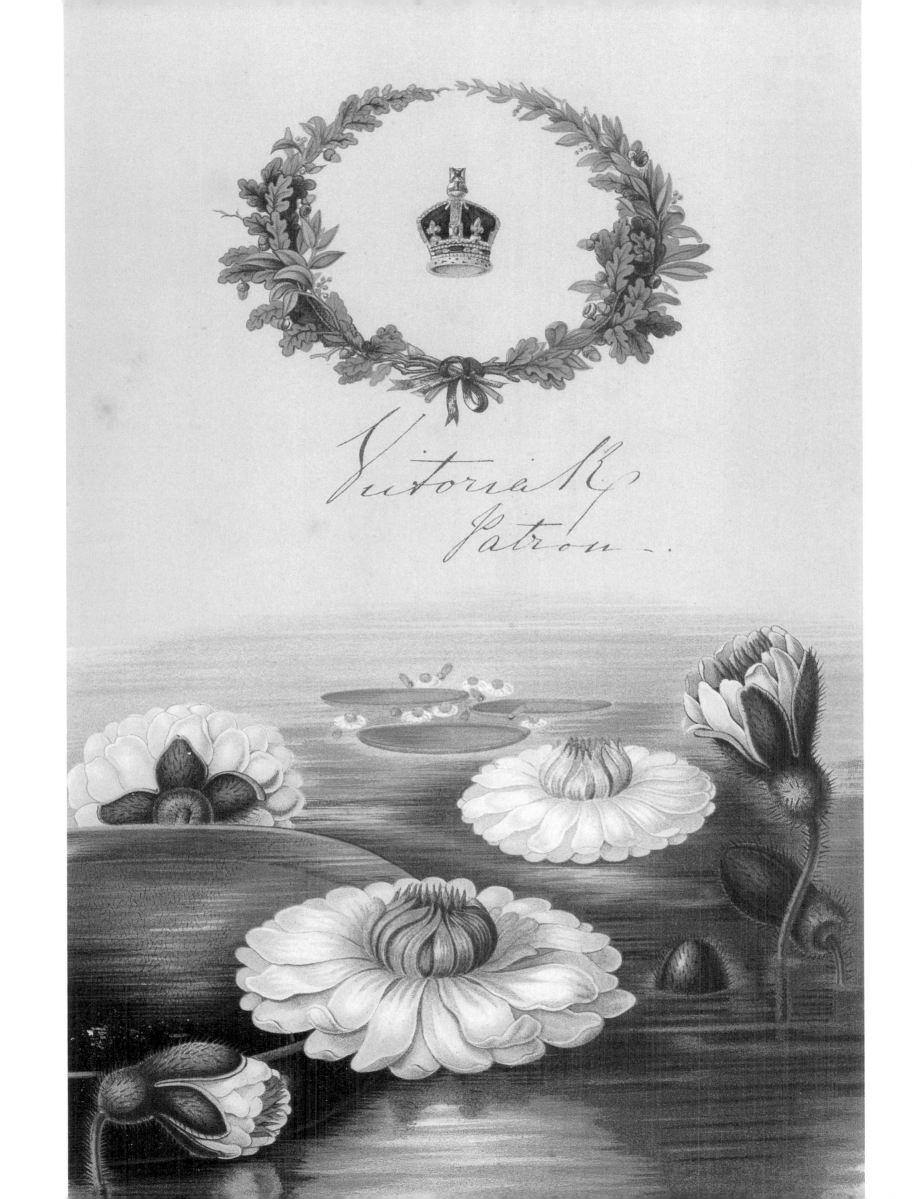

\mathcal{I}NTRODUCTION

Until the 1560s, most plants grown in European gardens were native to Europe and the Mediterranean region. Reliance on western European natives did not mean, however, that the gardeners of the sixteenth century were starved of variety. Elizabethan enthusiasts collected double-flowered forms, interesting deformities, and multiple-colour varieties: double forms of cheiranthus and calendula; different colours of acanthus, aconites, achilleas (only now returning to a wide range of colours); striped aquilegias; lilies of the valley with red and pink flowers; carnations and primroses that exhibited hose-in-hose or other unusual patterns of flowering. Shakespeare commented on the fondness for variegation in *The Winter's Tale*, when Perdita calls striped gillyvors (gilliflowers) 'nature's bastards' because they are raised in cultivation rather than true to wild forms, and refuses to plant them in her garden. Polixenes reasons with her that the gardener simply follows nature's own methods in vegetatively propagating interesting variants:

> ... this is an art
> Which does mend nature, change it rather, but
> The art itself is nature.
> *Per.* So it is.
> *Pol.* Then make your garden rich in gillyvors,
> And do not call them bastards.
> *Per.* I'll not put
> The dibble in earth to set one slip of them.

The first great wave of plant introductions to reach western Europe came from the Turkish empire. From the 1560s onward, crocuses, leucojums, erythroniums, ornithogalums, cyclamens, hyacinths, lilies, fritillaries, ranunculus, and above all tulips, flowed into Europe. This influx of new flowers prompted the first organised programmes for selecting and marketing flower varieties. The interest in oddities and colour variations, already evident with European plants like primulas and carnations, was reinforced by tulips, which produced new colour patterns with great ease (as a result of viral infection). Tulips were not the only flowers to excite the passions of plant enthusiasts. Hyacinths, too, became extraordinarily popular.

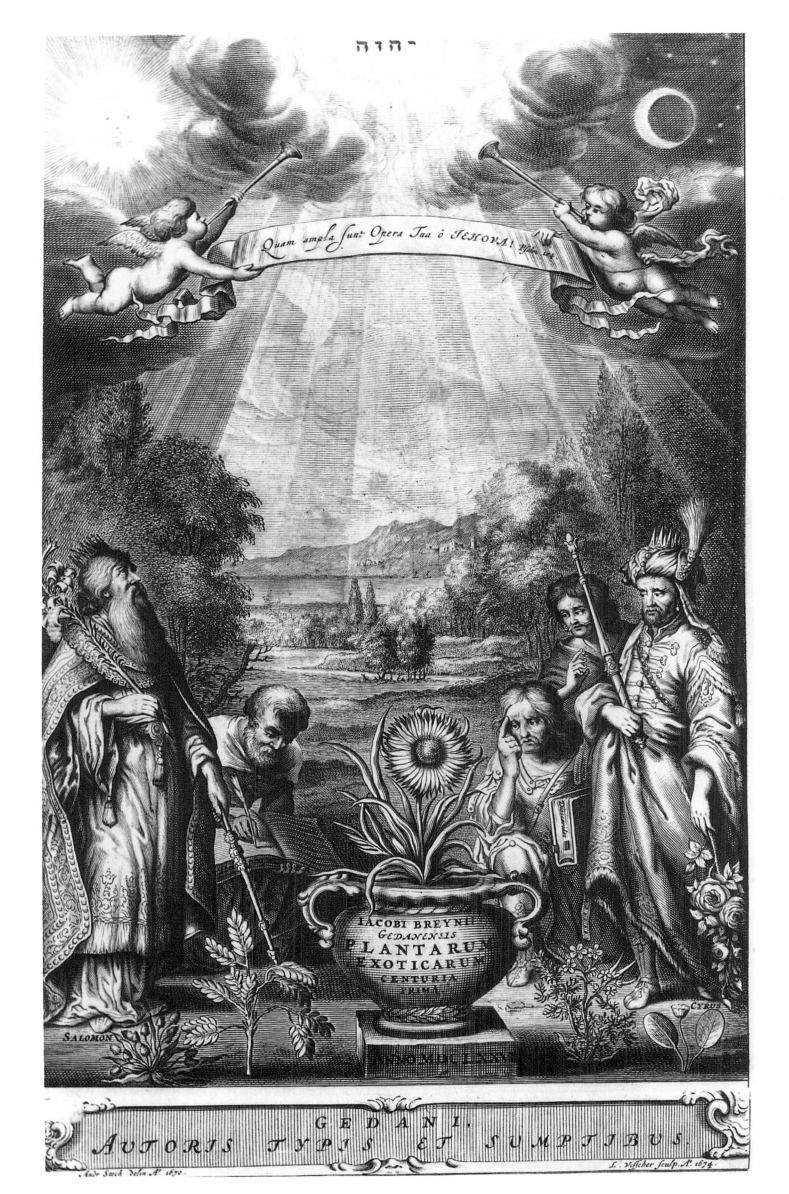

יהוה

Quam ampla sunt Opera Tua ô JEHOVA! Psal. 104.

IACOBI BREYNII
GEDANENSIS
PLANTARUM
EXOTICARUM
CENTURIA
PRIMA

SALOMON

CYRUS

GEDANI.
AUTORIS TYPIS ET SUMPTIBUS.

Andr Stech delin A. 1670.

L. Visscher sculp. A. 1674.

 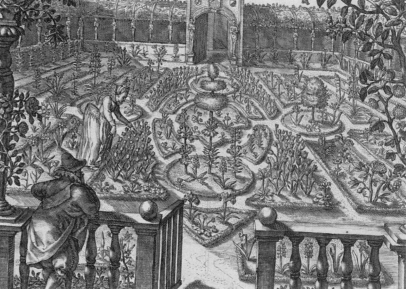

Not all these flowers were strictly speaking for garden use: the enthusiasts for new varieties – 'florists', as they were then called – were dedicated more to the show bench than to the flower garden. During the seventeenth and eighteenth centuries, societies sprang up – first in England, and later on the continent – for the specific purpose of competing in the production and display of new varieties. There came to be eight accepted categories of 'florists' flowers', which had their attendant societies of competitive growers: tulips, hyacinths, auriculas, polyanthus, carnations, pinks, anemones, and ranunculus. These continued to exercise the talents of gardeners well into the beginning of the nineteenth century.

Some American plants, among them the sunflower, had already arrived in Europe before 1600, but the real flood of ornamental plants from the New World began in the 1620s and continued for almost a century, bringing tradescantias, evening primroses, American strawberries, Virginia creeper, trilliums, rudbeckias, spiraeas, and Michaelmas daisies.

Gradually the North American introductions changed in emphasis, and trees and shrubs became the primary focus. But for the flower garden the major source of new plants was the Dutch colony at the Cape of Good Hope, and Leiden and Amsterdam became the centre of introduction to Europe. Most of these plants moved straight into the new greenhouses that the wealthy were building. Here crassulas, mesembryanthemums, stapelias, and other Cape succulents were grown, along with proteas, pelargoniums, and Cape heaths, and the range of large-flowered amaryllis and crinums. Others, nerines, kniphofias, and zantedeschias, proved hardy outdoors.

Many of the popular introductions of the eighteenth century were confined to the glasshouse, and flowers grown outside fell from fashion. This was the heyday of the English landscape garden, when a pastoral scene of rolling lawn and water replaced flower beds as the means of organising the precincts of a country house. Tree introductions were compatible with the landscape garden, but flowers were to a great extent irrelevant, and flower gardens were kept away

European gardens of the sixteenth and seventeenth centuries: a garden design by Vredeman de Vries, dating from 1583 (left); a garden featuring recently introduced bulbs, drawn by Crispijn van de Passe in 1614 (right).

from the principal views. This fashion spread throughout Europe from the 1770s and remained dominant in the early nineteenth century, when English gardeners began to bring back the flower garden near the house.

The eighteenth century had seen the development of the scientific expedition, with botanists and zoologists equipped to collect and bring back interesting new finds, so Australian plants began to enter cultivation even before any substantial European settlements were made. The name 'Botany Bay' indicates the importance ascribed to plant introductions from the new territory. As with South African plants, most of the Australian introductions went straight into the greenhouse and never emerged. Banksias, grevilleas, melaleucas, metrosideros, chorizemas, gompholobiums – all flourished as part of domestic horticulture for those who could afford to grow under glass.

The greatest period in the improvement of greenhouses began in 1817, when the great horticultural authority John Claudius Loudon invented the wrought-iron glazing bar. Loudon had initially looked forward to the day when everyone could have a collection of tropical plants, but by the 1830s he had become chastened, and was recommending that 'oranges, lemons, camellias, myrtles, banksias, proteas, acacias, melaleucas, and a few other Cape and Botany Bay plants, are all that can with propriety be admitted into a small conservatory'. So, while the fashion for Australian plants faded, its legacy continued in the English greenhouse throughout the century.

By 1820 the nursery trade had become a significant commercial force, and the largest nurseries, like Loddiges' of Hackney and Veitch's of Chelsea, were able to mount their own collecting expeditions. The introduction in the 1830s of the Wardian case, a closely glazed case in which plants could be placed with some earth and water, forming a self-sustaining environment, revolutionised the business of transporting plants overseas. New plants began to flood into Europe. From the British colonies in India came rhododendrons; from the west coast of America came conifers and a slough of ornamental annuals;

European gardens of the seventeenth and nineteenth centuries: the garden of Pieter de Wolff, in Amsterdam, 1676, showing greenhouse plants set out for the summer (left); the garden at Dirleton Castle, Scotland, in the 1870s, with bedding plants including pelargoniums, petunias and verbenas (right).

from Mexico came fuchsias and dahlias; from China came varieties of chrysanthemums, peonies, and camellias, the legacy of a long tradition of cultivation. And eventually, after opening to the West in 1854, Japan began to yield new irises and maples. Dahlias and chrysanthemums became the new florists' flowers of the age, sparking competitive societies into existence.

Just as important as the number of new species introduced was the sheer number of specimens. Once plants that had been regarded as rare specimens became sufficiently numerous, gardeners could take risks with them, exposing some to the winter to see how hardy they would prove. And so plants that had once been confined to the greenhouse, like rhododendrons and camellias, began to move permanently outdoors, and many half-hardy plants moved into the flower garden for the summer season, to return to protective cultivation in the winter. Meanwhile, the older florists' societies were dying out, despite periodic attempts to revive them. They were replaced by horticultural societies devoted to the newer introductions and less concerned with competitive variation.

A new concept had now been added to the plant enthusiast's repertoire: breeding. Once the existence of sexual reproduction in plants was established, its experimental use was initiated in the early eighteenth century, with Thomas Fairchild creating the first documented artificial hybrid ('Fairchild's mule' – a cross between a carnation and a sweet william). The first extensive programme for breeding new ornamental plant varieties was begun in the 1790s by William Rollisson, who produced Cape heaths for the greenhouse.

In the 1840s, selective breeding hit the flower garden in a big way. Authorities like John Claudius Loudon were calling for flower beds to be arranged as solid masses of colour, spurring a demand for plants that would have a larger proportion of flower to foliage. The first bedding varieties of pelargoniums from South Africa, and petunias, verbenas, and calceolarias from South America, began to appear.

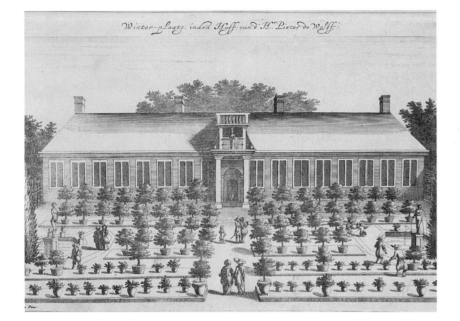

About 1870, continental gardeners developed an interest in English-style bedding, particularly in the latest fashion for 'carpet bedding', the use of low-growing foliage plants to create flat patterned beds. But, while in England carpet bedding and flower bedding were seen as two distinct styles, on the continent gardeners felt no hesitation about mixing them together, and the resulting composite style spread around the world during the 1880s. Parallel to this development was an interest in restoring and replicating the formal garden designs and plantings of the sixteenth and seventeenth centuries. Once again, this fashion developed first in England, but by the beginning of the twentieth century it had spread to the continent and beyond.

In recent years, new introductions for the garden have dwindled – the focus of plant exploration these days is medicinal plants, not ornamental plants. Novelty in the garden has therefore had to be satisfied by hybridisation. Begonias, impatiens, hostas, hemerocallis, and of course roses, have been the subject of major programmes of breeding. But, gradually coming to rival the breeding of novelties, revivalism has increased its hold on the plant world. The revival of old roses began between the world wars, and reached a peak with the work of Graham Stuart Thomas at Sunningdale Nurseries in the 1960s. Auriculas, which had come close to disappearing from cultivation, became the subject of a major fashion in the 1980s. There is now widespread interest in the range of cultivated varieties that formerly existed, and attempts are being made to protect and rediscover them. Perhaps in the future this interest will spread to the vanished Victorian bedding plants, to the varieties of hyacinths, anemones, and ranunculus that were grown in the eighteenth century, or to the curiosities of the Elizabethan garden.

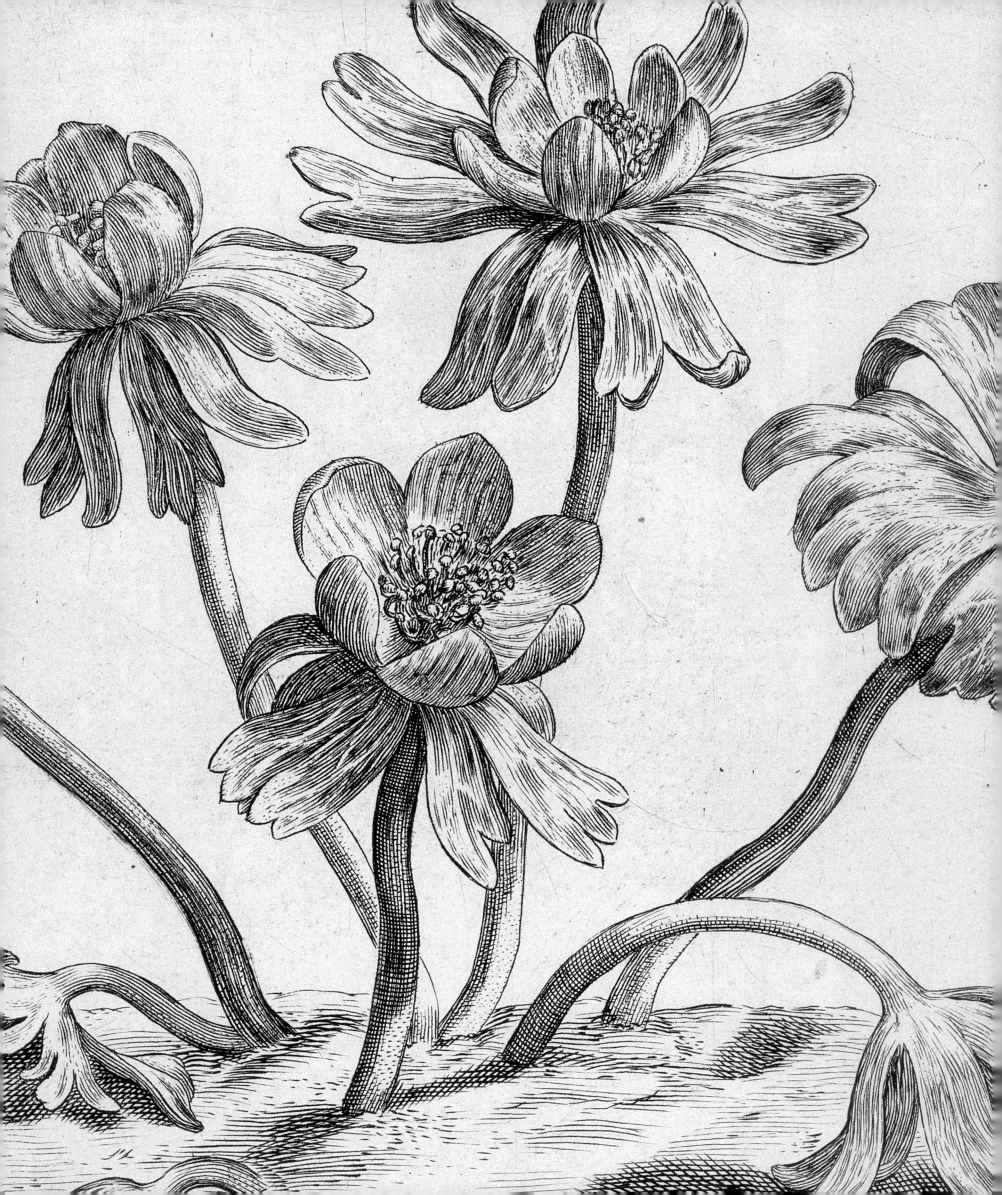

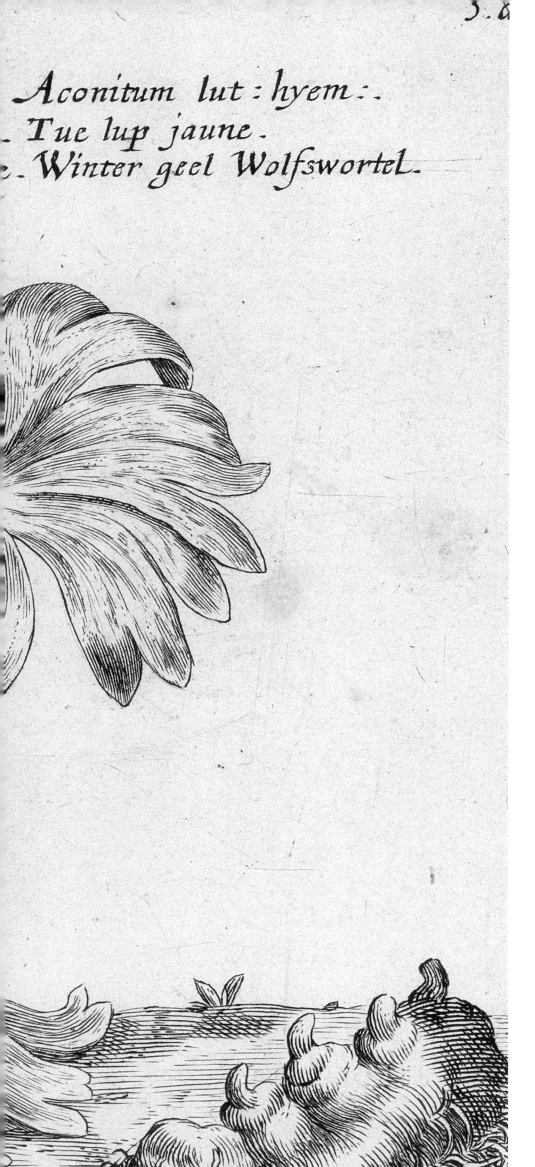

Aconitum lut: hyem:.
Tue lup jaune.
Winter geel Wolfswortel.

Chapter One

WINTER ACONITE A seventeenth-century illustration
from the *Hortus Floridus* of Crispijn van de Passe.

EUROPE

The first printed English books on gardening were published in the late sixteenth century. By that time garden plants from Asia had long since taken up residence in European gardens and the first introductions from the New World were appearing. But the native flora of Europe had not yet lost its predominance in the gardens of western Europe and of England. John Gerard was the first Englishman to publish a catalogue of his garden, and his *Herball* of 1597, although in principle devoted to the medicinal uses of plants, is our major source of information on what was grown in Elizabethan gardens. From Gerard we learn that sixteenth-century garden owners were enthusiastic about variegation and double flowers (a term that includes everything from flowers with more petals than usual, to 'hose-in-hose' flowers, with additional corollas growing from the centre of the main corolla). Drawing on the native flora alone, Gerard grew blue and white forms of ajuga, double aquilegias, double cheiranthus, double silenes, red and pink lilies of the valley, variegated fritillaries and wood anemones in yellow, white, purple, and scarlet. Of introductions from the continent, Gerard grew acanthus, red and yellow adonis, achilleas, single and double hollyhocks, thirteen sorts of allium, snapdragons, delphiniums, dictamnus, *Erythronium dens-canis*, eight forms of verbascum, and seventeen sorts of narcissus and daffodils.

John Parkinson's *Paradisi in Sole Paradisus Terrestris* of 1629 was the first English gardening book to describe the full range of available garden plants instead of merely offering generalised cultivation instructions. Parkinson was still growing acanthus and adonis; he had snapdragons in white, purple, yellow, and red, striped auriculas, and twenty-four sorts of roses. He devoted twenty-four pages to hyacinths, and forty-two to daffodils. The interest in double forms continued; he was enthusiastic about double calendulas, daisies, wallflowers, and daffodils.

During the seventeenth and eighteenth centuries, societies sprang up – first in England, and later on the continent – for competitively producing and displaying new floral varieties. Known as florists' societies ('florist' meaning a raiser of new varieties, not, as in later years, a floral decorator), they were devoted to eight categories of flowers: tulips, hyacinths, auriculas, polyanthus, carnations, pinks, anemones, and ranunculus. Of European origin were auriculas and polyanthus (both forms of *Primula*), and carnations and pinks (both forms of *Dianthus*).

Some forms of pinks were native to Britain, including the now endangered Cheddar pink (*Dianthus gratianopolitanus*). But the species that were to become most popular were continental introductions: the carnation (*D. caryophyllus*) from southern France, already fashionable by the reign of Edward III; the pink (*D. plumarius*) and the sweet william (*D. barbatus*) from the Mediterranean, which arrived during the sixteenth and early seventeenth centuries. Gerard described four sweet williams, twelve pinks, and single and double clove gilliflowers; Parkinson increased the numbers to eight sweet williams, fourteen pinks, nineteen carnations, and twenty-nine clove gilliflowers. Carnations and pinks became the clear favourites later in the century, when John Rea, in the second edition of his *Flora, seu de Florum Cultura* (1676), listed 360 varieties.

Gerard knew two forms of the native British *Primula veris*, seven forms of cowslip and oxlip (the latter a natural hybrid) and eight auriculas, which had recently arrived from the continent. By Parkinson's time, the auriculas in particular were on the increase; striped varieties had appeared and doubles were as popular as the double-flowered forms of other plants. By the time Samuel Gilbert published his *Florist's Vade-mecum* in 1682, striped and double-striped auriculas had become the most popular forms. In the middle of the eighteenth century, edged auriculas (called English auriculas on the continent) appeared, and doubles faded from fashion. Striped auriculas had vanished by the nineteenth century and have never been redeveloped. Meanwhile, by the 1680s, a red-flowered form had appeared. It became known as the polyanthus, and in the eighteenth century gold-laced varieties were developed – within decades it was the most popular English exhibition flower.

The late eighteenth and early nineteenth centuries were the golden age of the auricula and polyanthus. They continued to be grown as plants for exhibition rather than for the garden. A collector might display them on a purpose-built stage known as an auricula theatre, a nineteenth-century example of which survives at Calke Abbey in Derbyshire. But, during the later nineteenth century, the florists' societies that had once flourished in England began to diminish in number, and most of them had been wound up by the early twentieth century. Influencing this decline

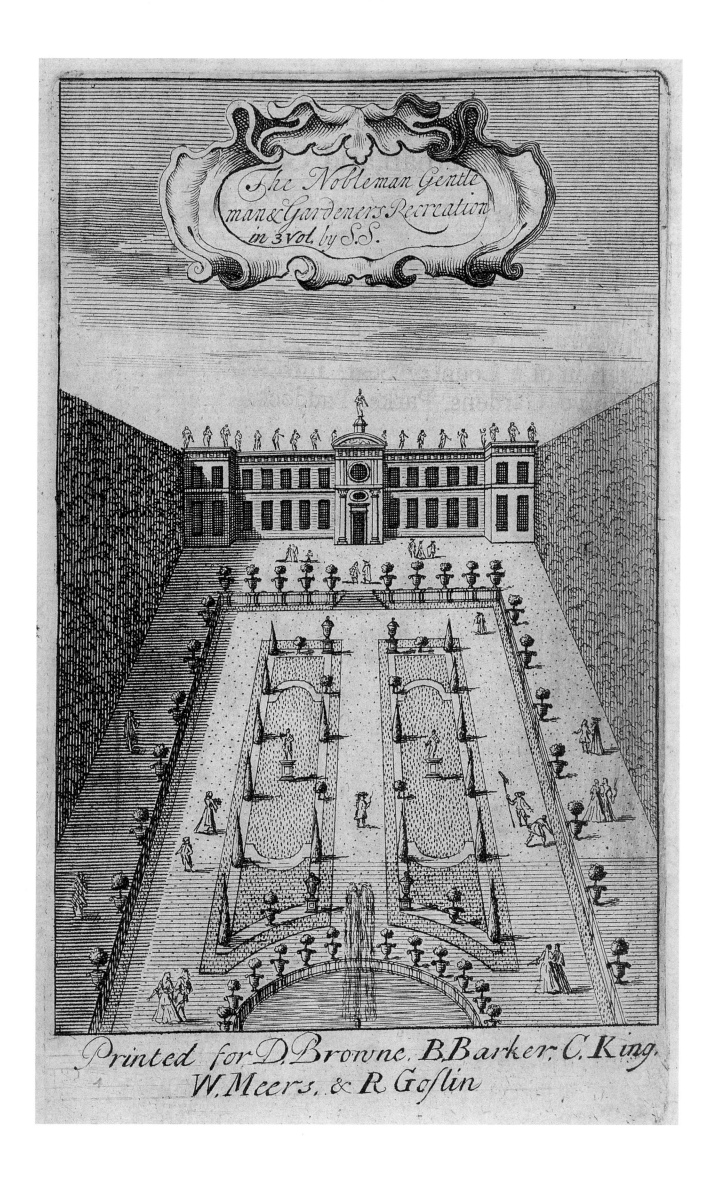

The Nobleman Gentle
man & Gardeners Recreation
in 3 vol. by S.S.

Printed for D. Browne. B. Barker. C. King.
W. Meers. & R. Goslin

An early eighteenth-century formal garden, which shows the typical layout and plantings of the period, from Stephen Switzer's *Ichnographia Rustica: or, the Nobleman, Gentleman, and Gardener's Recreation* (1718).

was the nineteenth-century rise of local horticultural societies devoted to growing the latest exotic introductions. These drew the well-to-do away from the traditional limited range of exhibition flowers.

In the early eighteenth century the flower garden profited from the introduction of the sweet pea, several species of *Cistus*, *Helianthemum umbellatum*, and the most important forms of *Cytisus*. Most of the older border plants continued their popularity, and colour variations were still eagerly sought. Double flowers were falling from fashion in England and France, though not in Germany, which since the Thirty Years' War had tended to be a generation behind western Europe in horticultural fashions. Johann Wilhelm Weinmann's *Phytanthoza* (published 1734–1747) reveals ranges of variation in poppies, rocket, wallflowers, scabious and lychnis that have not been explored in modern times. And, while in the early nineteenth century exotic introductions seemed to garner the largest press, certain plants of European origin flourished through the discovery of hybridisation techniques. There was a boom in hollyhock breeding from the 1830s; striped snapdragons emerged in the 1850s; and the pansy was developed in the 1820s and 1830s, followed by the garden viola (or tufted pansy as William Robinson called it) in the 1860s.

Of all the garden plants of European origin, by far the most popular and esteemed was the rose. The ancient Romans had grown roses on a large scale, for the production of scent as well as for garden decoration. In the Middle Ages roses were considered as important for their medicinal uses as for their beauty. Many of the roses that were thought of as different species were in fact garden hybrids of long standing, their garden origin having been undocumented or forgotten. The Gallicas were sufficiently popular in England to yield the red rose of Lancaster, and the Albas, the white rose of York. During the sixteenth century, the Centifolias or cabbage roses appeared, probably the result of accidental crossing between Albas and Damask roses. These, with the sweetbrier or eglantine, remained the basis of European rose growing until the introduction of yellow roses from China in the early nineteenth century.

The nineteenth century was the great age of historical revivalism. Garden designs from the past and from different national styles were rediscovered and experimented with, first in Britain and then across the continent.

The martagon lily (opposite) is native to Europe. It was grown in seventeenth-century gardens, as shown here in a period illustration, and by 1800 there were twenty varieties. Today there are no more than half a dozen varieties available.

As early as the 1820s some writers, such as John Claudius Loudon, recommended Parkinson's *Paradisus Terrestris* as a guide for planting a herbaceous border, and in the 1860s a stronger interest emerged in trying to replicate seventeenth- and early eighteenth-century planting in designs modelled on those periods. The 'old-fashioned garden' of the last third of the century eschewed modern bedding plants, and concentrated on larkspurs, rocket, hollyhocks, and other border plants used two centuries earlier. The immediate consequences were the attempt to grow improved varieties of these plants; breeding programmes for delphiniums, sweet peas, and peonies; and the attempt to recover once popular plants that seemed to have vanished. Peter Barr led a campaign to find again all the daffodils named by Parkinson, and the rescue of forgotten plants from cottage gardens was exaggerated into a period myth. One of the major horticultural fashions in the twentieth century was the recovery of old roses.

Another trend emerged in the late nineteenth century that has carried through to the present day. In 1870 William Robinson, the most influential British gardening journalist of the late nineteenth century, published his book *The Wild Garden*, coining a name for a trend that had been slowly developing over the preceding quarter-century. In Robinson's hands, the wild garden had a quite specific meaning: it was a garden of self-maintaining plants, a form of labour-saving garden, composed of plants (often exotics such as Chinese rhododendrons or Japanese knotweed) that could naturalise in the local climate. However, the concept also extended to the specialist collection of native plants, to which Robinson himself devoted a chapter. In one form or another, wild gardening spread throughout northern Europe and America between the 1880s and World War II. While the woodland garden, planted with exotic plants, absorbed the attention of early twentieth-century gardeners, the second half of the century saw a reaction in favour of native plants. The waning of many once-frequent species of birds, mammals, and insects reinforced this movement, with the widespread encouragement of gardening for wildlife. And so many native European, and specifically British, plants that had been relegated to subordinate positions since the beginning of large-scale plant exploration in the eighteenth century returned to prominence at the end of the twentieth century.

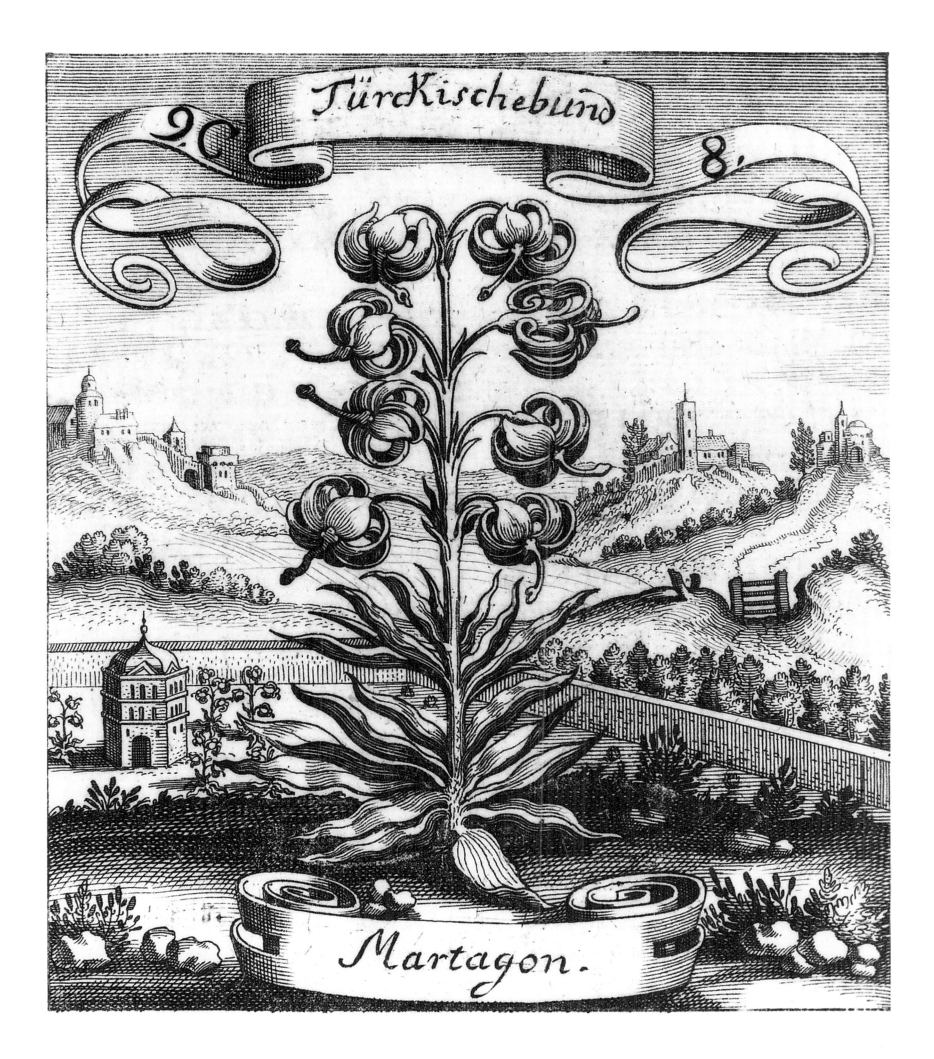

TürcKischebund

90

8.

Martagon.

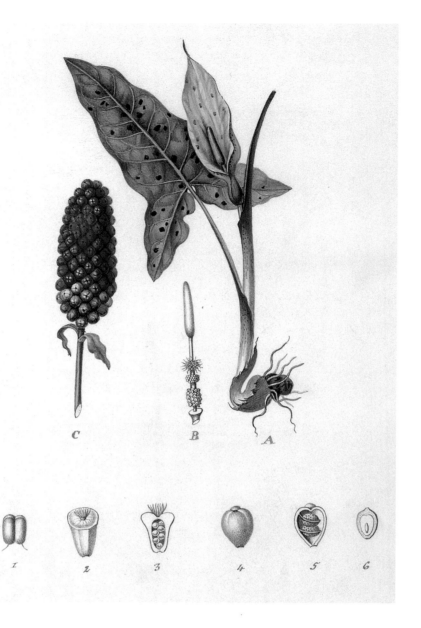

\mathcal{A}RUM MACULATUM &
\mathcal{A}RUM ORIENTALE SSP. ENGLERI

The native English *Arum maculatum* (above) was only the most familiar of a range of plants with flowers in the form of a spathe. *Arum orientale* (right) was introduced by the German botanist Marschall von Bieberstein from the Crimea in the eighteenth century. Well into the nineteenth century, *Arum* was an accepted name for a wide variety of aroids from around the world (later separated into *Dracunculus*, *Arisaema*, and other genera), which were grown as ornamental curiosities.

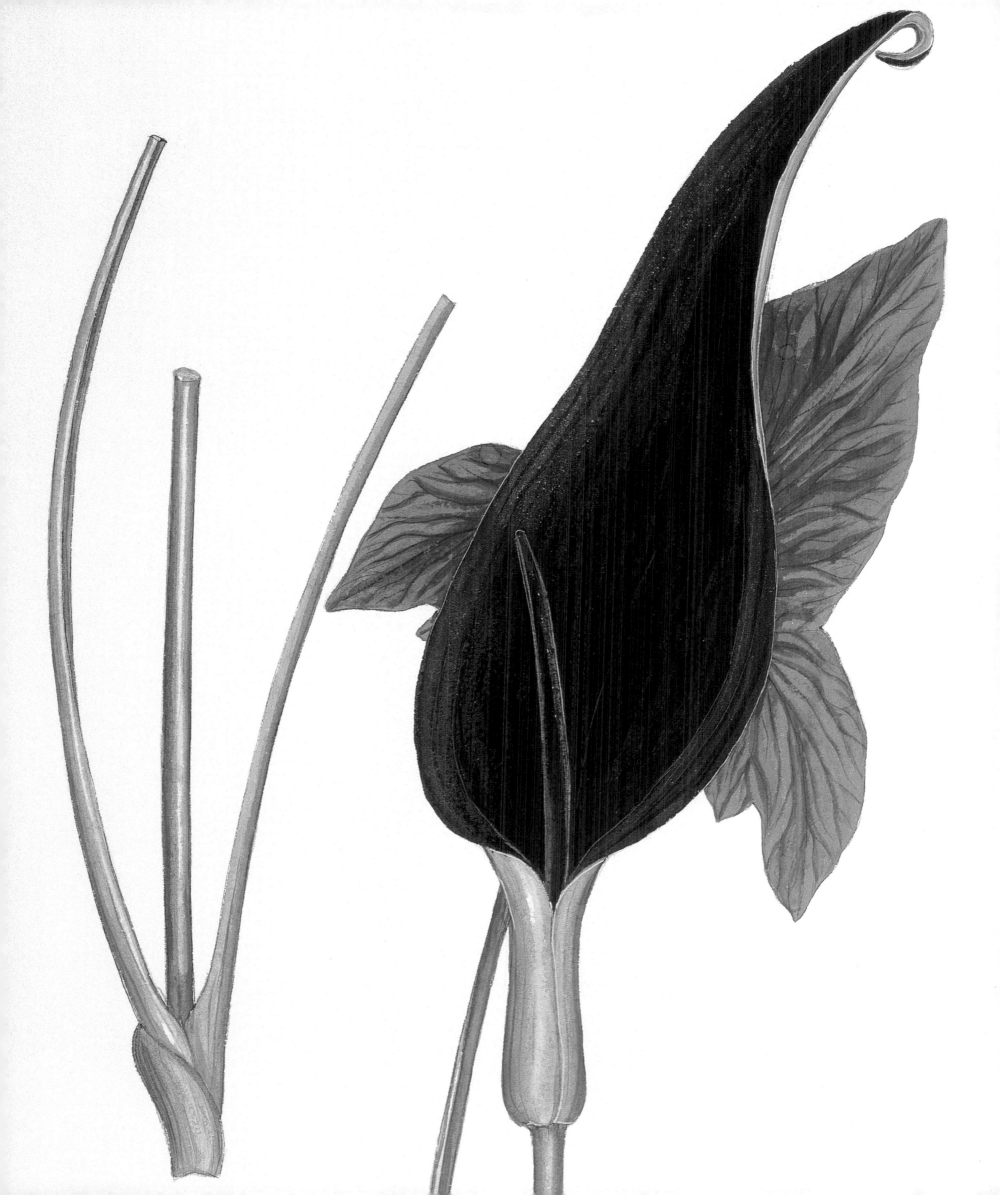

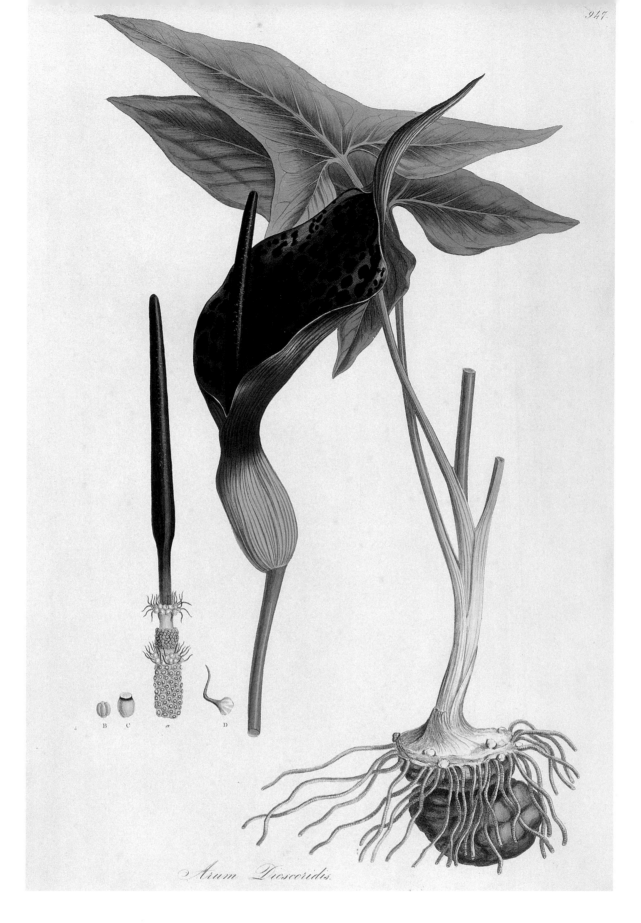

Arum Dioscoridis.

ARUM DIOSCORIDIS

Arum dioscoridis was named by John Sibthorp, the Oxford botanist who travelled to Greece in the 1780s in order to identify the plants in Dioscorides' first-century treatise on medicinal plants. Highly variable in its colouring and markings, it exists in several recognised varieties. The eighteenth century saw the introduction of several aroids, originally grouped together and only later separated into genera such as *Calla, Zantedeschia,* etc.

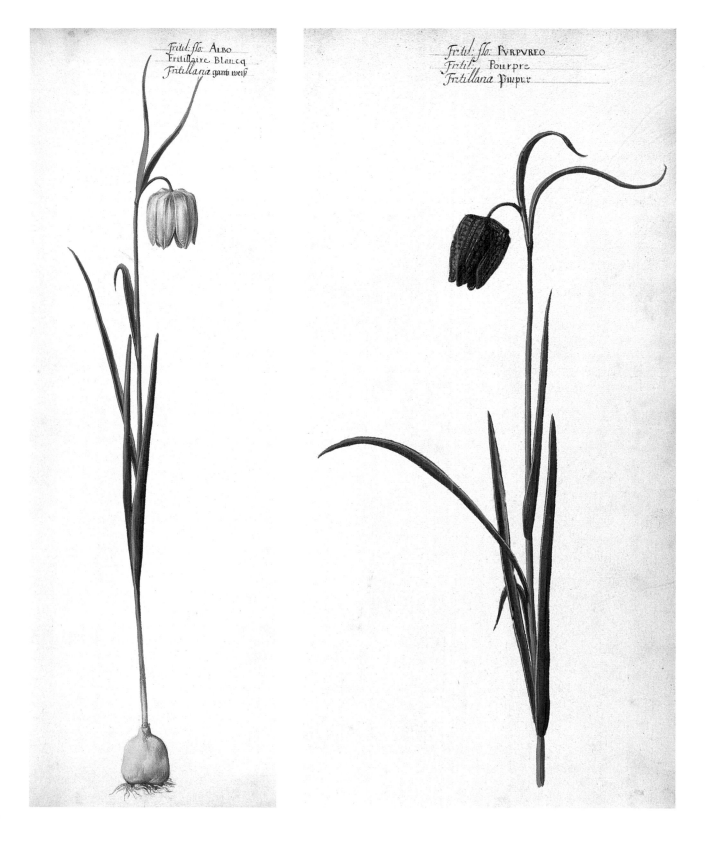

Fritil: flo: Albo
Fritillaire Blancq
Fritillaria gants weiß

Fritil: flo: Pvrpvreo
Fritil: Pourpre
Fritillaria Purpur

FRITILLARIA MELEAGRIS

Fritillaria meleagris was introduced into England from France in the sixteenth century, and only two
centuries later was discovered to be native, though rare, in England. It was much admired by early
collectors for the chequered patterns on its petals. Eight forms – white, yellow, in different shades of
purple, as well as double-flowered – were still extant in the late nineteenth century, when William
Robinson recommended it as a plant for the wild garden.

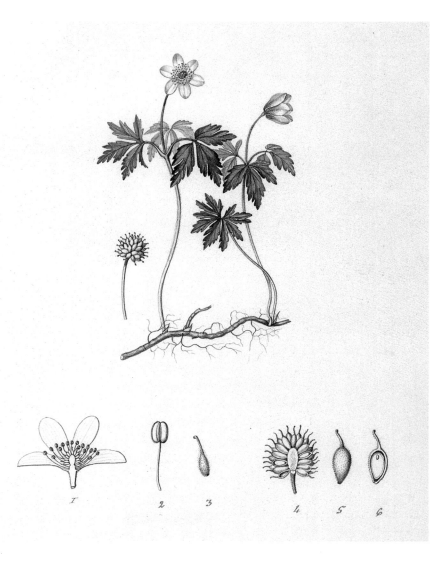

ANEMONE NEMOROSA

The British wood anemone, *Anemone nemorosa*, is now considered an indicator plant for ancient woodlands. It is highly variable, and in the sixteenth and seventeenth centuries English gardeners grew purple, blush, and double white forms. It underwent another vogue in the late nineteenth century, when the snowdrop hybridist James Allen raised the blue form 'Allenii', and his friend E. A. Bowles collected or developed several forms, which he described in his 1914 book *My Garden in Spring*.

ADONIS ANNUA

'I brought the seede, and haue sowen it in my garden for the beautie of the flowers sake,' said John Gerard in 1597 of the red-flowered *Adonis annua*; he also knew of a yellow-flowered form, not to be confused with the yellow *Adonis vernalis*, only introduced in the seventeenth century. Other species of *Adonis* have been introduced in the succeeding centuries but have not become common in the garden.

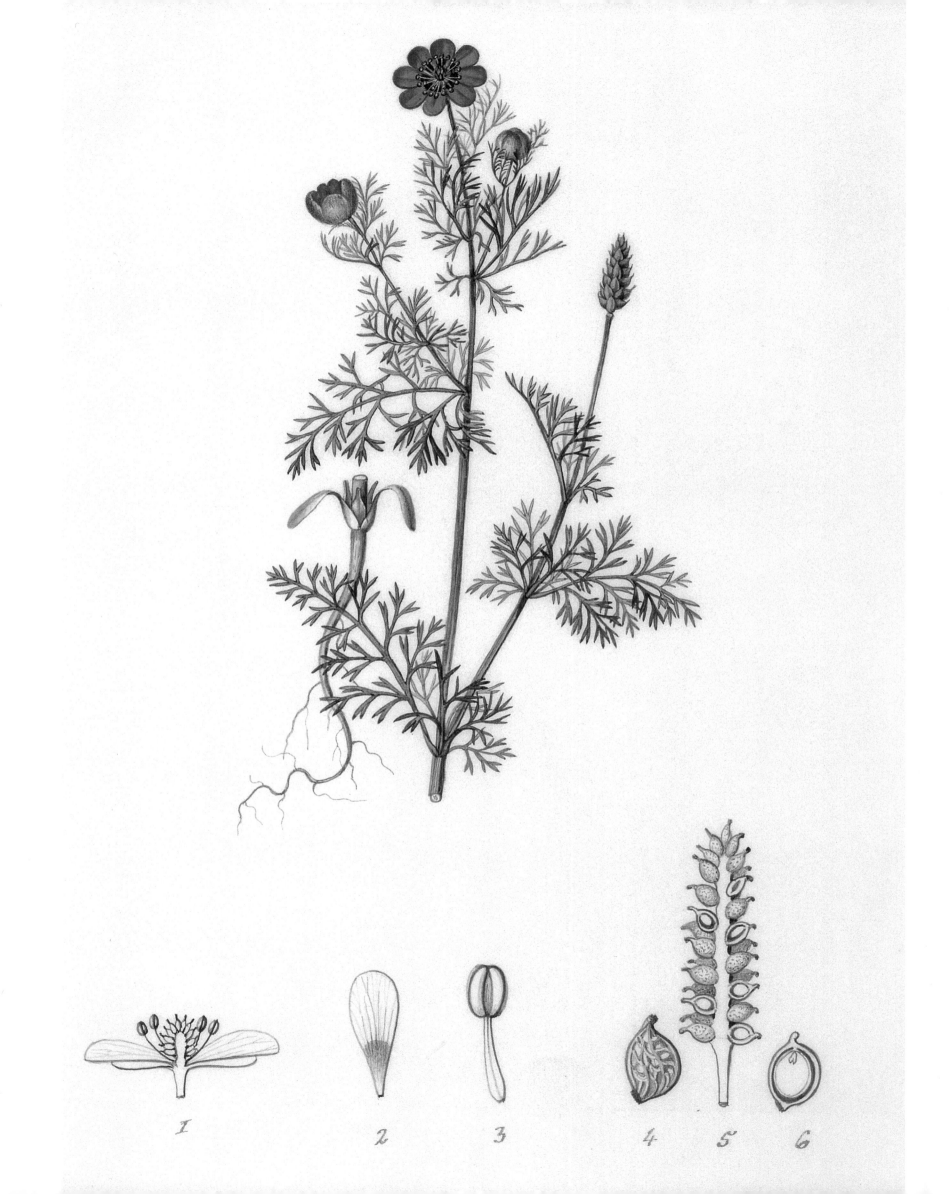

1 *2* *3* *4* *5* *6*

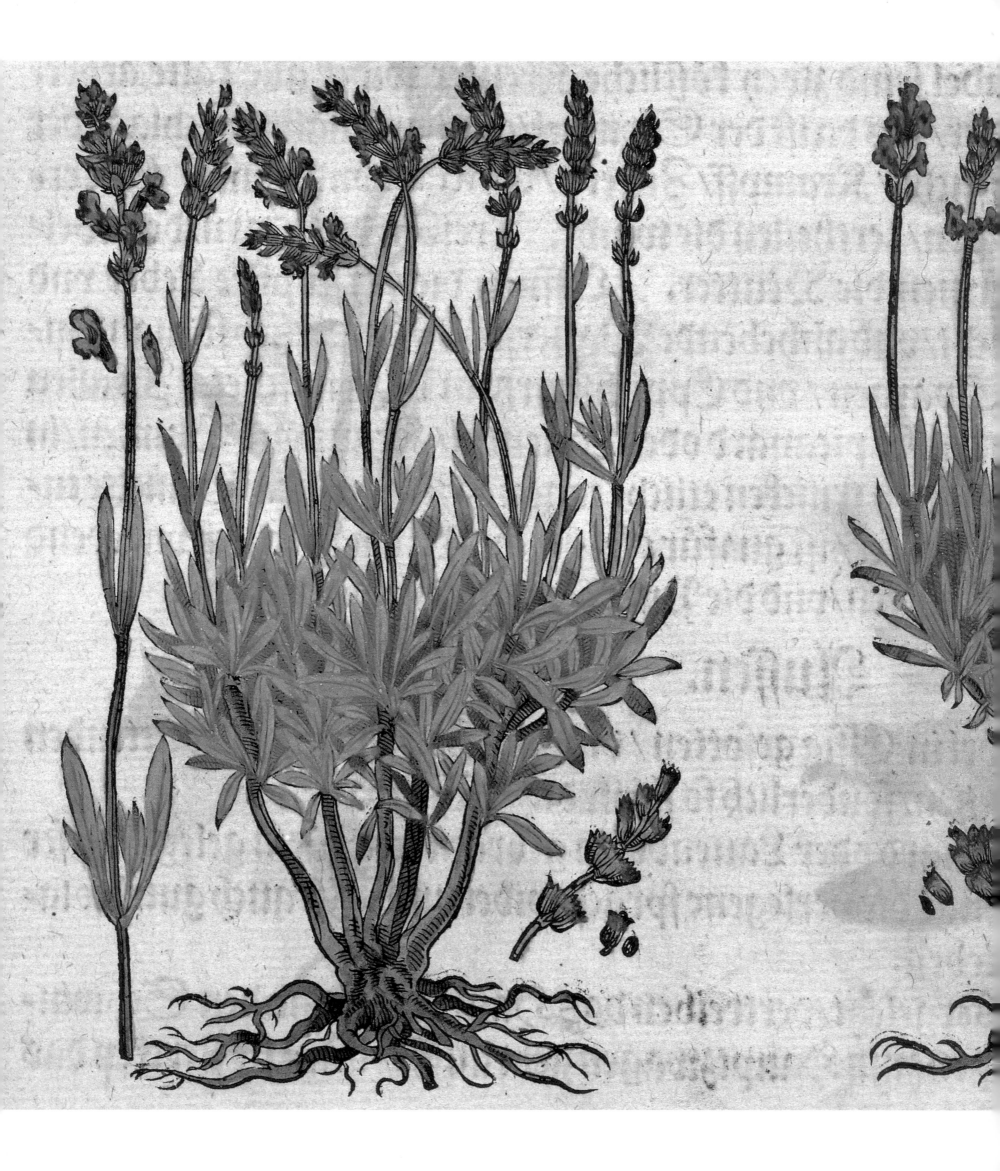

ℒAVANDULA

Lavender was introduced to Britain during the Middle Ages, if not earlier, and by the Elizabethan period was being used not only as a herb for flavouring and medicine but as a border plant, a means of edging flower beds, as a substitute for grass in lawns, and even as a shrub for shaping into topiary. In the late nineteenth century, it enjoyed renewed popularity as an 'old-fashioned' flower, cultivated for its Tudor associations, and was once again used for edging flower beds. This illustration comes from the *Kreutterbuch* (1586) by Pierandrea Mattioli.

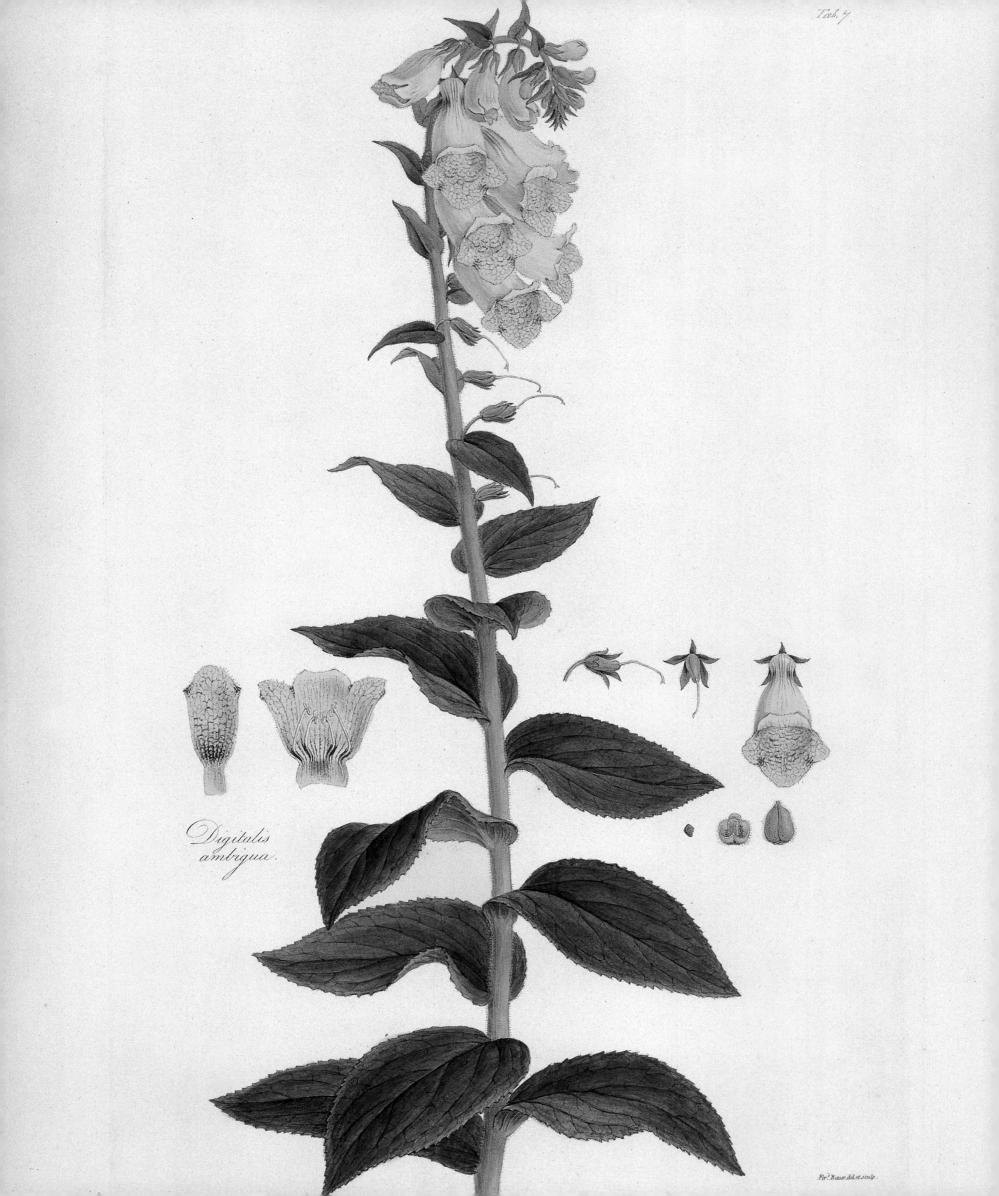

Tab. 7

Digitalis
ambigua.

Fer! Bauer del. et sculp.

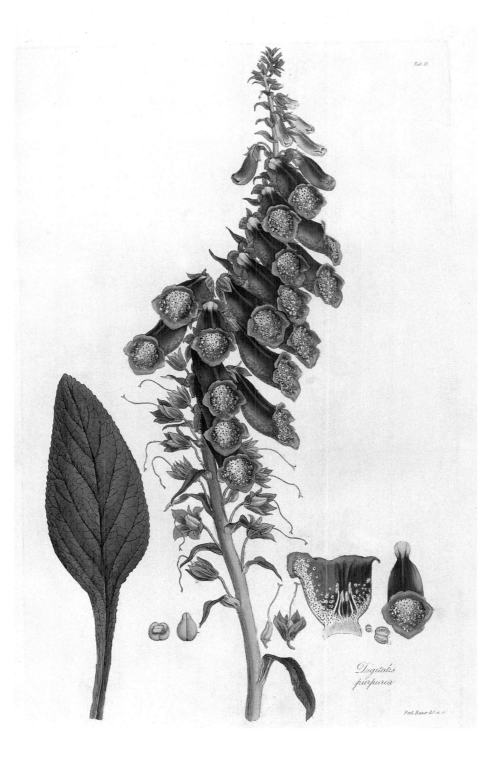

Digitalis purpurea

DIGITALIS GRANDIFLORA &
DIGITALIS PURPUREA

The native foxglove, *Digitalis purpurea* (above), was long grown in English gardens both for ornament and medicine. In the 1590s, John Gerard was growing two foreign species, and the number of species available increased steadily throughout the seventeenth and eighteenth centuries, until John Lindley's *Digitalium Monographia* of 1821 could list twenty-three (not all now recognised). Among these was *Digitalis grandiflora* (left), known to Lindley as *D. ambigua*. The native foxglove returned to popularity in the late nineteenth century as an 'old-fashioned' flower for the herbaceous border.

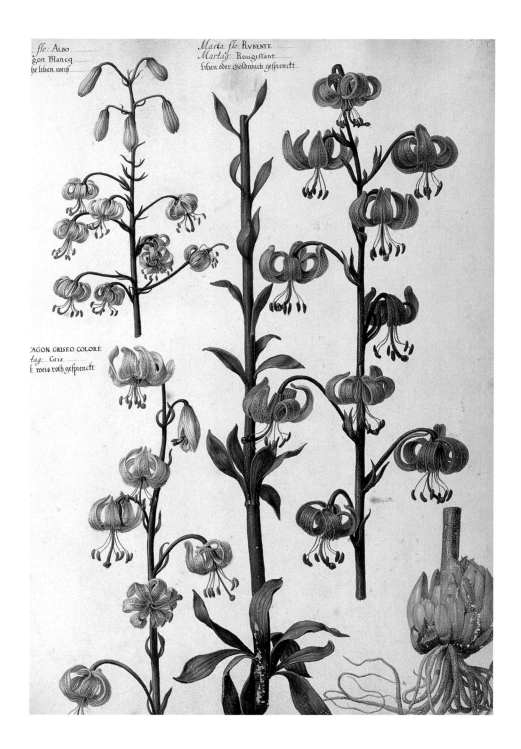

\mathscr{L}ILIUM MARTAGON & \mathscr{L}ILIUM CANDIDUM

Martagon lilies (above) and the Madonna lily *Lilium candidum* (opposite) are native in Europe, and martagons have been claimed to be native to the British Isles. John Parkinson recorded five forms of martagons in his garden in 1629, and at the beginning of the nineteenth century over twenty cultivars were available; but their popularity waned as tiger lilies and other new species arrived from Asia. In the 1890s, William Robinson recognised only three varieties, of which the white variety *album* was the most popular.

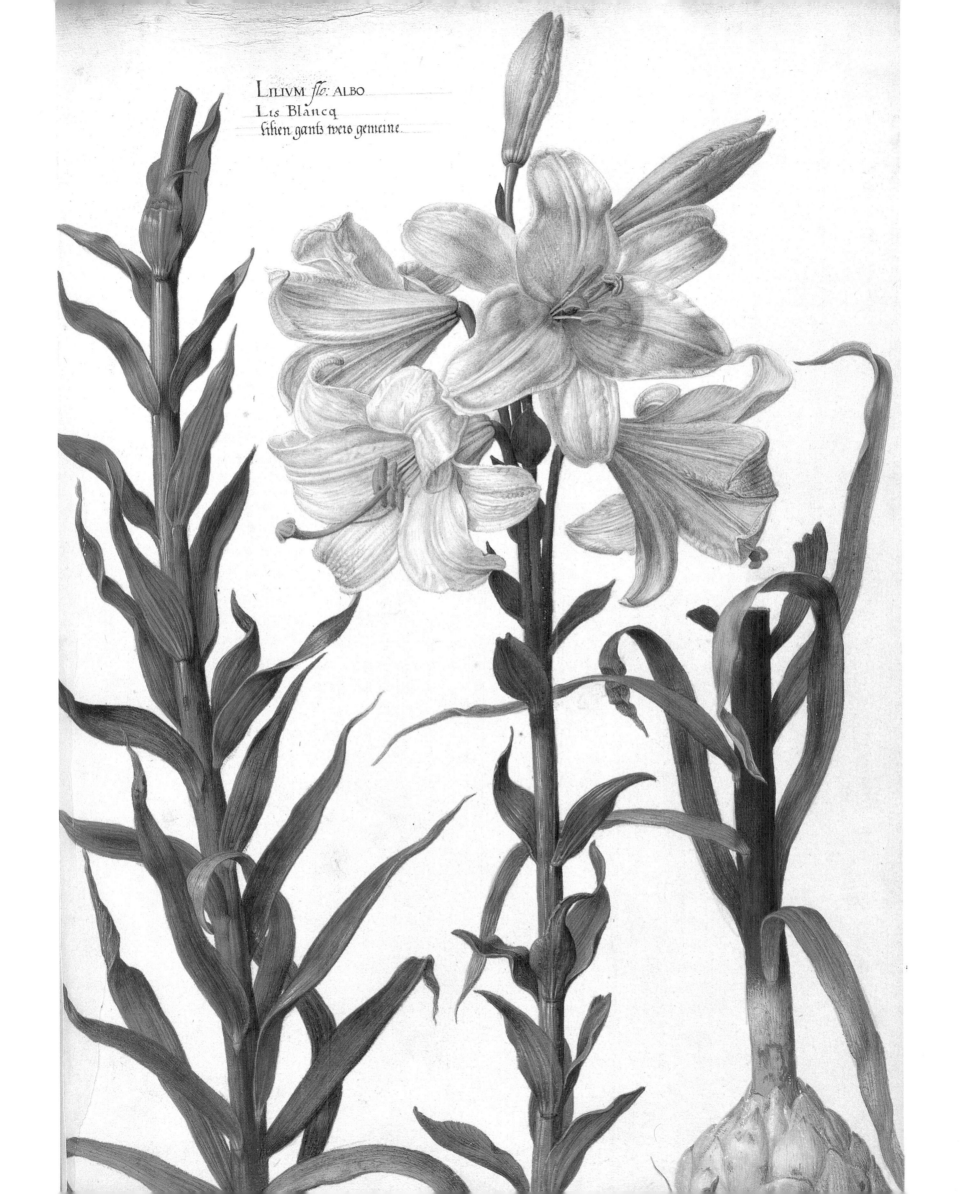

LILIVM *flo:* ALBO
Lis Blancq
filien gantz weis gemeine

Lilium album maculatum
Catal. Hortulanor. Batavor

ℒILIUM CANDIDUM VAR. PURPUREUM

Lilium candidum was traditionally known as the white lily, until other white species were introduced in the nineteenth century; it then became known as the Madonna lily, because of its association with the Virgin Mary in Renaissance paintings, and because of the Victorian interest in exploring, and sometimes inventing, medieval folklore. The eighteenth-century nurseryman Thomas Fairchild raised a form with pale purple stripes on the petals, shown here, which has since disappeared.

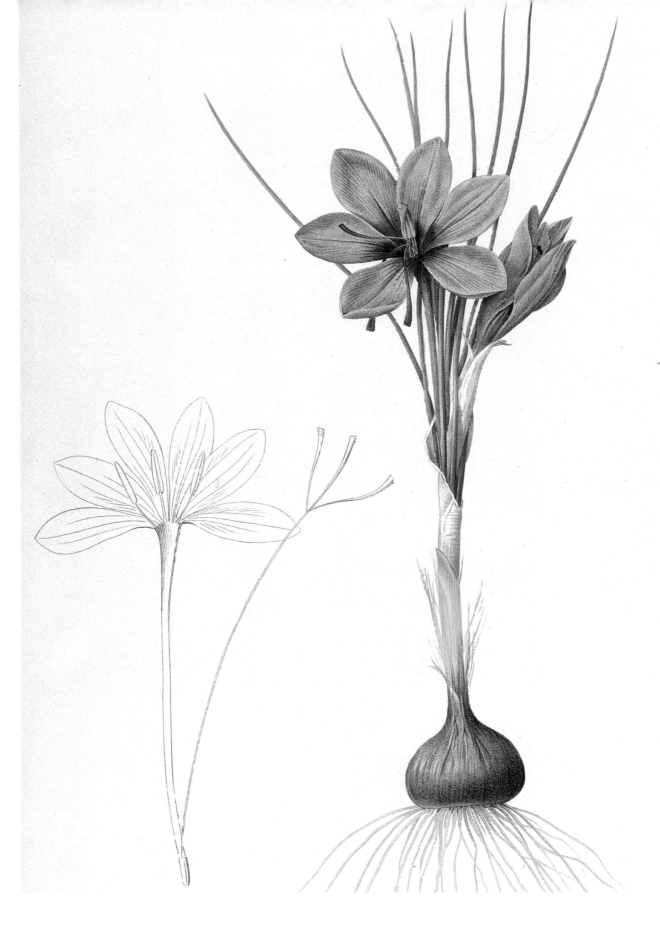

CROCUS SATIVUS

The saffron crocus was introduced, or re-introduced, into Britain in the Middle Ages, and became the basis of an industry; the town of Saffron Walden takes its name from the dye industry which grew up around this flower. As foreign crocuses with a wider colour range were introduced, the popularity of the saffron crocus steadily waned during the nineteenth century. William Robinson omitted it from his influential *English Flower Garden*.

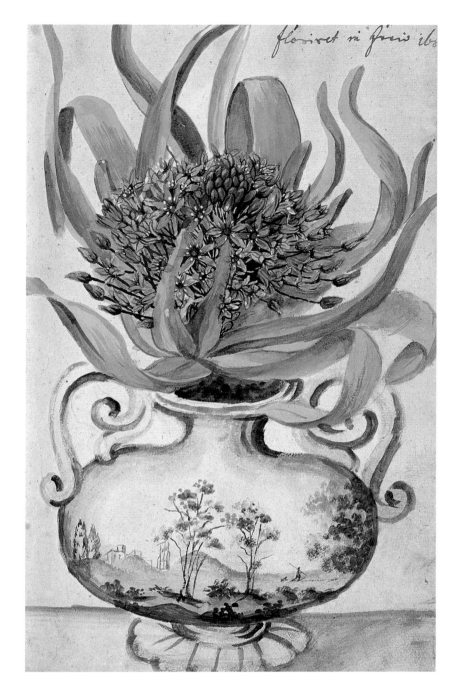

SCILLA LILIOHYACINTHUS

Scillas experienced their greatest popularity in the sixteenth and seventeenth centuries, when John Parkinson could list fourteen sorts. *Scilla peruviana* (a Spanish species, despite the name) arrived in the early seventeenth century, followed by *Scilla liliohyacinthus*, shown here from *Hortus Romanus* (1772–1784).

BELLIS PERENNIS CULTIVARS

Some two dozen forms of *Bellis perennis*, the common British daisy, exist today. Double forms, and the hen-and-chickens form (bottom centre), were collected by Elizabethan gardeners. A dozen different forms were grown in the eighteenth century, including long-petalled forms, doubles, and different colour patterns. Collecting daisy varieties remained popular in Germany longer than in England.

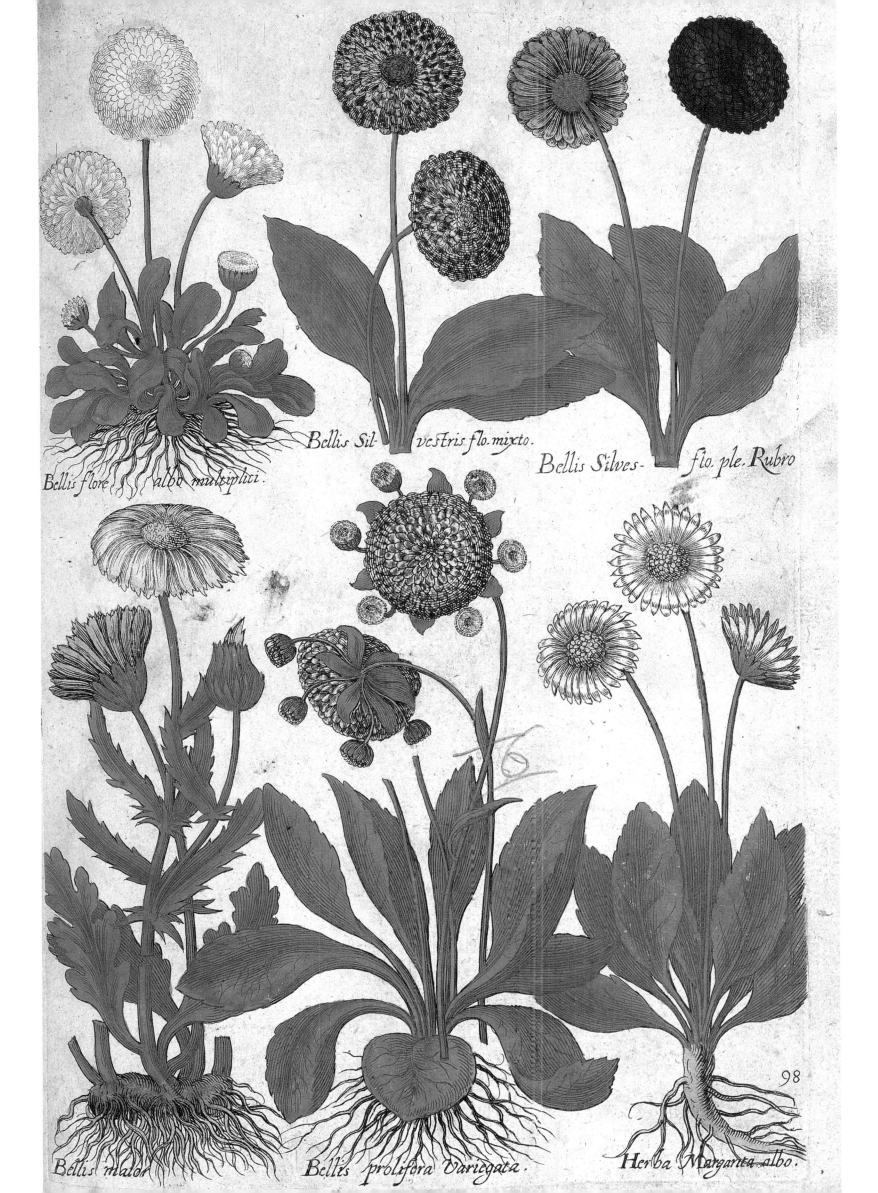

Bellis Sil- vestris flo. mixto.

Bellis Silves- flo. ple. Rubro

Bellis flore albo multiplici.

Bellis maior.

Bellis prolifera Variegata.

Herba Margarita albo.

98

Auriculas

Gerard knew two forms of the native *Primula veris*, seven forms of cowslip and oxlip (the latter a natural hybrid), and eight auriculas, which had recently arrived from the continent. By Parkinson's time, auriculas in particular were on the increase, striped varieties had appeared, and doubles were popular. By the time Samuel Gilbert published his *Florist's Vade-mecum* in 1682, striped and double-striped auriculas had become the most popular forms, but by the middle of the eighteenth century these were being displaced by edged auriculas. Striped auriculas had vanished by the nineteenth century, and have never been redeveloped. The English varieties shown here were published in *Aurikel Flora* (1801).

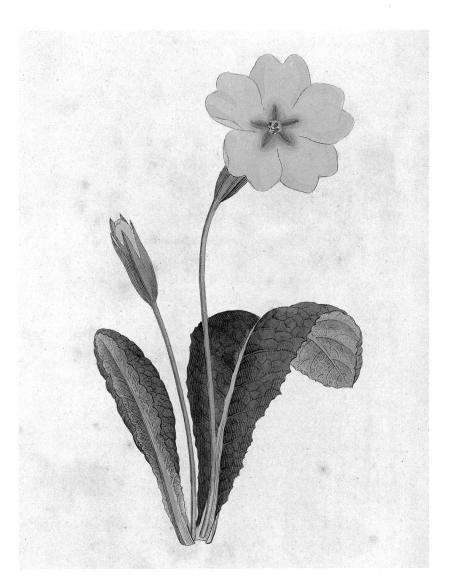

PRIMULA VULGARIS

The native English primrose, *Primula vulgaris*, has had a long career as a garden flower. Double-flowered forms were available in yellow and white in Gerard's time; in the mid-seventeenth century, blue and purple double forms were introduced from the continent. Late in the century, there were rumours about double red forms, but these only became available in the eighteenth century.

ERYTHRONIUM DENIS-CANIS

The dog's-tooth violet may have been introduced into Britain by Mathias de Lobel in the 1580s. There was much confusion over its status, since it was initially thought to be an orchid. A decade after its introduction, John Gerard knew two forms with different coloured flowers: white and purplish-white. By the 1620s Parkinson was growing red, purple, and white varieties.

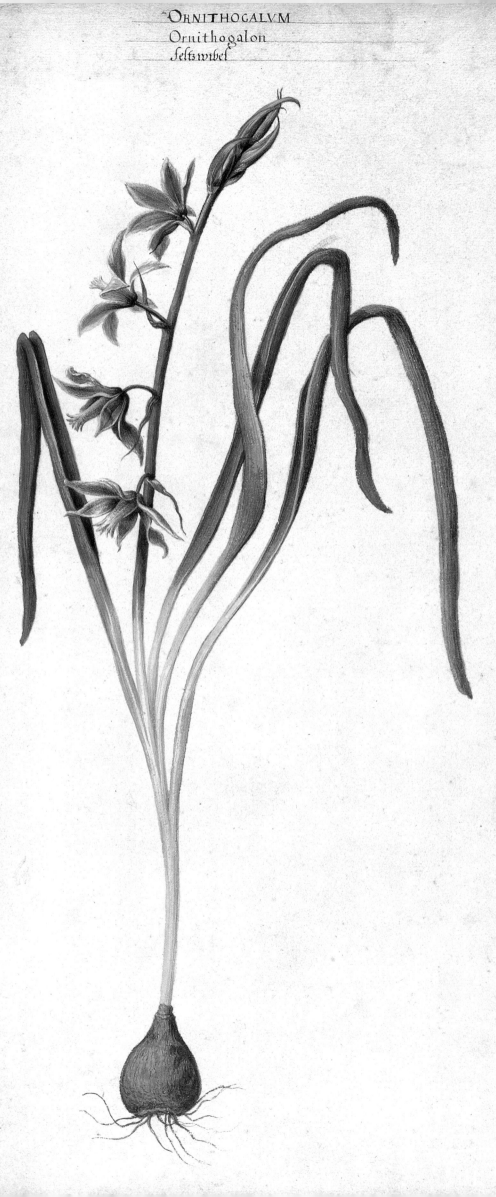

ᴏʀɴɪᴛʜᴏɢᴀʟᴠᴍ
Ornithogalon
feltswibel

⊙ʀɴɪᴛʜᴏɢᴀʟᴜᴍ ɴᴜᴛᴀɴꜱ

Ornithogalum umbellatum, the Star of Bethlehem, was introduced into England in the sixteenth century from France, but before long other species arrived which attracted greater attention, even though they required greenhouse cultivation. Among these was *Ornithogalum nutans*, treated as a greenhouse plant in the eighteenth century despite being hardy (and indeed becoming naturalised in England). But the intensity of interest these other species provoked died down, and *O. umbellatum* and *nutans* remain the most frequently grown today.

ᴀʀᴄɪꜱꜱᴜꜱ ᴊᴏɴQᴜɪʟʟᴀ

The jonquil's graceful shape and powerful sweet scent meant that it enjoyed a distinct reputation from other sorts of daffodil. The species is found in Spain and Portugal, and was introduced into northern Europe late in the sixteenth century; by the 1620s it was being grown in England, and a large number of different varieties became available.

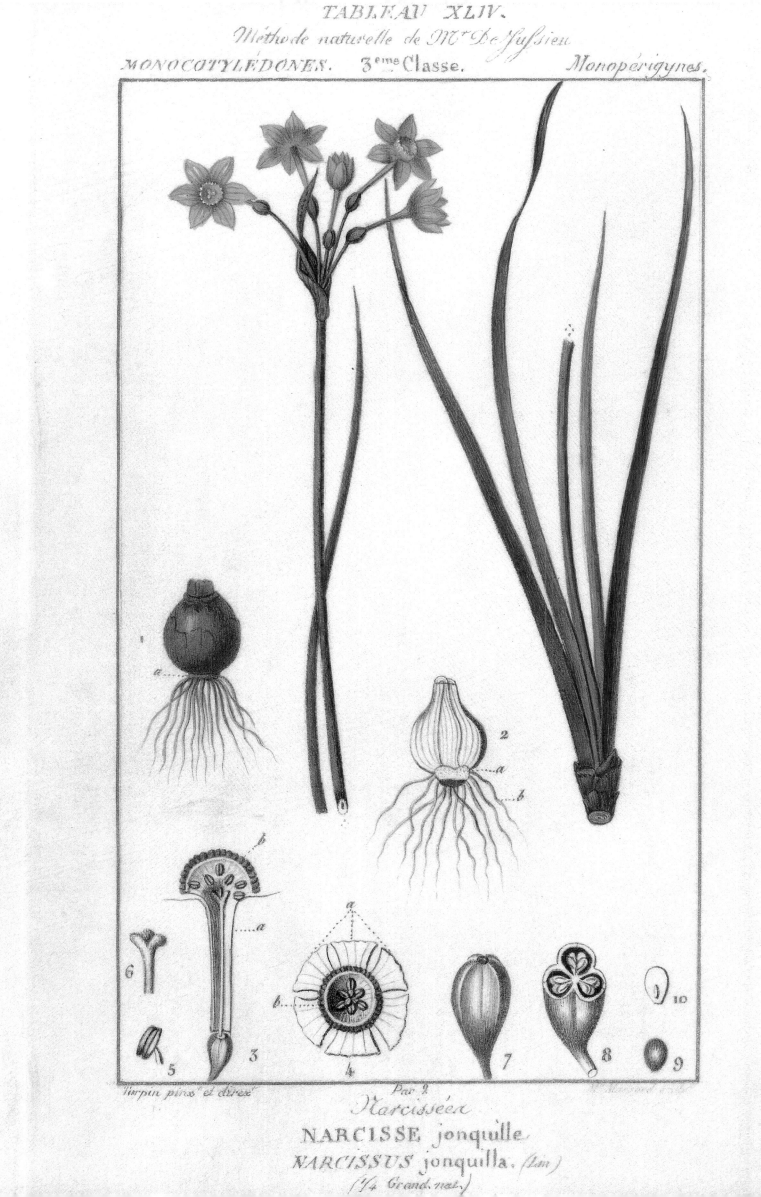

Turpin pinx.t et direx.t Par 2 Massard sculp.t

Narcisséen

NARCISSE jonquille
NARCISSUS jonquilla. (Lin.)

(1/4 Grand. nat.)

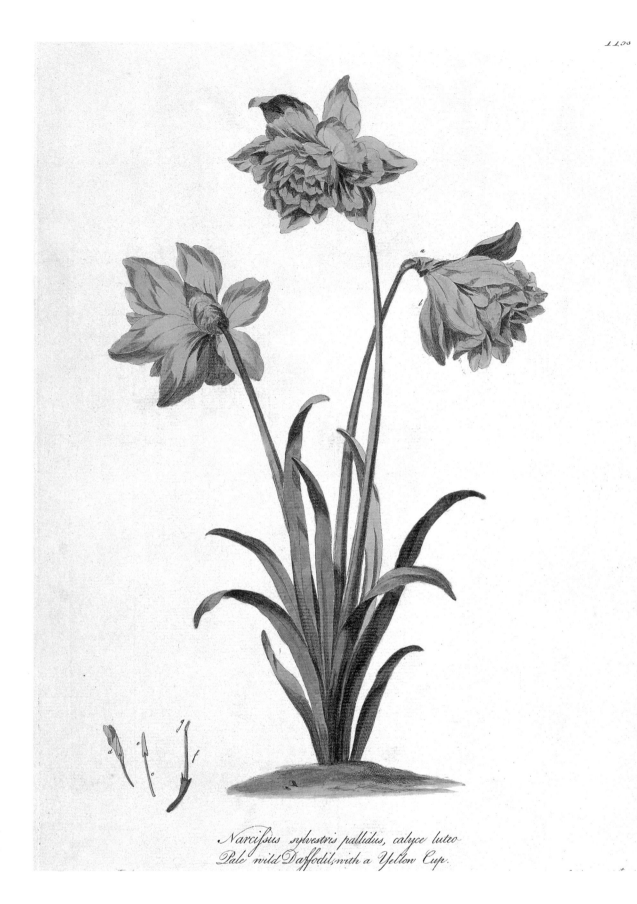

Narcissus sylvestris pallidus, calyce luteo
Pale wild Daffodil, with a Yellow Cup.

ℕARCISSUS PSEUDONARCISSUS

Daffodil breeding began in the 1830s, with the work of William Herbert, Dean of Manchester; but daffodils played only a minor role in the High Victorian flower garden. Their revival was largely the work of the Covent Garden seedsman Peter Barr. Barr began a search for all of Parkinson's daffodils, refusing to believe they had vanished, and this was enough to bring them back into fashion in the late nineteenth century. Daffodils were the first genus of plants to have a register of existing varieties compiled.

ℕARCISSUS × INCOMPARABILIS

From the 1870s on, the breeding of daffodil cultivars gathered speed, and different categories were devised for exhibition purposes. Today there are Trumpet daffodils, derived from *Narcissus pseudonarcissus*; large- and small-cupped daffodils, from *N. × incomparabilis*; Triandrus, Cyclamineus. Bulbocodium, Tazetta, and Poeticus daffodils, from their respective species; as well as doubles and split-corona varieties. At the last count, nearly 26,000 named cultivars are known to have existed, some 2000 of them currently available.

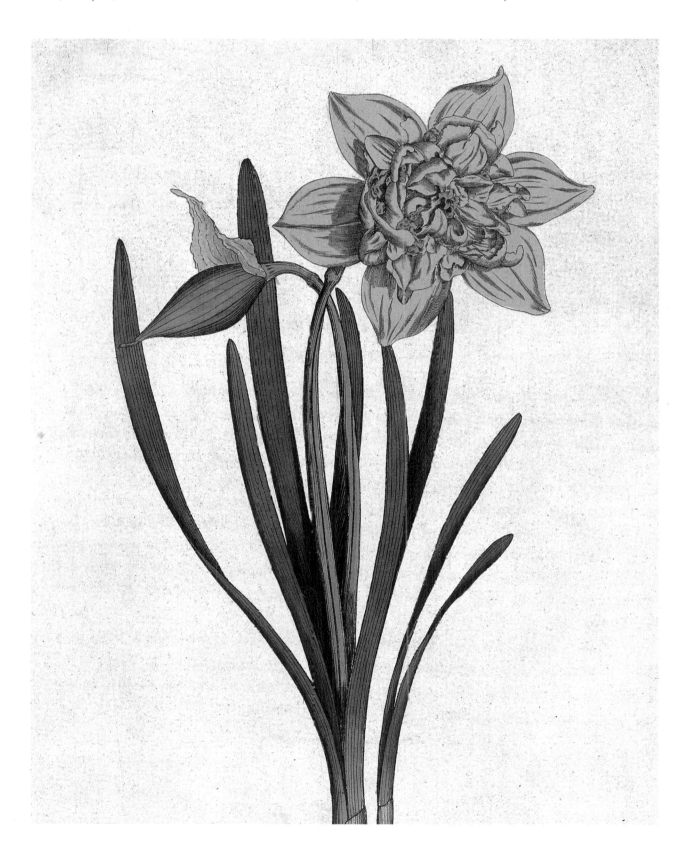

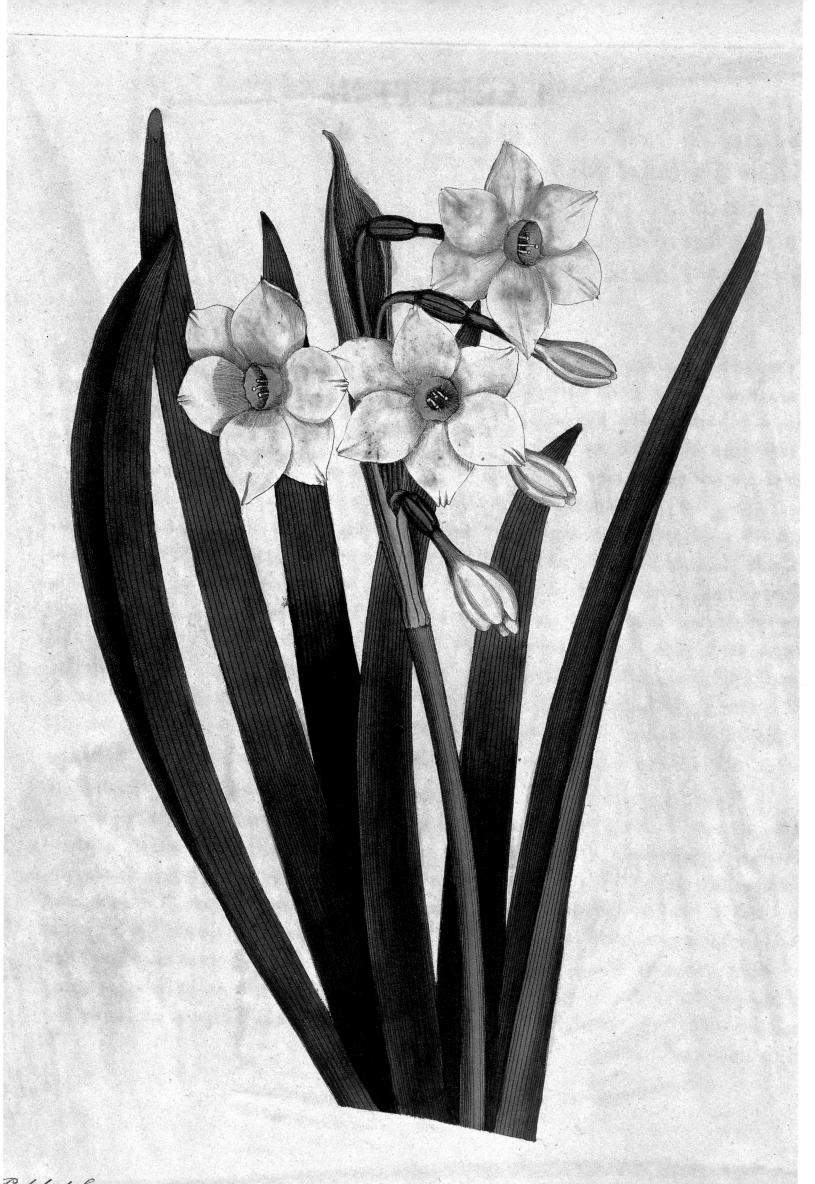

P. del. et Sc.

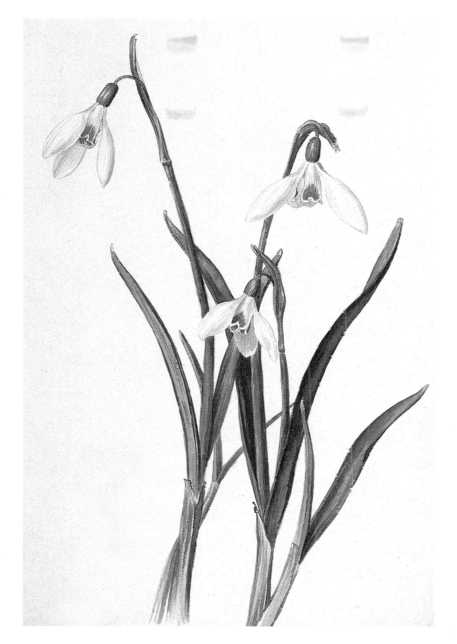

\mathcal{G}ALANTHUS 'ATKINSII'

The name 'snowdrop' first appears in the seventeenth century; before that *Galanthus nivalis* was known as a 'bulbous violet'. The late nineteenth century saw a spurt of interest in snowdrops, partly because new species were being introduced from eastern Europe. James Allen became England's major breeder of new cultivars, most of which have disappeared from cultivation. 'Atkinsii', shown here, was introduced by Peter Barr in the 1870s from southern Italy.

\mathcal{N}ARCISSUS TAZETTA

Narcissus tazetta, of Mediterranean and Asian origin, was exploited for garden use on the continent more than in England. Tazetta cultivars bear multiple flowers on a stem and tend to be strongly scented. *Narcissus poeticus*, with a natural distribution ranging from the Mediterranean to northern Europe, was popular in England and the continent. In the 1880s, the Dutch nursery of R. Van der Schoot crossed Poeticus cultivars with Tazettas, yielding a new group called Poetaz.

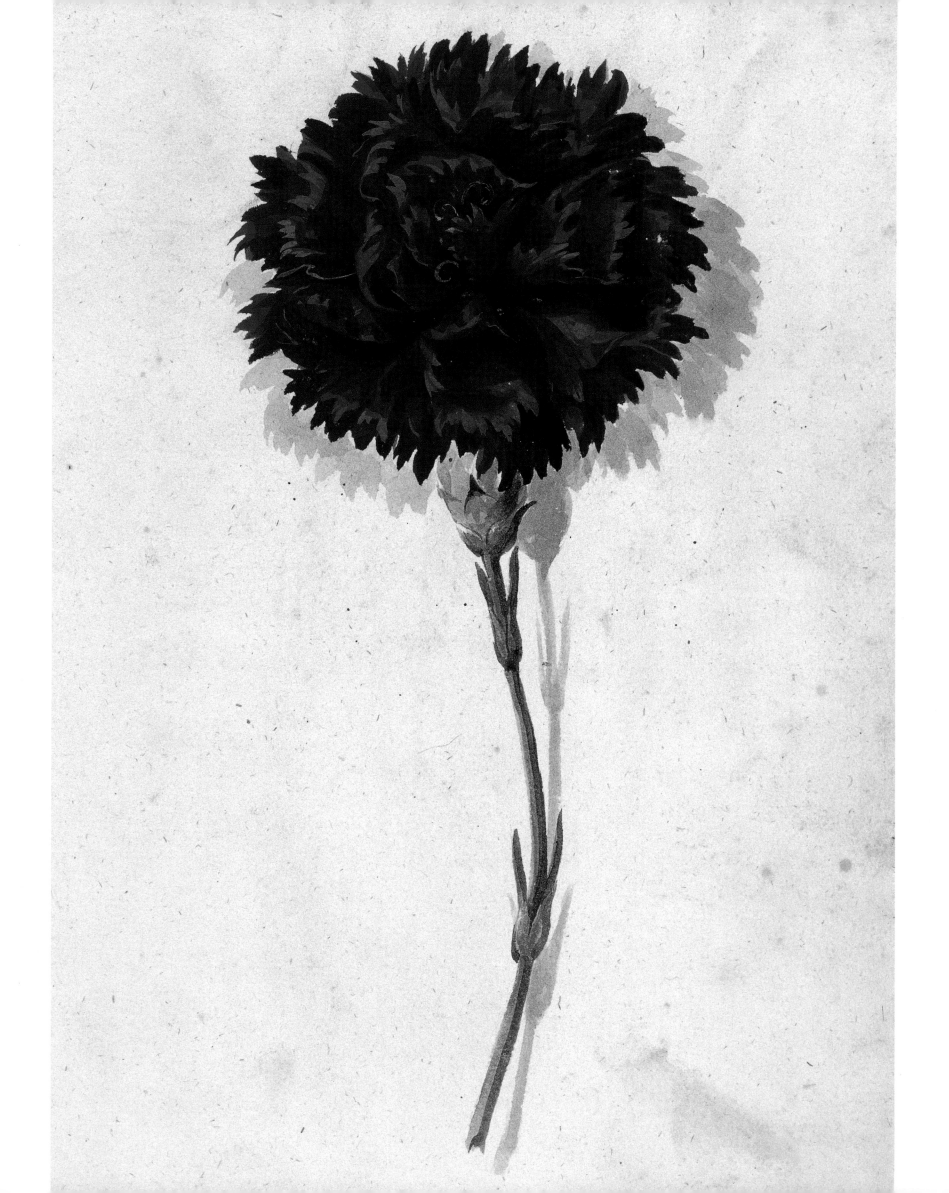

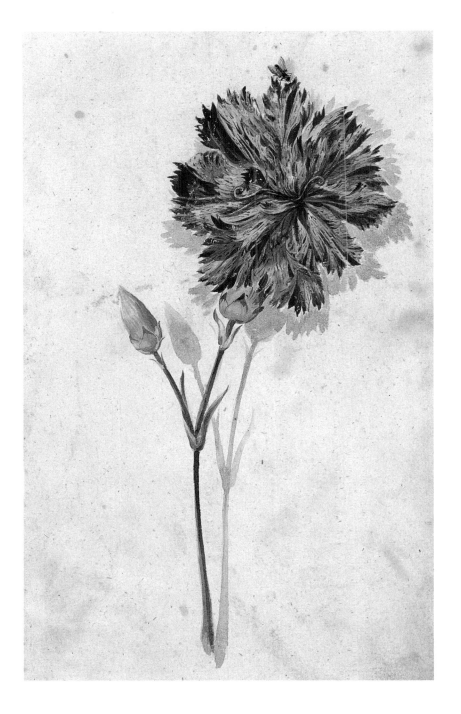

CARNATION CULTIVARS

The first record of cultivated carnations, as distinct from the wild *Dianthus caryophyllus*, dates from Spain in 1460. By the 1620s, Parkinson knew nineteen carnations and twenty-nine gilliflowers (a common term for the smaller forms). Ever since, in addition to the florists' carnations grown for the show bench, there have been categories of garden carnations developed, such as Malmaison carnations in the 1850s, grown for greenhouse and indoor display, and the perpetual-flowering carnations of the mid-twentieth century.

The unnamed carnations shown here exhibit the splashing of colours on the petals that was much admired in the seventeenth century, and led in the eighteenth to the development of two new categories: the flake and the bizarre. Flakes had stripes of a single colour on a white background, while bizarres had separate stripes of two or more colours. Both flakes and bizarres remained popular until the late nineteenth century, but disappeared in the twentieth.

Caryophylli Hortenses.

Schwartz Imperial.

Schöne Helene.

Schöne Helene.

Picolomini

Latripuz.

Oberster Wase.

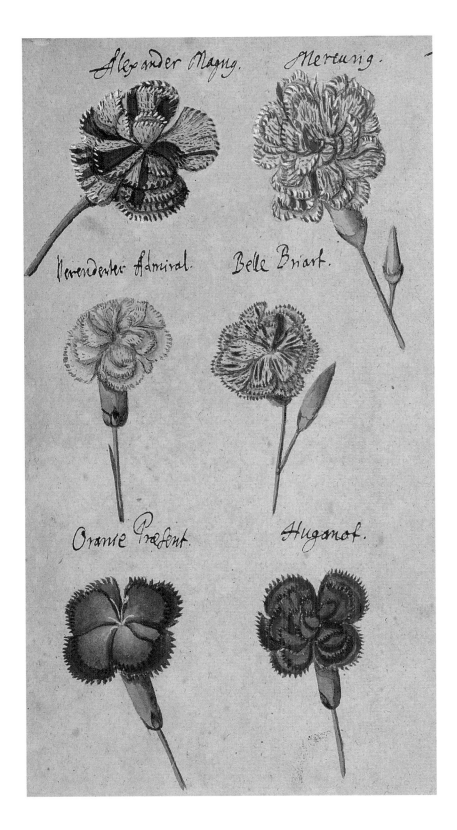

DIANTHUS CULTIVARS

The anonymous German illustrations on these pages show some of the variety of dianthus (a term which includes carnations and pinks) grown in the seventeenth century. They show the serrated edges that were still standard, but which were soon to fall from favour; but the tendency can already be seen in these varieties to produce larger, rounder petals that would eventually become smooth-edged.

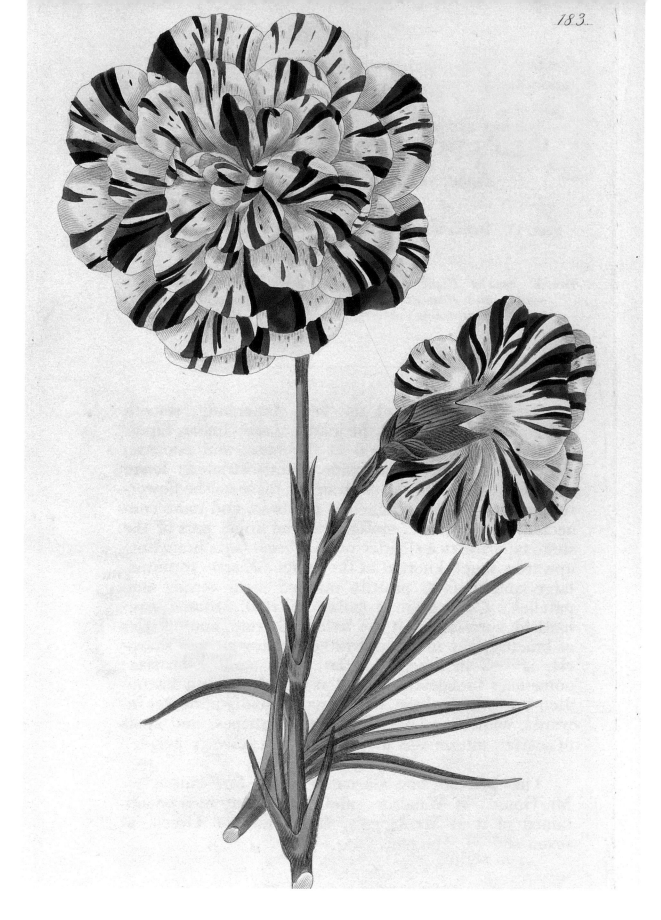

\mathcal{G}OULD'S 'DUKE OF YORK' CARNATION

This is a good example of an early nineteenth-century 'bizarre' carnation, with stripes of red and dark purple in the petals. If the colour had been confined to the edges instead of longitudinal stripes, the flower would have been called a picotee. Elaborate rules were developed for judging the size and symmetry of the flowers, although these drew the wrath of the influential journalist William Robinson, who attacked the artifice of exhibition flowers towards the end of the century.

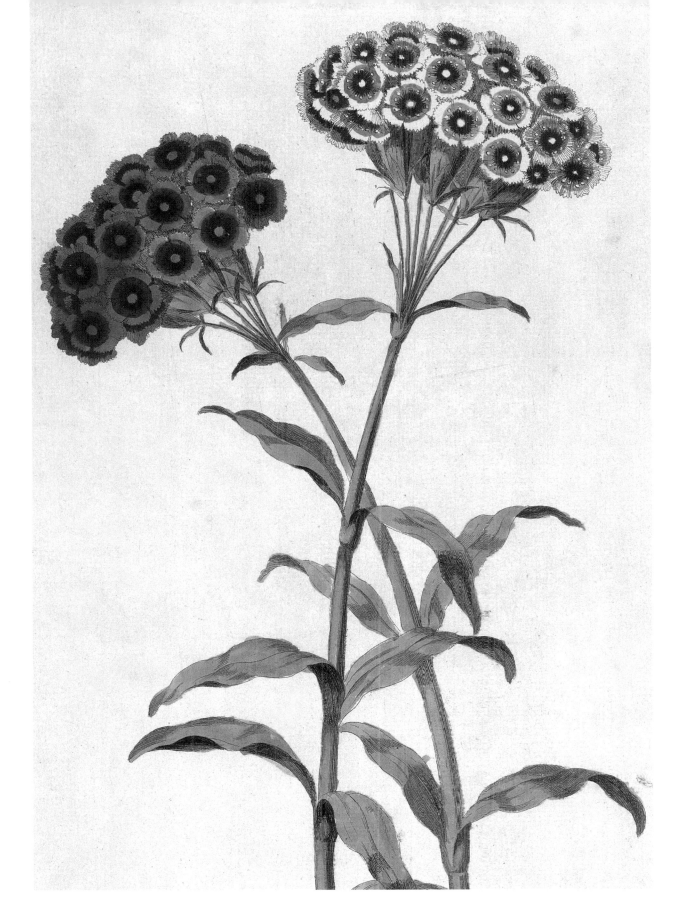

ⅅIANTHUS BARBATUS

Despite a modern myth connecting it to the battle of Culloden, the name 'sweet william' dates back to the sixteenth century at least; Gerard also used 'sweet john' and 'wild william' for related plants. In the early seventeenth century, forms were developed with a distinct central eye, and 'auricula-eyed' plants continued to be grown thereafter. In the early nineteenth century sweet williams were briefly treated as a florists' flower, before sinking back into the status of a cottage garden flower.

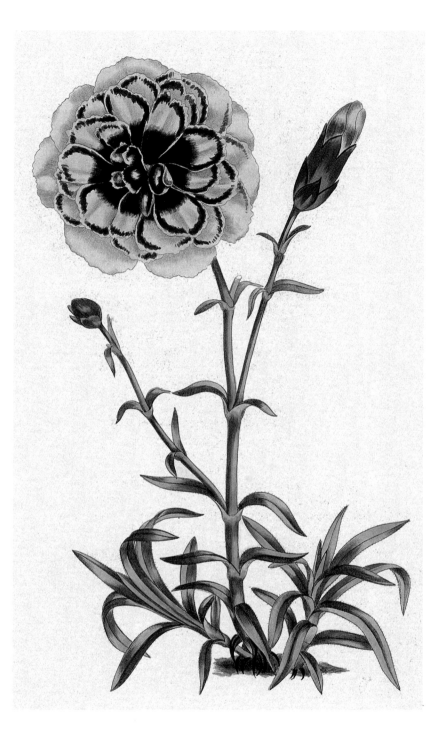

Davey's 'Juliet' Pink & Ford's 'William of Walworth' Pink

Pinks are derived from *Dianthus plumosus*, probably crossed with other species. Already popular in Gerard's time, they were not accepted as a category of florists' flower until the late eighteenth century, when laced pinks, with a narrow band of colour around the petals, were developed. Throughout the early nineteenth century, the race was on to produce cultivars with smooth-edged petals; once this was achieved, the pink was the leading florist's flower, from the 1830s to 1860s. The pinks 'Juliet' (above) and 'William of Walworth' (opposite) were illustrated by Edwin Dalton Smith for Robert Sweet's *The Florist's Guide* (1827–1832).

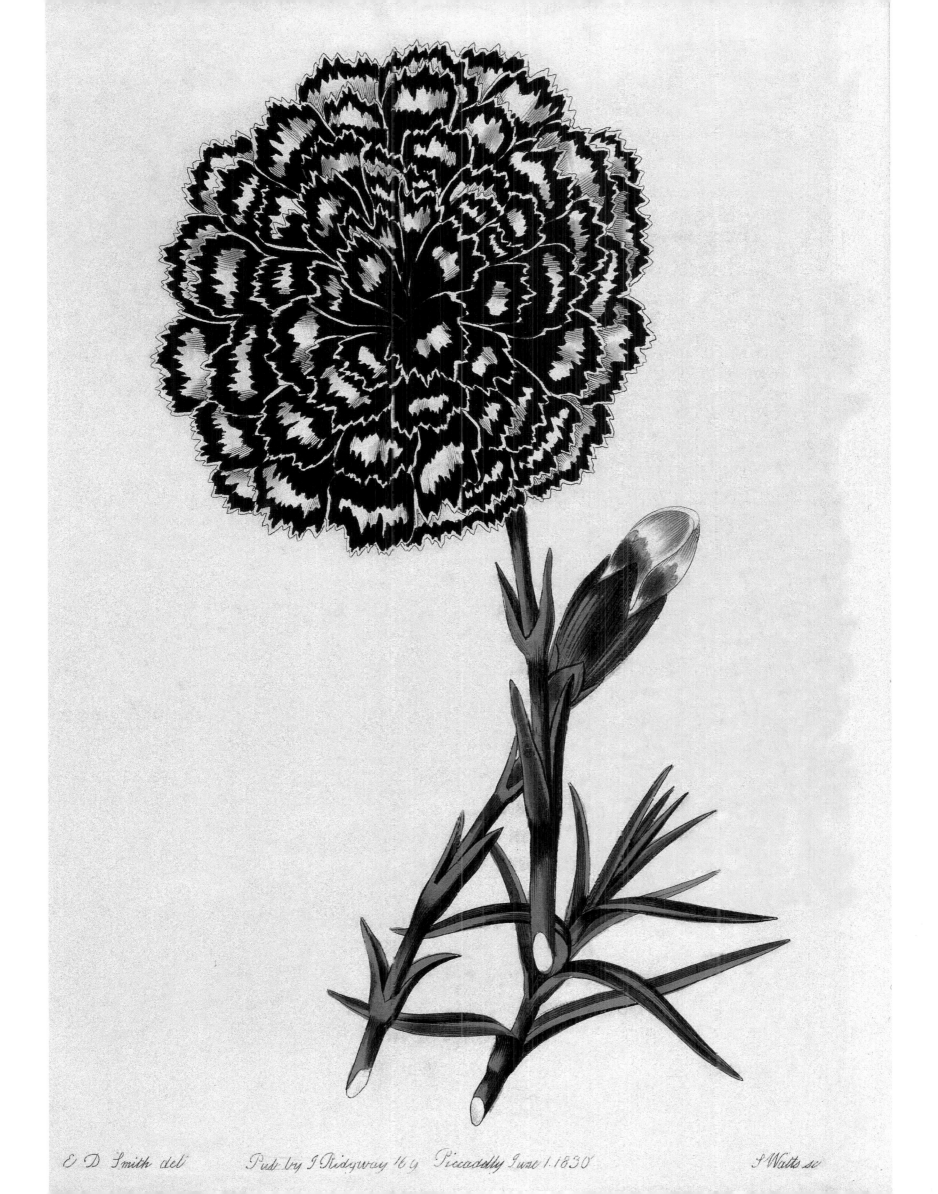

E D Smith del Pub by J Ridgway 16g Piccadilly June 1. 1830 S Watts sc

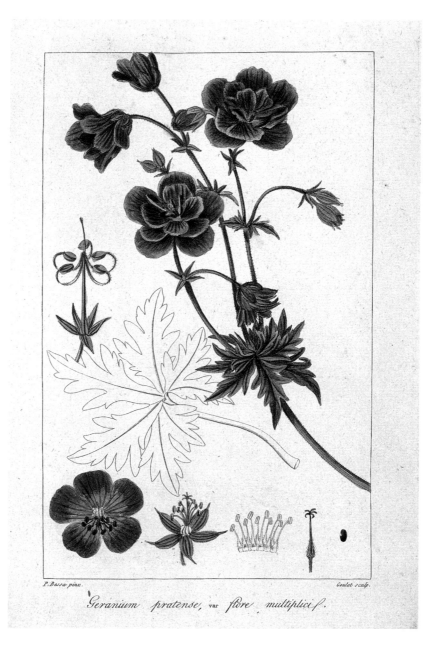

Geranium pratense, var flore multiplici.

GERANIUM PRATENSE

The geraniums, or cranesbills, of Europe number almost forty species, of which Herb Robert (*G. robertianum*) and the meadow cranesbill (*G. pratense*) have been the most widely grown. In the second quarter of the nineteenth century, the hardy geraniums were popular for growing as standards, but then experienced a phase of comparative neglect, ousted by their African relatives the pelargoniums, before returning to favour in the twentieth century.

AQUILEGIA VULGARIS VAR. FLORE-PLENO

The columbine is native to Britain, and one of the oldest of British garden flowers. Gerard grew red, purple, blue, white, and mottled forms, as well as double varieties of most of the colour range. In the 1860s and 1870s, new species such as *Aquilegia chrysantha* were introduced from western North America, and stimulated the breeding of new hybrids with longer spurs, a process pioneered by James Douglas at his nursery at Great Bookham in Surrey.

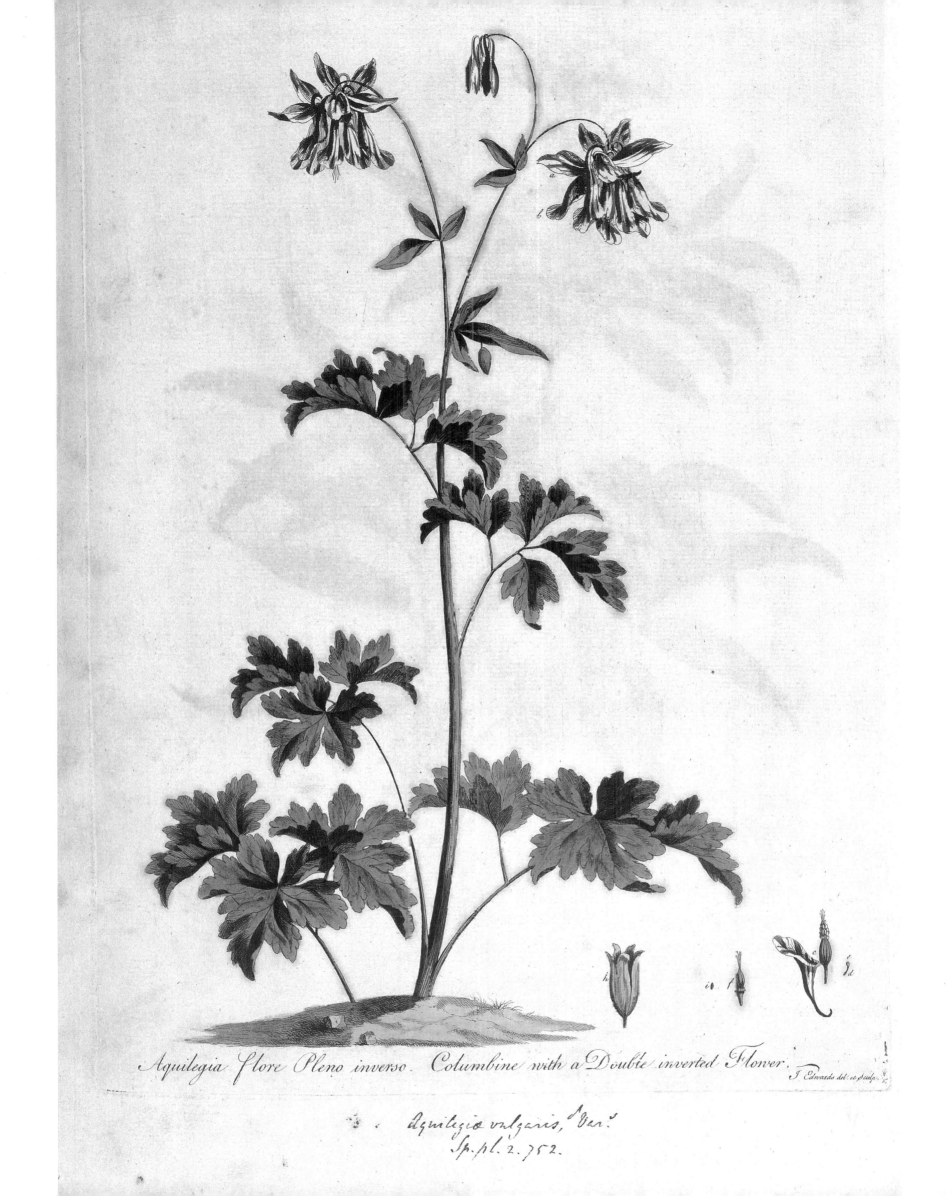

Aquilegia flore Pleno inverso. Columbine with a Double inverted Flower.

J. Edwards del. et sculp.

Aquilegia vulgaris, Var.
Sp. pl. 2. 752.

ALLIUM MOLY

The name 'Moly' was used by John Gerard and his contemporaries for any species of *Allium* grown for ornamental rather than culinary purposes; he grew five sorts, and Parkinson fourteen. What we now consider the true *Allium moly* was not grown in England until 1604, when Edward, Lord Zouche, introduced it. Mrs Loudon, in the mid-nineteenth century, considered alliums essential for the bulb garden, listing seven species; a generation later William Robinson suggested eighteen, while still dismissing them as 'not an important garden family'.

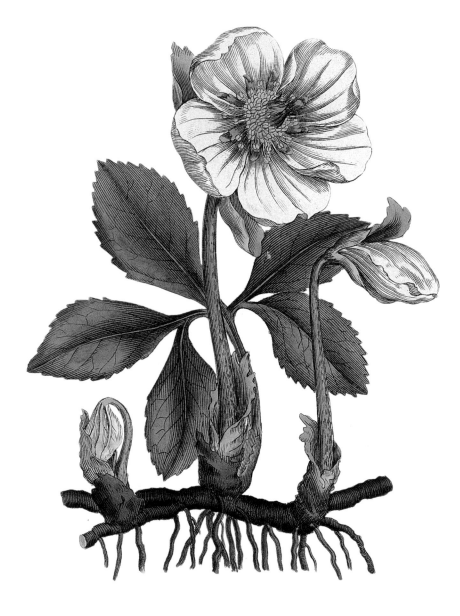

Helleborus niger

Helleborus niger, the Christmas rose, was a popular garden plant for generations before exotic species were introduced commercially in the nineteenth century. In the 1870s, nurseryman Peter Barr, botanist F. W. Burbidge, and amateur gardener T. H. Archer-Hind began to breed new varieties, and hellebores enjoyed a heyday, though most of the nineteenth-century cultivars have disappeared – including 'St Brigid', which was cultivated for over fifty years.

Gagea lutea & Armeria maritima

The sea-pink or thrift, *Armeria maritima* (opposite left), was one of the first plants used in England for planting as edging in knot gardens, and continued to be used for that purpose even after box was introduced in the late seventeenth century. It was reported in the 1710s that 'both the English and the Dutch adorn their Court-yards with this plant'. Also shown, is *Gagea lutea* (opposite right), a British native, grown by Gerard but considered by him as an ornithogalum.

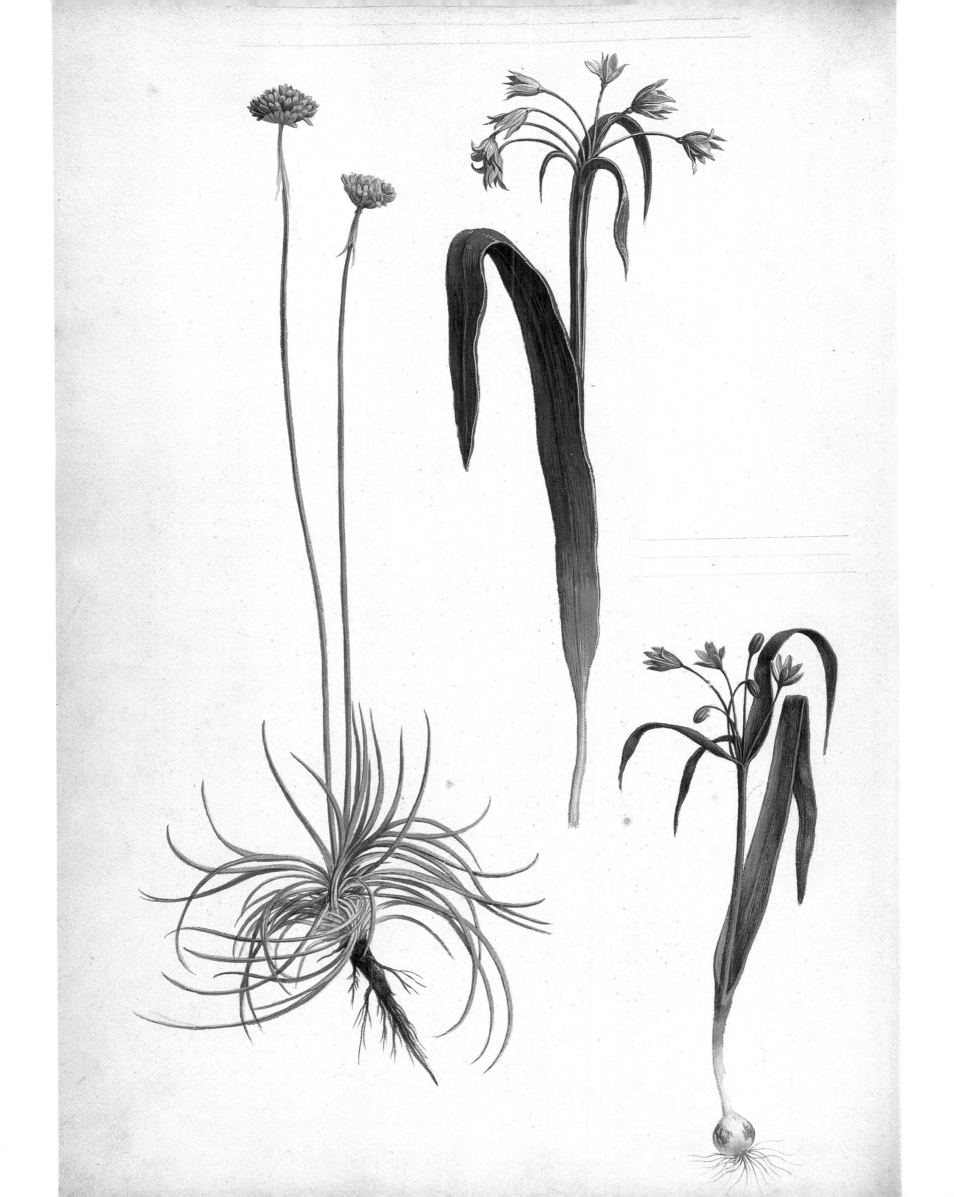

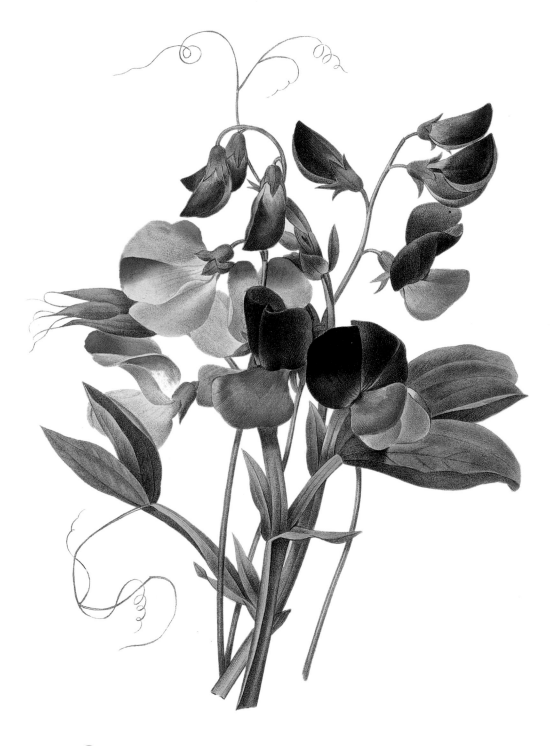

\mathcal{L}ATHYRUS ODORATUS

The first sweet pea arrived in England in 1699, in the form of seeds sent from Sicily by the Abbé Francisco Cupani to Robert Uvedale, an Enfield schoolmaster and collector of exotic plants. Little attempt at breeding was made until the nurseryman Henry Eckford began to concentrate on them about 1870, producing hundreds of varieties, including the Grandiflora range. In 1901, Silas Cole, the head gardener at Althorp in Northamptonshire, raised 'Lady Spencer', the first sweet pea with a waved edge to the petals. Throughout the Edwardian period sweet peas created more enthusiasm than any other garden flowers; in 1911, to celebrate the first ten years of the Sweet Pea Society, the *Daily Mail* offered a £1000 prize for the best group of sweet peas. Most of the nineteenth- and early twentieth-century cultivars have now disappeared, but new sweet pea varieties still continue to appear, although at a diminished rate.

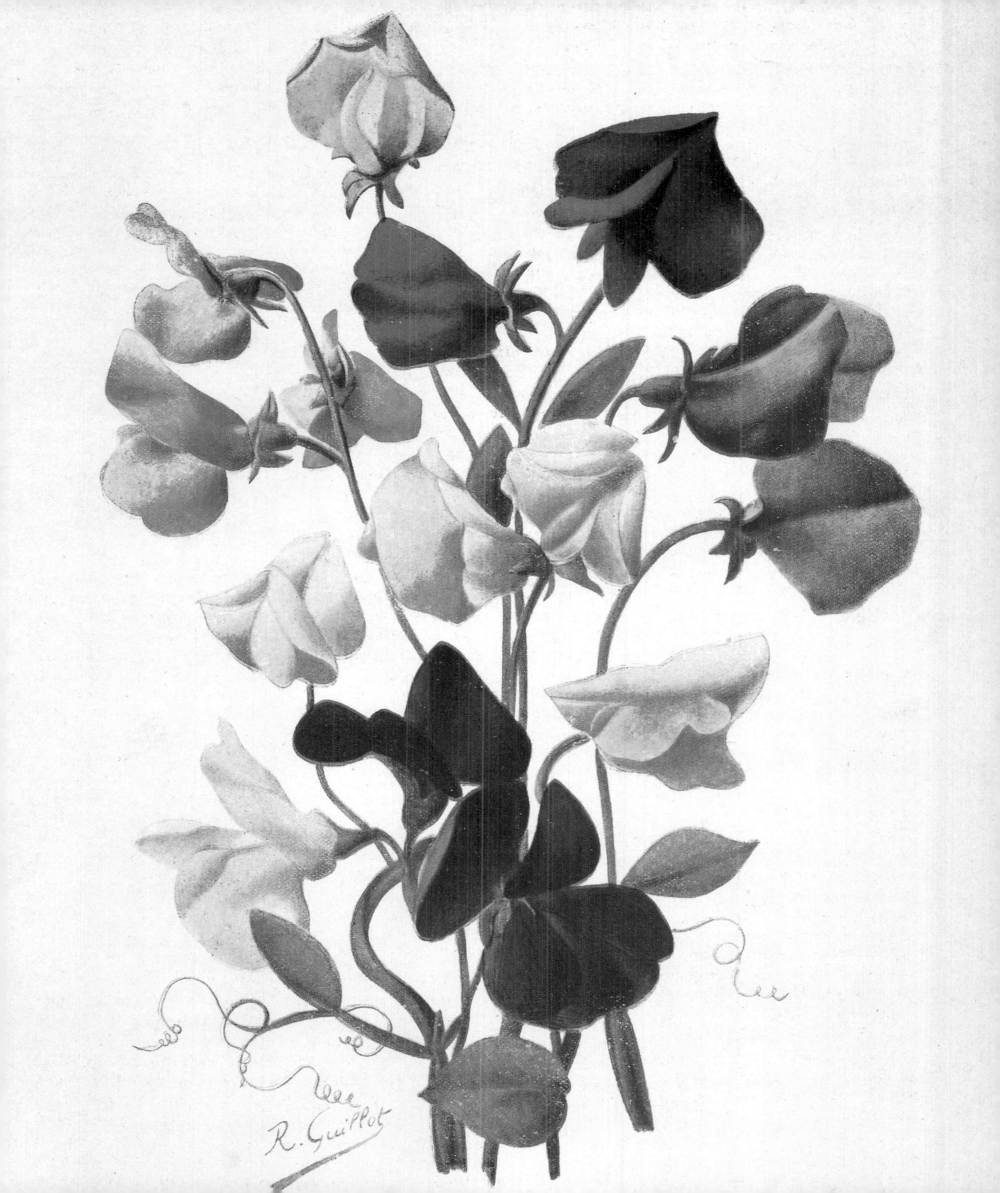

R. Guillot

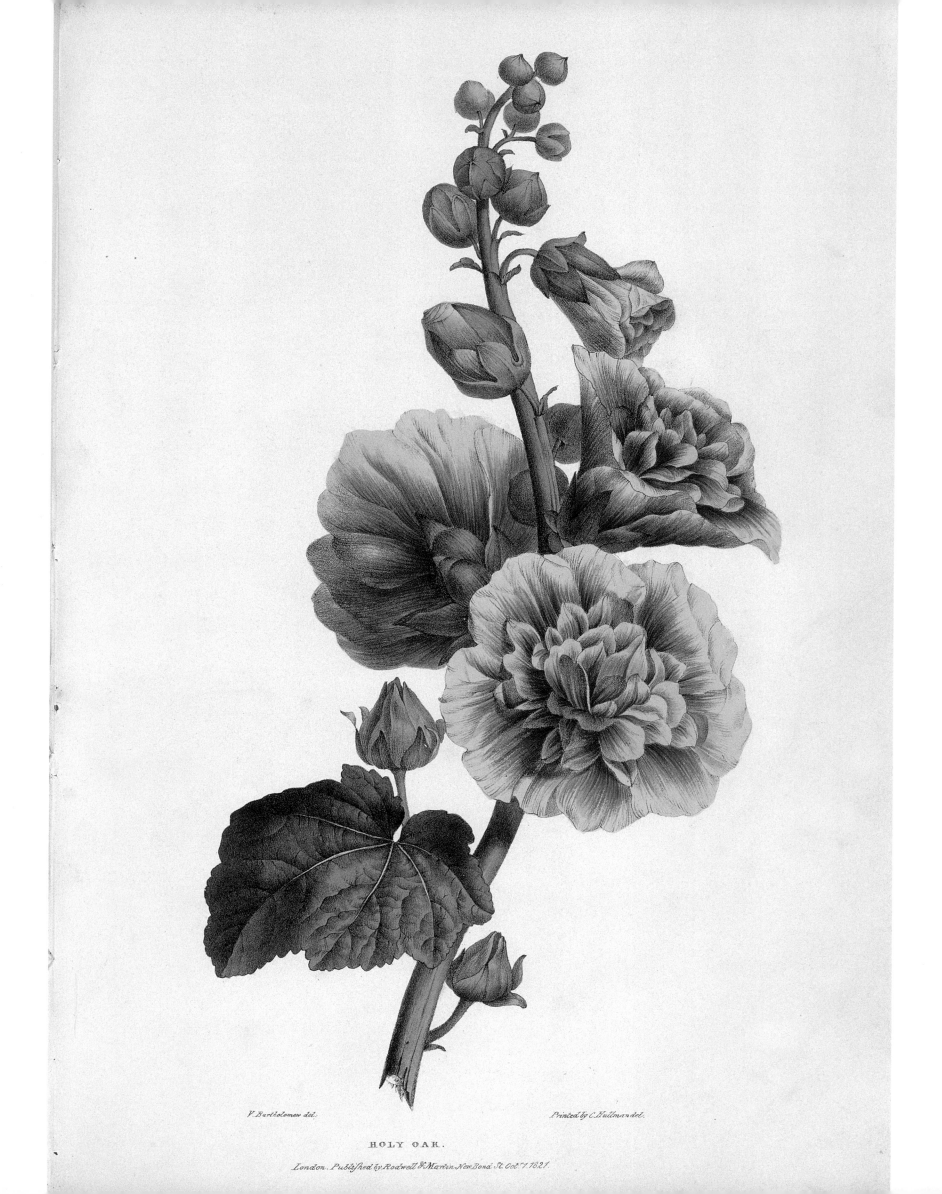

V. Bartholomew del.

Printed by C. Hullmandel.

HOLY OAK.

London, Published by Rodwell & Martin, New Bond St. Oct.r 1. 1821.

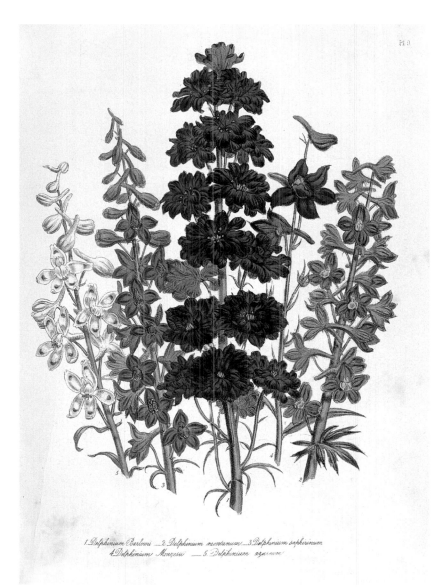

1 Delphinium Barlowi __ 2 Delphinium montanum __ 3 Delphinium saphirinum.
4 Delphinium Menziesii __ 5 Delphinium azureum.

DELPHINIUM

Not so long ago the genus *Delphinium* included both annual and perennial species, all of which were called larkspurs. But the older separation between the two has now been revived, and only the perennials remain in *Delphinium*: the annuals, to which the name 'larkspur' originally applied, have returned to their older generic name of *Consolida*. *Delphinium elatum*, the first perennial species, only arrived in the early 1600s, and was grown in single and double forms.

HOLLYHOCK

Hollyhocks were already well-known in England in the early sixteenth century. In the eighteenth century hollyhocks with variegated flowers were introduced from Asia, and in the early nineteenth century they became a sort of florists' flower, with two English nurserymen, Jabez Jay Chater and William Chater, their major breeders. After the arrival of hollyhock rust in the 1870s, the cult of the hollyhock declined, but the plant survived as a 'cottage garden flower'.

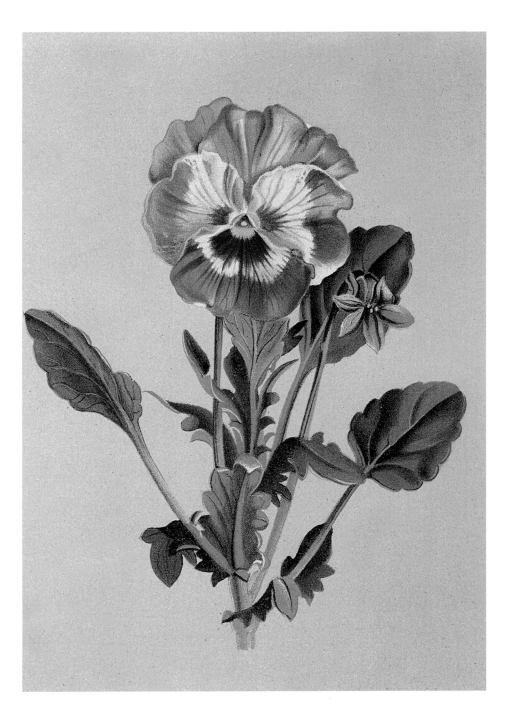

\mathcal{P}ANSY & \mathcal{V}IOLA TRICOLOR

Viola tricolor, native to England, was known in Elizabethan times in three colours (purple, yellow, and white), and called the heartsease or pansy. It was not until the nineteenth century that it attracted the attention of breeders. Hybrids of *Viola tricolor* and *Viola lutea*, with large petals, almost circular in shape, and varying colour patterns, were developed by different growers from the 1810s, and took the name of pansy (the cultivar *Viola tricolor* 'Grandiflora' is shown opposite). In the 1860s, the Scottish nurseryman James Grieve crossed pansies with *Viola cornuta*, and produced the first violas, although the journalist William Robinson campaigned for the name 'tufted pansy'. A decade later, the Scottish doctor Charles Stuart bred the first violettas: dwarfer violas without rays on the petals. All three types were in their heyday in the late nineteenth century, but violas and violettas have stayed in cultivation longer than pansies.

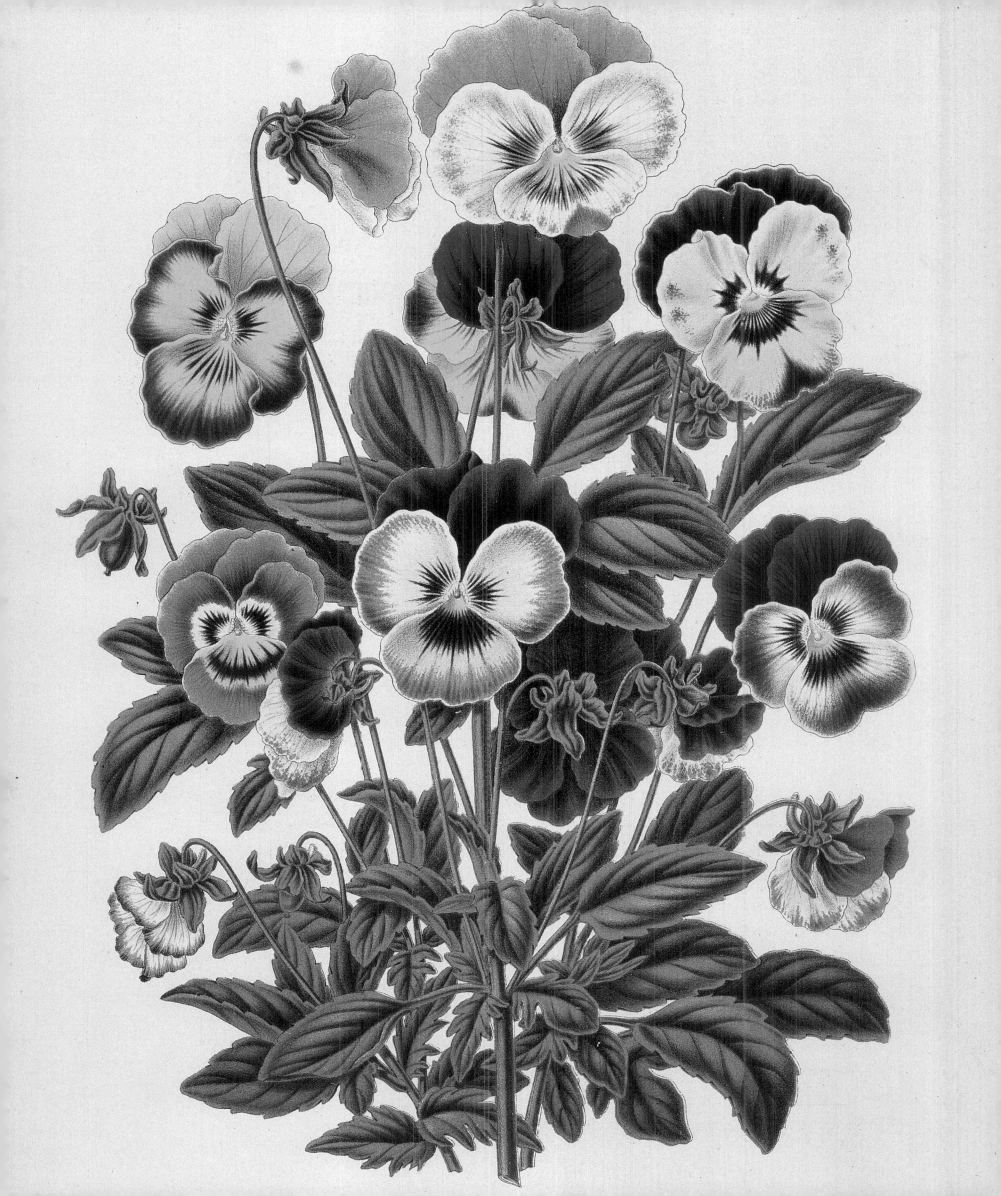

CARLINA ACANTHIFOLIA

Thistles, teazels, and similar plants entered gardens because of their medicinal uses, but by Parkinson's time several were being grown as ornamental plants. Parkinson, who regarded thistles as beautiful, grouped them together with acanthus, and offered advice for growing a dozen different sorts. While never among the most popular of border plants, various species formed a part of 'old-fashioned' gardens in the late nineteenth century, precisely because of Parkinson's use of them. *Eryrgium giganteum* became known in the early twentieth century as Miss Willmott's Ghost, in honour of the celebrated gardener Ellen Willmott, who would plant it and give it to friends.

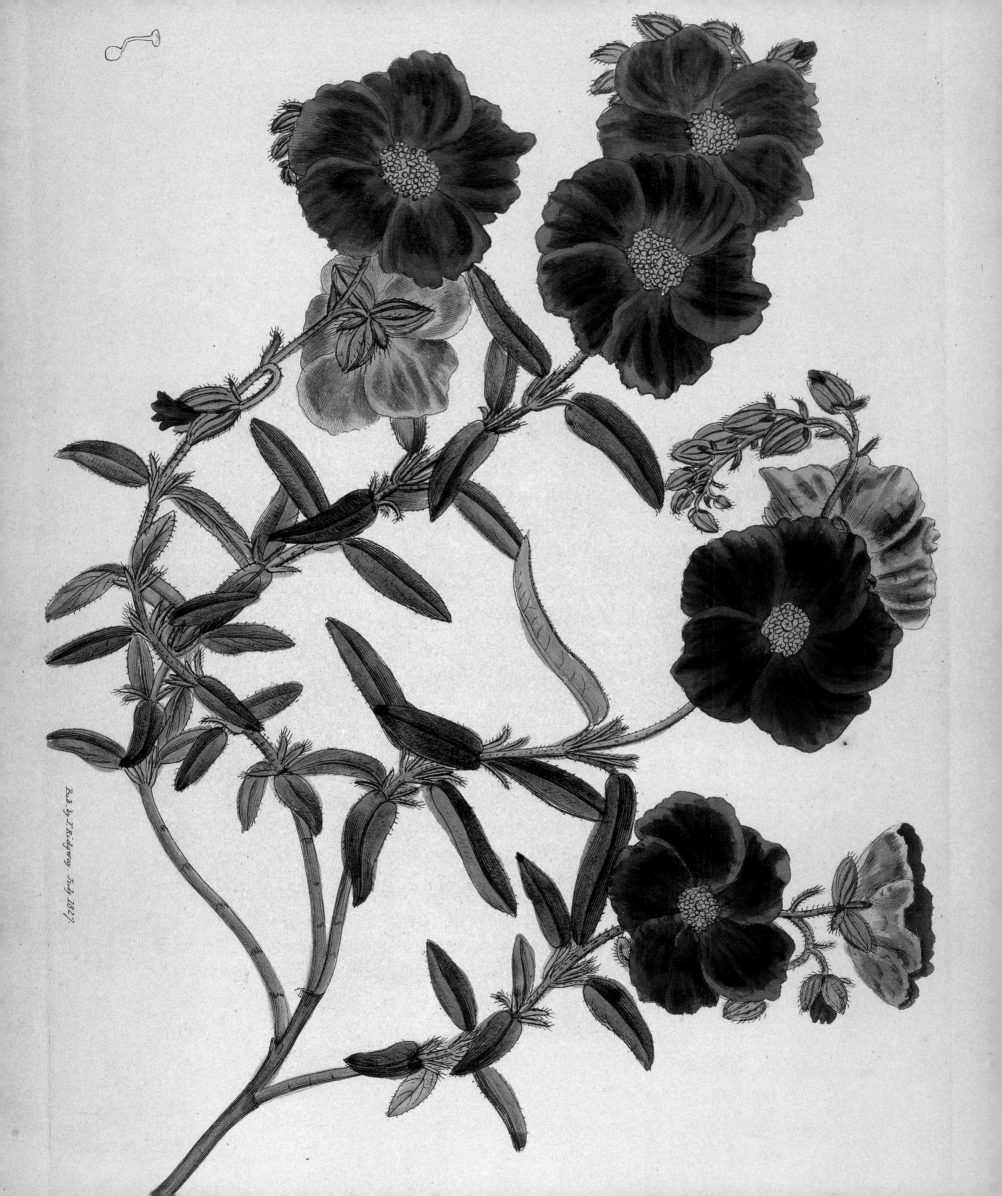

Pub. by I. Ridgway. July 1827.

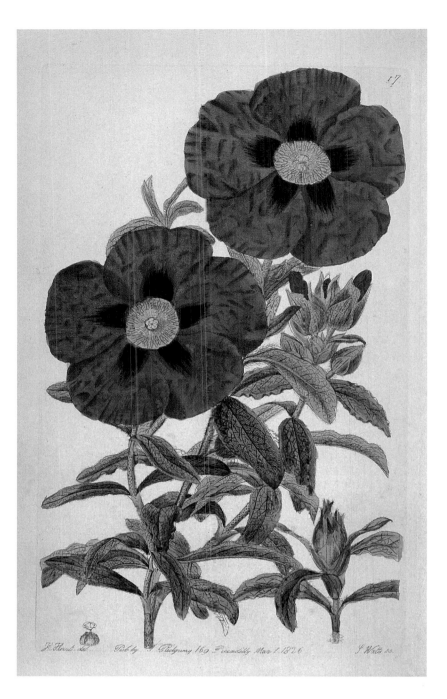

\mathcal{C}ISTUS × PURPUREUS &
\mathcal{H}ELIANTHEMUM CANESCENS

Rock roses were already popular garden plants in Gerard's time; in his 1597 *Herball* he described thirty-eight sorts of cistus and helianthemum (by which he meant any dwarfer variety). Such a large range was not described again until the nineteenth century, when the introduction of many Mediterranean and Near Eastern species revived enthusiasm for them. In the 1820s Robert Sweet published an illustrated account of over 100 species then being grown in London nurseries. Depicted in it were *Cistus × purpureus* (above), which flowered in James Colvill's nursery in 1826, while the helianthemum opposite was introduced by Reginald Whitley's nursery in Fulham.

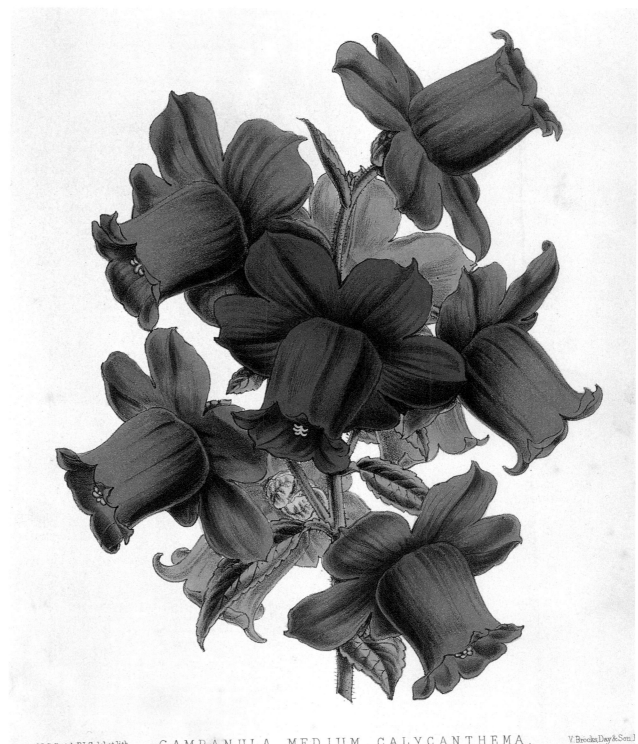

W.G.Smith,F.L.S.del et lith. CAMPANULA MEDIUM CALYCANTHEMA. V.Brooks,Day&Son.]

CAMPANULA MEDIUM 'CALCYANTHEMA'

Several species of *Campanula* have been popular in European gardens. *Campanula medium* (Canterbury or Coventry bells) was grown by Gerard in the seventeenth century. In the nineteenth century, one form of it, with a flattened corolla around the base of the bell, enjoyed great popularity under the name 'Calycanthema' (above); this was available in England until very recently.

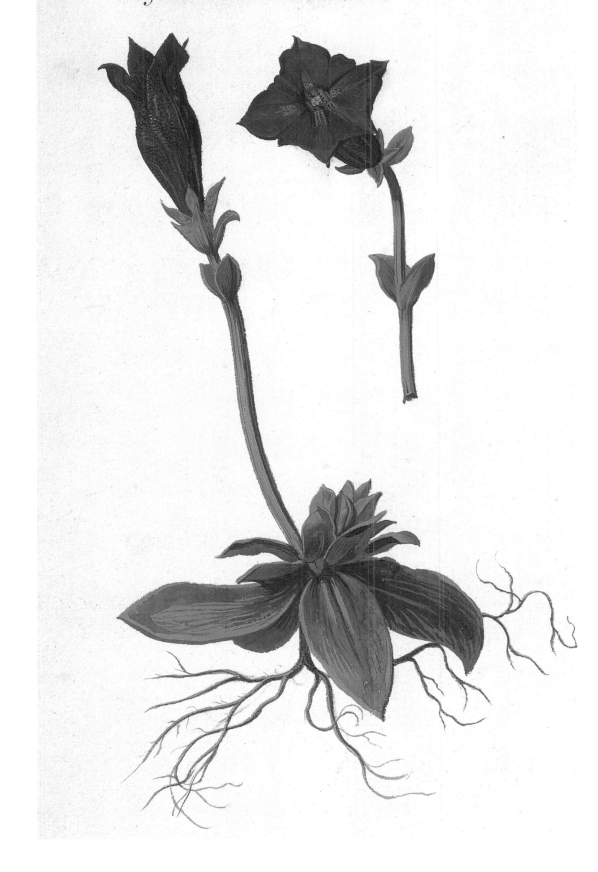

GENTIANA *flo:* CERVLEO

Gentian oder blauwe Herbstlilien

GENTIANA ACAULIS

Gentians were much employed as medicinal plants in the Renaissance, but by Gerard's time alpine gentians were already extensively planted at some country houses, and beginning to naturalise in Britain. Parkinson described only two gentians because he found them difficult to grow. *Gentiana acaulis* is now a debated term, with some authorities regarding it as a group of species rather than a single species. Commonly called the gentianella, it was adopted as the symbol of the Alpine Garden Society in the 1930s.

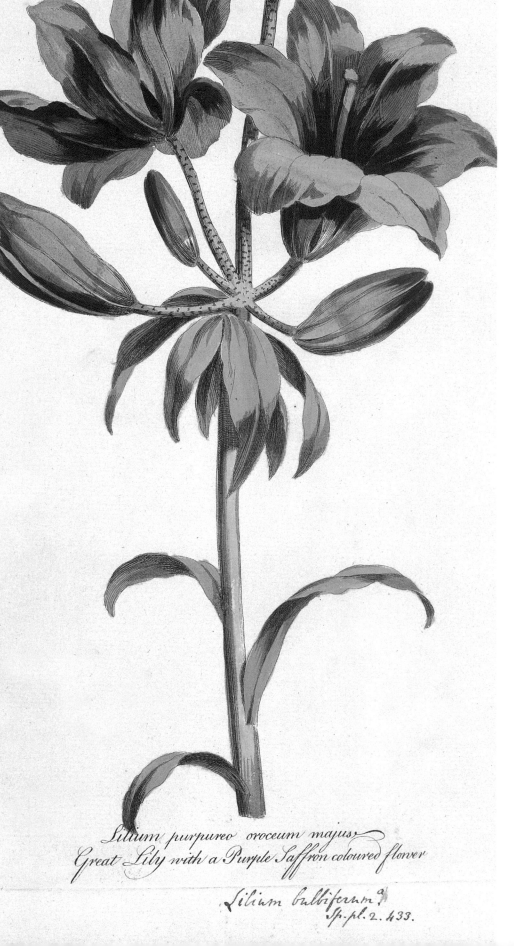

Lilium purpureo croceum majus
Great Lily with a Purple Saffron coloured flower

Lilium bulbiferum.
Sp. pl. 2. 433.

ℒILIUM BULBIFERUM

Lilium bulbiferum, native to southern France and central Europe, was one of the most frequently illustrated of lilies in the sixteenth and seventeenth centuries. Variegated and double-flowered forms continued to be grown in the eighteenth, but since then its use as a garden flower has steadily declined. It is nonetheless the only European lily to have been extensively used in breeding modern hybrids: in the 1920s it was crossed with *L.* × *maculatum* to produce the *Lilium* × *hollandicum* hybrids, whose descendants continue today as popular garden lilies.

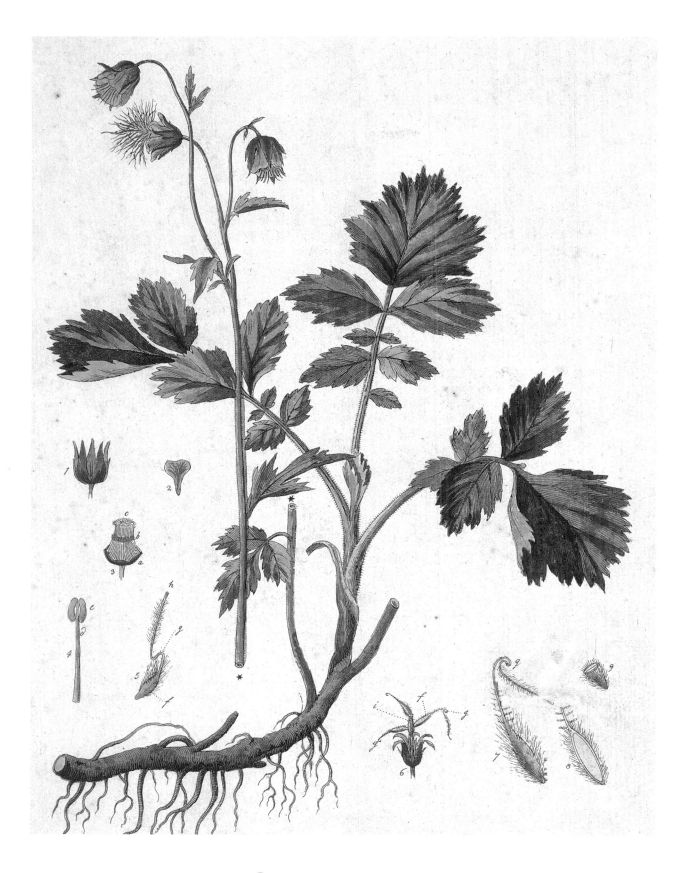

GEUM RIVALE

Geum rivale, the water avens, was a common garden plant in the sixteenth century, and is still grown today as a border plant, with half a dozen or more cultivars available. Geums became especially popular after the introduction of South American species in the nineteenth century, in particular *Geum chiloense*

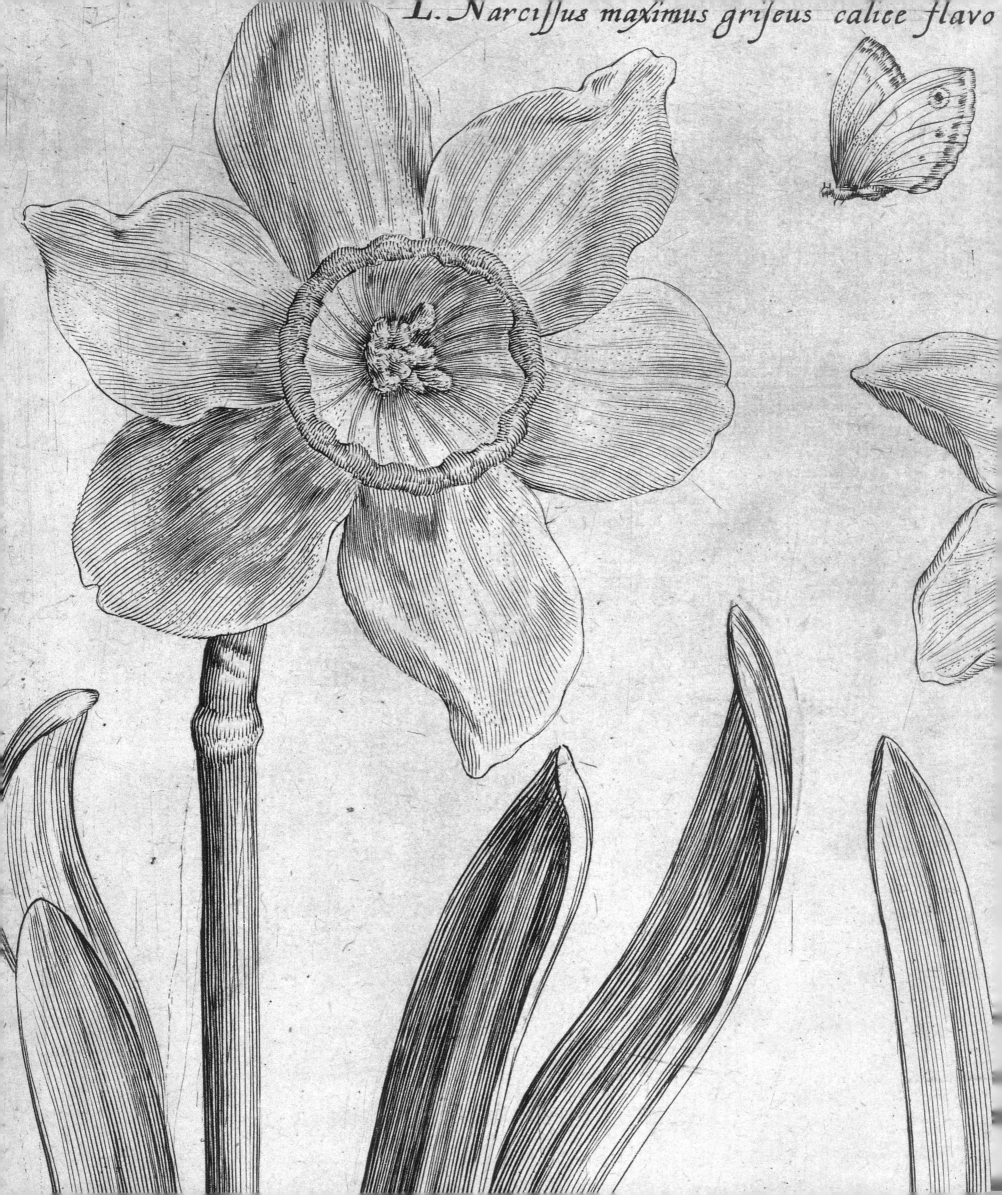

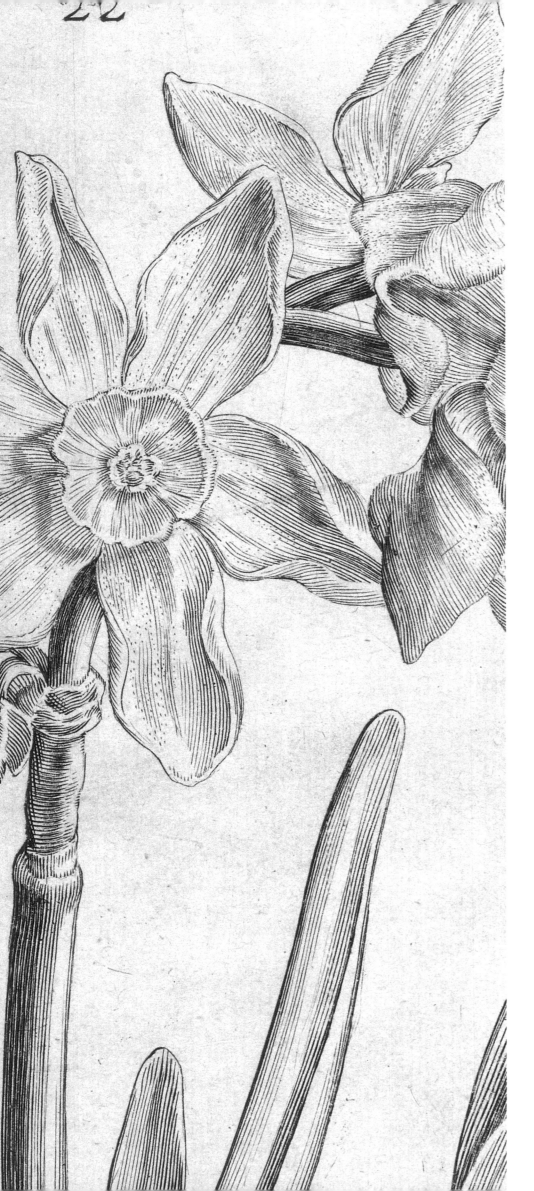

CHAPTER TWO

NARCISSUS Various species of narcissus, including *Narcissus odorus*, from the *Hortus Floridus* (1614) of Crispijn van de Passe.

TURKISH EMPIRE

The first great wave of plant introductions to reach western Europe arrived in the sixteenth century from the Turkish empire, which at the time encompassed much of eastern Europe. The schism between the Roman and the Greek churches in the tenth century meant that a break between western and eastern Europe had been established even before the Turkish conquest of Constantinople in 1453. Thereafter, the Turks began progressively to move north and west through the Balkans and up the Danube; twice they reached as far west as to besiege Vienna, but both times were repulsed. All through the sixteenth and seventeenth centuries, western Europe remained aware of the expanding empire to the east.

One of the first western Europeans to realise the botanical wealth of the Turkish empire was Ghiselin de Busbecq, the Holy Roman Empire's ambassador to Constantinople from 1554 to 1562. He was struck by the varieties of flowers he saw growing in Turkish gardens, and sent bulbs of tulips, hyacinths, anemones, and crown imperials to his friend Clusius (Charles de l'Escluse) in Vienna. Clusius eventually moved to Leiden, bringing his new bulbs with him; he had already been circulating them to an extensive network of colleagues around Europe.

Crocuses, colchicums, leucojums, erythroniums, ornithogalums, cyclamens, alliums, hyacinths, lilies, fritillaries, ranunculus, and above all tulips flowed into Europe from the 1560s onward. Ironically, some of these plants were native to eastern Europe, but this was not easy for early botanists to ascertain. It was not until the decline of the Ottoman empire in the nineteenth century that botanists from western Europe explored that area.

Many of these plants were highly variable and, while hybridisation was not yet understood, growers sought eagerly for new variations that appeared spontaneously and could be vegetatively propagated. John Gerard grouped tulips into fourteen categories in 1597, complaining that to try to describe all the varieties would be to 'number the sandes'. In 1629, John Parkinson outlined a classification of sixteen major forms, with forty-eight cultivars of *Tulipa praecox* and fifty-five of *Tulipa media*. By the 1660s, John Rea listed 184 varieties. Gerard described ten foreign anemones, with Parkinson naming thirty-three cultivars. By mid-century, Thomas Hanmer grew forty-eight varieties, including plush flowers, in his Welsh

garden (his record of which was published in 1933 as *The Garden Book of Sir Thomas Hanmer*). Parkinson grew ten forms of *Cyclamen persicum*. *Nigella damascena*, *Physalis alkekengi* (the so-called 'Chinese lantern'), *Syringa vulgaris*, *Hibiscus syriacus*, *Lychnis chalcedonica* and *L. flos-cuculi* were also introduced into Europe during the sixteenth century.

Of all the new plants from the Turkish empire, it was the tulip that achieved the greatest initial popularity – and notoriety. Thomas Johnson, revising Gerard's *Herball* in 1633, suggested that tulips might have been the 'lilies of the field' referred to in the Bible (Matthew 6. 28–29). Their colour range, and their capacity to produce variegated forms unpredictably, made them highly marketable.

The European interest in oddities and colour variations was already evident in the popularity of highly variable native plants like primulas and carnations. Tulips produced new colour patterns with great ease (as the result of viral infection), and the enthusiast would watch for a new variant that could be reproduced by vegetative propagation. Tulips were the first plants to be the subject of marketing and commercial exploitation on a large scale. During the early seventeenth century, the Dutch economy became tied to a dangerous extent to the market in tulip novelties, with disastrous results when the bottom fell out of the market in 1637.

Already by the 1620s the prices of the more spectacular varieties were rising fast, and fortunes were being made by canny growers, and lost by the unlucky. The most coveted variety was 'Semper Augustus', which was already selling for 1000 florins a bulb in the 1620s. Initially, tulip sales took place in the summer, after flowering was over, when bulbs could change hands before replanting. In the early 1630s, pure market speculation took over, and bulbs began to be sold in anticipation, even before they were lifted. From 1634 to 1637, tulip sales became so frenzied as to earn the retrospective title of tulipomania.

In December 1636 and January 1637, competitive bidding pushed tulip prices to previously unheard-of levels; a bulb of 'Semper Augustus' fetched 10,000 guilders. Finally, in February 1637, the market was flooded, and crashed. Bulbs that had been sold for staggering prices one day could not find a buyer the next. Delegates from the principal cities of the

The first anemones were sent to Europe from Constantinople in the mid-sixteenth century, and were to become one of the eight established florists' flowers. This illustration appeared in *Hortus Floridus* in 1614.

Netherlands met to find a way out of the financial disaster, and set terms for the honouring of sales contracts. Many tulips were finally sold for five to ten percent of the previously agreed sale prices.

Tulips never again reached the excesses of popularity they had achieved in the 1630s, but continued to attract high prices and produce new exhibition categories. Parrot tulips made their appearance in the late seventeenth century, 'Dutch' tulips in the eighteenth century, and Rembrandts and Cottage Tulips in the late nineteenth. In England, tulips reached their height of popularity in the 1820s and 1830s.

Other categories of florists' flowers of west Asian origin soared in popularity in the late seventeenth and eighteenth centuries. In 1629 Parkinson had red, yellow, white, and striped forms of ranunculus, including semi-doubles. In his *Universal Botanist* of 1777, Richard Weston named 1100 cultivars. Gerard knew of hyacinths, but had no cultivars himself; Parkinson had blue, white, and purple forms, including semi-doubles. By 1777 Richard Weston could enumerate 575 cultivars, including reds. (The first true double hyacinths emerged in the 1680s, through the nurseryman Pieter Voorhelm in Haarlem.) The price of hyacinths rose steadily during the early eighteenth century, with desirable bulbs fetching hundreds of guilders in the Netherlands, peaking in the 1730s without causing the sort of crisis that tulips had a century earlier.

For botanical travellers in the eastern Mediterranean, the incentive for seeking new flowers was as much a matter of scholarship as of uncovering some lucrative novelty for the garden. Debates over the identity of the plants named in ancient writings were a mainstay of academic botany for centuries. The identification of plants in Pliny's *Historia naturalis*, written in the first century AD, had already been opened to controversy by Niccolò Leoniceno in the fifteenth century. Many of the sixteenth-century herbals, or books on medicinal plants, were based on Dioscorides' first-century treatise; and Pierandrea Mattioli's commentary of 1554 was the first in a series of progressively rigorous attempts to determine exactly which plants Dioscorides had been referring to. It was to see these same plants that the Oxford botanist John Sibthorp made his expedition to Greece in the 1780s, resulting in the publication of the spectacular *Flora Graeca* after his death. This endeavour has carried on in the work of the botanist John Raven, who disputed traditional identifications in the 1970s.

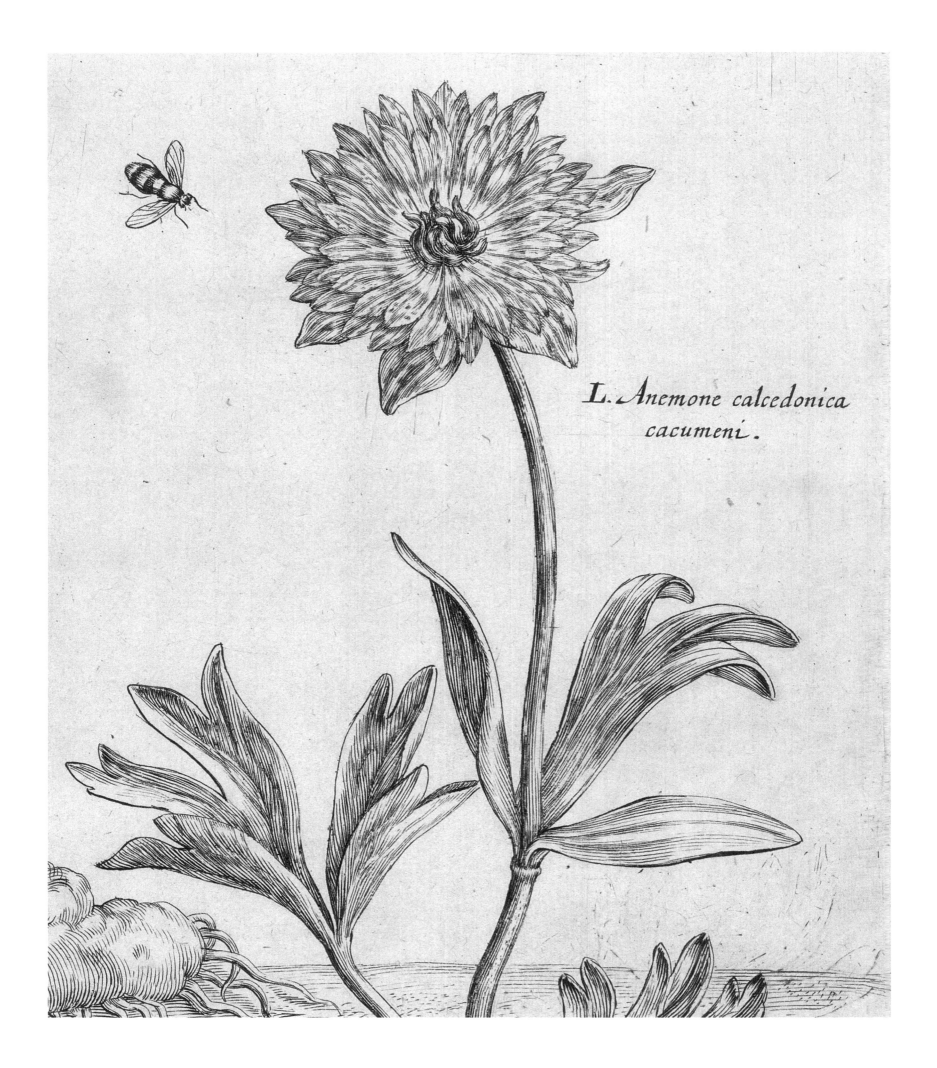

L. Anemone calcedonica cacumeni.

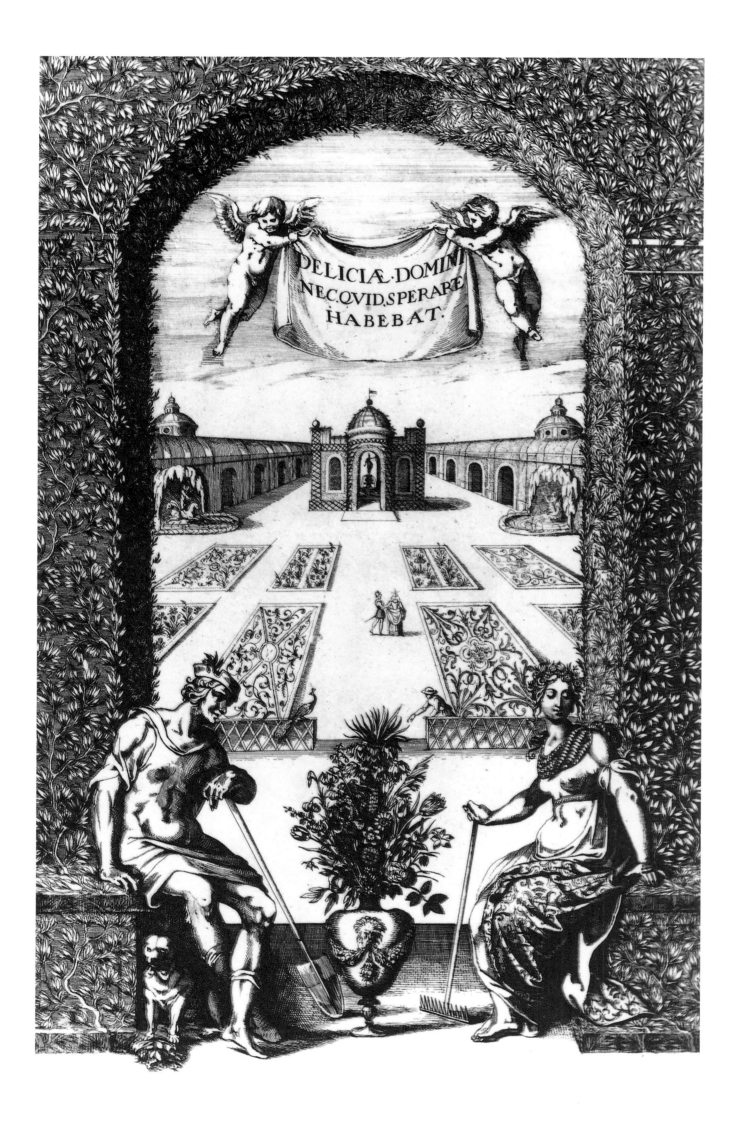

This formal seventeenth-century garden introduces Daniel Rabel's *Theatrum Florae* (1633). The bouquet in the centre of the scene includes recently arrived flowers from the Turkish empire including crown imperials and tulips.

And there was, of course, the Bible. The late seventeenth century saw the beginnings of systematic attempts to identify all the plants referred to in the Scriptures. Mountains of scholarship were assembled, in the form of works like Ursini's *Arboretum Biblicum* (1699) and Celsius' *Hierobotanicon* (1745), on the basis of what proved to be inadequate knowledge of the region's flora. The desire to see at first hand the flora of Palestine inspired the journeys of the botanists Pierre Belon in the 1540s, Leonhard Rauwolf in the 1570s, and Joseph Pitton de Tournefort in 1700.

Through expeditions such as these, a significant flow of west Asian plants continued to reach Europe. Alyssum and gypsophila arrived during the eighteenth century, with *Scabiosa caucasica*, *Eryngium giganteum*, and *Aubrieta deltoidea* following in the first decades of the nineteenth. Meanwhile, the progressive Austro-Hungarian annexation of the European parts of the former Ottoman empire meant that Western botanists had increased opportunities to explore the Balkans and make inroads into Turkey itself. The major introductions of the later nineteenth century were Balkan snowdrops and chionodoxas, *Alchemilla mollis* from the Carpathians, and west Asian species of *Eremurus*, which began to be hybridised in the 1920s and 1930s by Sir Frederick Stern in his celebrated garden at Highdown in Sussex.

None of these flowers had quite the impact of *Rhododendron ponticum*, which was introduced to Europe in the 1760s. Although it was later to be found in the Iberian peninsula, it arrived from the Caucasus in 1763. At first it was grown in glasshouses, and then as an addition to the 'American garden', or peat garden. By 1836 the Hackney nursery of Loddiges was listing twenty-eight varieties. In 1841, its first year of publication, the weekly newspaper *Gardeners' Chronicle* published correspondence from gardeners reporting that ponticum could successfully seed itself in ordinary British soil. Before long, gardeners were filling their woodlands with it, both for the aesthetic floral effects and for its ideal qualities as underwood for game coverts. It remains, in Britain at least, one of the most enduring and prolific plant introductions from the region that was once known as the Turkish empire.

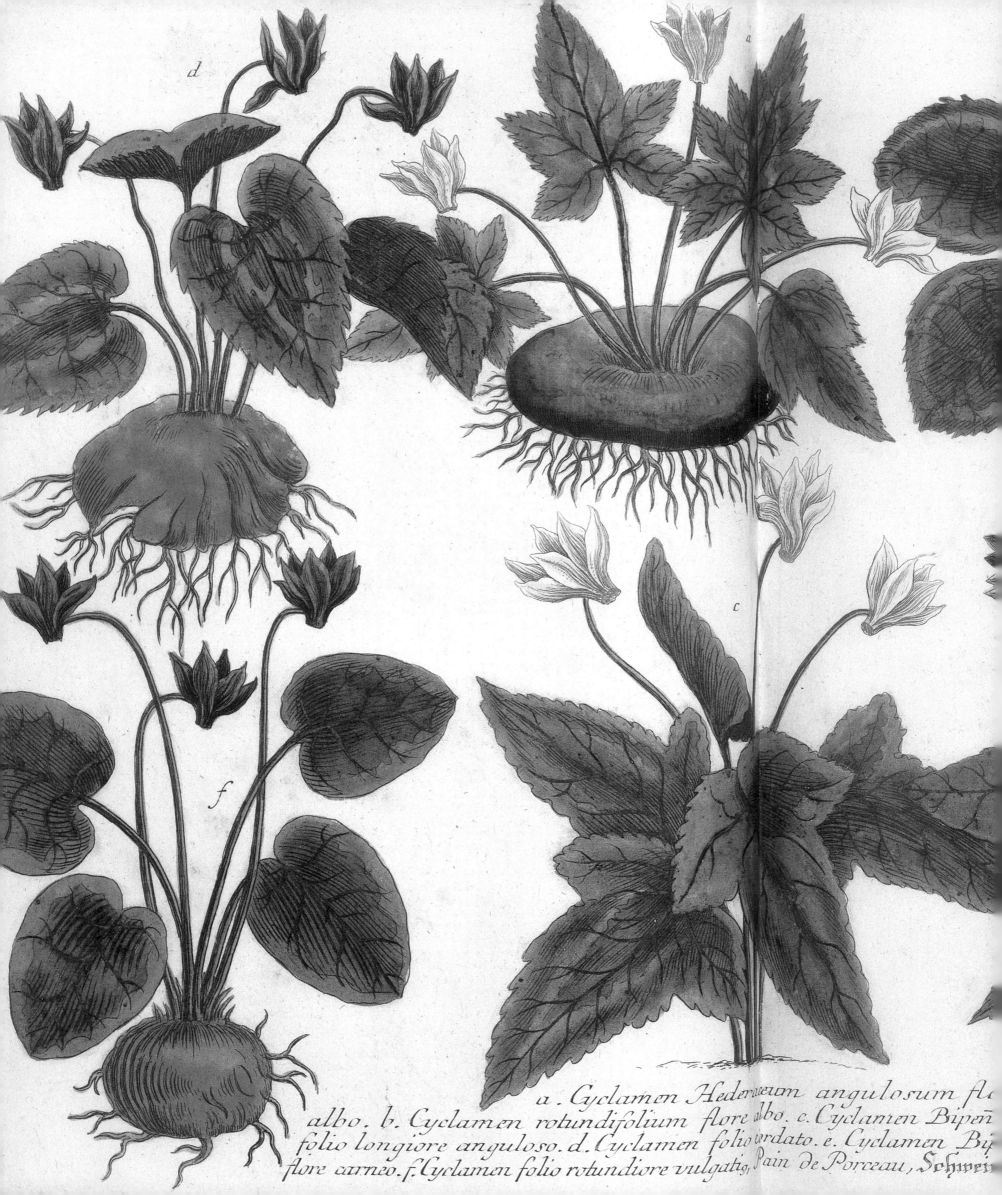

a . Cyclamen Hederæum angulosum fl.
albo. b. Cyclamen rotundifolium flore albo. c. Cyclamen Bipen
folio longiore anguloso. d. Cyclamen folio cordato. e. Cyclamen Bi
flore carneo. f. Cyclamen folio rotundiore vulgatis, Pain de Porceau, Schwei

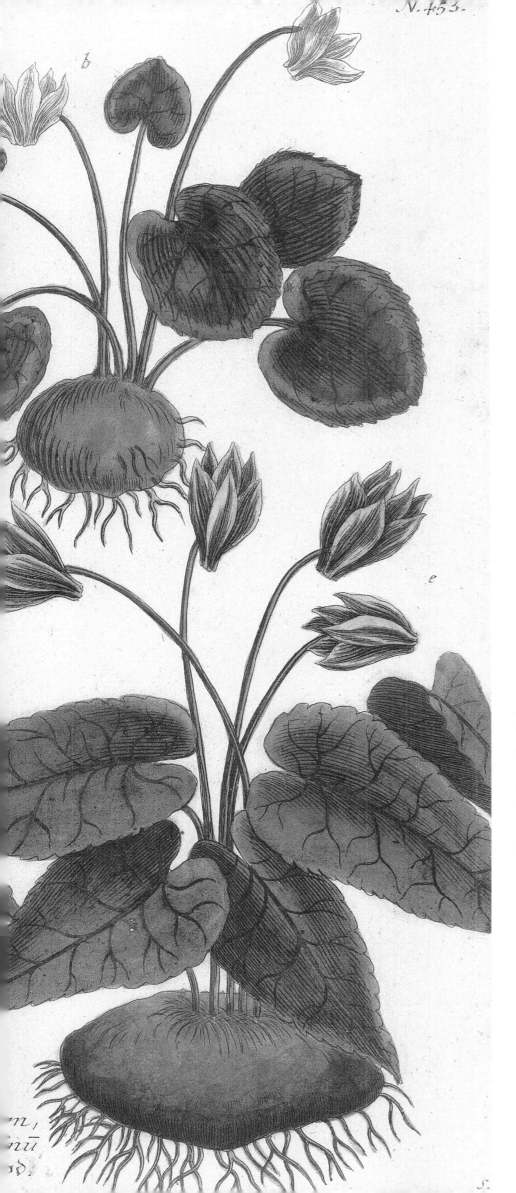

CYCLAMEN

Cyclamen persicum was introduced in the 1730s, the first important example of cyclamens grown primarily as greenhouse varieties. From the 1860s on, these became the subjects of intensive breeding, and white, red, pink, and purple cultivars appeared by the end of the century, to be followed in the twentieth by violet, dark red, and scarlet forms. In recent decades, the interest of breeders has shifted from flower colour to leaf patterning. This early illustration of cyclamens comes from *Phytanthoza* (1734–1747) by Johann Wilhelm Weinmann.

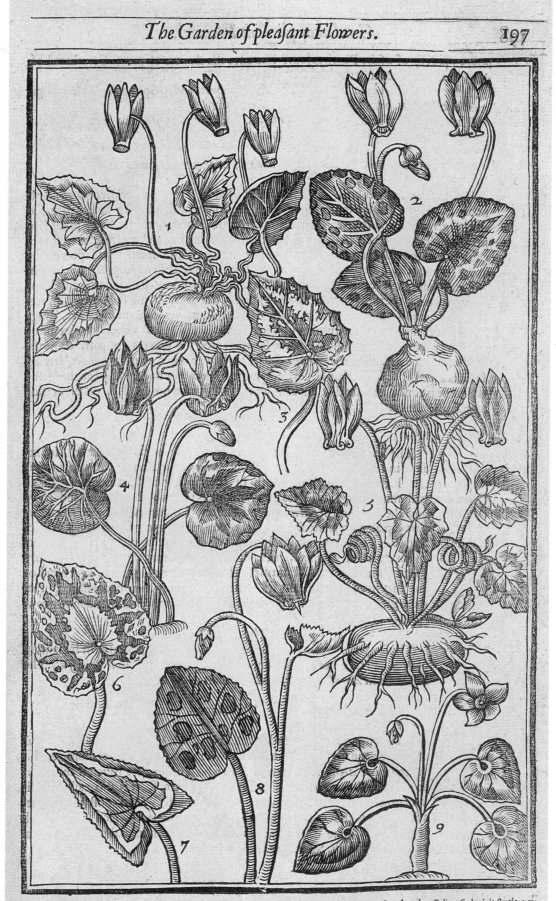

1. *Cyclamen Vernum flore purpureo*, Purple flowred Sowebread of the Spring. 2. *Cyclamen æstivum*, Summer Sowebread. 3 *Folium Cyclaminis Cretic vernalis flore candido* A leaf of Candie Sowebread. 4. *Cyclamen Romanum Autumnale*. Romone Sowebread of the Autumne. 5. *Cyclamen hederæ foliæ Autumnata*. Ivie leafed Autumne Sowebread. 6. *Folium Cyclaminis Autumnalis flore albo*. A leafe of the Autumne Sowebread with a white flower. 7. F lium *Cyclaminis angusti folii Autumnalis*. A leaf of the long leafed Sowebread. 8. *Cyclamen Antiochenum Autumnale flore amplo purpureo duplici*. The double flowered Sowebread of Antioch. 9. *Cyclamen vulgare folio rotundo*. The common round leafed Sowebread.

Cyclamen

The first cyclamens arrived in England in the second half of the sixteenth century. Gerard knew two species, one of them *Cyclamen europaeum*, and thirty years later John Parkinson had ten varieties, shown in this illustration from his *Paradisi in Sole Paradisus Terrestris* (1629). Thereafter, however, there was little development of new cultivars, and there were few introductions of other hardy cyclamen species until the nineteenth century.

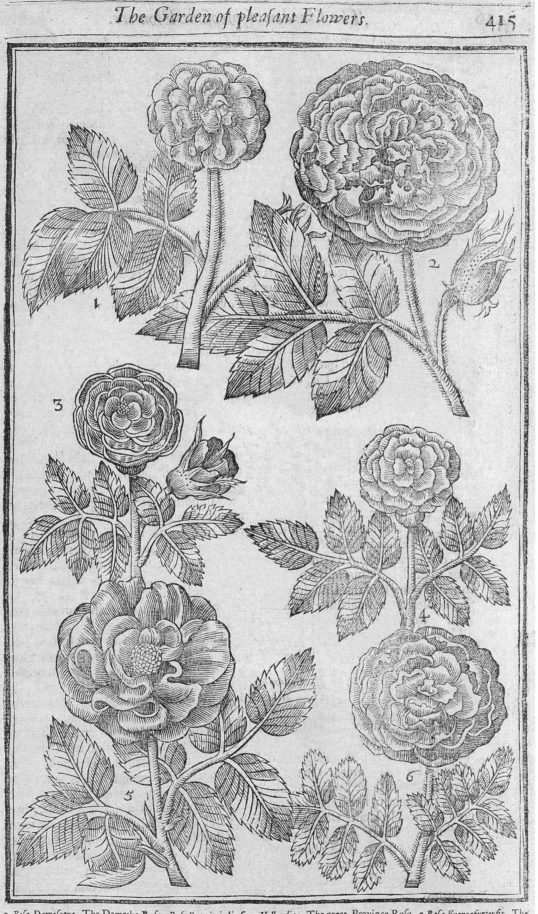

1 *Roſa Damaſcena,* The Damaske Roſe. *Roſa Provinſialis ſive Hollandica.* The great Province Roſe. 3 *Roſa Francafurtenſis,* The Franckford Roſe. 4 *Roſa rubra humilis,* The dwarfe red Roſe. 5 *Roſa Hungarica,* The Hungarian Roſe. 6 *Roſa lutea multiplex,* The great double yellow Roſe.

Roses

Parkinson listed twenty-four roses in his *Paradisus Terrestris*, some of them shown here; this was ten more than Gerard had known thirty years earlier. Parkinson's list included damask roses (*Rosa × damascena*), a long-established hybrid resulting from the introduction of Near Eastern roses during the Crusades; the red rose (*Rosa × gallica*), familiar since Roman times and identified with the house of Lancaster; the white English rose (*Rosa × alba*), identified with the house of York; and the striped York and Lancaster rose (*R. damascena* var. *versicolor*).

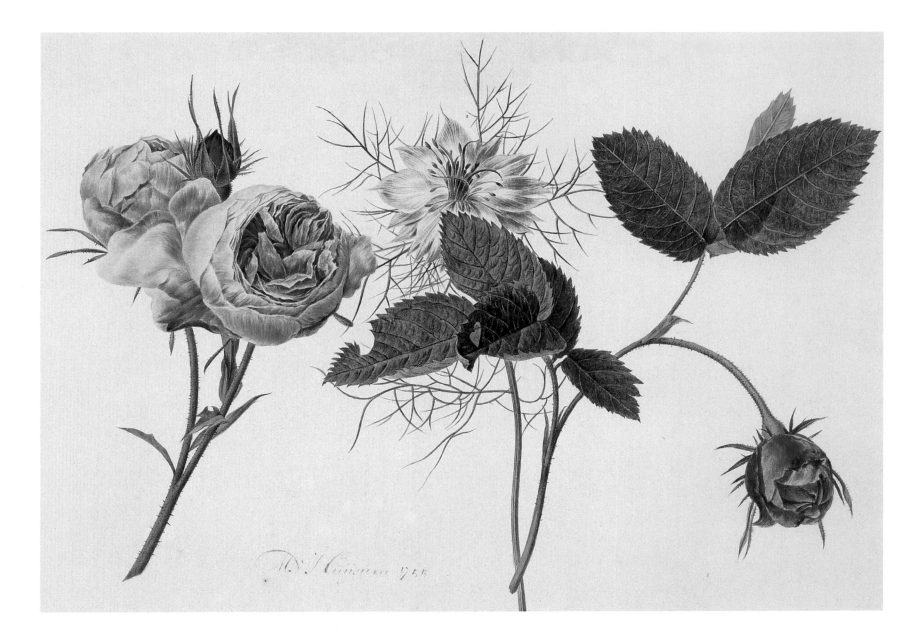

Roses and Nigella & Rosa sulphurea

The roses known in Europe up to the sixteenth century were red or white; the first yellow roses to be introduced were *Rosa foetida*, the 'yellow rose of Asia', in the 1580s, and *Rosa sulphurea* (opposite), now called *Rosa hemisphaerica*, which Clusius received from Turkey via Strasbourg in 1601. Both of these were known to Parkinson by 1629. Even so, yellow roses remained rare until the nineteenth century and the introduction of Chinese species.

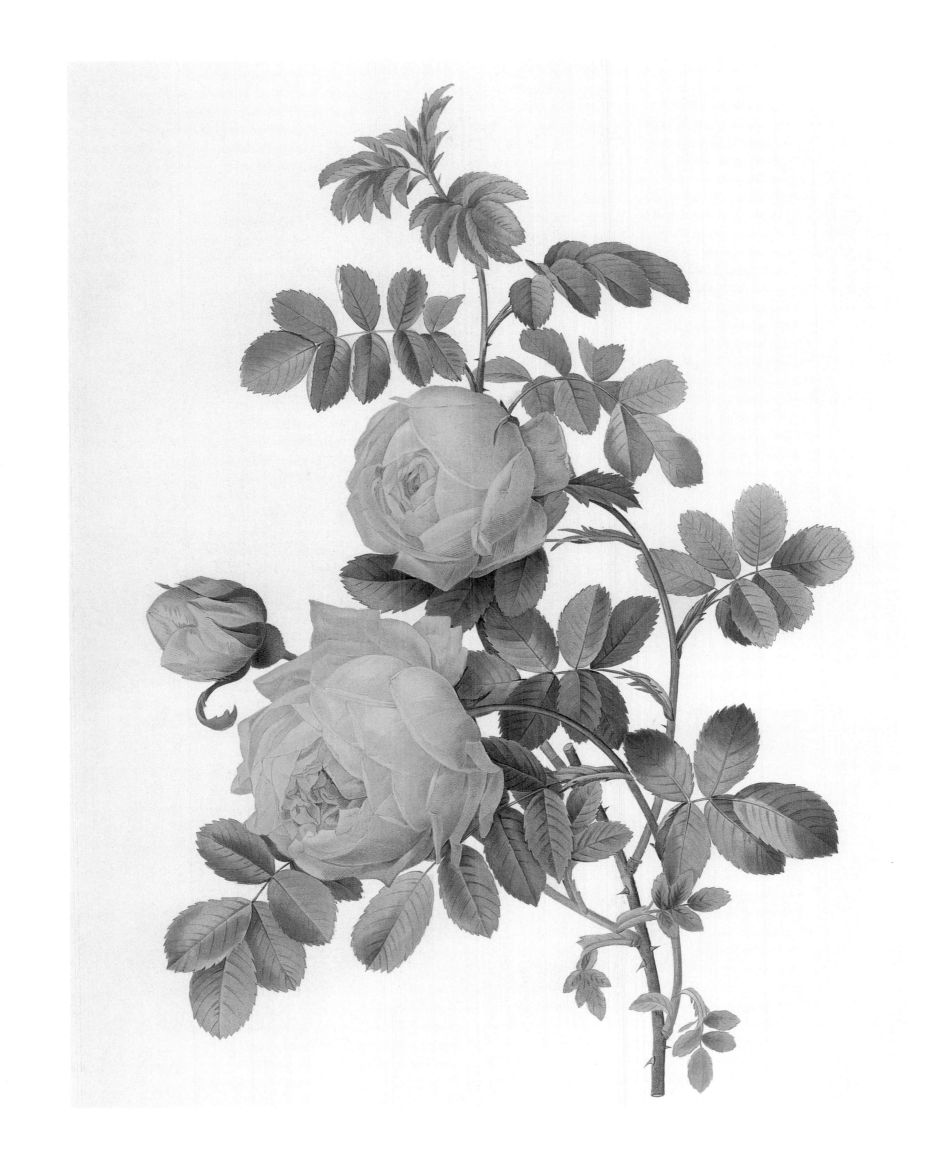

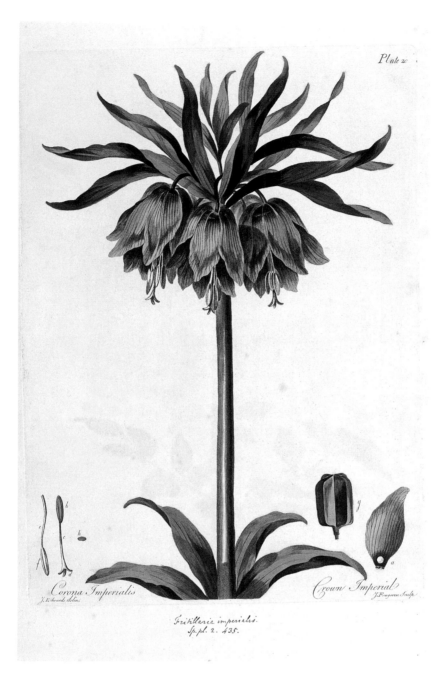

FRITILLARIA IMPERIALIS

Originally called the Turkish lily, *Fritillaria imperialis* was introduced from Turkey to Vienna in the 1570s, and derived its later name, the crown imperial, from association with the emperors of the Holy Roman Empire. It was the first plant featured in Parkinson's *Paradisus Terrestris* of 1629: 'The Crowne Imperiall for his stately beautifulness, deserueth the first place in this our Garden of delight.' He knew only the one form, although he had heard that a white-flowered variety had been raised. These illustrations of the flower come from *Edwards' Herbal* (above), written and illustrated by John Edwards in 1770, and and *De Koninglycke Hovenier* (opposite), illustrated by Hendrik Cause in 1676.

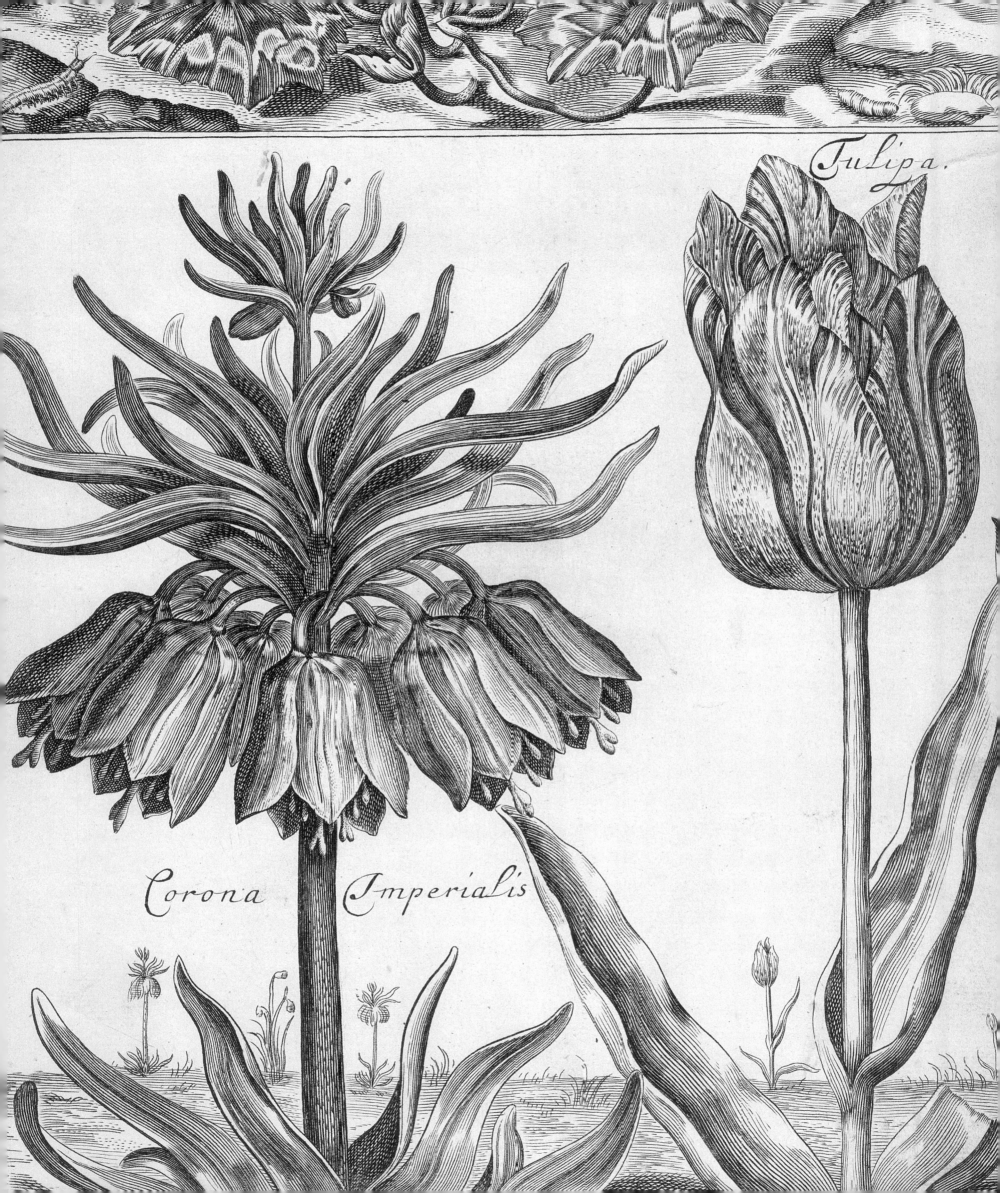

Tulipa.

Corona Imperialis

M. cum pri-re.

Lilium persicum Dod.

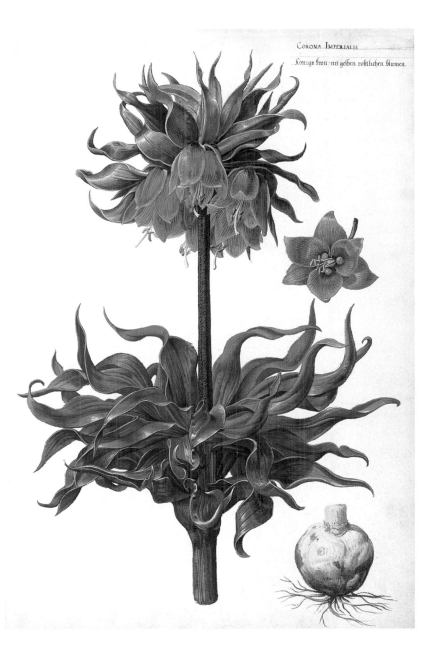

CORONA IMPERIALIS

Königs kron mit gelben röhlichen blumen.

FRITILLARIA IMPERIALIS

The crown imperial was greatly popular in the seventeenth and eighteenth centuries, with over a dozen varieties eventually grown. Most of these, including ones with variegated leaves, have died out, but today there are once again more than a dozen varieties available, with a colour range from yellow to red.

FRITILLARIA PERSICA

Fritillaria persica, the second flower to be discussed by Parkinson, was another species to be introduced early via Constantinople. Parkinson knew only the smaller form, but a larger form was introduced from Russia in the eighteenth century by the German botanist Marschall von Bieberstein.

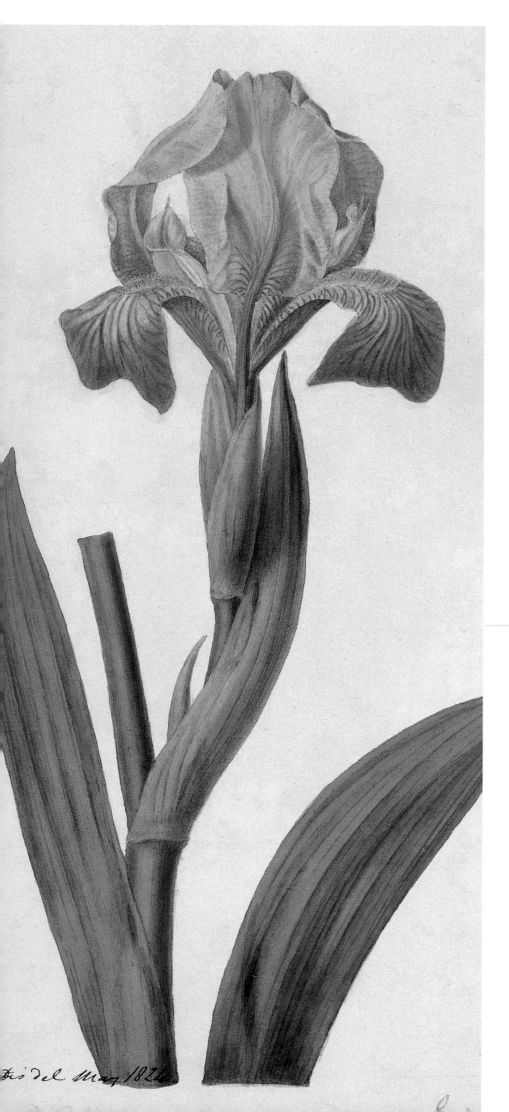

Iris del May 1826

I RIS SPURIA

Rhizomatous irises, like the yellow flag *Iris germanica*, have been grown in gardens for centuries, and yielded the French royal symbol of the fleur-de-lys. But from the late sixteenth century new bulbous irises from Turkey and southern Europe began to command attention, and flag iris varieties dwindled. The colour range of *Iris spuria* made it popular in the sixteenth and seventeenth centuries.

I RIS PERSICA

This iris was known to Gerard, and was enthusiastically grown in the sixteenth and seventeenth centuries. To quote the great English iris expert W. R. Dykes: 'Imagine a pearly white flower washed over with turquoise-blue and sea-green laid on unevenly; give it a blotch of warm purple-brown on the blade of the falls and a central orange stripe, and you will have some faint idea of the beauties of *I. persica*.'

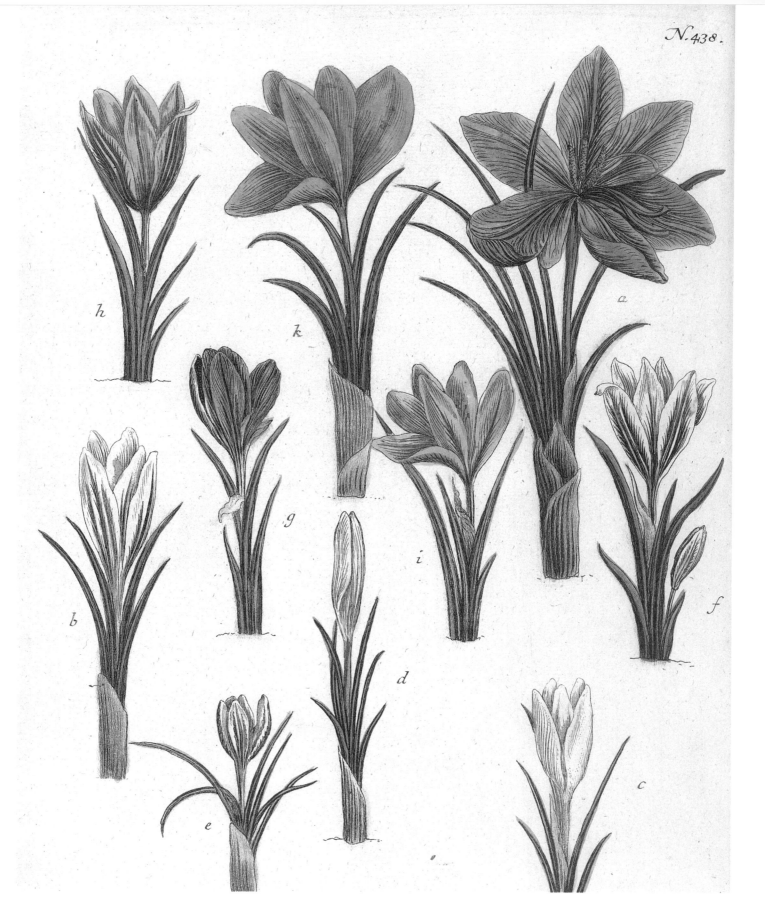

CROCUS CULTIVARS

The Dutch dominated the trade in crocuses until the nineteenth century. 'Our tulip-growers have beaten the Dutch in the quality of their best novelties,' wrote Englishman George Glenny in 1851, 'and we see no reason why we should not beat them in crocuses'. A campaign for English crocus growing resulted in a significant bulb industry in Lincolnshire, which included tulips and daffodils by 1900.

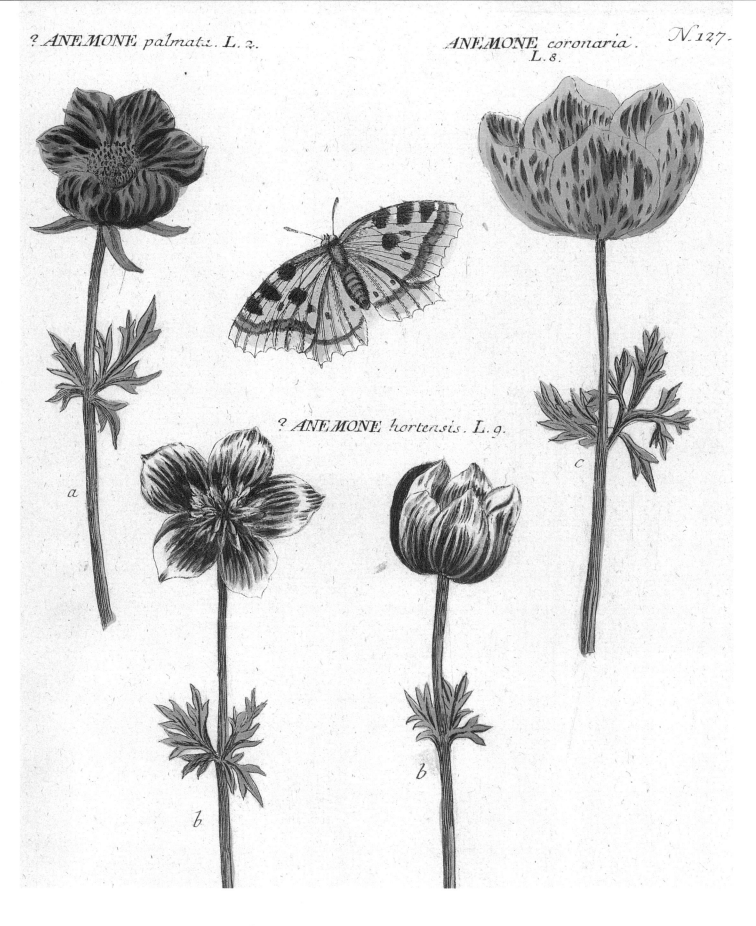

? *ANEMONE palmata. L. 2.*

ANEMONE coronaria.
L. 8.

N. 127.

? *ANEMONE hortensis. L. 9.*

ᴀNEMONE CULTIVARS

Anemone coronaria and *A. pavonina* are distributed throughout southern Europe in the wild, but were nevertheless introduced into European gardens from Turkey in the sixteenth century. Clusius described thirty-eight varieties in 1601; by 1682, Samuel Gilbert estimated there were nearly a hundred. The most important garden for early cultivars was Sermoneta, near Rome, said to have 28,000 specimens. The varieties shown here were illustrated in *Phytanthoza* (1734–1747).

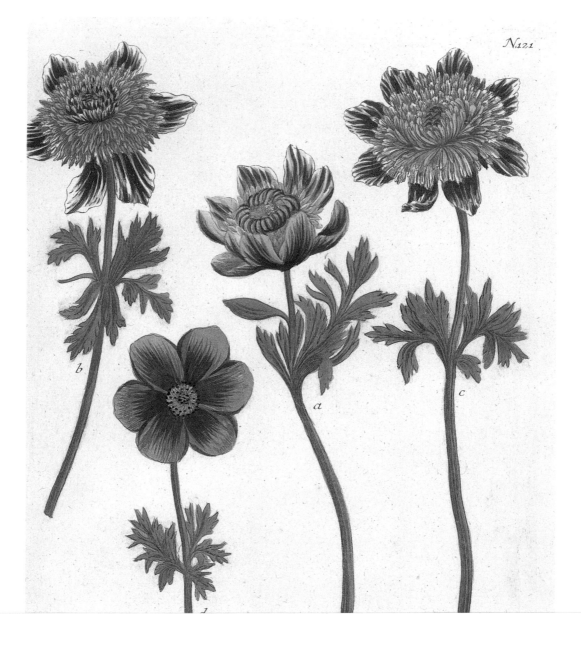

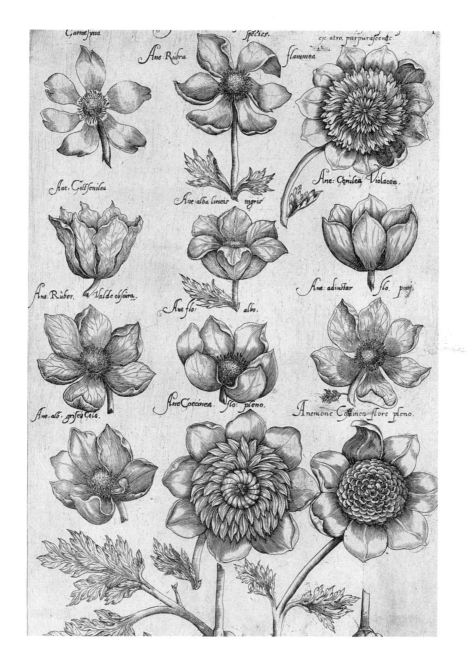

ANEMONE CULTIVARS

The seventeenth century was the heyday of the florists' anemone. These
varieties were illustrated in Emanuel Sweert's *Florilegium* of 1612. By the late
1700s the number of varieties grown was already declining. A new stimulus came
from northern France, where the De Caen strain of *Anemone coronaria* was
developed in the early nineteenth century, briefly enjoyed popularity as a
florists' flower, and was then revived late in the century as a cut flower.

TULIP CULTIVARS

Busbecq, the Holy Roman Empire's ambassador in Constantinople, first saw
tulips in Turkish gardens in the 1550s, and sent specimens to Vienna. They were
being grown in European gardens by the 1560s. They were particularly admired
for their tendency to display an unanticipated colour pattern in the petals – the

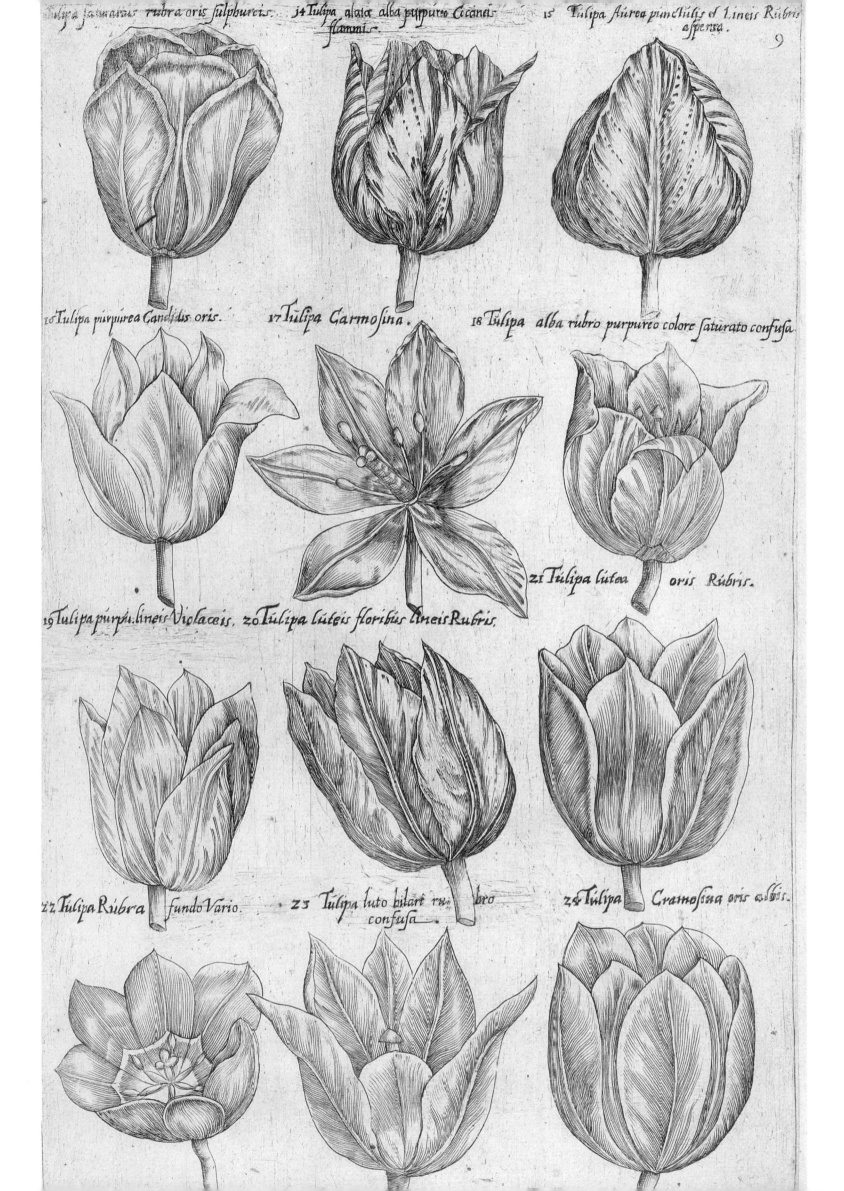

Tulipa sammarus rubra oris sulphureis. 14 Tulipa alata alba purpureo Cccaneis
flammi·

15 Tulipa Aurea punctulis et Lineis Rubris
aspersa.

9

16 Tulipa purpurea Candidis oris. 17 Tulipa Carmosina. 18 Tulipa alba rubro purpureo colore saturato confusa

21 Tulipa lutea oris Rubris.

19 Tulipa purpu. lineis Violaceis. 20 Tulipa luteis floribus lineis Rubris.

22 Tulipa Rubra fundo Vario. 23 Tulipa luto bilari ru bro
confusa. 24 Tulipa Cramosina oris albis.

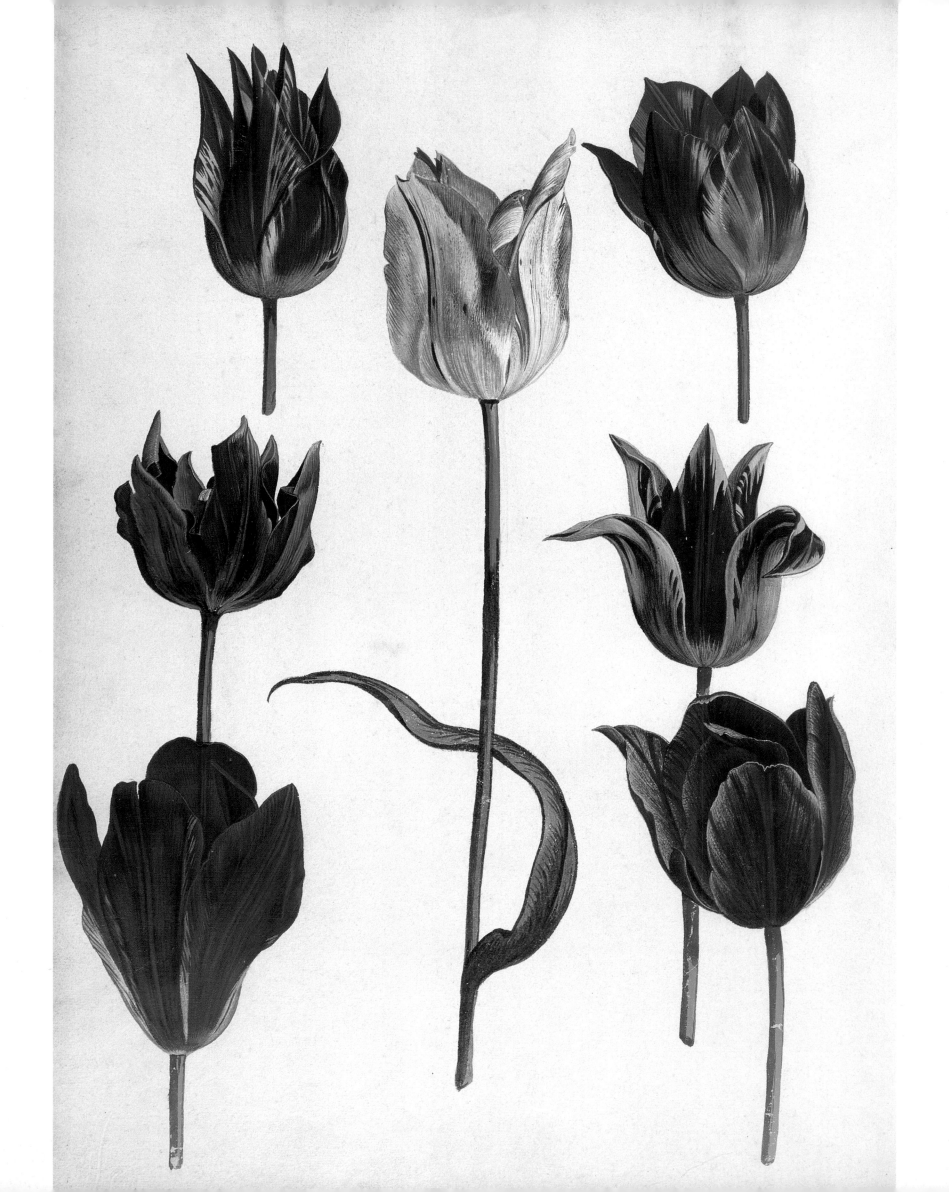

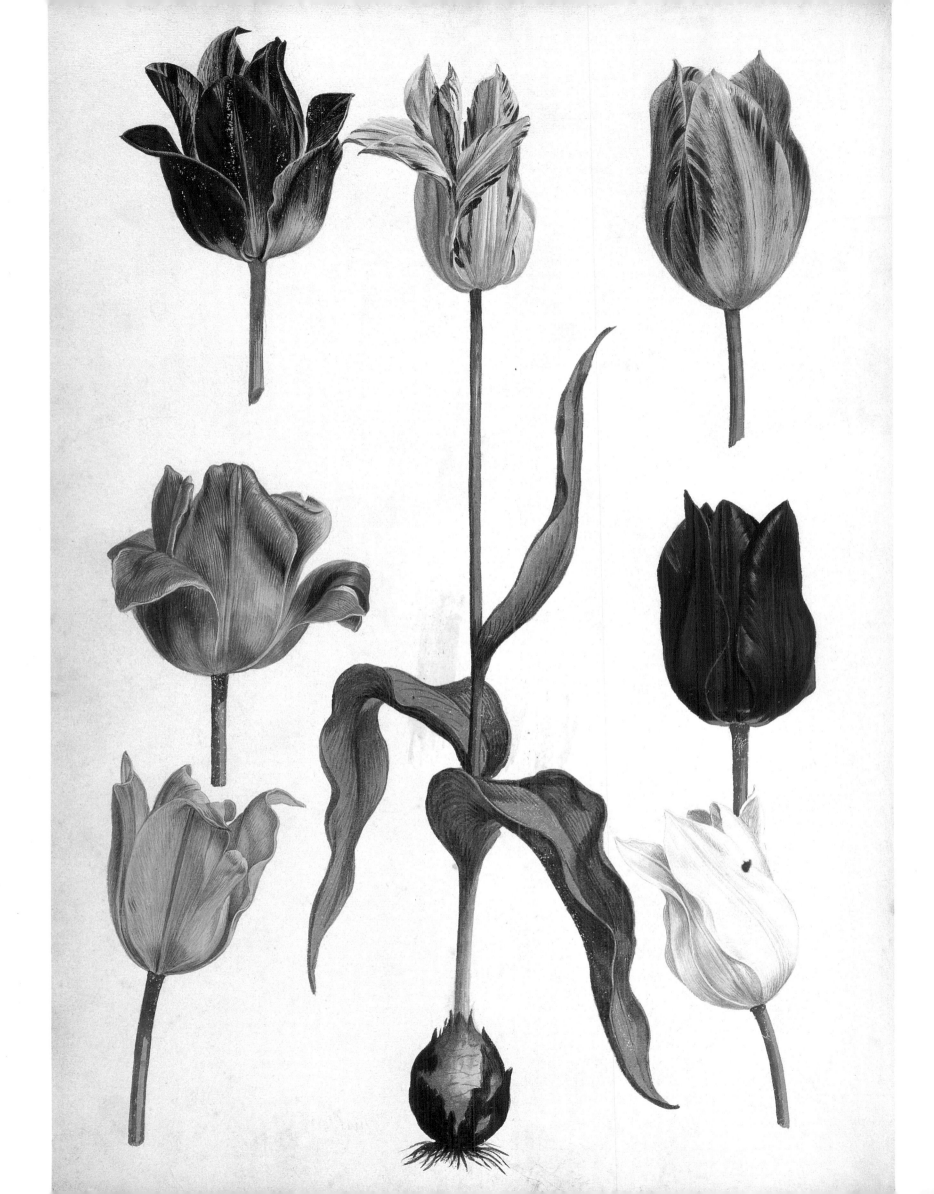

𝒯ULIPA 'ORANGE DUC THOL'

Before long, tulips were being traded for enormous prices, and dealers purchased bulbs in advance of flowering in the hope they would break with an exciting new pattern, which could be propagated vegetatively and sold widely. The resulting market correction in 1637 nearly bankrupted Holland, but did not end the search for new varieties. (The range of tulip cultivars shown on the previous pages, probably drawn in the 1630s, indicates something of the range available.) However, the rise of the hyacinth in the early eighteenth century relegated tulips to second place, and most of the early varieties disappeared. One survivor was 'Orange duc Thol', a variant of which is illustrated here in a drawing attributed to August Wilhelm Sievert.

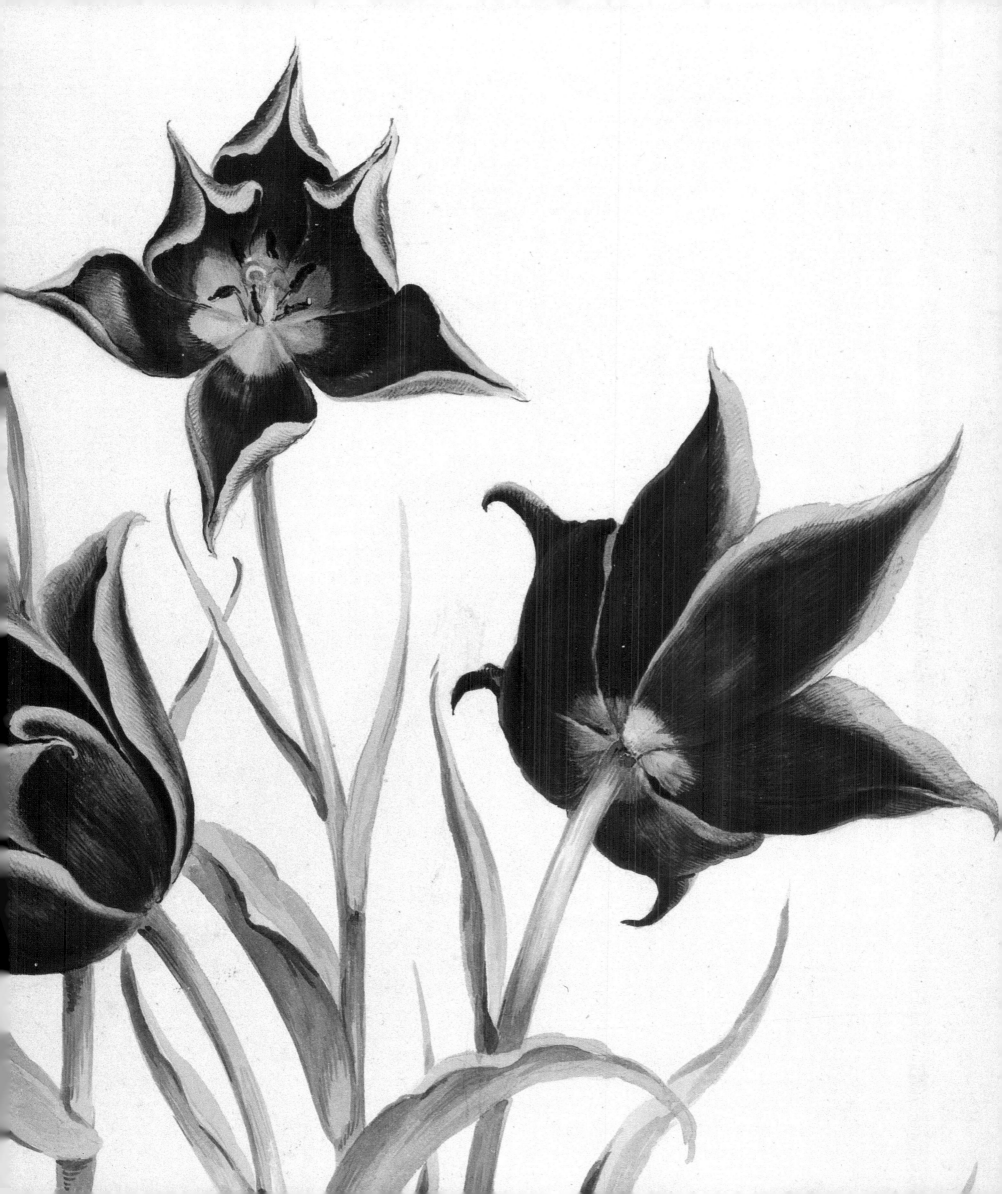

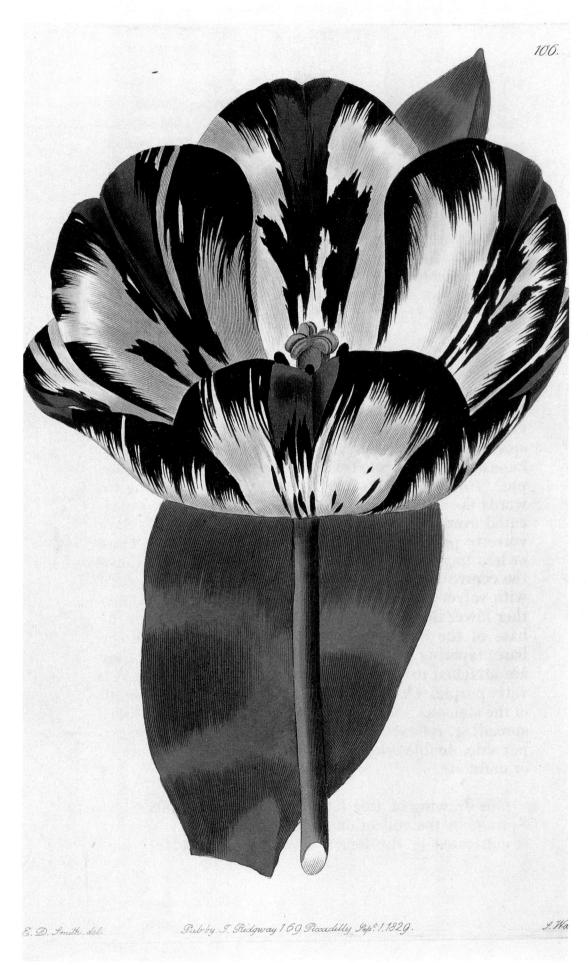

106.

E. D. Smith. del. *Pub by J. Ridgway 169 Piccadilly Sep.ᵗ 1.1829.* *S. Wa*

Tulipa 'Lord Holland'

In the eighteenth century, the French succeeded the Dutch as the leading developers of new tulip strains, and in the early nineteenth century it was the turn of the English. The 1820s to 1840s saw an English tulip fever which never reached the extremes of the 1630s. The three preferred classes were the bybloemen (purple on white, such as 'Lord Holland'), the rose (red on white), and the bizarre (red on yellow, such as 'Peregrinus Apostolicus', opposite).

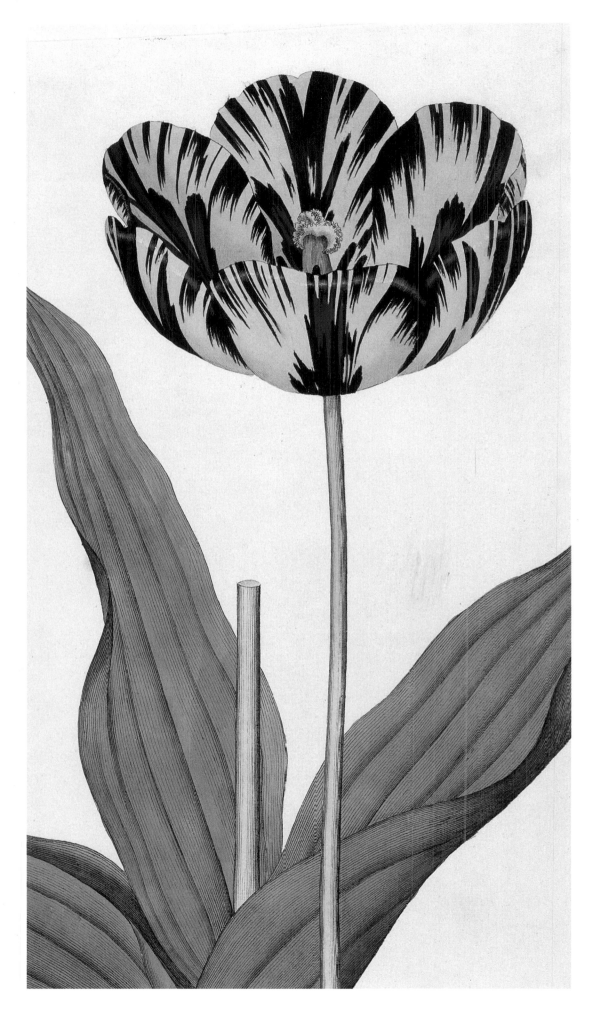

TULIPA 'PEREGRINUS

APOSTOLICUS'

In the late nineteenth century, the Dutch began once again to take the lead in tulip breeding. The Haarlem nurseryman E. H. Krelage introduced a new exhibition category, the Darwin tulip, in the 1880s: these were followed by Rembrandts, Triumphs, and Fleur-de-Lys or lily-flowered tulips, with the nurseries of Krelage and Van Tubergen playing a major role in developing most of these. The flower bed, however, has now replaced the show bench as the main focus for tulip display.

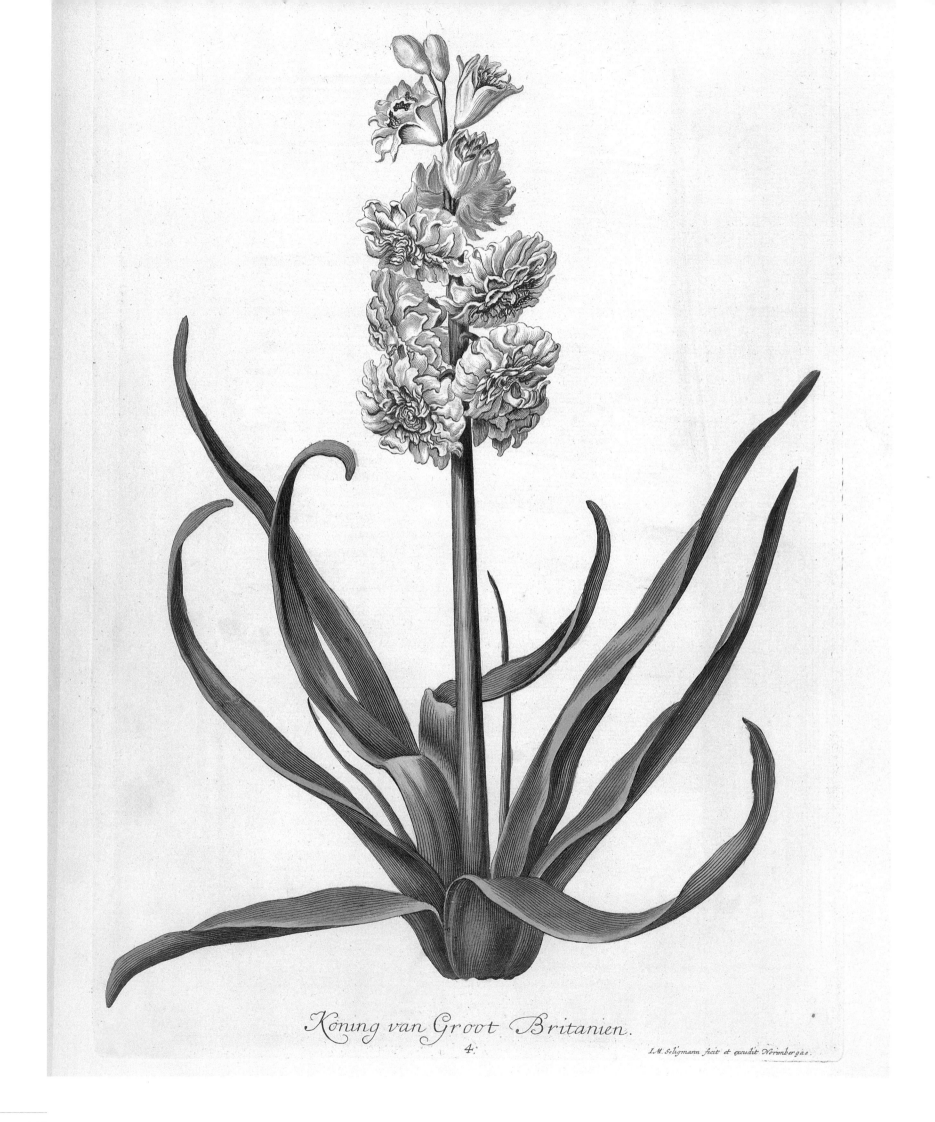

Koning van Groot Britanien.

4.

J.M. Seligmann fecit et excudit Norimbergæ.

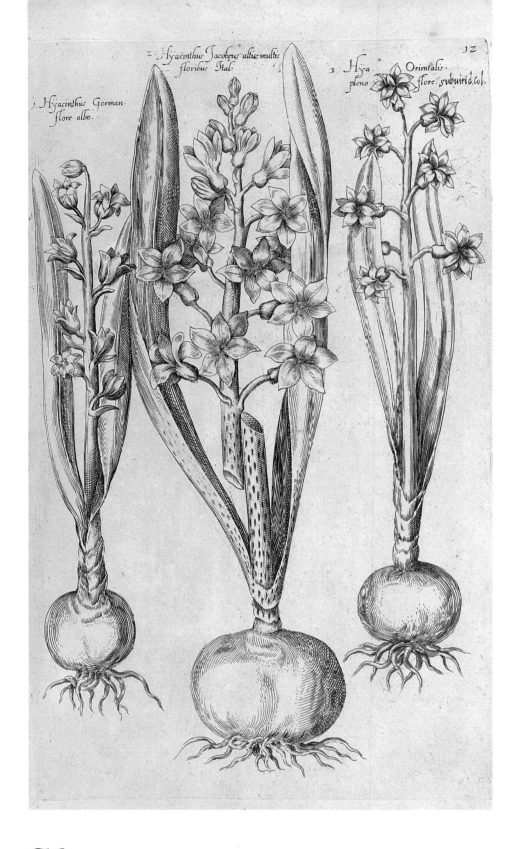

ℋYACINTH 'KONING VAN GROOT BRITANIEN'
& ℋYACINTH CULTIVARS

The hyacinth, already extraordinarily popular in Turkey, reached Europe in the mid-sixteenth century and was illustrated (above) in Emanuel Sweert's *Florilegium* of 1612. The earliest varieties were red or pink; by the 1590s John Gerard had heard of white and purple varieties, but was unable to obtain them. Semi-double forms were much favoured by collectors, until the first true doubles were grown by Pieter Voorhelm in the 1680s. Hyacinth 'Koning van Groot Britanien' (opposite) was one of the most famous doubles, because of the contrast between the white outer and the red inner petals.

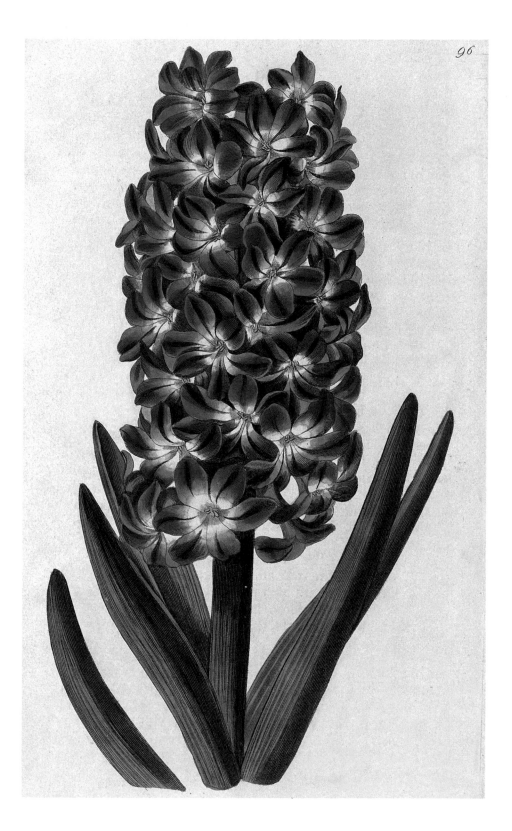

96

\mathcal{H}YACINTH 'LYRA GRANDIS'

Hyacinths were not confined to the florists' show benches; much of the bulk in sales came from general domestic use. The popularity of hyacinths spread up and down the social scale, from the cottage garden to the shop window. Unusually for a florists' flower, the pattern of the individual flower was considered less important than the total shape of the inflorescence, and stripes or distinct patterns on the petals were discouraged.

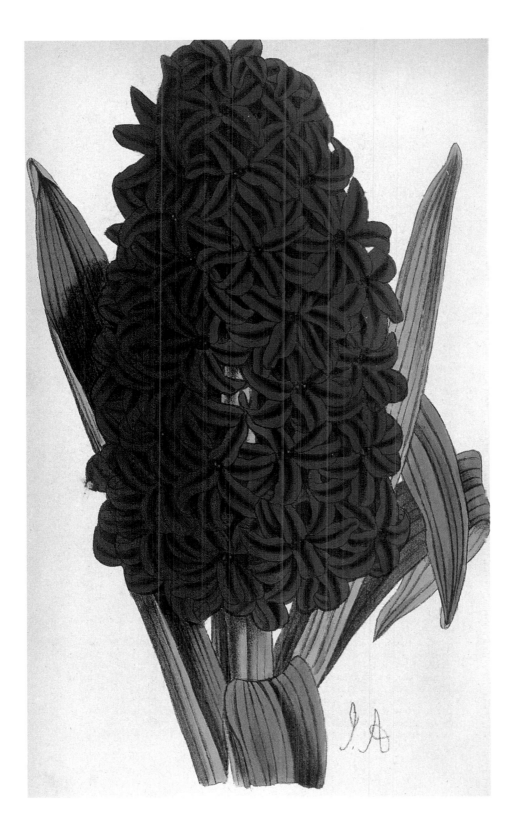

ℋYACINTH 'PRINCE ALBERT VICTOR'

The last phase of the hyacinth's history as a florists' flower saw the shift from the pyramidal shape formerly sought after, to the cylindrical column still popular today. A preference for darker colours was already noticeable in the late eighteenth century. 'Prince Albert Victor', bred by the English nurseryman William Paul, was greeted as a breakthrough in the production of deep reds and purples. But by the twentieth century pale colours had become fashionable, and the Victorian hyacinths, like their predecessors, have now disappeared.

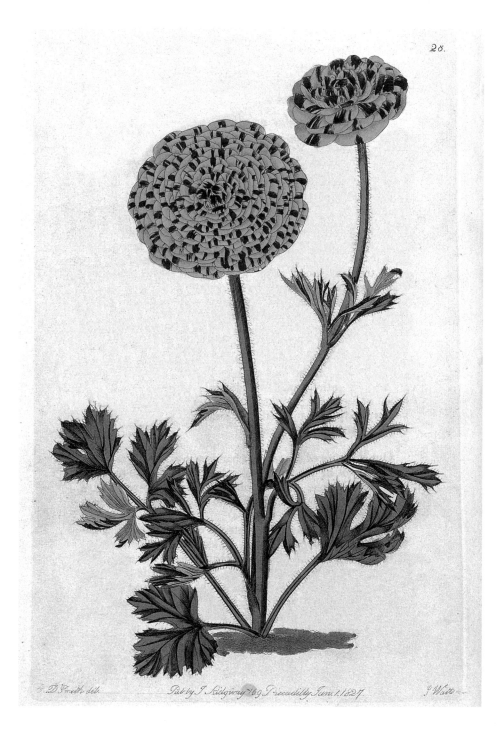

Ranunculus 'le mélange des beautés' & Ranunculus 'vereatre'

Like the anemone, the cultivated ranunculus was introduced from Turkey despite the presence of wild forms throughout southern Europe. By Parkinson's time, in the 1620s, it was available in yellow, white, and red, in striped and double-flowered forms, but it was not until the mid-eighteenth century that the number of varieties began to multiply. In the 1790s the nurseryman James Maddock claimed that there were more varieties of ranunculus than of any other plant. *Ranunculus* 'Le mélange des beautés' (above) and *Ranunculus* 'Vereatre' (opposite) were illustrated for Robert Sweet's *The Florist's Guide* (1827–1832).

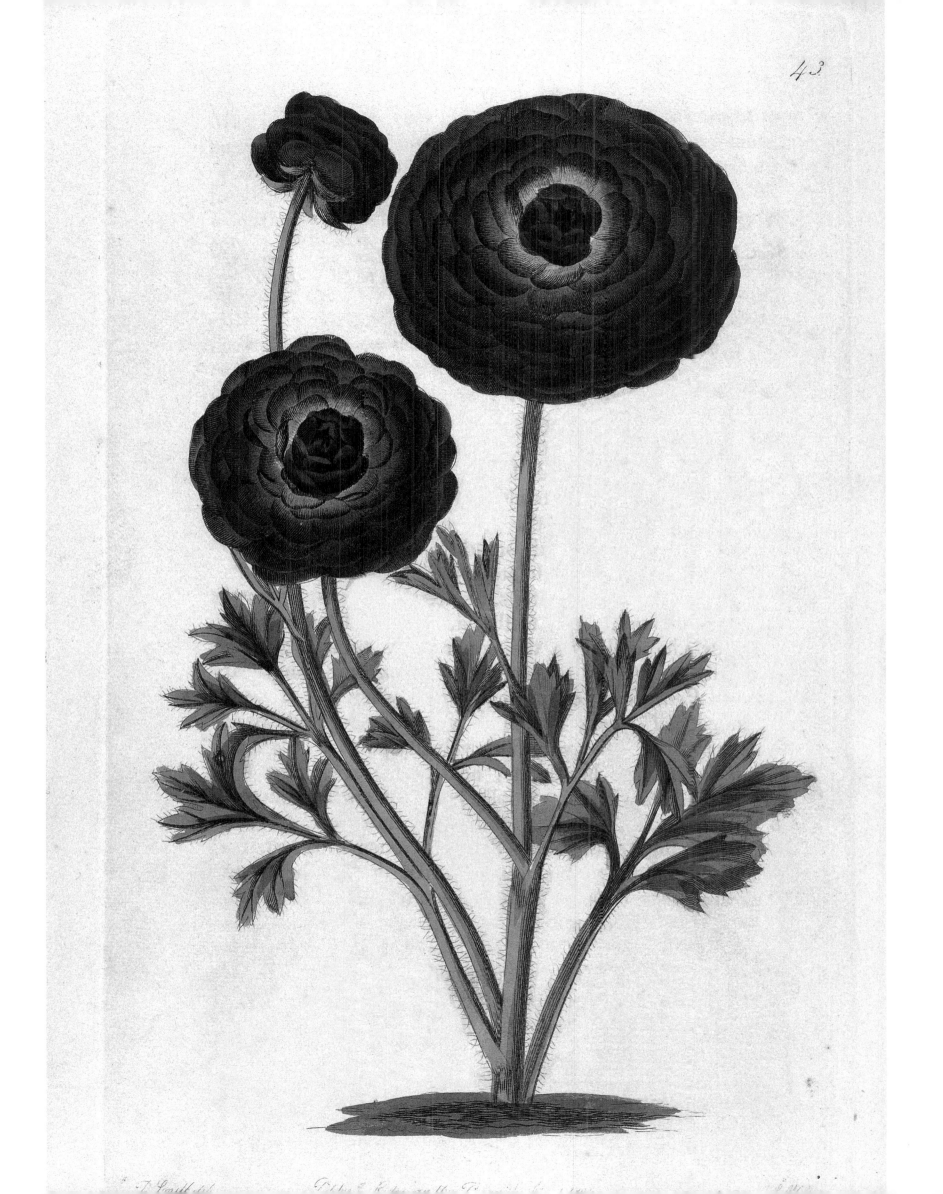

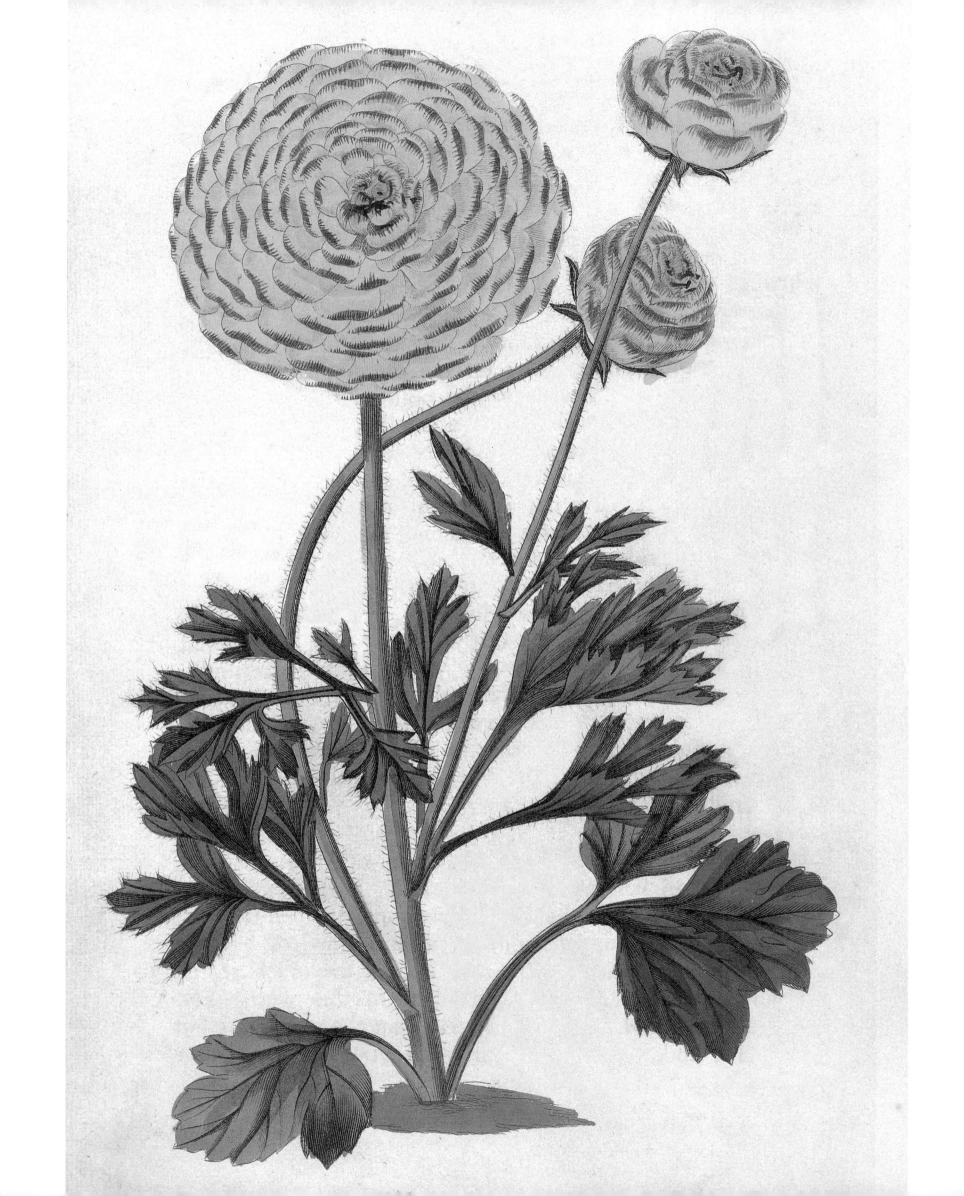

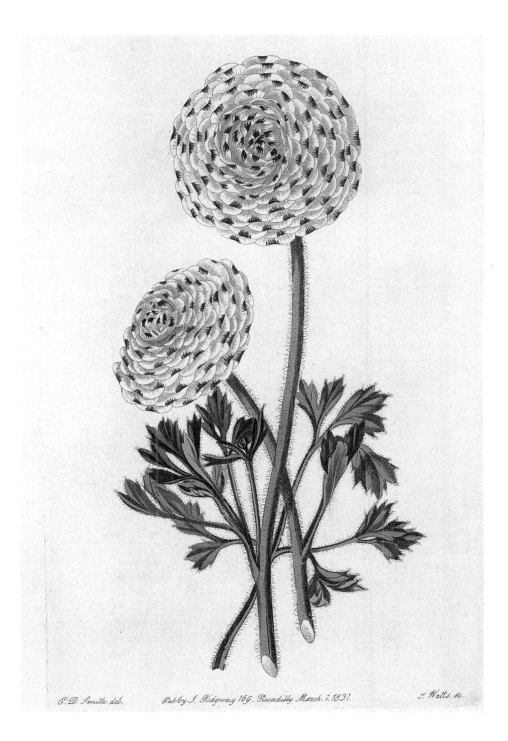

C.D. Smith. del. Pub. by J. Ridgway 169. Piccadilly March. 1. 1831. S. Watts. sc.

RANUNCULUS 'GADWIN DOUGLAS' & RANUNCULUS 'CUPID'

The heyday of the ranunculus in England ran from the 1780s to the 1830s. Single-coloured forms were grown extensively for general garden use, as well as the highly patterned forms for competition. Symmetrical, hemispherical flowers with stripes or edges of contrasting colour were the ideal for the show bench. By the 1850s the fashion was fading, however, and by the 1880s the florists' ranunculus was effectively extinct. The varieties 'Gadwin Douglas' (opposite) and 'Cupid' (above) appeared in *The Florist's Guide* (1827–1832).

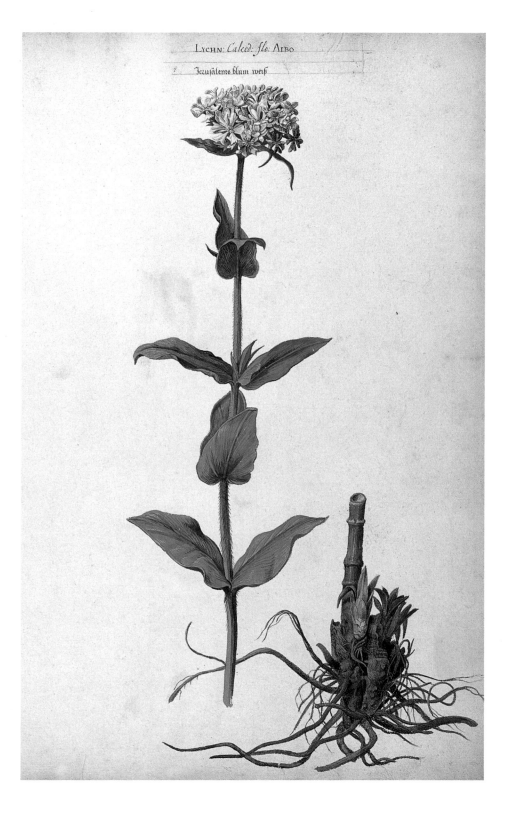

ℒYCHNIS CHALCEDONICA &
𝒮ILENE COELI-ROSA

These plants, once grouped together as *Lychnis*, are now divided into two different genera. *Lychnis chalcedonica* (above) and *L. coronaria* were introduced in the Middle Ages, and double forms and colour variants were collected by Parkinson and his contemporaries. *Lychnis* (now *Silene*) *coeli-rosa* (opposite) was less popular in England than in Germany, where it was commonly called Rose of Heaven. *Lychnis chalcedonica* became one of the popular 'old-fashioned' flowers of the late nineteenth century, while *L. coronaria* was the focus of much breeding in the late twentieth century.

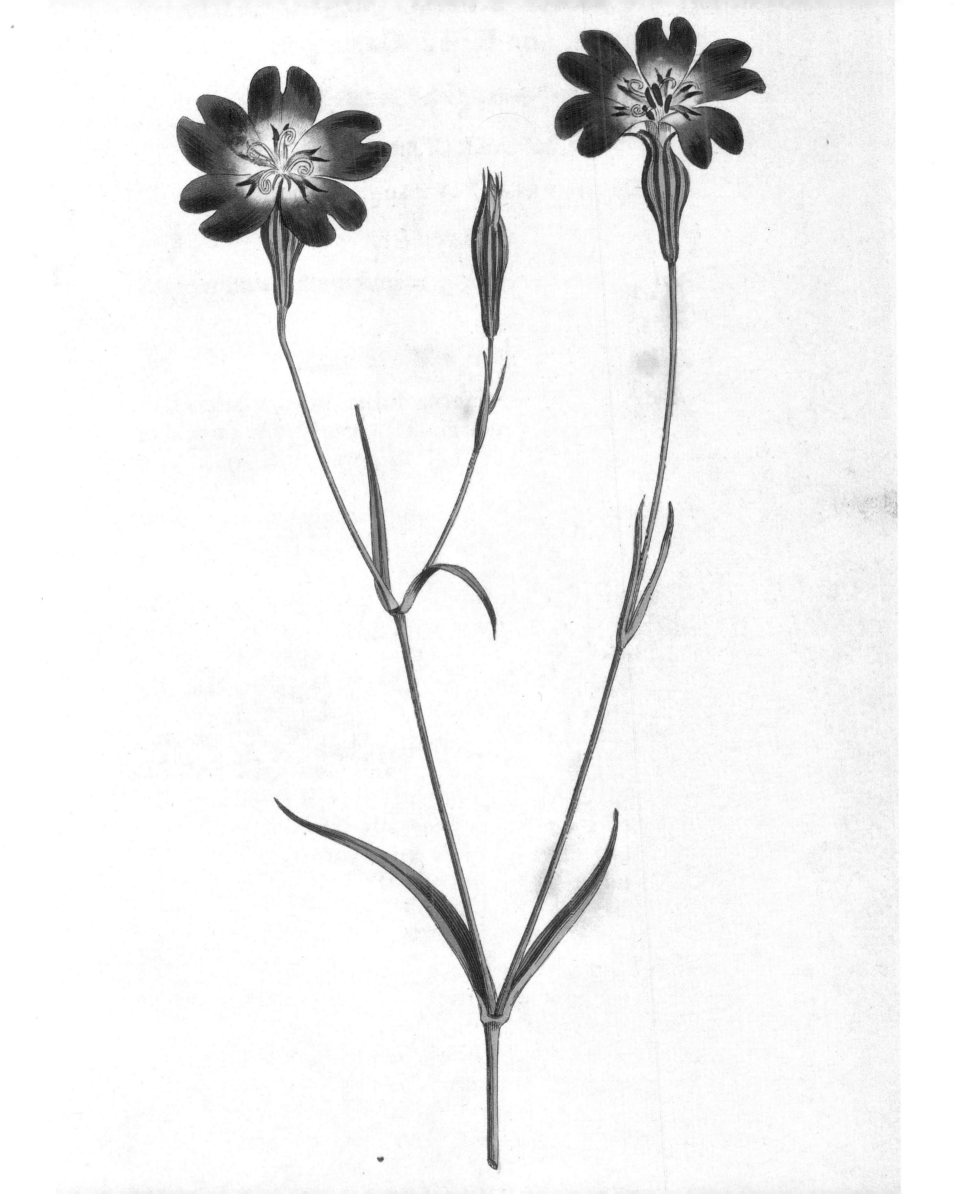

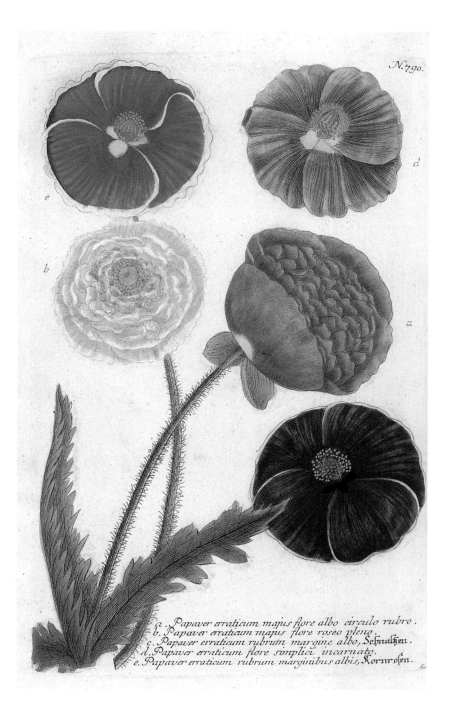

a . Papaver erraticum majus flore albo circulo rubro.
b. Papaver erraticum majus flore roseo pleno.
c. Papaver erraticum rubrum margine albo, Schnalken.
d. Papaver erraticum flore simplici incarnato.
e. Papaver erraticum rubrum marginibus albis, Kornrosen.

\mathcal{P}OPPY CULTIVARS

Although *Papaver somniferum*, the opium poppy, is found throughout southern Europe, the stimulus to its ornamental use in gardens came after double-flowered forms were introduced from Constantinople in the sixteenth century. By the 1650s they were being grouped into violet, carnation, curled, fringed, and feathered poppies. The enthusiasm of continental growers then spread to *Papaver rhoeas*, varieties of which became known as Dutch poppies, even though the species is native to Britain. These illustrations from Weinmann's *Phytanthoza* (1734–1747) show something of the range of colours and shapes available in eighteenth-century Germany, including white forms similar to the Shirley poppies that William Wilks bred in England in the 1880s.

Papaver erraticum majus roseum margi =
e albo, Kornrosen. b. Papaver erraticum majus
re pleno margine rubro striato. c. Papaver erraticum
ijus flore rubro pleno. d. Papaver erraticum majus flore
herrimo pleno. e. Papaver erraticum majus rosei coloris
s albis notatum. f. Papaver erraticum majus flore pleno marginibus rubris.
g. Papaver erraticum majus simplex oris albis notatum.
h. Papaver erraticum majus flore pleno roseo.

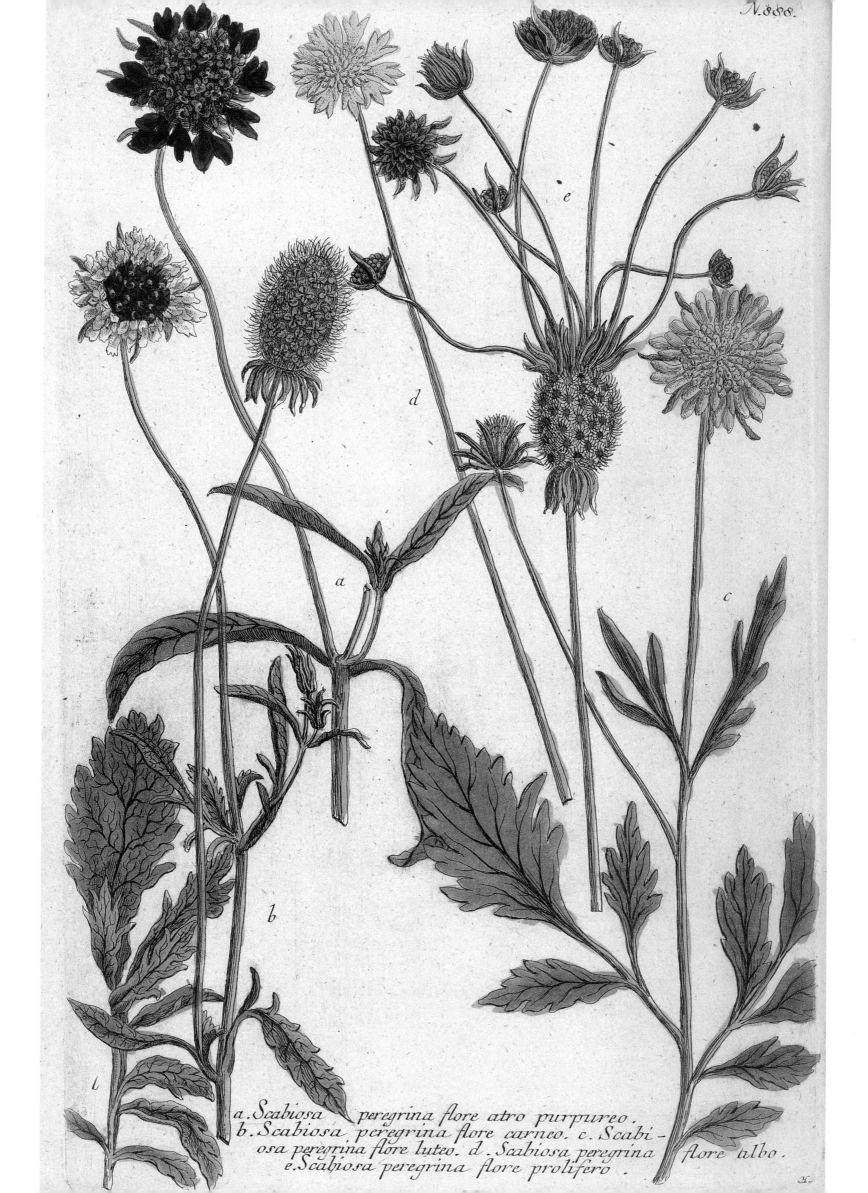

a.*Scabiosa peregrina flore atro purpureo.*
b.*Scabiosa peregrina flore carneo.* c.*Scabi-*
osa peregrina flore luteo. d.*Scabiosa peregrina flore albo.*
e.*Scabiosa peregrina flore prolifero.*

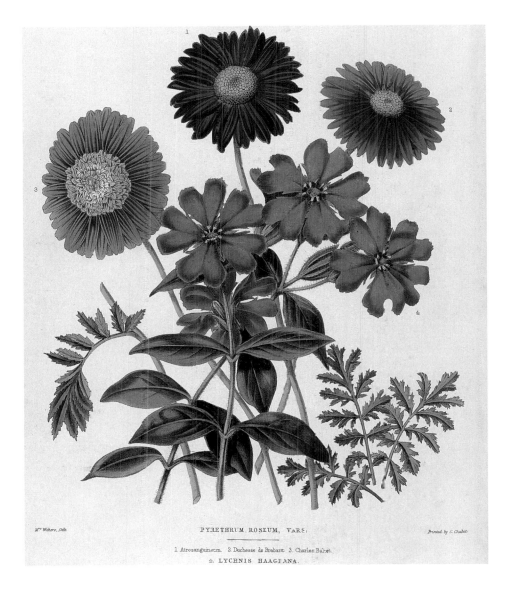

PYRETHRUM ROSEUM, VARS.

1 Atrosanguineum. 2 Duchesse de Brabant. 3 Charles Baltet.
4. LYCHNIS HAAGEANA.

TANACETUM COCCINEUM

The pyrethrums (now *Tanacetum*, shown here with a *Lychnis*, centre) were known in England from white- and yellow-flowered forms until the 1850s, when darker seedlings and double forms became available. From the 1860s they were enthusiastically bred until the early twentieth century. Kelways' nursery was the longest-lasting of pyrethrum breeders in England; until recently there were still some two dozen varieties, but many of these have now become unavailable commercially.

SCABIOSA

The first scabious to become known in northern Europe was *Scabiosa atropurpurea*, introduced by Clusius from Italy in 1591. As the illustration here from *Phytanthoza* (1734–1747) shows, variant forms of scabious were eagerly grown in eighteenth-century Germany. *Scabiosa caucasica*, although introduced by Loddiges' Nursery in Hackney at the beginning of the nineteenth century, only became widely popular in the twentieth century, promoted by Ellen Willmott of Warley Place in Essex. Some two dozen varieties are now available.

Sonne-blom.

Flos Africanus.

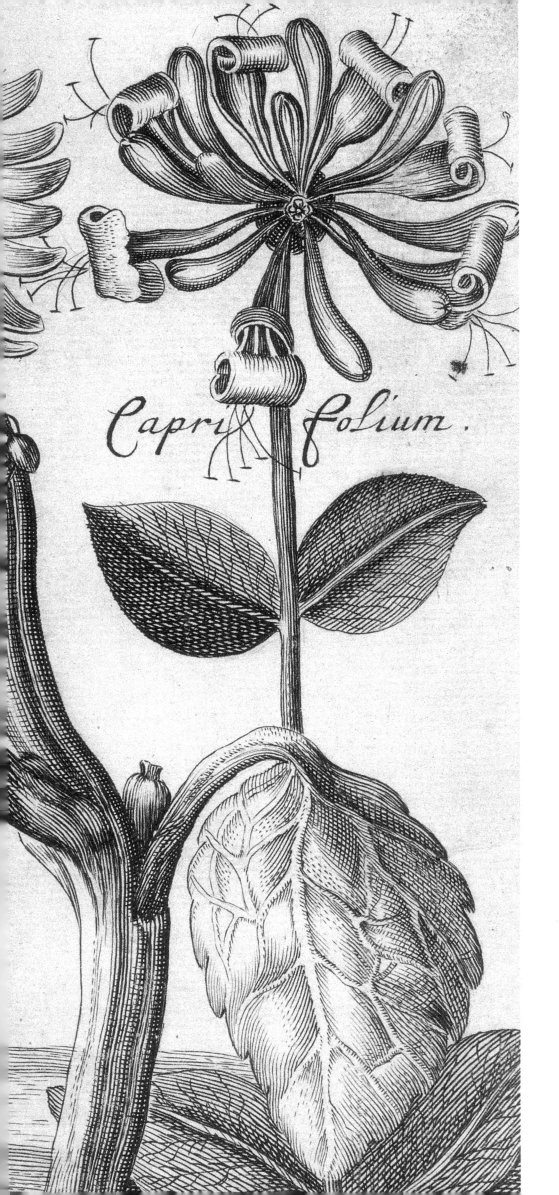

Capri folium.

CHAPTER THREE

EXOTIC garden flowers from *De Koninglycke Hovenier*, an anonymous Dutch gardening treatise published in 1676.

An African aloe from Munting's *Phytographia Curiosa* (1704). There is no agreement among commentators which species of aloe this is. Most African aloes introduced into Europe did not flower in captivity for years, and it is possible that the flowers were drawn from conjecture rather than from knowledge.

Paxton pioneered the bedding of lobelias at the Crystal Palace in the 1860s; kniphofias had to wait until nearly the end of the century before they were drawn into the hybridist's orbit, and nerines until the Edwardian period.

None of these ever attained quite the universality that awaited the pelargonium. The first specimens arrived in Europe in the seventeenth century, and others followed during the eighteenth. By the later years of that century pelargoniums had become popular glasshouse plants, and new species were eagerly collected by connoisseurs. By the 1820s they were being used for summer bedding in the outdoor garden. But most of these pelargoniums were woody-stemmed plants, with a comparatively small amount of flower in proportion to leaf and stem; and nurserymen and amateurs began attempting to cross the more ornamentally flowered with the dwarfer species.

The first true bedding pelargoniums appeared on the market in the early 1840s, and for twenty years they shared the parterre garden with petunias, verbenas, and calceolarias. As time passed, pelargoniums became the dominant single type of flower for display beds. In 1864, the gardening journalist Shirley Hibberd wrote that 'the odds and ends of the bedding list that, previous to the year 1860, made so many features of interest … are nearly all swept away … [pelargoniums] are now so varied in habit and colour that with [them] alone a skilful artist can produce almost any effect that may be required'.

Pelargoniums never suffered the eclipse that wiped out the other bedding plants. They endured the rivalry of tuberous begonias during the last decades of the nineteenth century, and continued to be indispensable plants for the parterre, and for the municipal park, throughout the twentieth century. During the Edwardian period they finally fell from fashion among the horticultural elite. Many nineteenth-century pelargoniums are still commercially available today, and the last third of the twentieth century even saw a revival of zonals, the variegated-leaved forms of *Pelargonium zonale*, which had been the favourites of the 1860s and 1870s. Indeed, as late twentieth-century breeders introduced ever brighter flower colours in begonias and impatiens (the other leading categories of bedding plants in recent years), there was a reaction in favour of pelargoniums, which were seen as less garish.

Other South African plants which arrived during the nineteenth century, but which were never the objects of such

Fig. 97.

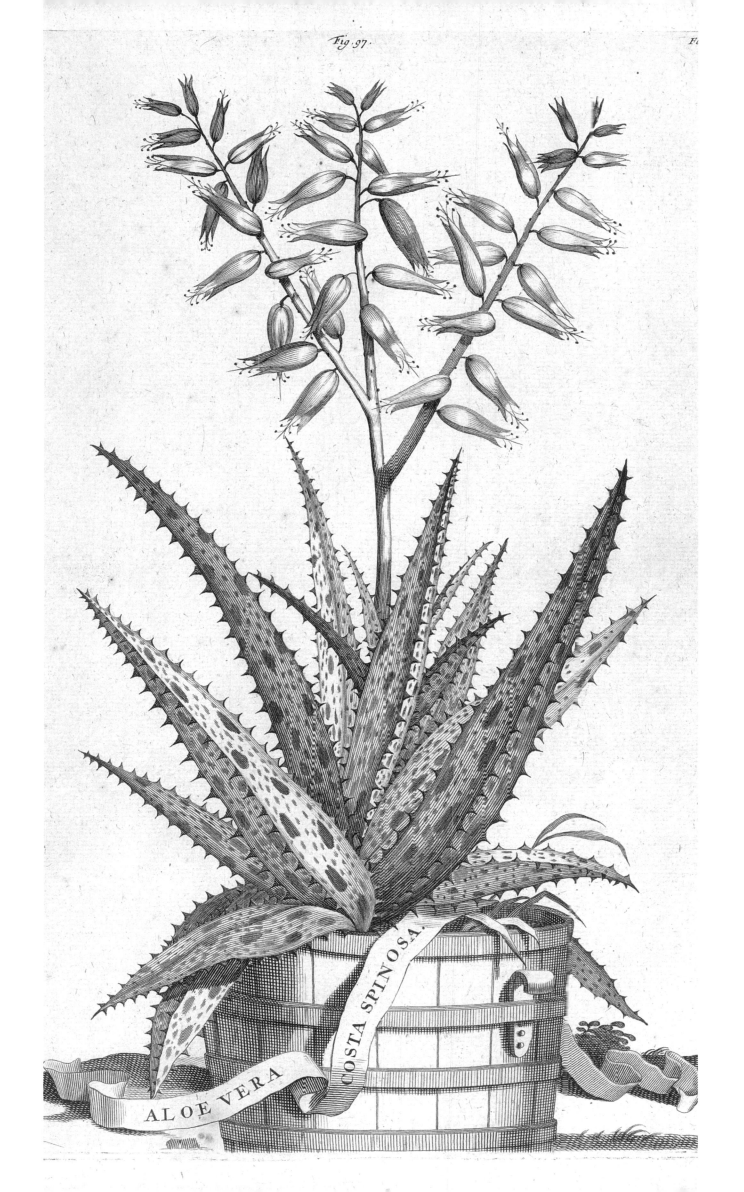

ALOE VERA COSTA SPINOSA.

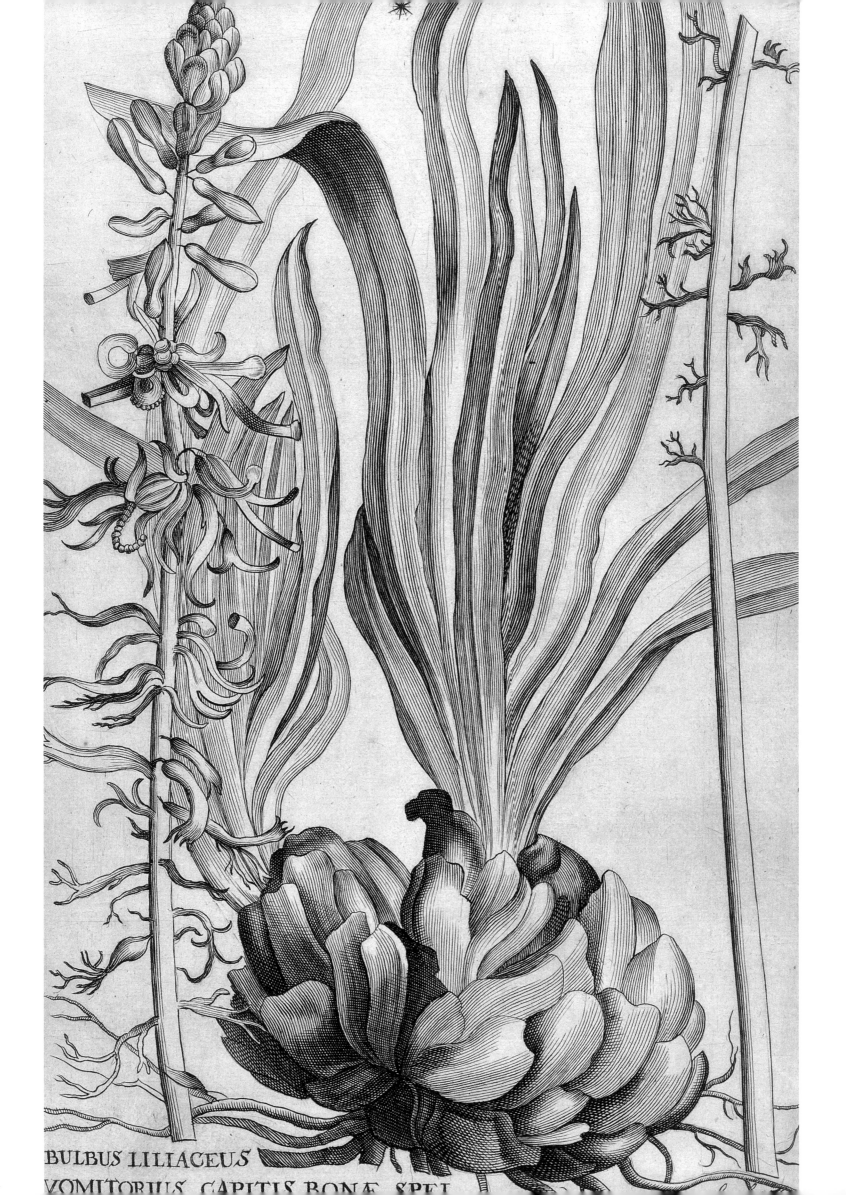

BULBUS LILIACEUS
VOMITORIUS CAPITIS BONÆ SPEI

An engraving from Jacob Breyne's *Exoticarum* of 1678, depicting a bulb he received from the Cape of Good Hope in 1678 and succeeded in growing in his garden. It has not been conclusively identified but may belong to the Iridaceae.

cult-like enthusiasm as either Cape heaths or pelargoniums, included *Freesia*, *Schizostylis*, *Crocosmia*, *Gerbera*, *Nemesia*, and *Gazania*. Another addition to this list in more recent times has been *Rhodohypoxis*, which was introduced as long ago as the 1870s, but only began to be valued when rock gardens became popular in the early twentieth century. In the 1860s the plant collector Friedrich Welwitsch added significantly to the stock of desert flora in the 1860s by introducing *Welwitschia mirabilis*, but this curious plant has never been cultivated outside botanic gardens, at least in the United Kingdom.

Tropical Africa has never added greatly to the European garden flora, for obvious climatic reasons; but two genera have become important as greenhouse and indoor plants. *Streptocarpus rexii* was introduced from East Africa in the 1820s, but it was not until a century later that hybrids began to appear, mainly in America. By the late twentieth century it was becoming one of the most popular houseplants. The other genus came to light as a result of German colonisation. In 1892, Baron Walter von St Paul-Illaire sent specimens of a newly discovered plant to Hermann Wendland at the Berlin Botanic Garden. Wendland named it *Saintpaulia* in the discoverer's honour, and, as the last important botanical discovery of the nineteenth century, it made an initial splash in the press. Once again, however, it was not until the 1920s, and again in America, that it attracted the attention of hybridists, and under the vernacular name of African violet achieved popularity as a houseplant.

Finally, the last third of the twentieth century saw a sudden boom in the use of East African species of *Impatiens* as a bedding plant. *Impatiens walleriana*, the busy lizzie, was first grown in England in the 1880s, but was generally ignored in favour of species from the Indian subcontinent until after the middle of the twentieth century. In the 1960s it began to attract the serious attention of breeders, and several series of cultivars were launched on the market, with a colour range extending from scarlet to white. In the 1990s the African forms of *Impatiens* faced competition from cultivars of New Guinea species, but at the start of the twenty-first century they are still one of the most popular and widely used bedding plants, both in England and America.

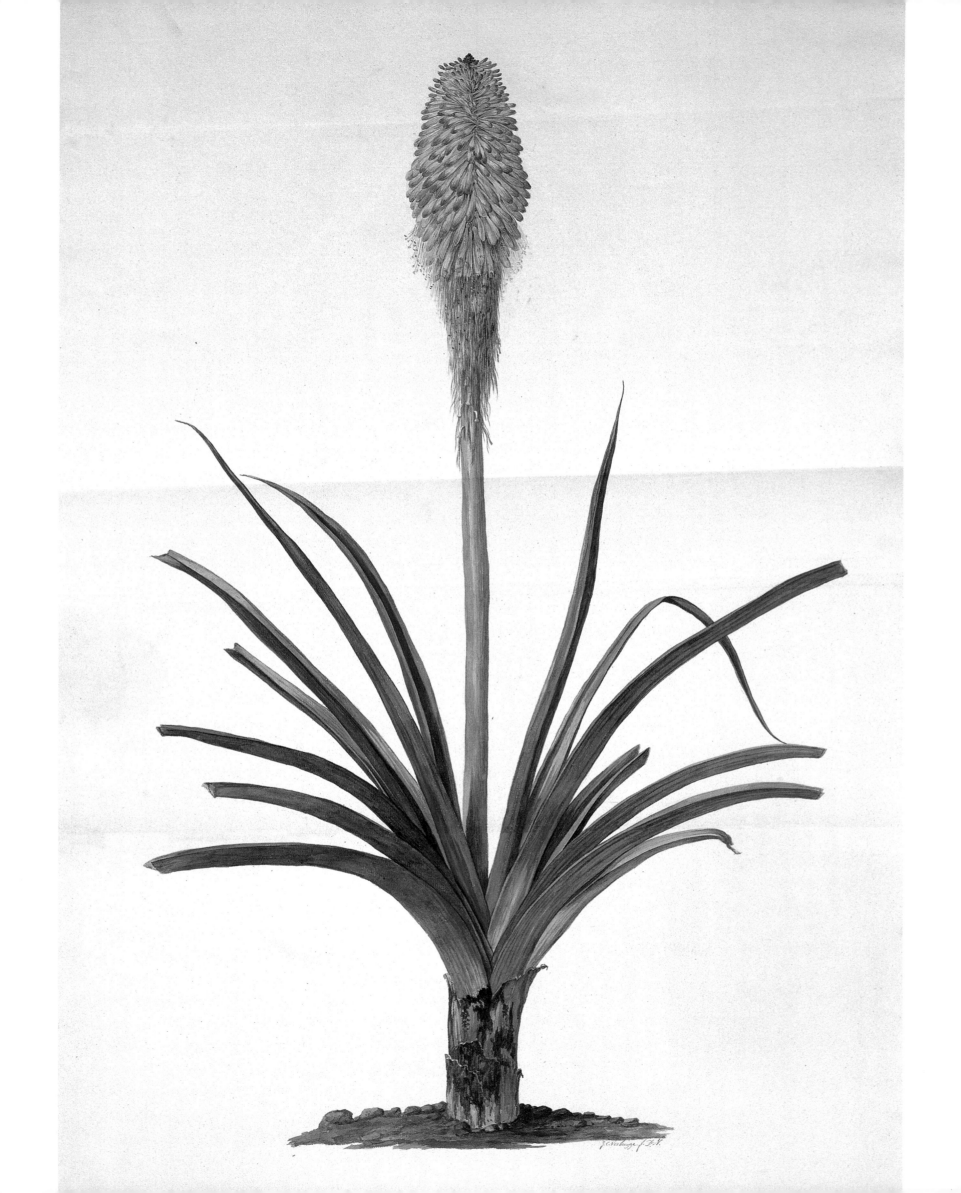

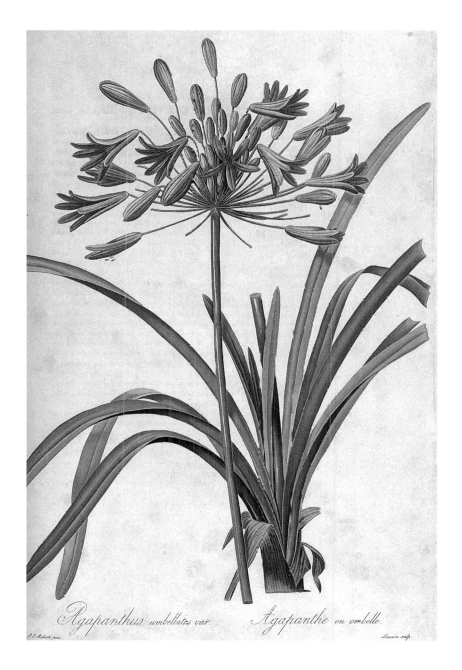

Agapanthus umbellatus var. *Agapanthe en ombelle.*

AGAPANTHUS AFRICANUS

Agapanthus umbellatus, now *A. africanus*, as illustrated here by Redouté, was known to Parkinson in 1629, and once it was distinguished from the crinums, was believed to be the only species. As a result, there were no attempts at hybridisation until the end of the nineteenth century, and it was only in the mid-twentieth that the full range of species became known.

KNIPHOFIA UVARIA

The popular name for this flower has shifted from the elegant torch lily to the modern red-hot poker, and the cultivar names have become similarly acerbic: compare 'Star of Baden-Baden', a survivor of the main period of kniphofia breeding associated with Max Leichtlin of Baden, with a modern name like 'Toffee Nosed'. *Kniphofia uvaria* was the first variety to reach Europe, in 1707.

ZANTEDESCHIA AETHIOPICA

Zantedeschia was first observed in the late seventeenth century, and introduced into England in 1731. Variously known as the arum lily or calla lily, it became a popular greenhouse and garden plant. Other species have been subsequently introduced, the most important being *Z. elliottiana* in the 1890s, but it has never been found in the wild and may have been a hybrid. It has certainly been used for hybridising, and today *Zantedeschia* cultivars with yellow and pink flowers are available, as well as forms with variegated foliage.

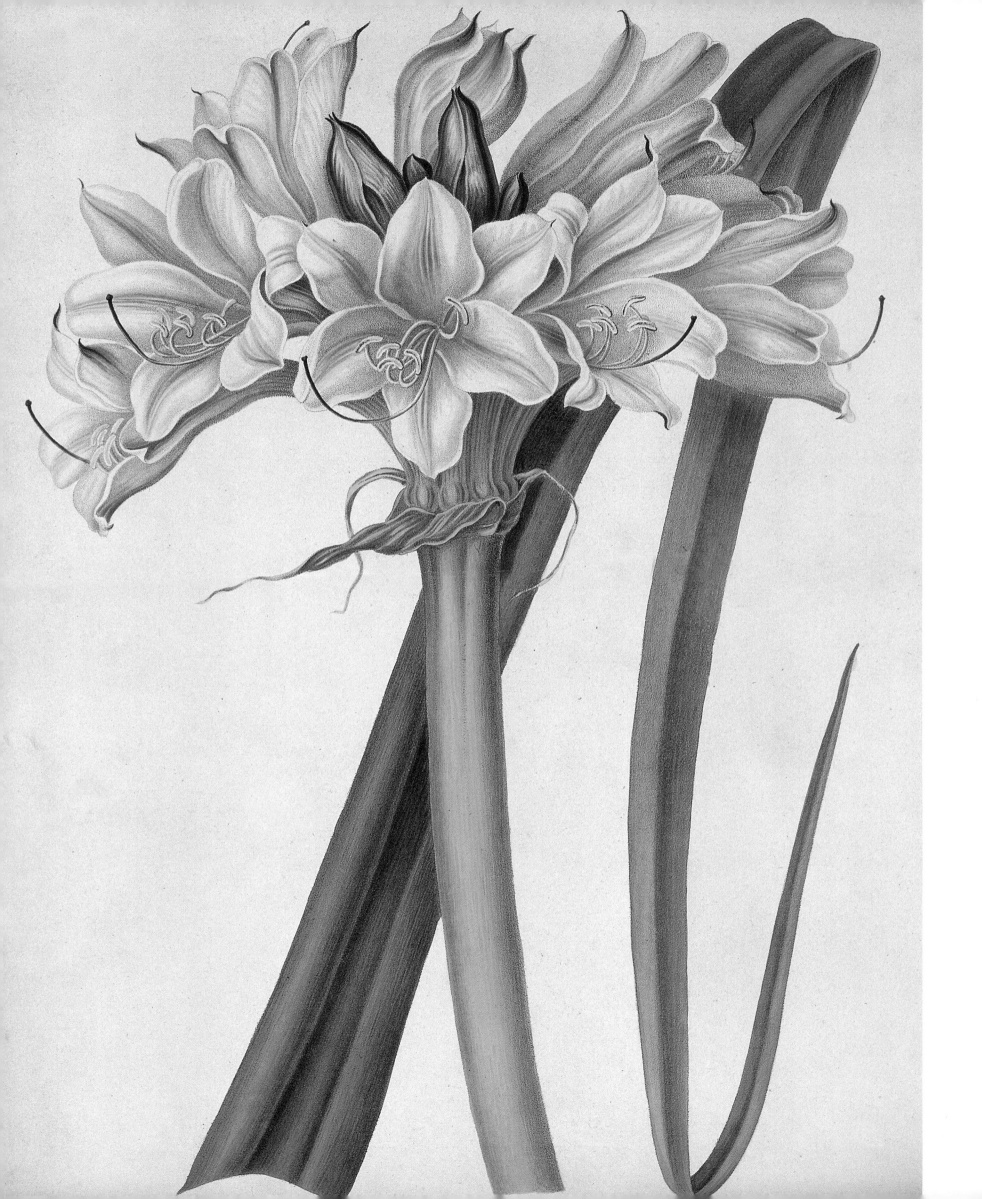

Ixia grandi flora. *Ixia a grande fleur.*

P. J. Redouté pinx. Chapuy sculp

SPARAXIS GRANDIFLORA

Various species of *Sparaxis* were introduced into Europe in the eighteenth and nineteenth centuries, when African bulbs were at their height of popularity for greenhouse cultivation. The major early introductions were *Sparaxis fragrans* in 1793 and *Sparaxis grandiflora* in 1803 (illustrated here by Redouté and now considered a subspecies of *Sparaxis fragrans*), but by the 1840s Mrs Loudon could list eleven species being grown in England.

CRINUM BULBISPERMUM

Crinum bulbispermum was introduced into England in the 1750s, and grown by Philip Miller at the Chelsea Physic Garden under the name *Amaryllis longifolia*. Francis Masson collected it in the 1770s and brought it to Kew; by the early nineteenth century it was being offered by several London nurserymen. Various pink-and-white-flowered cultivars can still be obtained today.

CRINUM AUGUSTUM

One of the most popular plant groups for the early nineteenth-century greenhouse was the genus *Crinum*. Species from South Africa, Mauritius, the Indian Ocean islands, and Australasia yielded large white flowers that were eagerly sought after, and filled the pages of Priscilla Susan Bury's *Selection of Hexandrian Plants* in the 1830s. One of the most popular, *Crinum augustum*, first flowered at the Liverpool Botanic Garden in 1829; Mrs Bury's illustration was made from a specimen grown by Richard Harrison of Aigburgh.

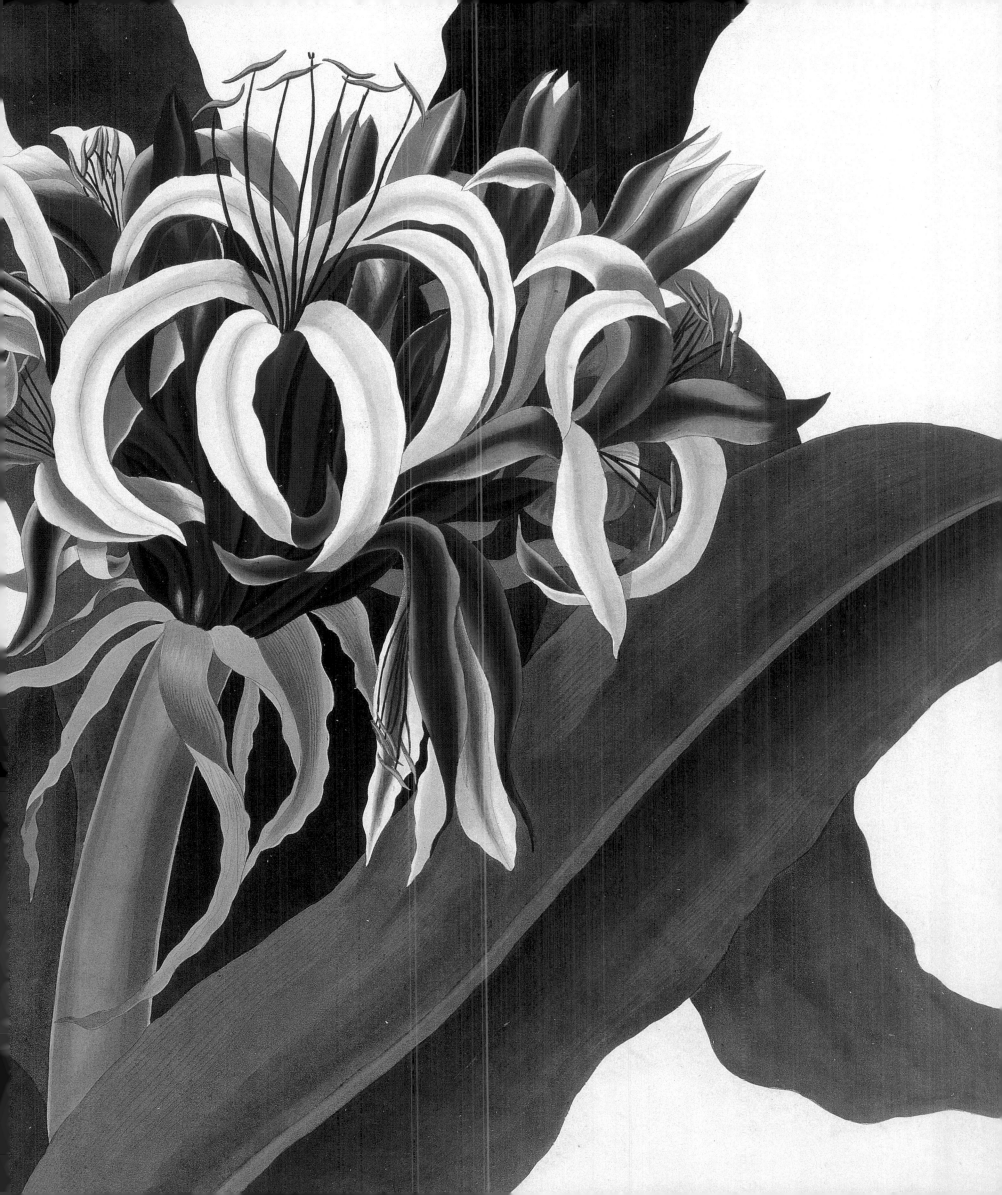

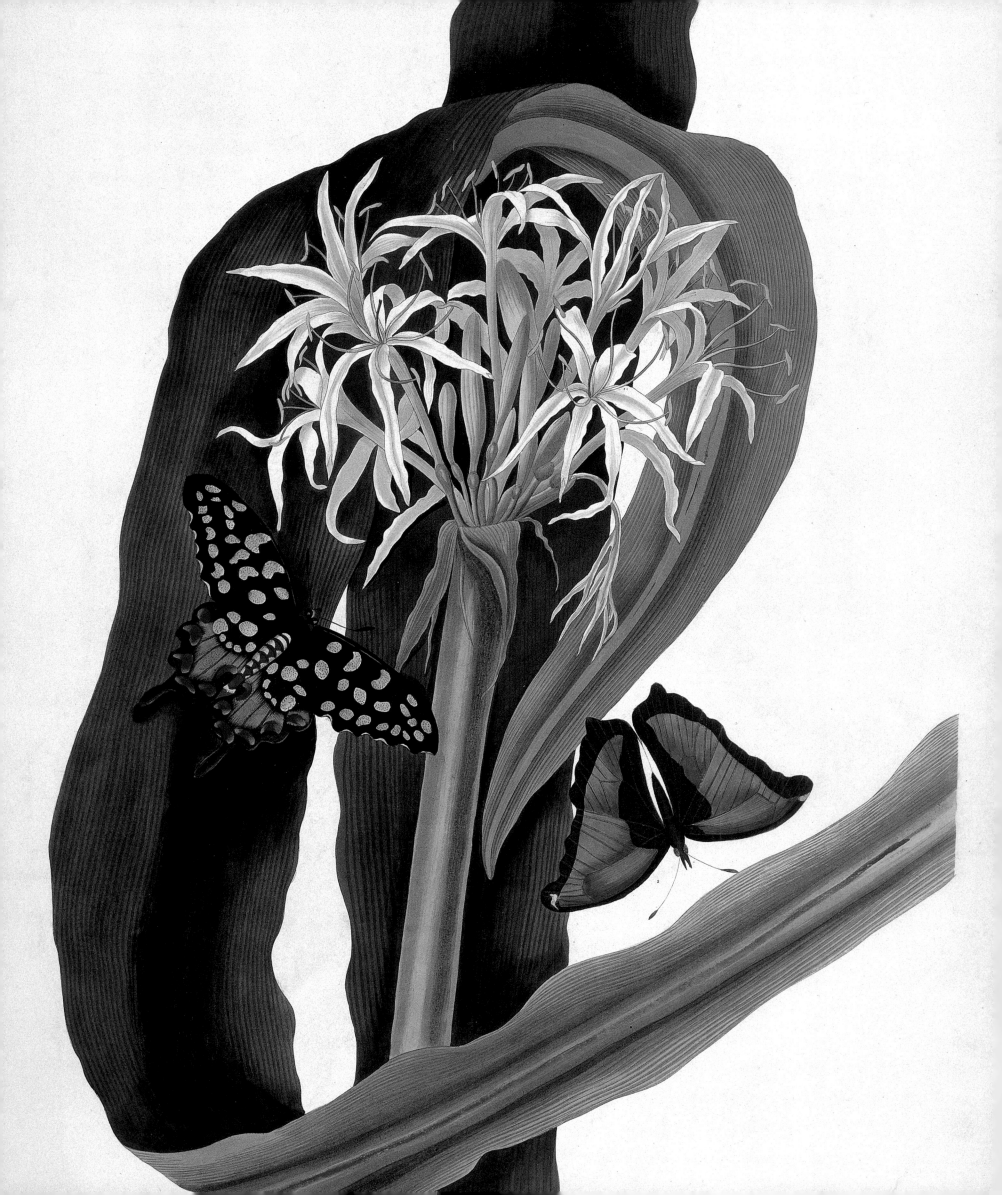

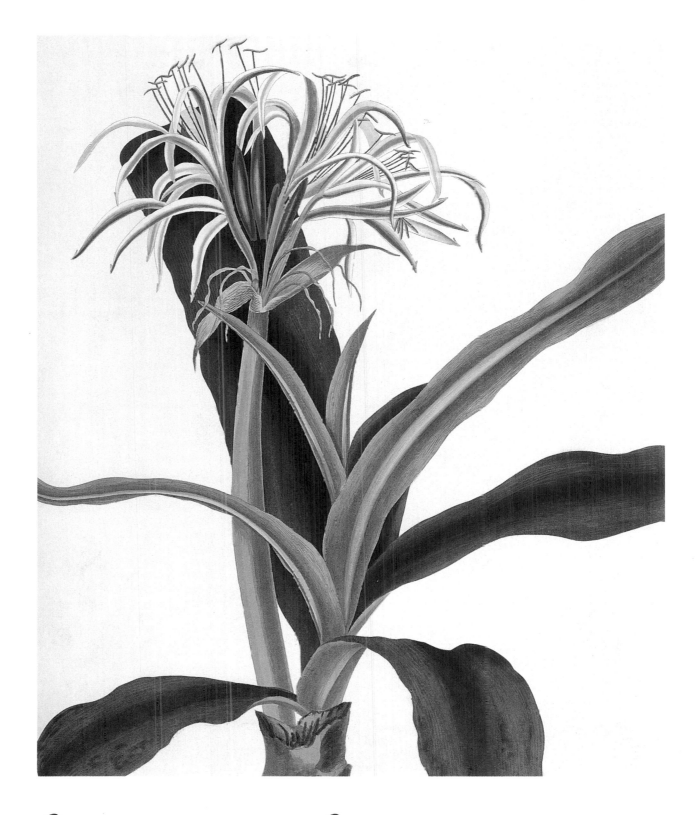

\mathcal{C}RINUM PEDUNCULATUM & \mathcal{C}RINUM HYBRID

These crinums were illustrated by Priscilla Bury in her *Selection of Hexandrian Plants*. During the 1820s, efforts were made to produce *Crinum* hybrids – the one pictured above was raised by Richard Harrison, but the principal breeders were William Herbert, Dean of Manchester, and the nurseryman Robert Sweet. During the 1830s the popularity of the large-flowered Cape bulbs began to decline, though *Crinum* fared better than its rivals, with more species still extant in the 1850s than of *Amaryllis* or *Brunsvigia*. In more recent years, *Crinum* has been crossed with *Amaryllis belladonna* to create a hybrid genus called × *Amarcrinum* or × *Crinodonna*.

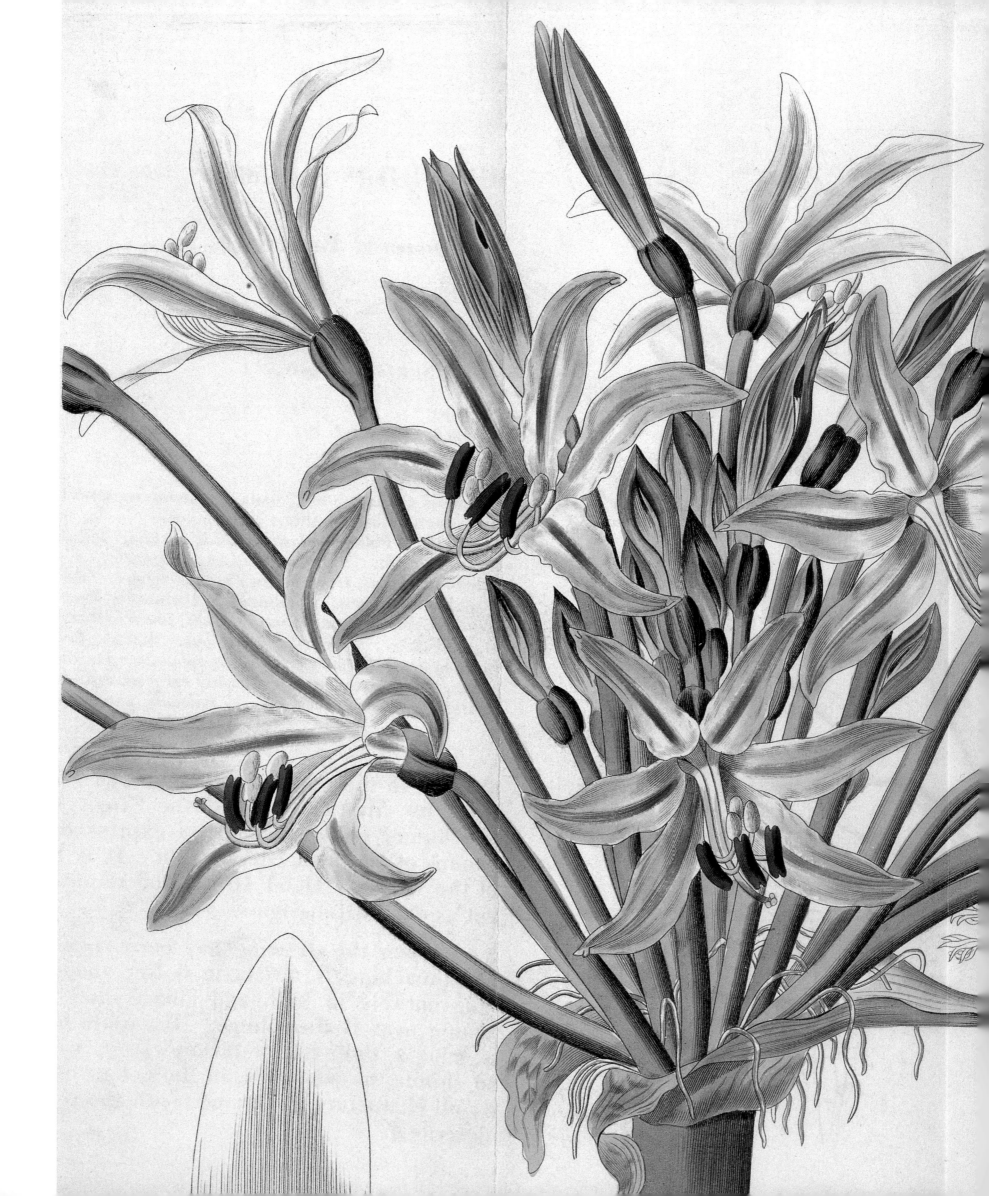

ℬRUNSVIGIA GRANDIFLORA

Various species of *Brunsvigia* (named in honour of the House of Brunswick) arrived in Europe from the 1750s to the 1820s. They were as popular as those other African introductions *Amaryllis* and *Crinum*, but the large number of cultivated species that had once flourished had greatly diminished by the 1850s. *Brunsvigia* has been crossed with *Amaryllis* to create plants marketed variously as × *Bruasdonna* and × *Amarygia*; and crossed with *Crinum* to produce × *Brunscrinum*.

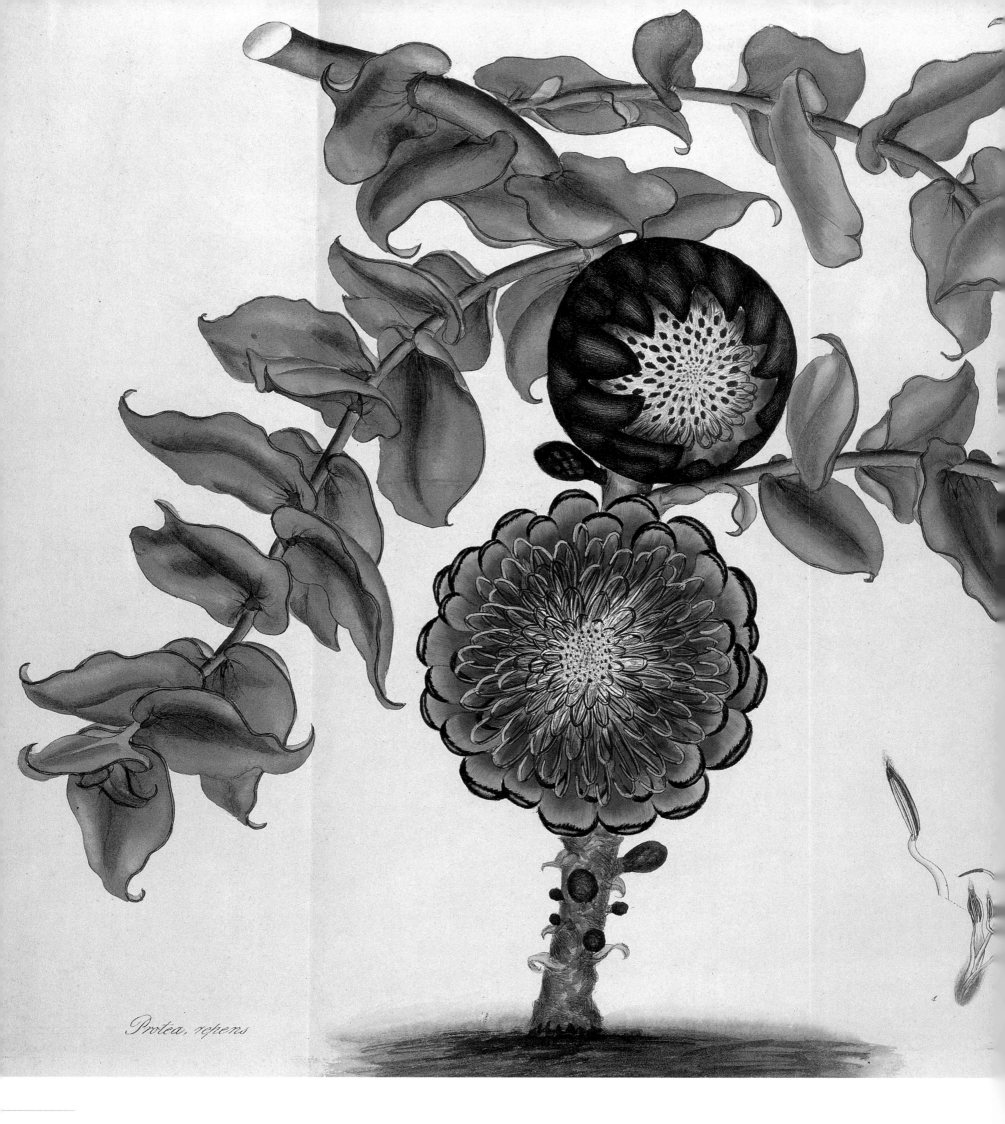

Protea, repens

Pl. 453.

Pleuranthe amplexicaule.
Knight Ord. Prot. p. 51.

Icon protea flores bona.
Kn.

Protea amplexicaulis.
R. Br. Lin. trans. v. 10. 95.

Protea repens

In Clusius' *Exoticorum* of 1605 there is a report of an 'elegant thistle' collected by a Dutch trader in South Africa a few years earlier. This has since been identified as *Protea neriifolia* – the first South African plant to be described in Europe. Specimens began to arrive in the Netherlands in the mid-seventeenth century, but few in comparison with the flood that swept into Europe in the late eighteenth century through the English collectors Francis Masson and James Niven. Henry Andrews' *Botanist's Repository*, begun in 1797, depicted over 42 species of proteas (some now reclassified into other genera) already known as greenhouse plants, including *Protea repens* illustrated here.

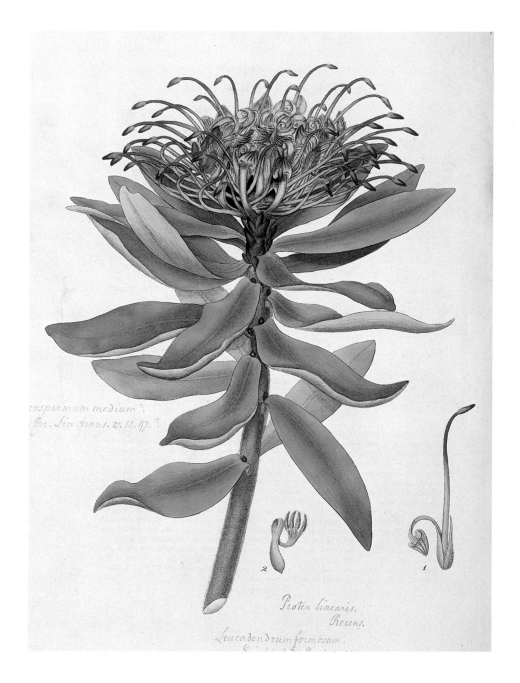

ℙROTEA COMPACTA & ℙROTEA CORDATA

The first, and for 150 years the only, book on the cultivation of proteas was published by the Chelsea nurseryman Joseph Knight in 1809. For several decades, proteas flourished in European greenhouses, but by mid-century greenhouse management was changing. Early greenhouses had been heated by hot air, creating a dry environment suitable for proteas, but once steam and hot-water heating came in, the typical greenhouse became too moist for them, and proteas faded from the English scene. These illustrations of *Protea compacta* (formerly *formosa*) and *Protea cordata* (right) are from a 1797 issue of the *Botanist's Repository*.

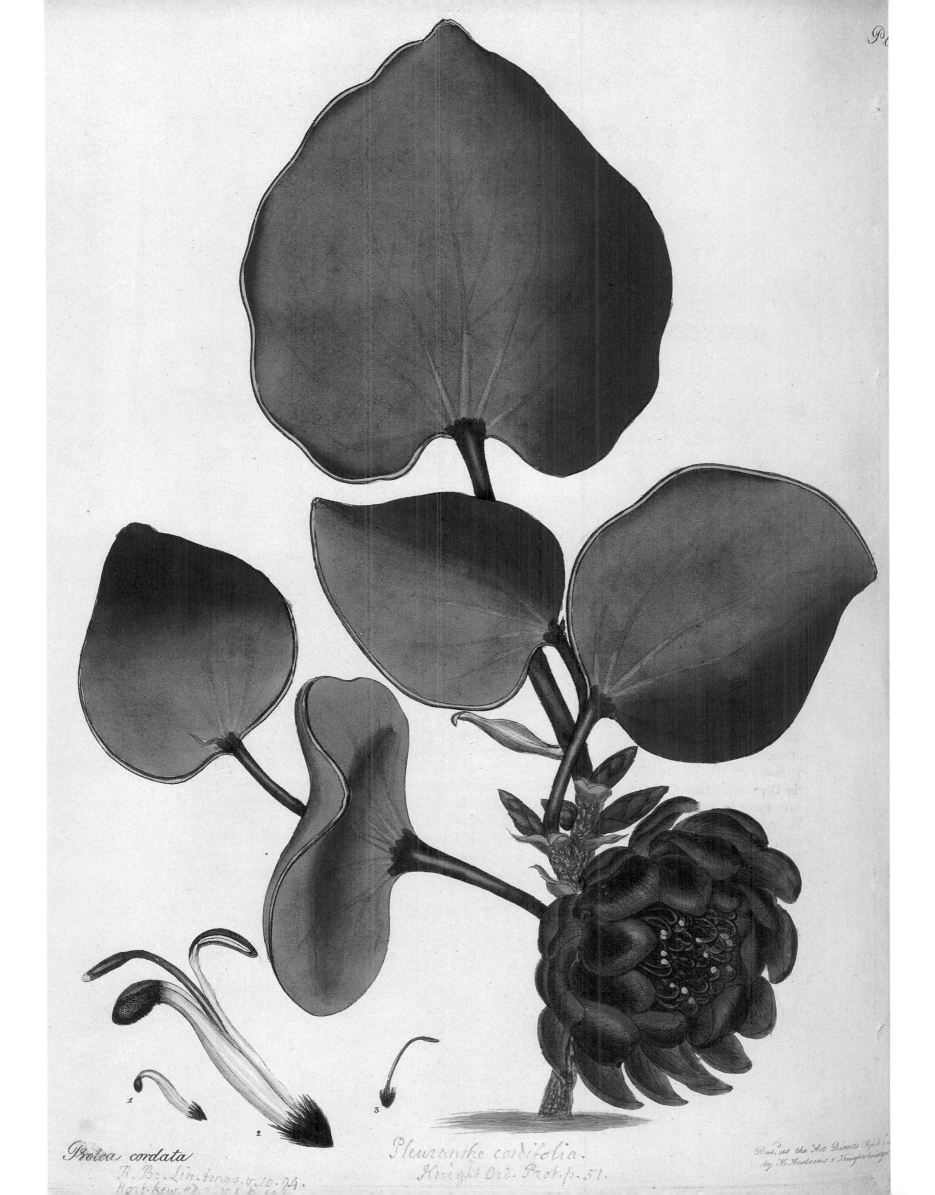

Protea cordata

Pleuranthe cordifolia.
Knight Ord. Prot. p. 51.

Protea cordata
R. Br. Lin. trans. v. 10. 94.
Hort. Kew.

Pub. as the Act Directs April 1.
by H. Andrews Knightsbridge

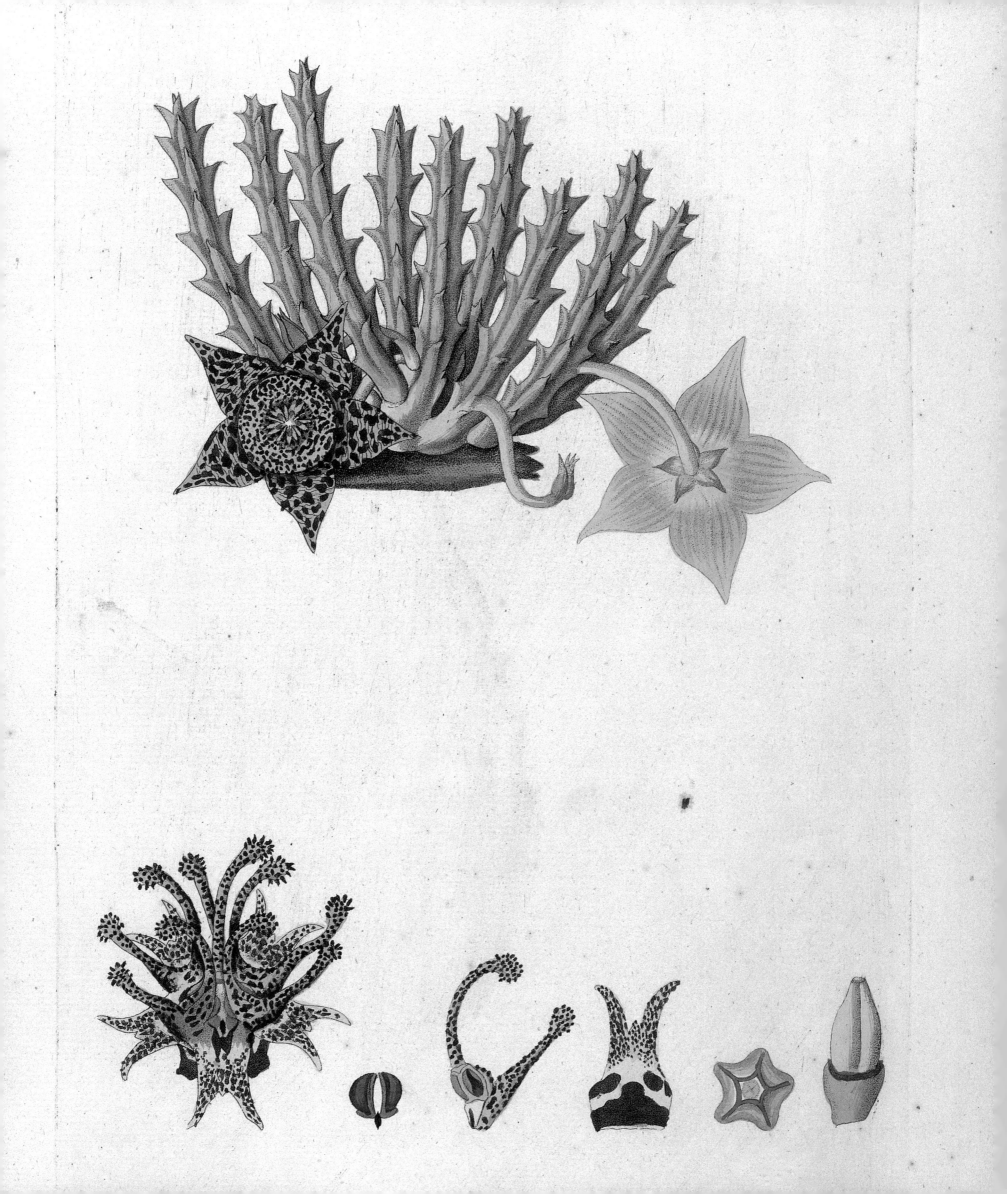

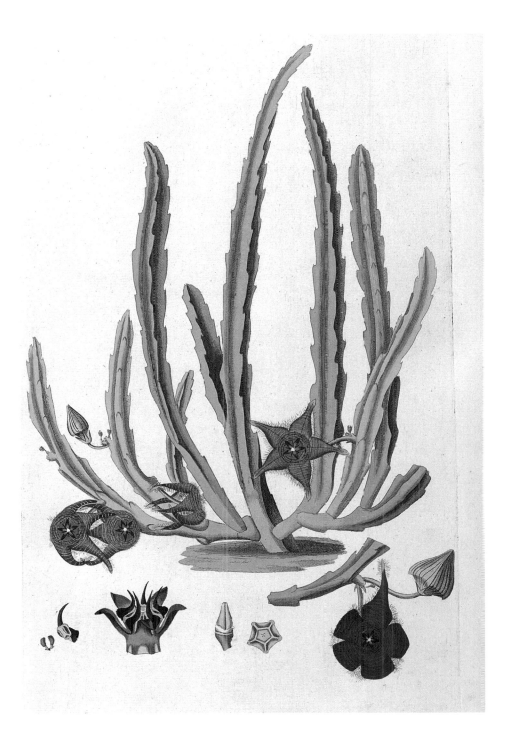

STAPELIA CLYPEATA & STAPELIA DEFLEXA

Stapelias were first described in the 1640s as fritillarias – an assigned category that did not last long. Mrs Loudon described them in 1844 as 'curious stove-plants. with showy flowers proceeding from the root, which smell so much like carrion, that flesh-flies have been known to lay their eggs upon them'. Despite this drawback, or even because of it, stapeliads were regarded as exciting curiosities. *Stapelia clypeata* (left) and *Stapelia deflexa* (above) were illustrated for *Stapeliarum in Hortis Vindobonensibus Cultarum Descriptiones* (1806–1820).

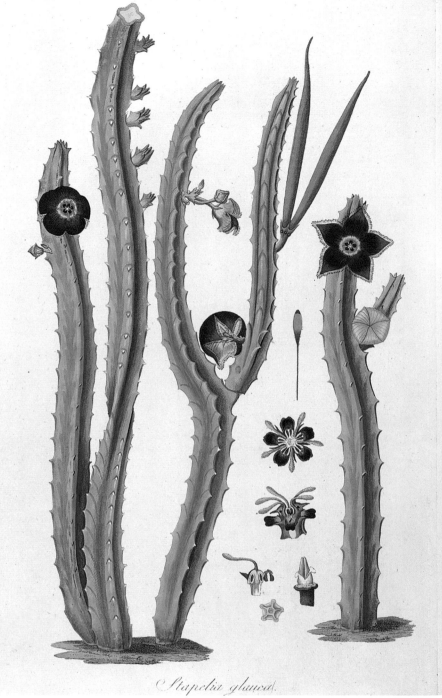

Stapelia glauca.

Stapelia glauca &
Stapelia pedunculata

The only book published by Francis Masson (*Stapeliae Novae*) was devoted to stapeliads –
he had collected several species in the 1790s. Then in 1806 Nicolaus Joseph Freiherr von
Jacquin, Director of the Vienna Botanic Garden, published a larger monograph, *Stapeliarum
in Hortis Vindobonensibus Cultarum Descriptiones*, including these illustrations (*Stapelia glauca*,
above; *Stapelia pedunculata*, right). The Hackney nursery of Conrad Loddiges had the
largest collection of stapelias in England, but by mid-century they were in steep decline. In
1844 Mrs Loudon 'regretted that many species, formerly known to our gardens, are lost'
with 'scarcely any new ones … to take their place'.

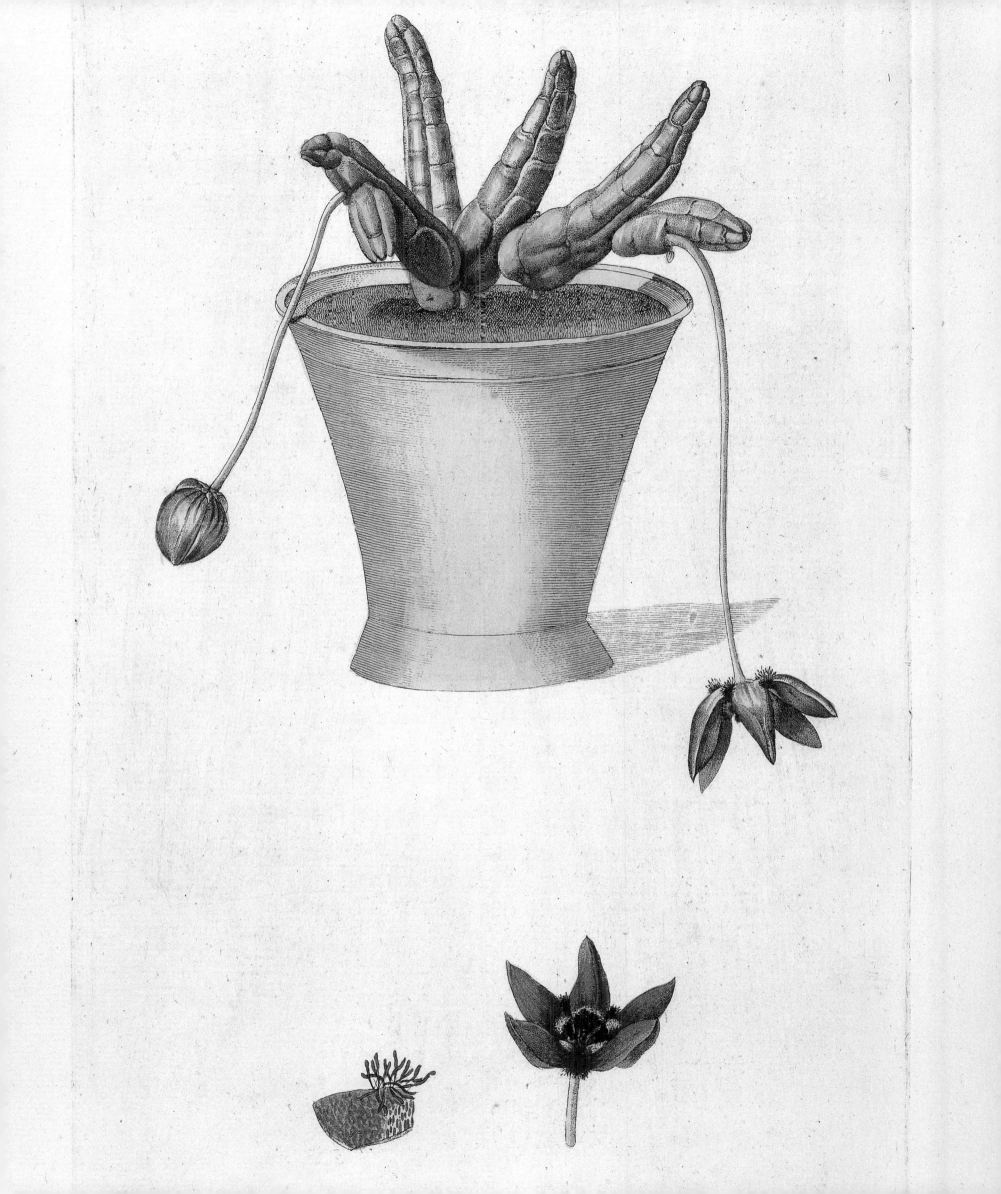

S TAPELIA CAMPANULATA

Stapelia campanulata is one of the species of stapeliads collected in South Africa by Francis Masson, and depicted in his book *Stapeliae Novae* (1796–1797).

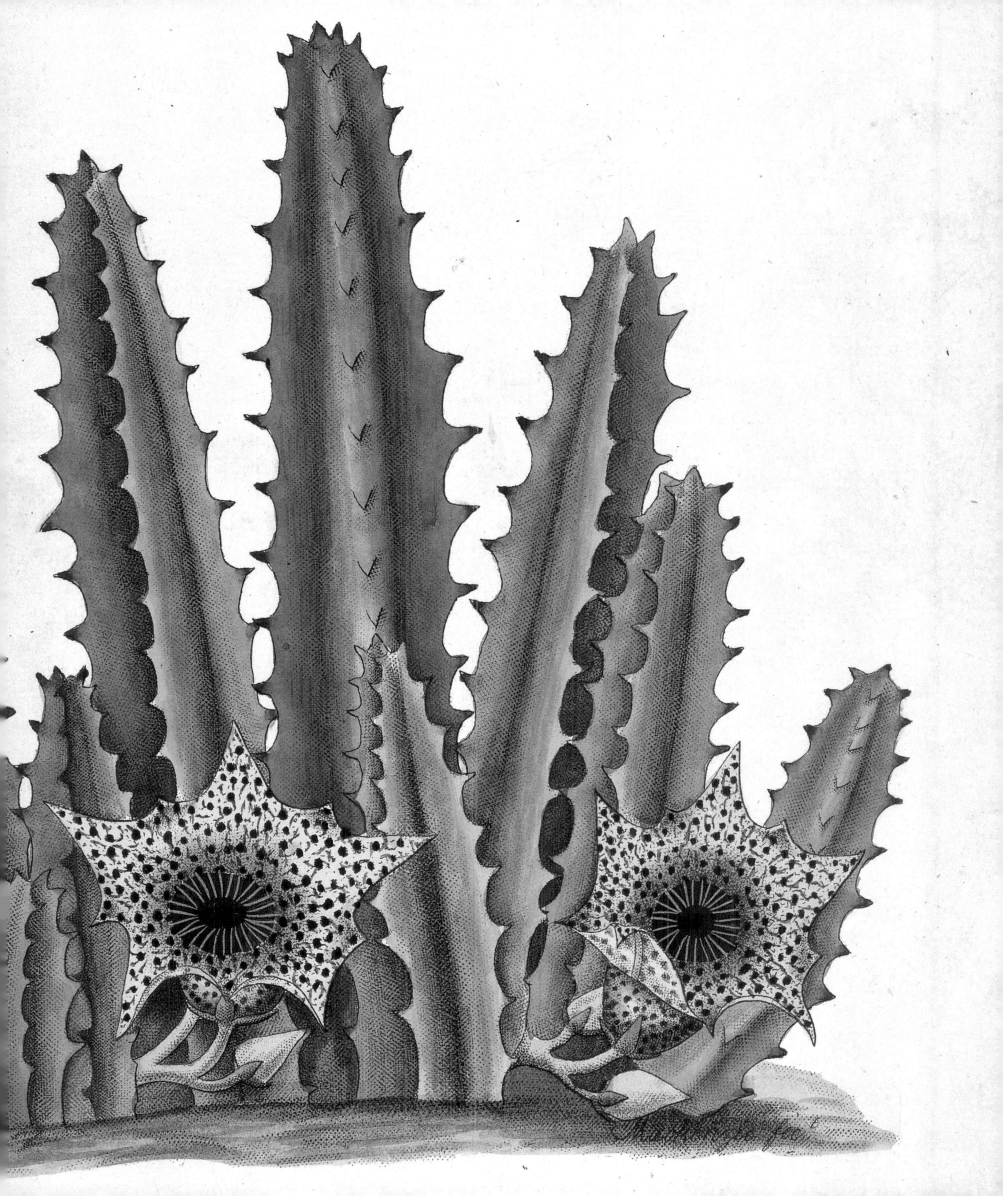

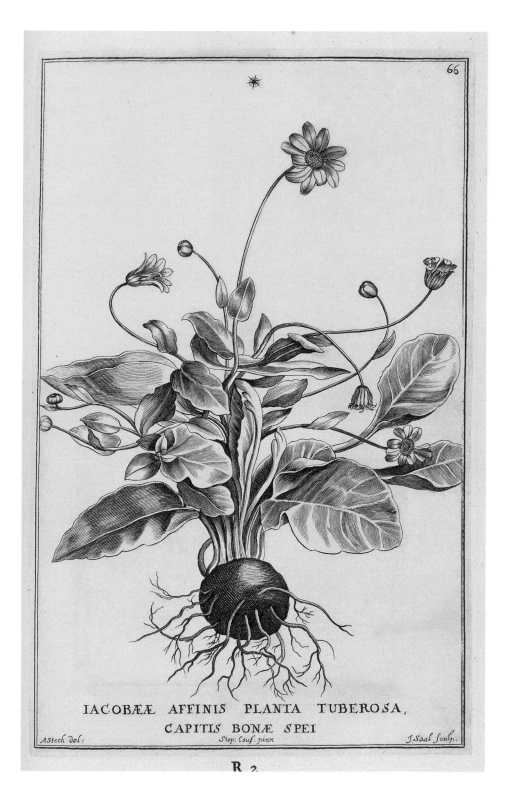

IACOBÆÆ AFFINIS PLANTA TUBEROSA,
CAPITIS BONÆ SPEI

A.Stech del: Step: Couf: pinx J.Saal sculp:

R 2.

OTHONNA BULBOSA

South African Compositae were popular in the seventeenth and eighteenth centuries, albeit not as much as succulents. Species of Arctotis and Othonna were introduced and grown in European glasshouses (this early illustration of *Othonna bulbosa* appeared in *Exoticarum* by Jacob Breyne in 1678). But in the late nineteenth century they languished. There was a short-lived attempt to promote South African annuals as bedding plants in the 1920s and 1930s, and since the mid-1940s *Arctotis* and *Dimorphotheca* have produced a large range of cultivars. *Othonna* species are still available, but have so far eluded the hybridist.

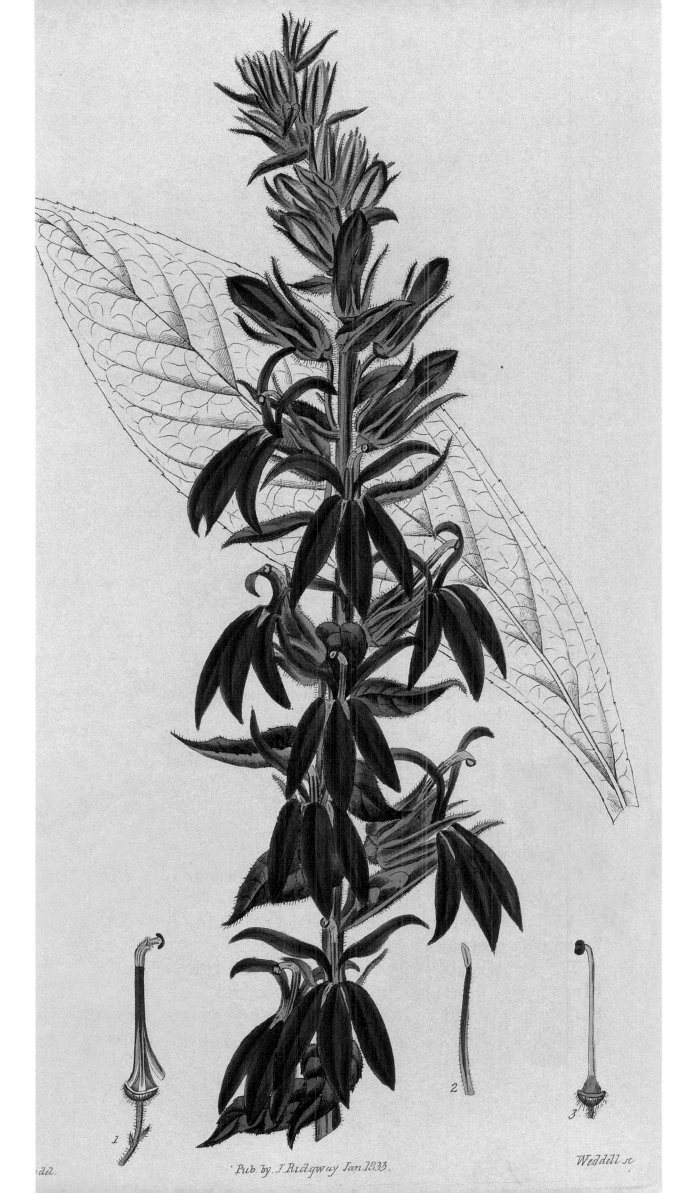

Pub. by J. Ridgway Jan 1833.

Weddell sc

LOBELIA SPECIOSA

African lobelias began to be introduced in the eighteenth century. *Lobelia erinus* arrived in the 1750s, but was not used as a bedding plant until the 1860s, by which time compact varieties were being produced and marketed under the name *Lobelia speciosa*. Further cultivars continued to appear throughout the twentieth century; at mid-century, there was an international vogue for using dwarf lobelias as edging plants. Today cultivars can be found in various shades of blue, red, and white.

167

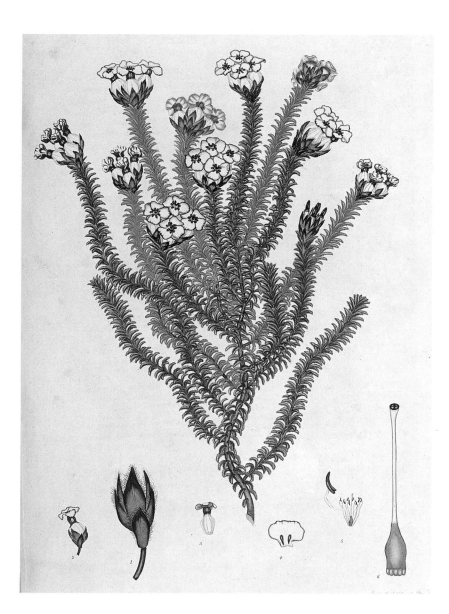

ℰRICA OBBATA &
ℰRICA CERINTHOIDES

Erica cerinthoides (right) was introduced into Europe in 1774, the first of the South African, or Cape, heaths to arrive. The collector Francis Masson was the principal eighteenth-century source, introducing eighty-six species in all; a further fifteen species were introduced between 1796 and 1800 by a young nurseryman named William Rollisson. Cape heaths were to prove one of the most important groups of greenhouse plants throughout the following century.

D

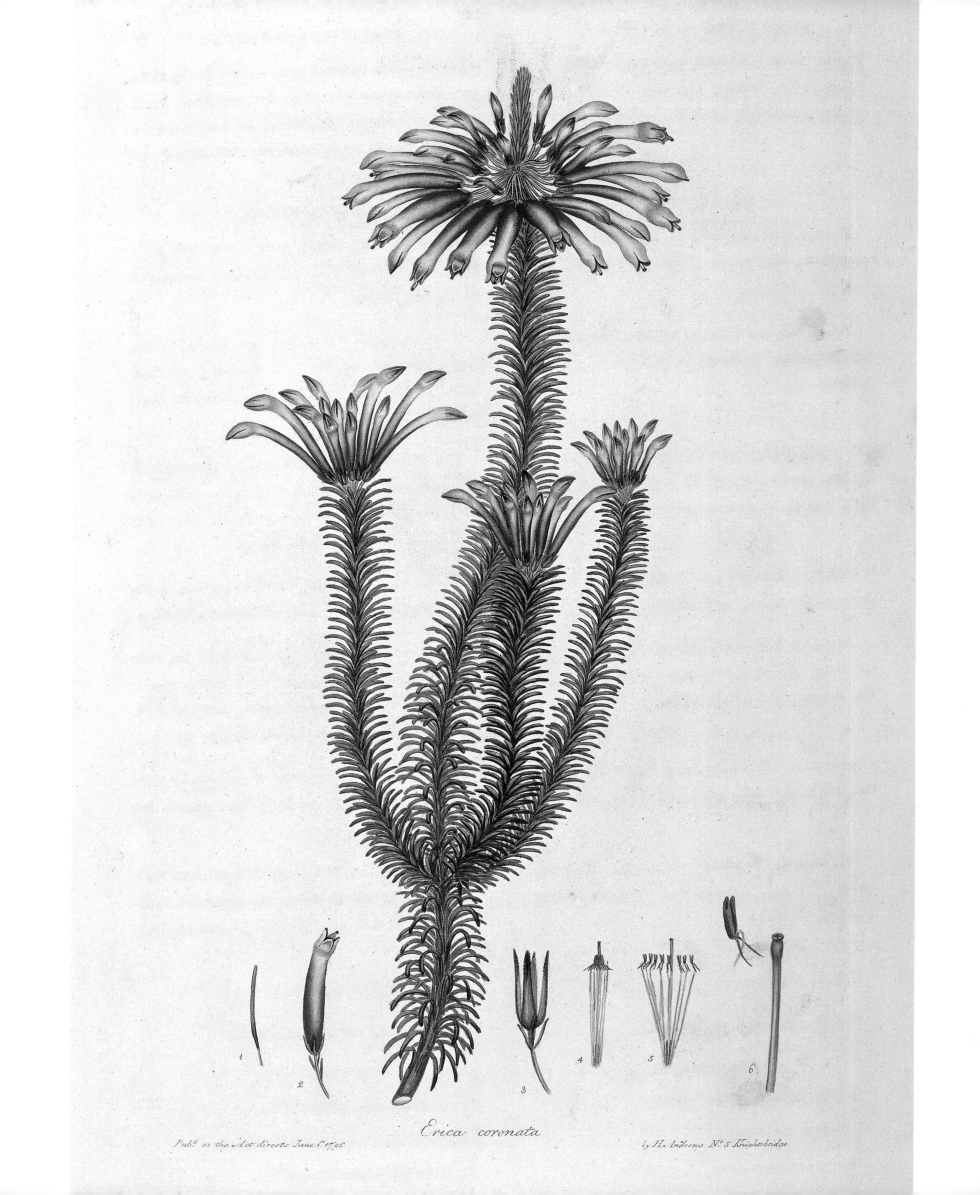

Erica coronata

Pub.d as the Act directs June 1. 1796.

by H. Andrews N.o 5 Knightsbridge

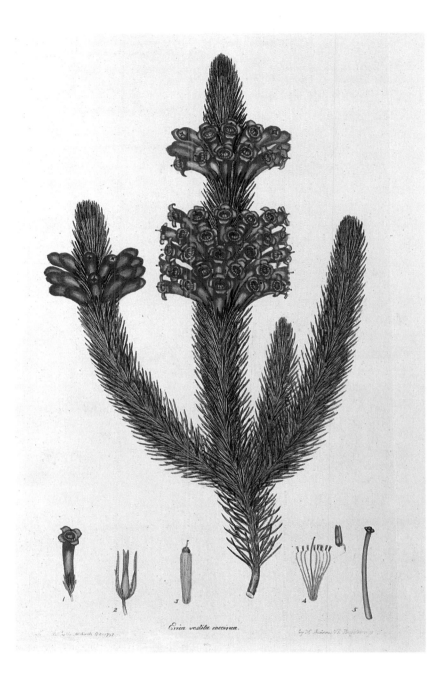

Erica vestita coccinea.

ℰRICA CORONATA &
ℰRICA VESTITA

William Rollisson's nursery was established in Tooting, then south of London, in the 1790s, and it lasted until 1879. There Rollisson undertook the first systematic programme of hybridisation – of Cape heaths. In 1826 the *Gardener's Magazine* published the record of his breeding programme: 285 varieties, together providing continuous flowering throughout the year. The popularity of Cape heaths began to diminish after the mid-1800s; by 1876 a similar list revealed only 143 varieties, but it was not until World War I that their long occupation of the English greenhouse finally ended. These early illustrations of Cape heaths are from *Coloured Engravings of Heaths* (1794–1830) by Henry Charles Andrews.

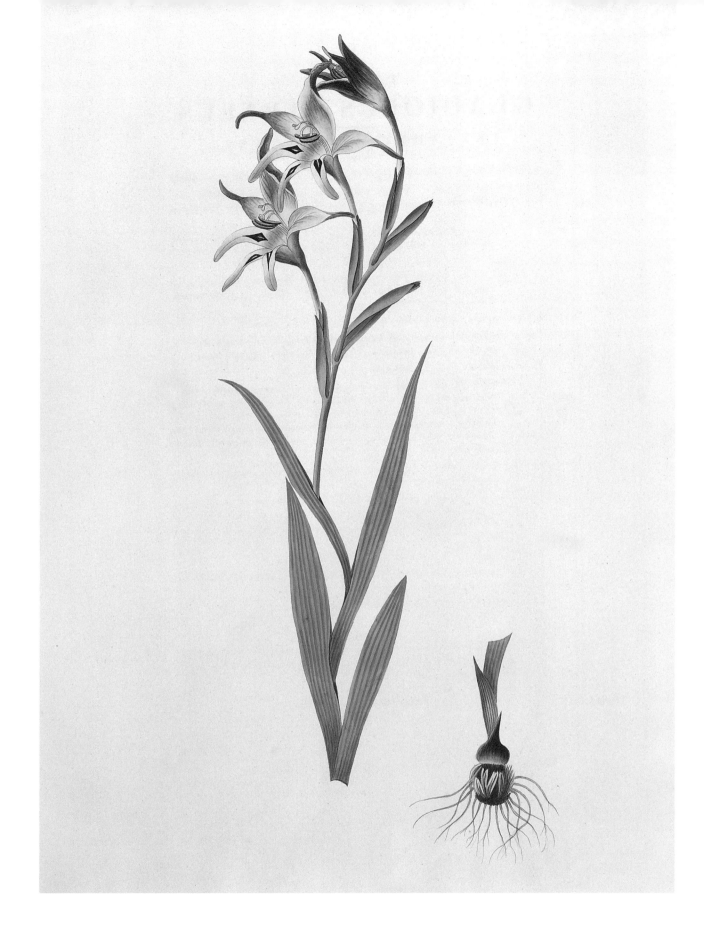

\mathcal{G} LADIOLUS CARNEUS

Although European species of gladiolus were being grown in Gerard's time, they were eclipsed by the South African species which began to arrive once the Dutch Cape Colony was established. A red 'Ethiopian' gladiolus was already known in the mid-seventeenth century, but the main flood of species began in the 1740s, and continued unabated into the late 1800s. The different species, such as this one illustrated in *Hortus Sempervirens* (1796–1830) by Johann Simon Kerner, were enthusiastically grown in greenhouses.

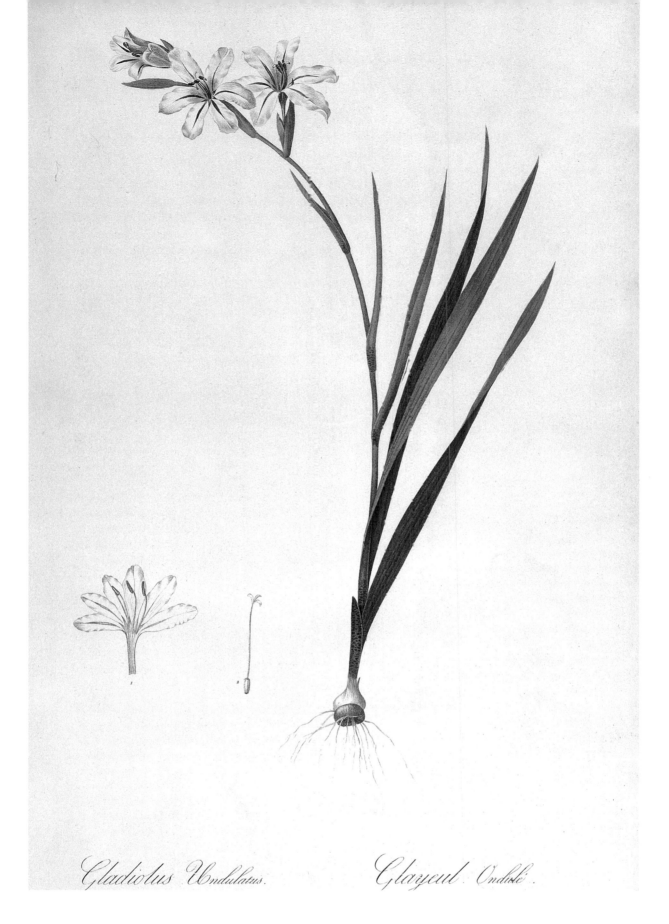

Gladiolus Undulatus. *Glayeul Ondulé.*

GLADIOLUS UNDULATUS

William Herbert, the Dean of Manchester, was a pioneer hybridist of ornamental plants. In addition to working on daffodils, crocuses, and amaryllis he began breeding gladiolus hybrids in the 1820s, as did the Chelsea nurseryman James Colvill. Gladiolus cultivars have spread through European and American gardens for nearly two centuries now. In South Africa there has been a reaction against the emphasis on these Euro-American cultivars, and the native species now have a dedicated following.

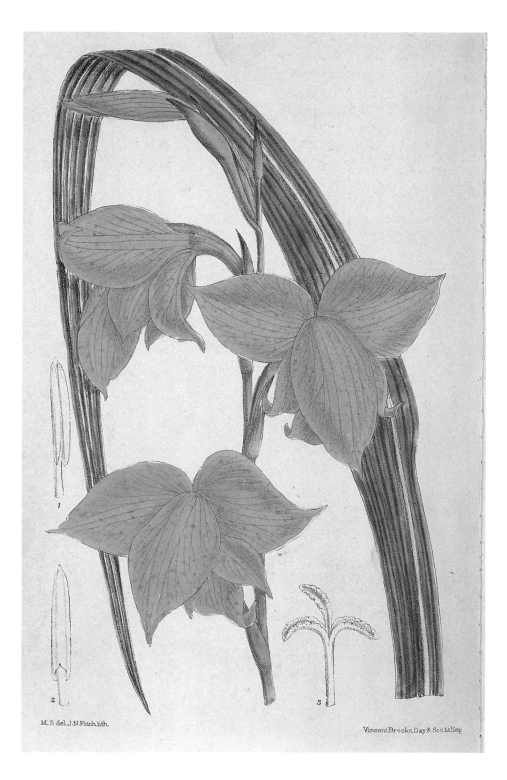

M.S del J.N.Fitch lith.

Vincent Brooks, Day & Son Lt! Imp

\mathcal{G}LADIOLUS PRIMULINUS & \mathcal{G}ANDAVENSIS HYBRID

The first great successes of gladiolus breeding were the Ghent gladioli, or Gandavensis hybrids, first launched in 1842 by the nurseryman Louis Van Houtte. These were rivalled by the English Brenchleyensis hybrids from 1848, the French Lemoinii hybrids in the 1880s and the Childsii hybrids, originally bred by Max Leichtlin of Baden, but taken to America and continued there by John Lewis Childs. *Gladiolus primulinus* (above) was re-introduced in 1904 (having arrived in 1887 but been lost), and the subsequent Primulinus hybrids became the early twentieth century's major line of development.

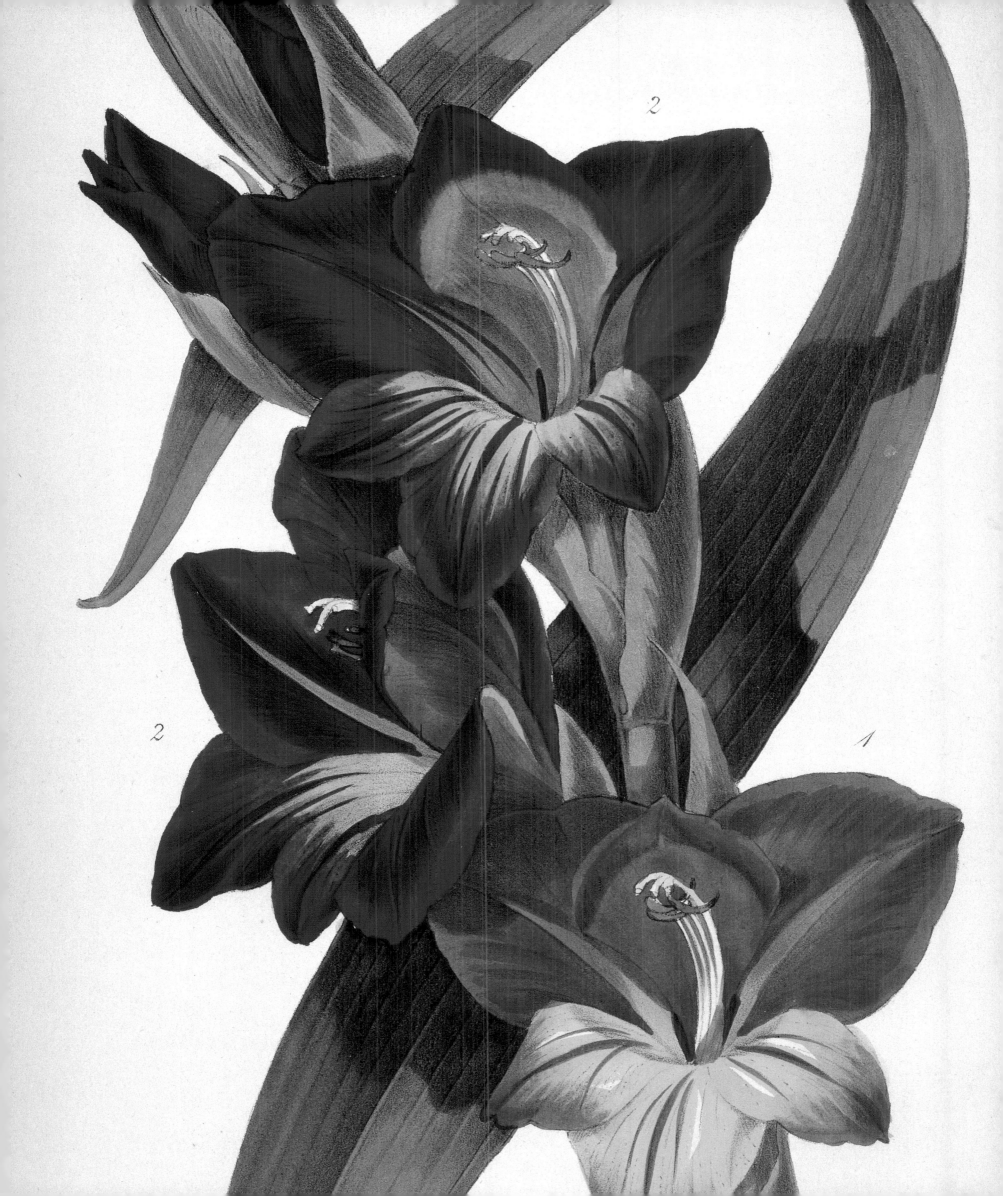

\mathcal{A}MARYLLIS BELLADONNA

There is much confusion over the name *Amaryllis*; most of the plants marketed under that name today are South American, and officially assigned to the genus *Hippeastrum*, leaving *Amaryllis* for the South African species. They were very popular in the early nineteenth century, and hybridised by William Herbert and others; Robert Sweet listed 175 hybrids in the 1830s. The introduction of new species in the 1860s reawakened an interest in breeding that lasted fifty years.

\mathcal{G}LADIOLUS PRIMULINUS HYBRIDS

The nursery firm of James Kelway, of Langport, Somerset, began using *Gladiolus primulinus* in hybridisation, creating a group of Langprim cultivars, but these were overshadowed by the Primulinus hybrids created by the nurseryman Frank Unwin, which in the 1920s were accepted as the standard for the group in Britain. Primulinus hybrids proved less popular in America, where small-flowered plants called Miniatures became the leading trend up to the 1940s.

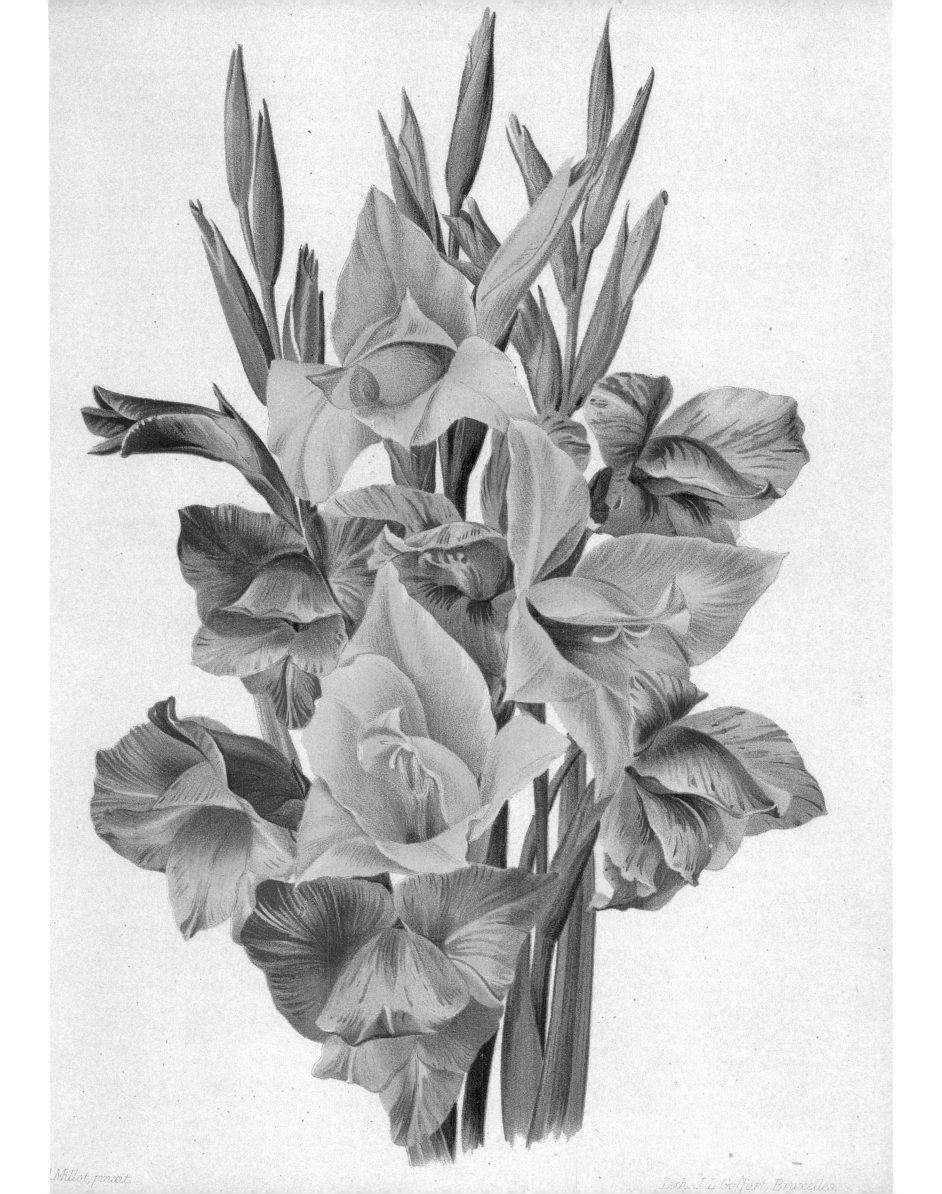

Millot, pinxit. Imp. J L Goffart, Bruxelles

ℬABIANA NANA

Originally described by Henry C. Andrews as *Gladiolus nanus*, this plant was transferred in the 1820s into the genus *Babiana*, which had been created in a reform of the classification of African irises. *Babiana* shared in the period enthusiasm for *Gladiolus* and *Ixia*, with which they were often confused.

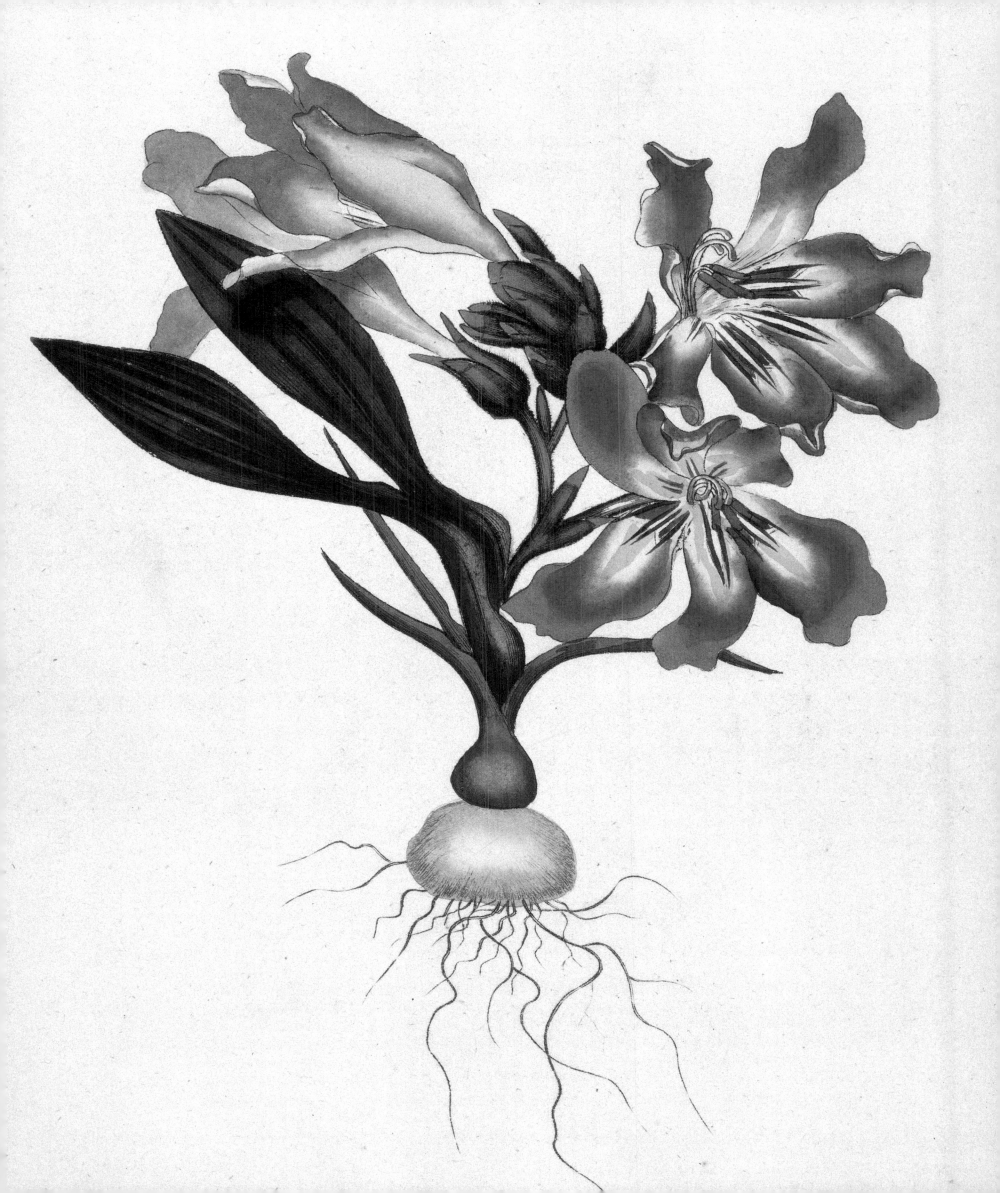

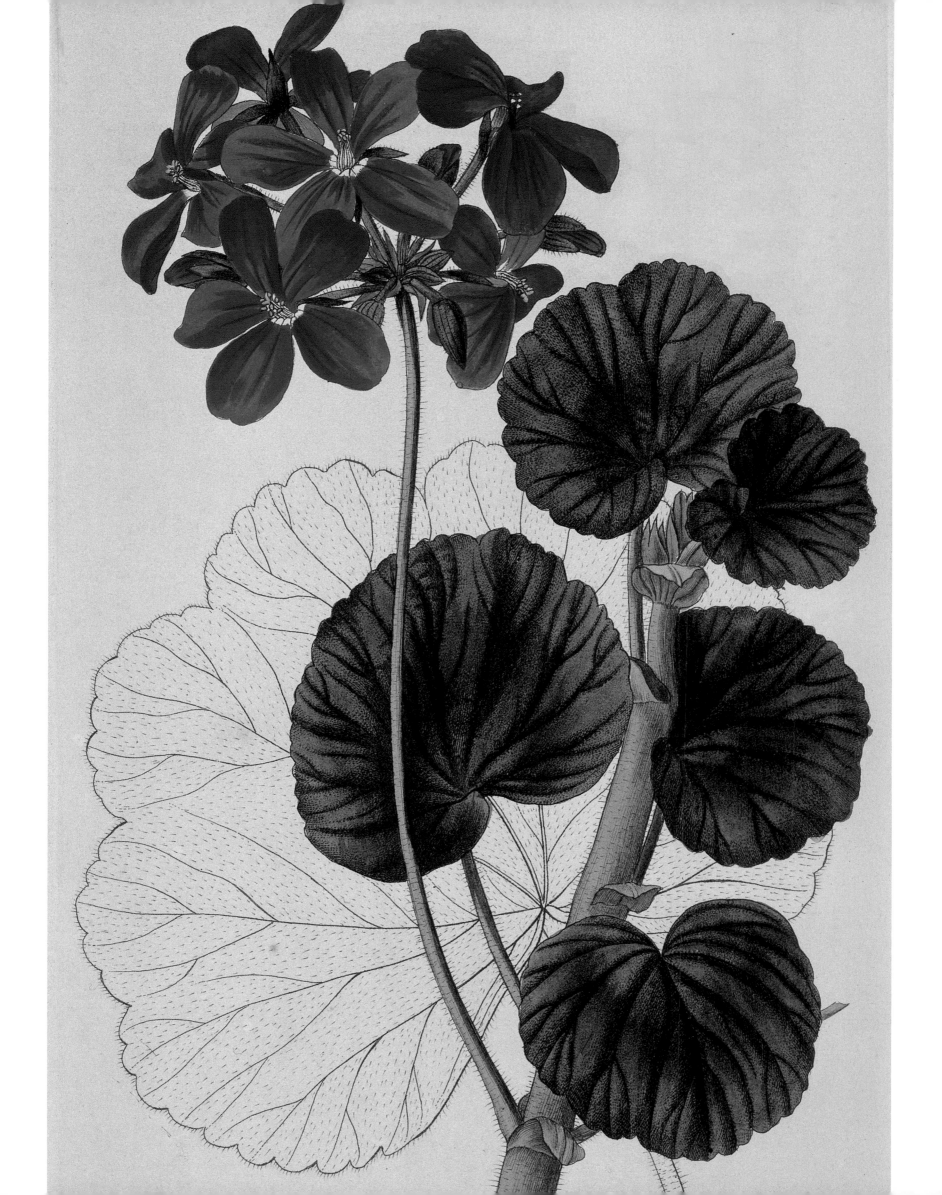

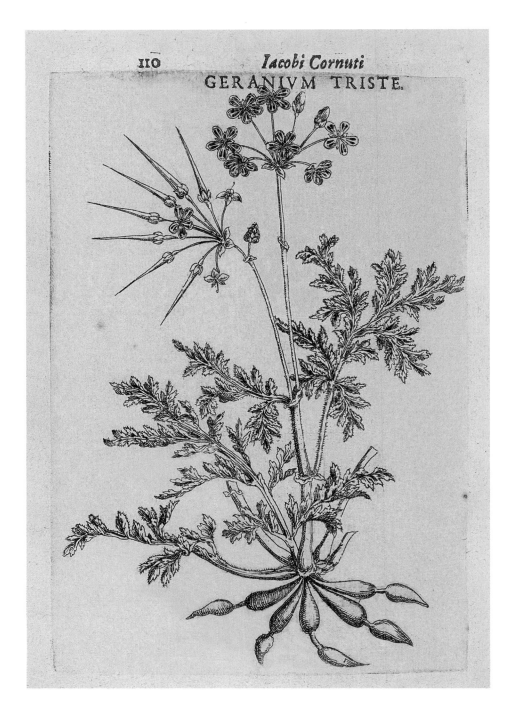

110 *Iacobi Cornuti*
GERANIVM TRISTE.

\mathcal{P}ELARGONIUM TRISTE &
\mathcal{P}ELARGONIUM INQUINANS

Pelargonium triste (above) was illustrated in the 1630s, and had become a greenhouse plant by the end of the century; *P. peltatum* was introduced in 1701, and *P. zonale* in 1710. The name *Pelargonium* was coined by the French botanist Tournefort, but Linnaeus collapsed it into the genus *Geranium*, from which it re-emerged in the 1790s. By that time the English had learned to call them geraniums, and have never abandoned the habit. Henry C. Andrews' *Geraniums* depicted 124 species being grown in 1905; Robert Sweet produced the multi-volume *Geraniaceae* with 500 species in the 1820s; and the Austrian Leopold Trattinick issued a supplement with 240 more, including *Pelargonium inquinans* (opposite).

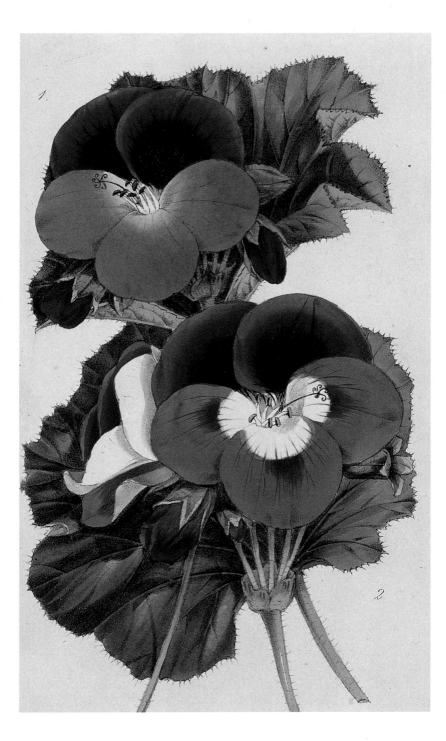

\mathcal{P}ELARGONIUM CULTIVARS

The early pelargoniums used in British gardens were tall plants with woody stems and a small proportion of flowers. By the 1830s the race was on to breed varieties that were dwarfer, suitable for summer bedding, with a higher proportion of flower to foliage. 'Tom Thumb', the first true bedding pelargonium, was marketed in 1844, and by the 1860s pelargoniums had become the most important of bedding plants. They never suffered an eclipse as great as did petunias and verbenas, and some Victorian cultivars are still extant.

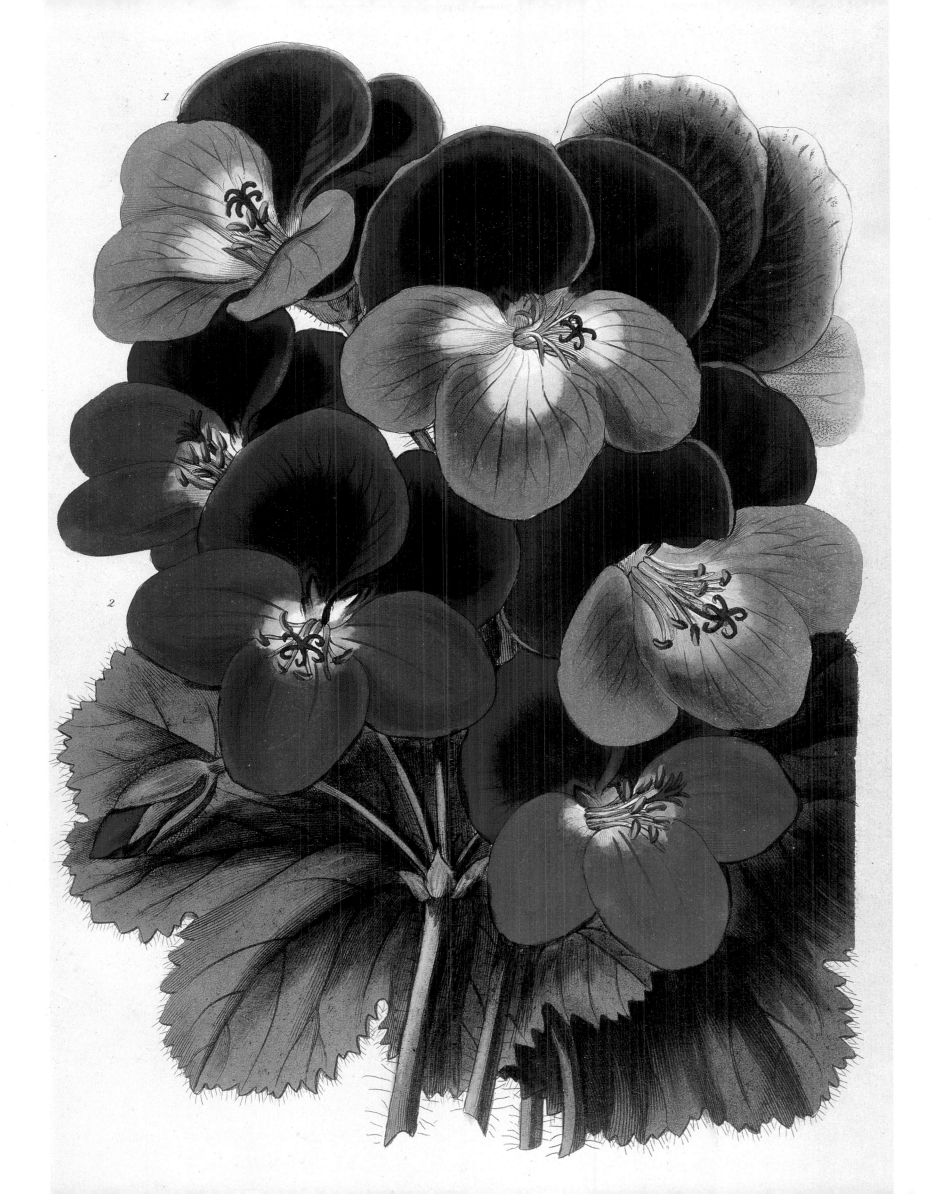

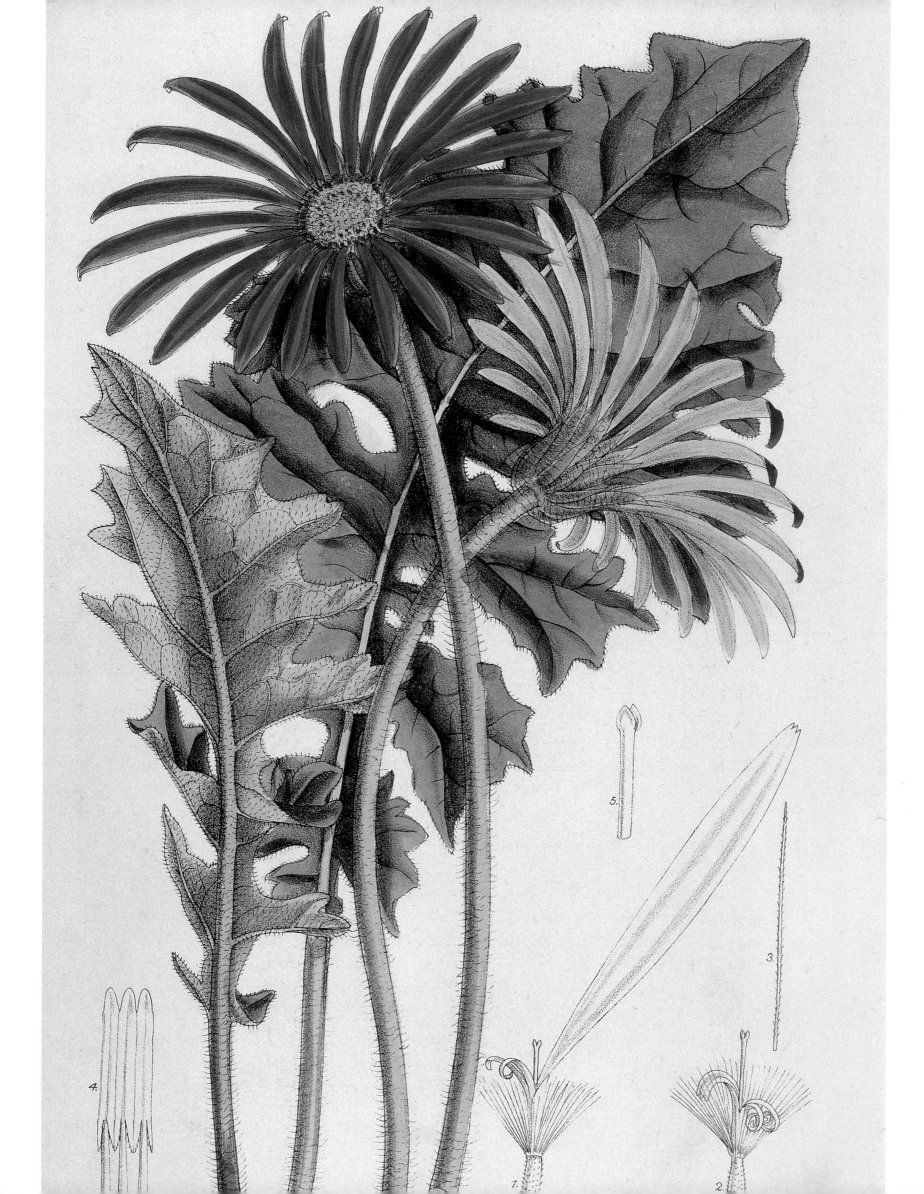

Gazania splendens

Gazania rigens was introduced in 1755, and in the mid-nineteenth century various cultivars, marketed as *Gazania splendens* (depicted here with *Callicarpa dichotoma*), were used for bedding. Their use declined in the early twentieth century; in fact, as recently as the 1950s, no cultivars were listed in English books on annuals. Today, an ever-increasing number of gazania cultivars for bedding hits the market every year, mainly in yellow, pink, and white, though greens and pale purple have recently been added to the range.

Gerbera jamesonii

Gerbera jamesonii was introduced into Europe in 1887. In the 1920s, French nurseries began to breed double forms, but since the 1940s American and Australian firms have been the leaders in developing new cultivars and extending the colour range. Most gerbera production until recently was directed at the cut-flower trade, but in the 1980s new short-stemmed cultivars were produced in Japan, and a new market has opened up for gerberas as plants for containers.

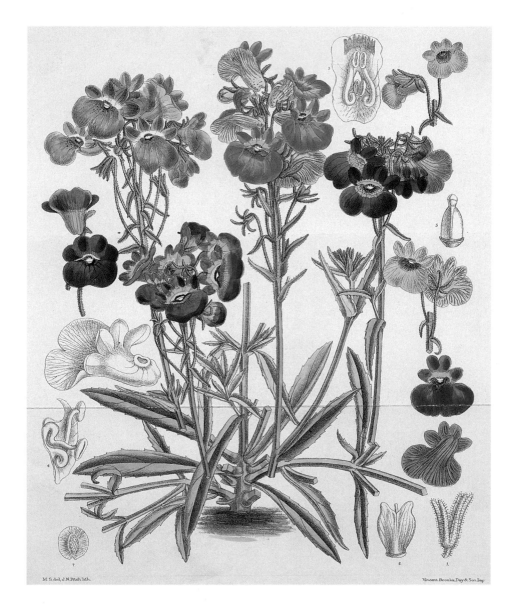

M.S.del.J.N.Fitch.lith. Vincent Brooks Day & Son Imp.

NEMESIA STRUMOSA

The first nemesia to be exhibited at the Royal Horticultural Society, in 1892, won an Award of Merit, but the production of garden forms was slow. During the 1930s, South African annuals, most notably *Nemesia* and *Dimorphotheca*, were promoted for municipal bedding schemes in Britain, but this incipient fashion was interrupted by World War II. Since then, nemesias have been extensively hybridised. They were originally orange, but red, yellow, white, and purple nemesias have been developed, as have bicoloured flowers.

CROCOSMIA AUREA

Crocosmia took longer to arrive in Europe than the other South African bulbs, because it does not grow at the Cape of Good Hope, but further inland. *Crocosmia aurea* was introduced in 1846, as *Tritona aurea*, and assigned to the new genus in 1851. The first hybrids were made by Victor Lemoine at Nancy in the 1880s. He marketed them as *Montbretia crocosmiaeflora*, and the hybrid forms are still widely known as montbretias.

CROCOSMIA AUREA *Planch.*

CHAPTER FOUR

THE SUNFLOWER (*Helianthus annuus*), as shown in *Hortus Floridus* in 1614, by which time it was already a familiar garden plant.

Shown opposite is the sort of passionflower illustration that circulated before the plants were actually grown in Europe: an idealised view which exaggerated the characteristics that were believed to symbolise the passion of Christ.

By the end of the century the term 'American plants' had taken on a specific meaning: the flowering shrubs associated with eastern American peaty swamps – rhododendrons, azaleas (subsumed into the category of *Rhododendron* in the 1820s), kalmias or mountain laurels, andromedas, magnolias, and the like. Meanwhile, the expansion of the new United States led to the botanical exploration of the lands west of the Mississippi. Lewis and Clark's expedition of 1804 resulted in the discovery of *Gaillardia aristata, Mimulus luteus, Calochortus* and *Clarkia elegans*, and *Erythronium grandiflorum*, and in the 1810s botanic gardens began to flourish in America. In the 1820s the Horticultural Society of London sent David Douglas as a plant collector on three journeys to America. He introduced over 200 plants into England and, in addition to the conifers for which he is most famous (the Douglas fir being named in his honour), he brought back *Mimulus moschatus, Lupinus polyphyllus, Clarkia elegans*, and *Eschscholzia californica*.

American annuals flooded into England between the 1820s and 1840s, providing much of the plant selection in the early, experimental days of the bedding system. John Caie, the Duke of Bedford's gardener at his London estate, was credited with first working out the rules of colour combination for the bedding system (the use of solid blocks of colour arranged for high contrast). He was using *Clarkia, Collinsia, Collomia, Eschscholtzia, Gilia, Mimulus, Nemophila, Oenothera, Platystemon* and *Polemonium* for bedding in the 1830s.

By the 1850s the rate of introductions from America was declining. The remainder of the century saw additions to the ranks, but no discoveries of new genera for the flower garden. The exception was succulents, which continued to yield objects of fascination. For a brief time in the early nineteenth century cacti and orchids seemed neck and neck in the race to dominate the glasshouse, but John Claudius Loudon condemned the fascination for cacti as evidence of depraved taste, and orchids won out. In Mediterranean countries, however, American cacti were hardy, and were introduced for a variety of purposes. Opuntia hedges were widely planted in north Africa; and extensive cactus gardens like that at the Villa Thuret at Antibes began to stimulate interest. In the twentieth century, and on into the twenty-first, succulents have returned to popularity on a large scale, more than five centuries after they first caught the imagination of European gardeners.

Fleur
de la
Passion.

Anthoine Serrurier. fe.

\mathcal{P}ASSIFLORA CAERULEO-RACEMOSA &
\mathcal{P}ASSIFLORA × CAERULEA

In 1577, Nicolas Monardes' account of the economic products of the American colonies was translated into English under the title *Joyfull Newes out of the Newe Founde Worlde*. It included an account of the 'maracot' plant in which the structure of the flowers was compared to the passion of Christ. The style was likened to a whipping post; the stigma, three nails; the corona filaments, a crown of thorns; ten petals and sepals, ten disciples present at the crucifixion; 'all as true as the Sea burnes', as Parkinson said. Interest was provoked by exaggerated representations of the plant, and it was not until 1620 that a living plant flowered in Europe, in the Farnese gardens in Rome. Within a decade it was being grown in England, and other species followed throughout the eighteenth century. The first hybrid, *Passiflora × caeruleo-racemosa* (above), was grown in 1820 by the Fulham nurseryman Thomas Milne.

a

ℋIPPEASTRUM STRIATUM

A seemingly endless nomenclatural controversy hangs over the name *Amaryllis*.
Various South American plants originally included in this genus were separated and
classed as *Hippeastrum* by William Herbert in 1821. But generations had become
accustomed to thinking of them as *Amaryllis*, and throughout the twentieth century
the American Amaryllis Society continued to condemn *Hippeastrum* as an invalid
name. It has been argued that Linnaeus actually had the American plants in mind
when he coined the name *Amaryllis*. These illustrations of *Hippeastrum striatum*
are from *A Selection of Hexandrian Plants* (1831–1834) by Priscilla Bury.

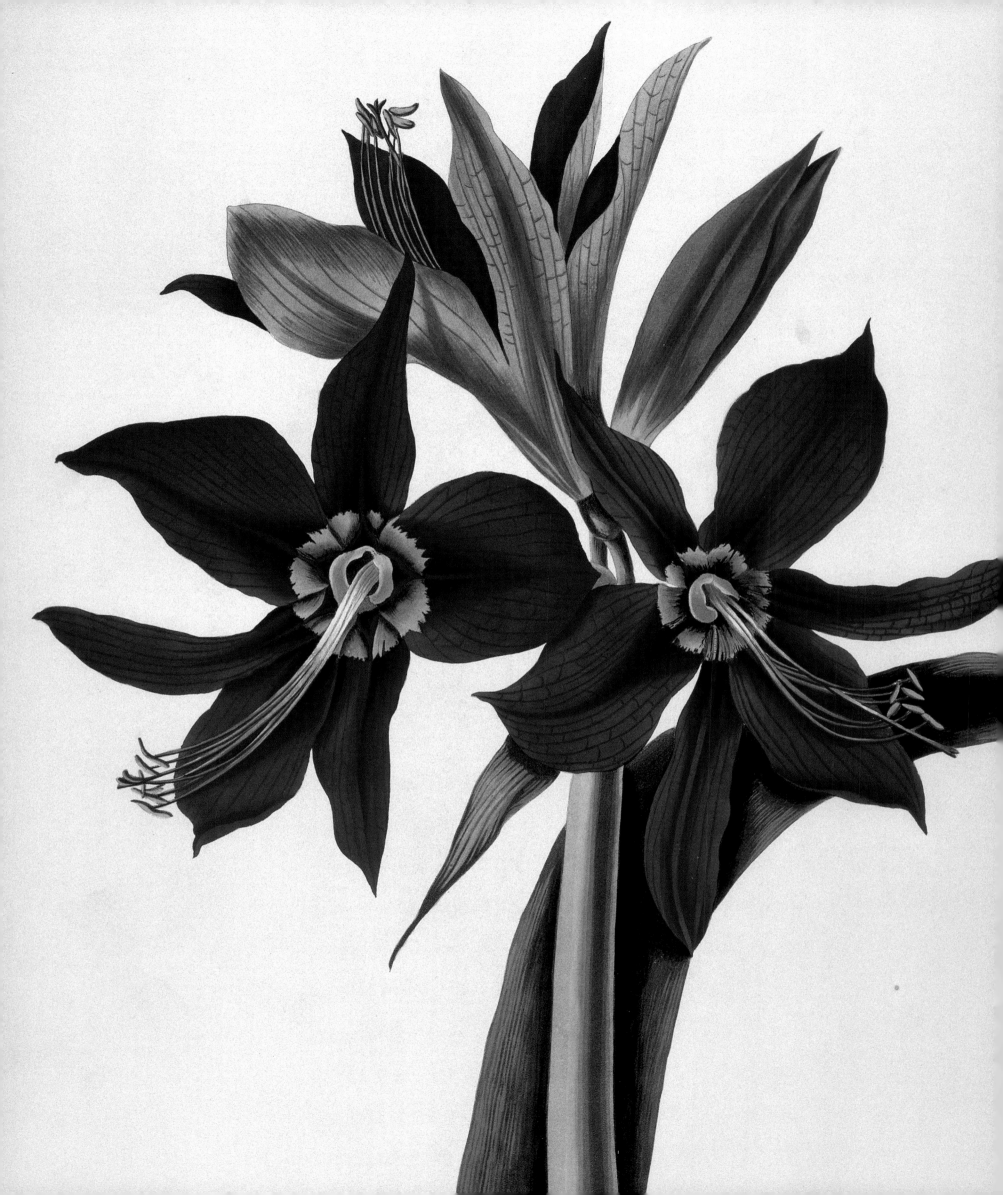

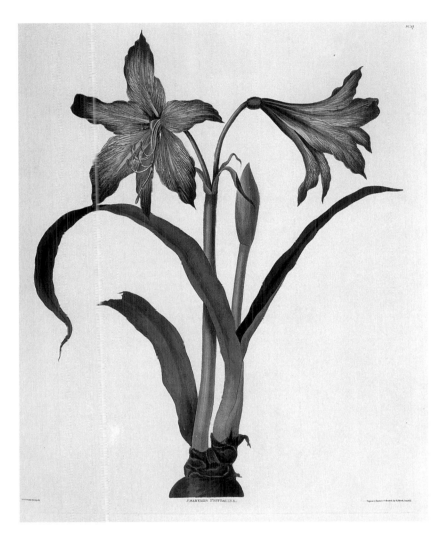

HIPPEASTRUM AULICUM &
HIPPEASTRUM PSITTACINUM

Hippeastrum species flowed into England in the late eighteenth and early nineteenth centuries, and Liverpool became a showcase for the new introductions. (*H. psittacinum*, above, first flowered there in 1813.) The first hybrid hippeastrum had been produced in 1799 by a watchmaker named Arthur Johnson: a cross between *H. vittatum* and *H. reginae*. By 1839, the third edition of Robert Sweet's *Hortus Britannicus* recorded sixty-three species and seventy-nine cultivars being grown in British gardens – or greenhouses. These illustrations of *Hippeastrum aulicum* (left) and *H. psittacinum* are by Priscilla Bury.

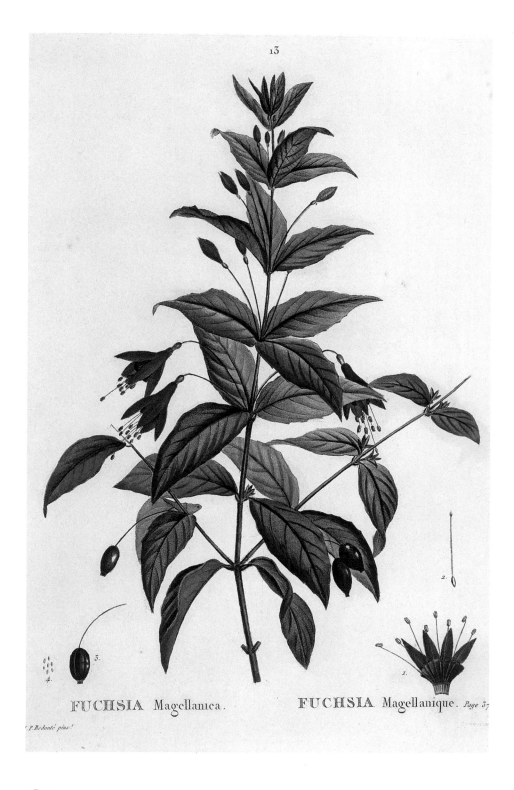

FUCHSIA Magellanica. FUCHSIA Magellanique. *Page 37*

ℱUCHSIA MAGELLANICA

The fuchsia was named by Charles Plumier in 1693, in honour of the pioneering sixteenth-century botanist Leonhard Fuchs. It was not until about 1790 that *Fuchsia magellanica* was introduced into cultivation, through the Kennedy and Lee Nursery in Hammersmith. Several more species arrived between 1820 and 1850, notably *F. fulgens*, introduced from Mexico by the Horticultural Society's collector Theodor Hartweg; this became the ancestor of the modern hybrid fuchsia, initially through the English breeder James Lye, from the 1860s to the 1890s, and then Victor Lemoine of Nancy at the turn of the century.

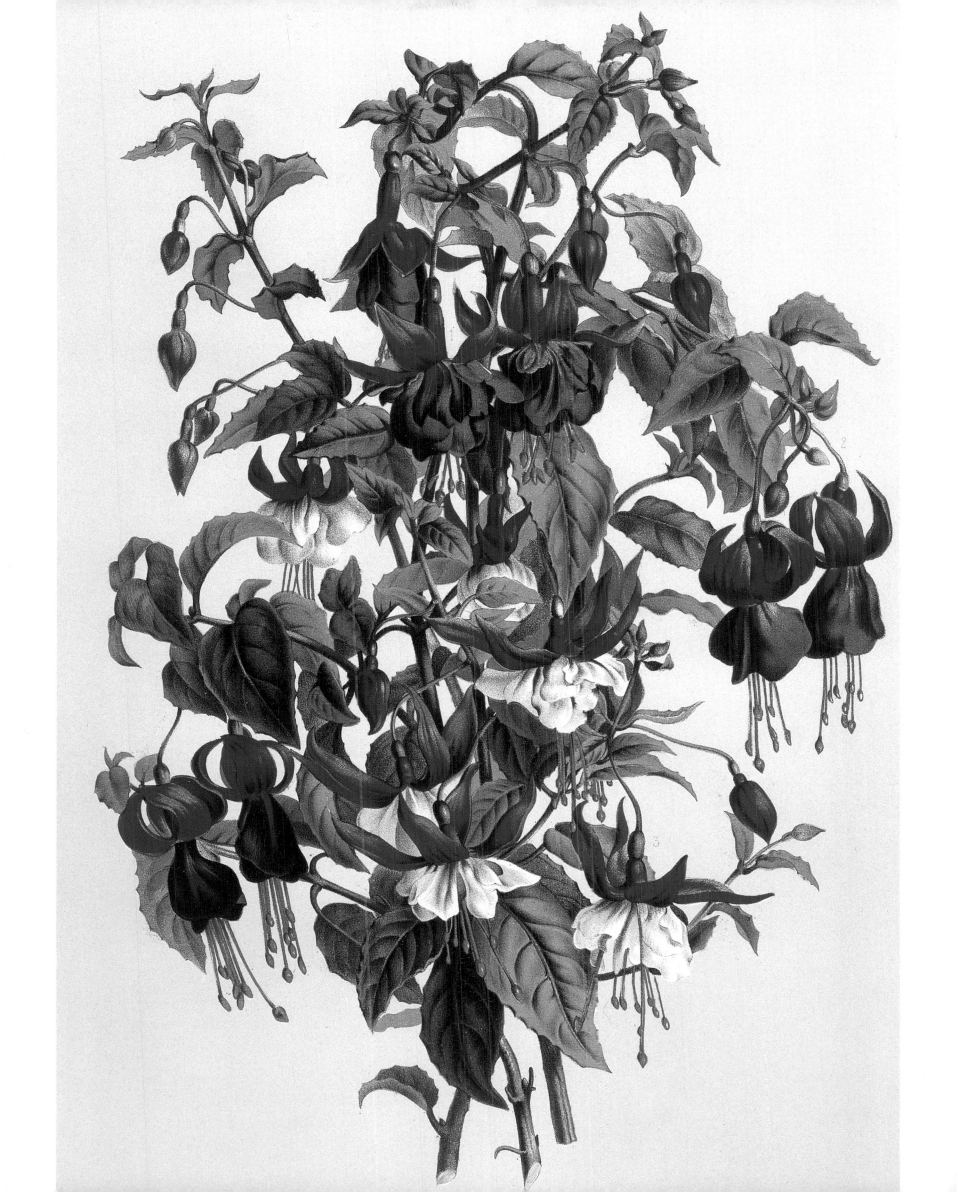

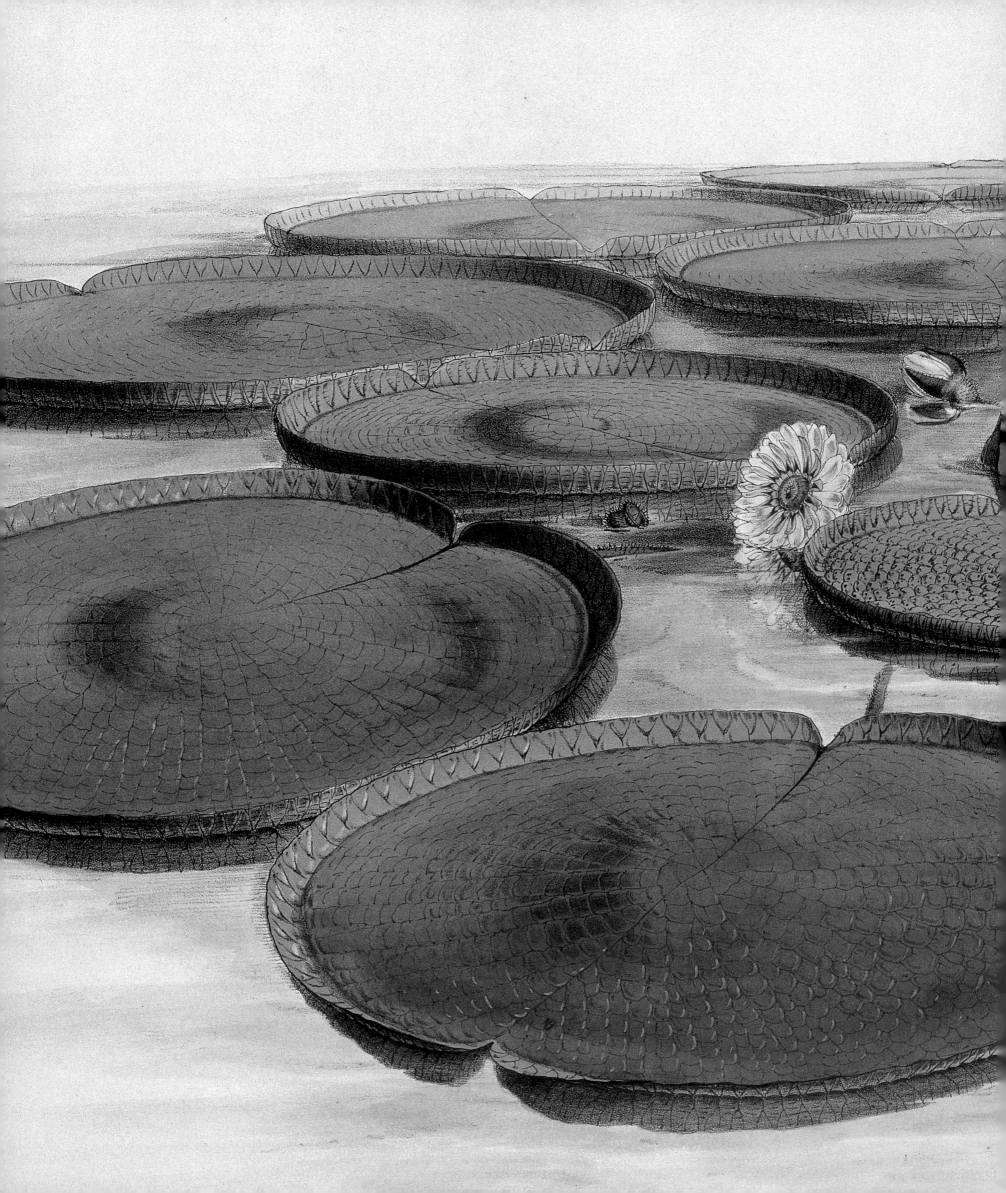

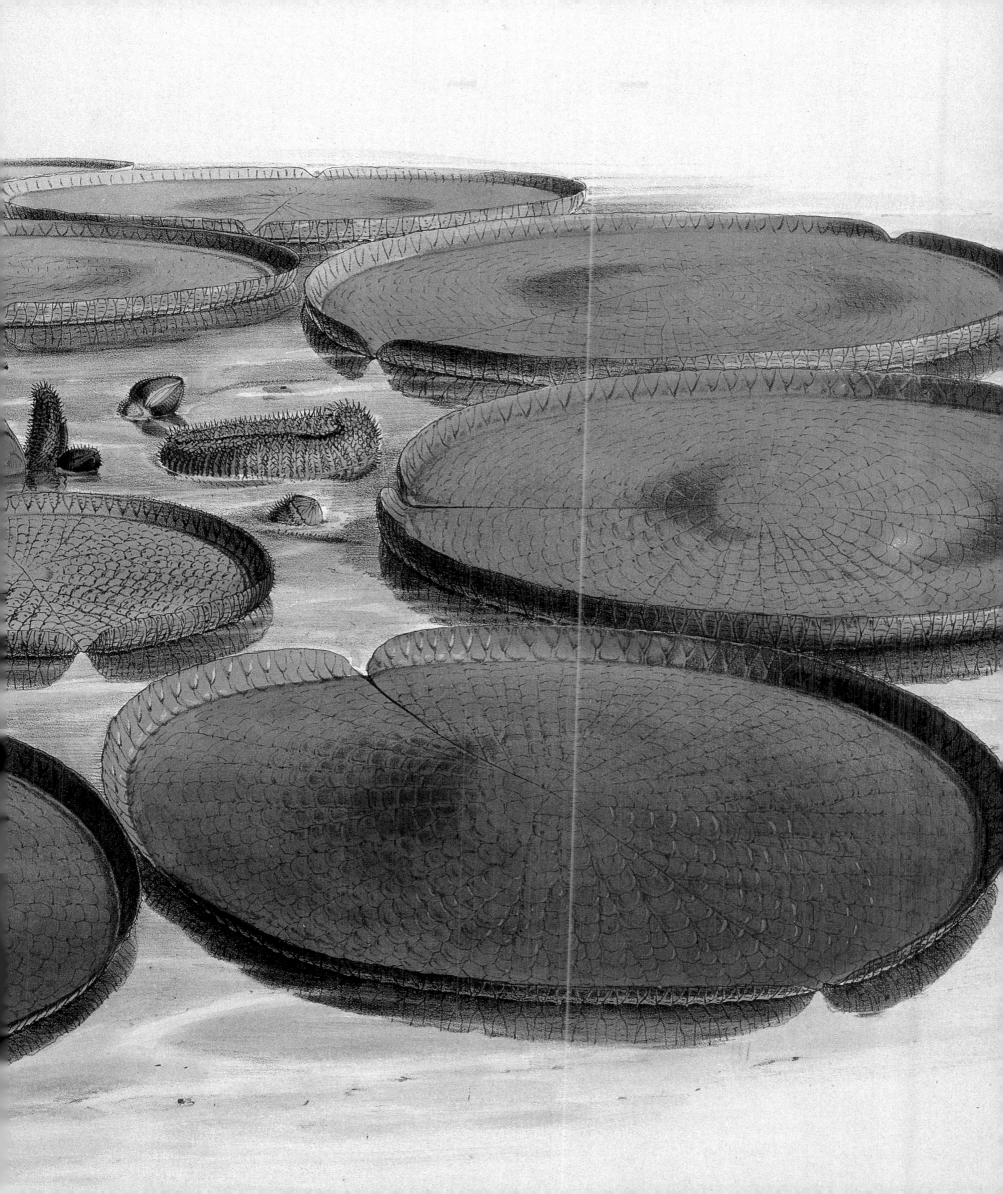

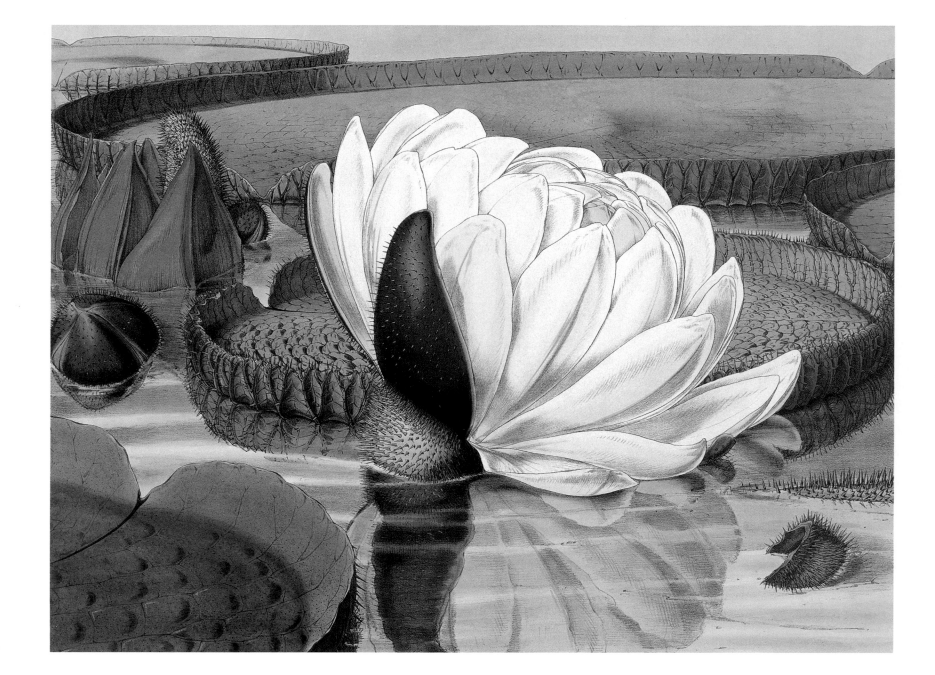

VICTORIA AMAZONICA

In 1838, the collector Robert Schomburgk introduced the largest water-lily ever seen, and John Lindley named it *Victoria regia* in honour of the Queen (but it had already been described, and *V. amazonica* is now the correct name). In 1849, Kew and Chatsworth competed to see who could flower it first. Chatsworth won, and the head gardener, Joseph Paxton, built a pioneering glasshouse to accommodate it. *The Illustrated London News* for 17 November that year carried an illustration of Paxton's daughter Annie standing on a floating leaf to demonstrate its sturdiness, and most later growers of victorias felt compelled to duplicate the feat. Walter Hood Fitch illustrated *V. amazonica* (previous page, opposite, and below) in Sir William Jackson Hooker's volume entitled *Victoria Regia* (1851).

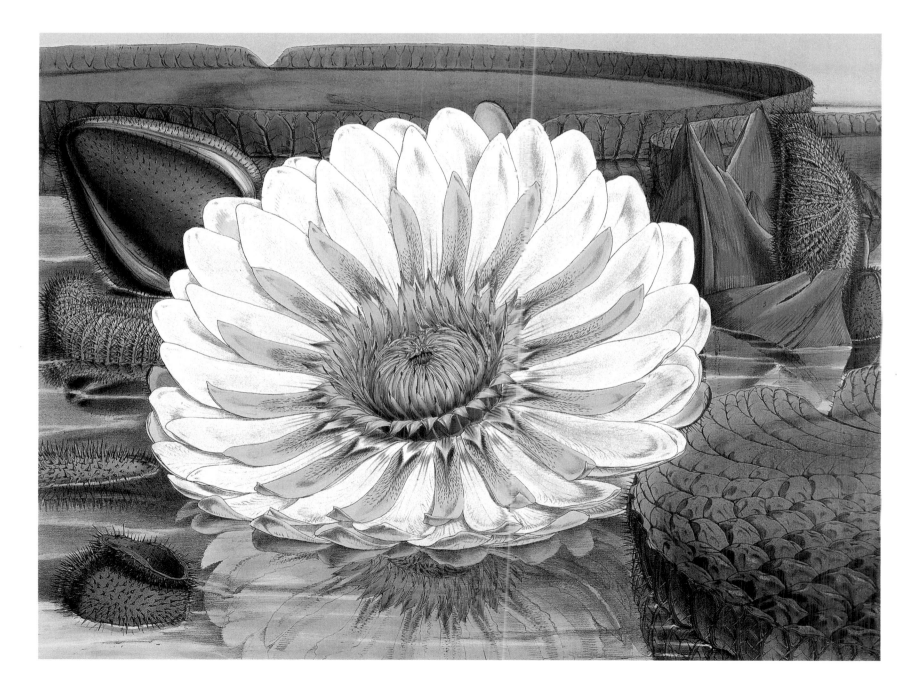

N.º 174

Lawrds fecit. Pub Nov 1 1791 by W Curtis S.t Georges Crescent.

ℬUDDLEJA GLOBOSA

The buddleja was named after the early eighteenth-century English botanist Adam Buddle. *Buddleja globosa* was introduced in 1774 by the Kennedy and Lee Nursery in Hammersmith, at first as a greenhouse plant. Because of doubts as to its hardiness, *B. globosa* was never grown as extensively as the later purple-flowered introductions, but its unique orange flowers were always admired.

𝒞ALCEOLARIAS

The first calceolarias reached England in the 1770s, but the more ornamental Peruvian and Chilean species had to wait until the 1820s: *C. corymbosa* and *C. integrifolia* in 1822, *C. biflora* in 1826, *C. bicolor* in 1829. George Penny of the Milford Nursery near Godalming produced the first hybrids, and from the mid-1830s calceolarias became an undeclared florists' flower, though confined to greenhouses, with colour variations in stripes, dots, and patches eagerly sought.

GREEN'S, SEEDLING CALCEOLARIA'S _ PLATE 2.

\mathcal{C}ALCEOLARIAS

Calceolarias were leading a double life by the 1850s. On the one hand, new hybrids were developed that increased the size of the bubble and the complexity of the colour patterns, to make decorative plants for the greenhouse and show bench. On the other, flowers with solid colour began being used for bedding in the 1840s. The opening of London's Crystal Palace Park in 1854 saw calceolarias join pelargoniums, petunias, and verbenas as the major bedding plants of the period. In the twentieth century they underwent a catastrophic decline, and none of the nineteenth-century cultivars now survive, though new equivalents of the florists' calceolaria have begun to appear again as F1 Hybrid Bubbles.

Off. lith. & pict. in Horto Van Houtteano

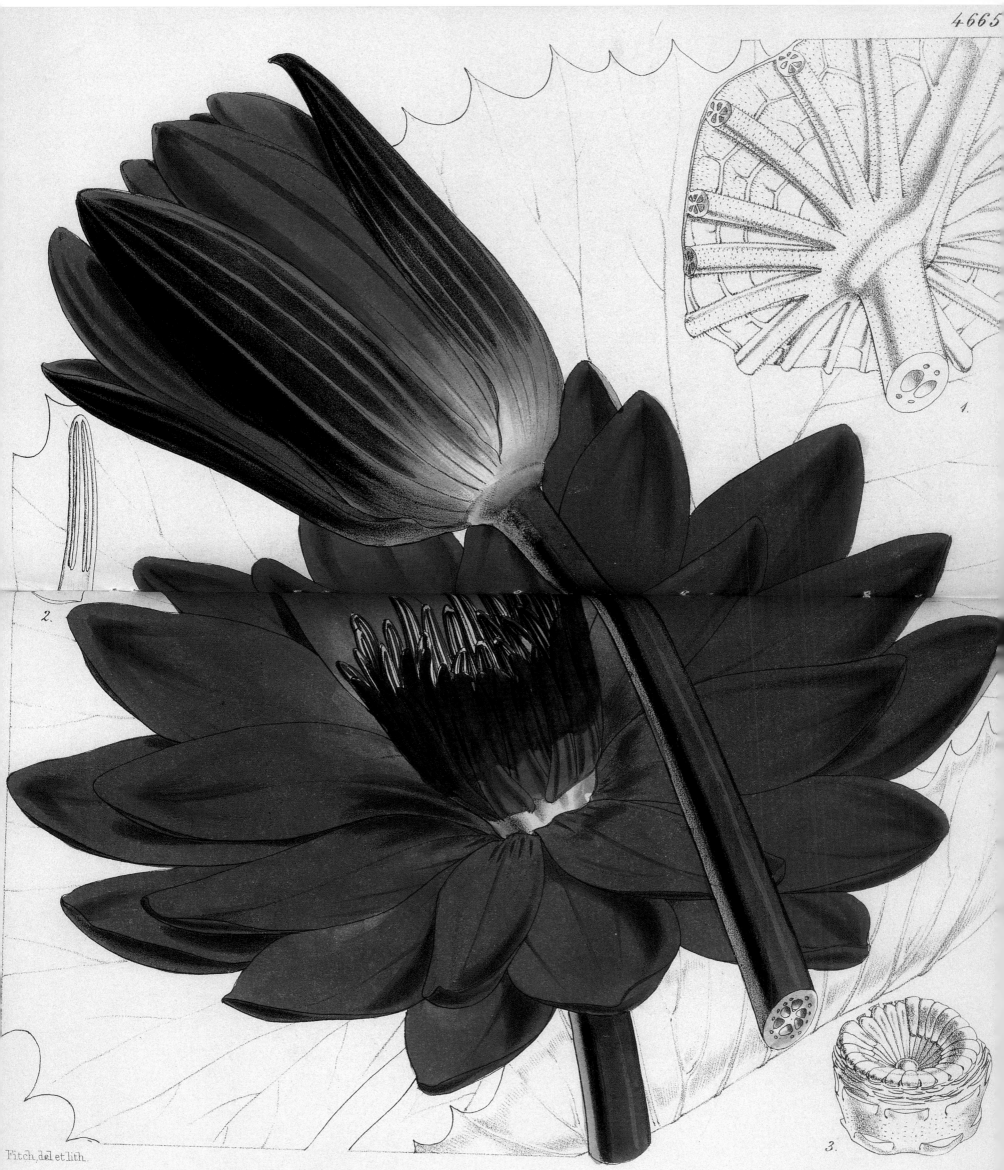

Fitch, del et lith.

F. Reeve, imp.

CANNA INDICA

Cannas reached Europe about 1570, but were also extensively grown in the East Indies. The first attempts to produce hybrid cannas took place in France in the 1840s, and focused on foliage. As a result, cannas were long treated as foliage plants in England. Production of flowering hybrids began in the late 1850s, again the work of French nurserymen like Crozy and Sisley at Lyon, Lemoine at Nancy and Vilmorin in Paris. Some of the late nineteenth-century varieties are still available.

THE DUKE OF DEVONSHIRE'S HYBRID NYMPHAEA

The first hybrids of tropical water-lilies, like this one bred at Chatsworth in the 1850s, were confined to glasshouses. Then, in 1891, the *Revue Horticole* announced that Joseph Latour-Marliac, a nurseryman at Temple-sur-Lot, had succeeded in growing hybrids that were hardy outdoors, using the American species *Nymphaea flava* and *N. tuberosa*. A flurry of competition ensued, with James Hudson becoming the leading English breeder, but the French Marliacea hybrids outlasted all their rivals.

GUNNERA SCABRA

The last of the big foliage discoveries, and the one that lasted longest as a feature in the outdoor garden, was the gunnera. *Gunnera manicata* was discovered in 1867 by the Belgian nurseryman Jean Linden, and quickly superseded the smaller species that had previously been known (such as *G. scabra*, now *G. chilensis*, introduced about 1850). Long after the demise of subtropical gardening, gunnera continued to hold a place in the wild and water gardens of Britain and Europe.

GUNNERA SCABRA *Rz & Pav.*

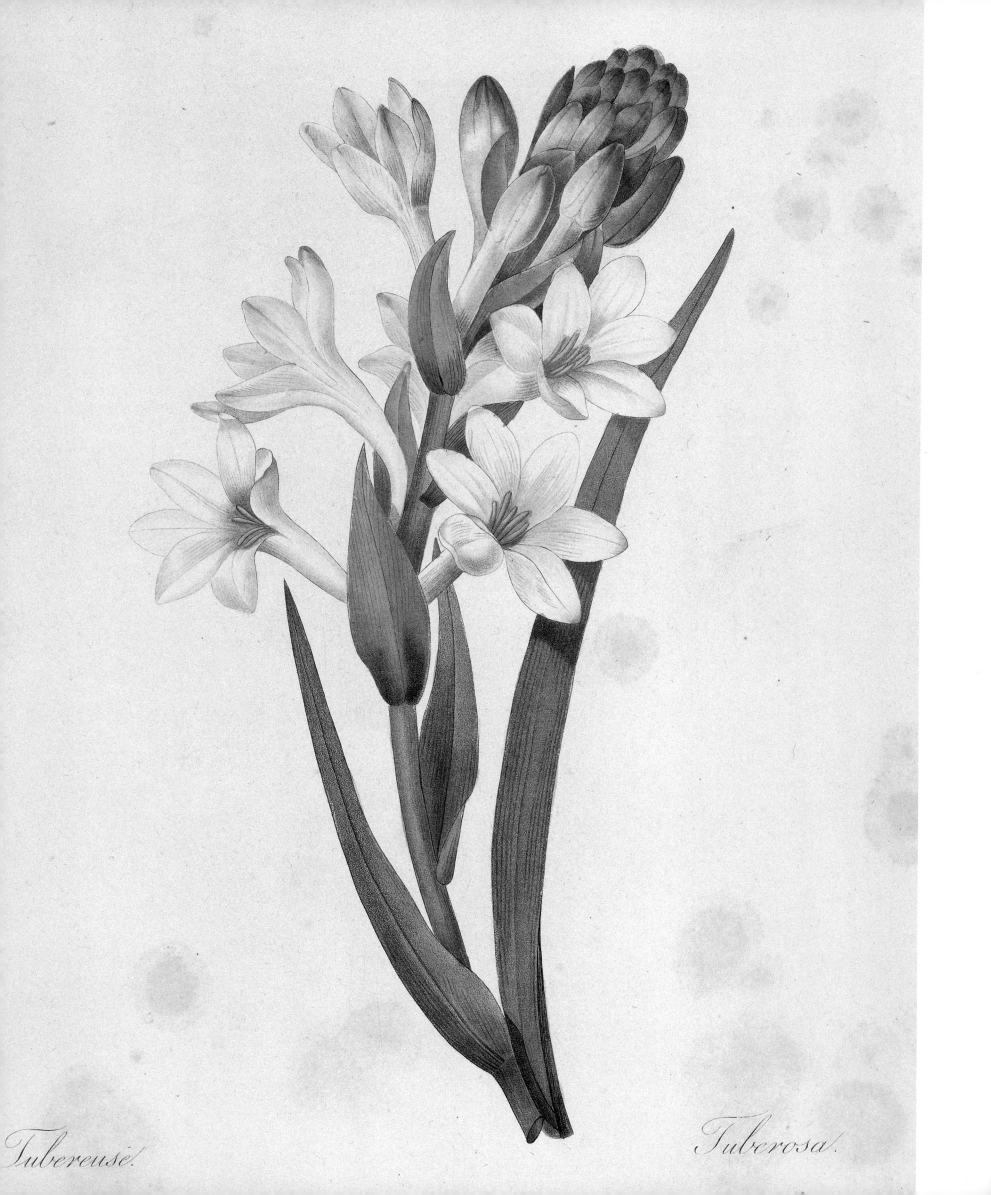

Tubereuse. *Tuberosa.*

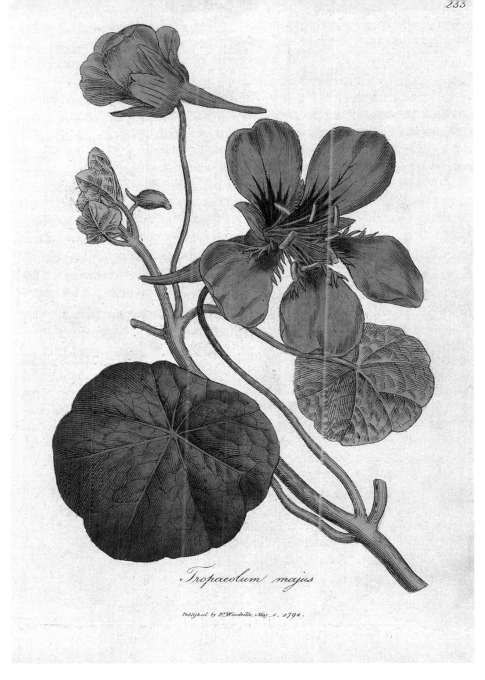

Tropaeolum majus

Published by D. Woodville, May 1, 1794.

Tropaeolum Majus

The principal species of garden nasturtium arrived in England in the sixteenth and seventeenth centuries. The yellow-flowered *Tropaeolum minus* was known to Gerard; *Tropaeolum majus* was available by 1690; and the first double-flowered forms appeared in Italy in the 1750s. *T. lobbianum* (now *T. peltophorum*) was introduced in 1843, becoming popular later in the century. The first modern semi-doubles, the Gleam hybrids, were launched internationally about 1930: 'Golden Gleam' won an RHS Award of Merit in 1932.

Polianthes Tuberosa

The tuberose was introduced into Europe in 1629, and by the second half of the century had become one of the most esteemed garden flowers, for its scent as much as for its beauty. Louis XIV placed orders for over 10,000 tuberoses at a time for the royal gardens at the Trianon, where they filled the flowerbeds, and they supported almost as extensive an industry in Italy as hyacinths did in Holland. They were introduced into the Philippines possibly before they reached Europe, and for centuries were regarded as East Indian plants.

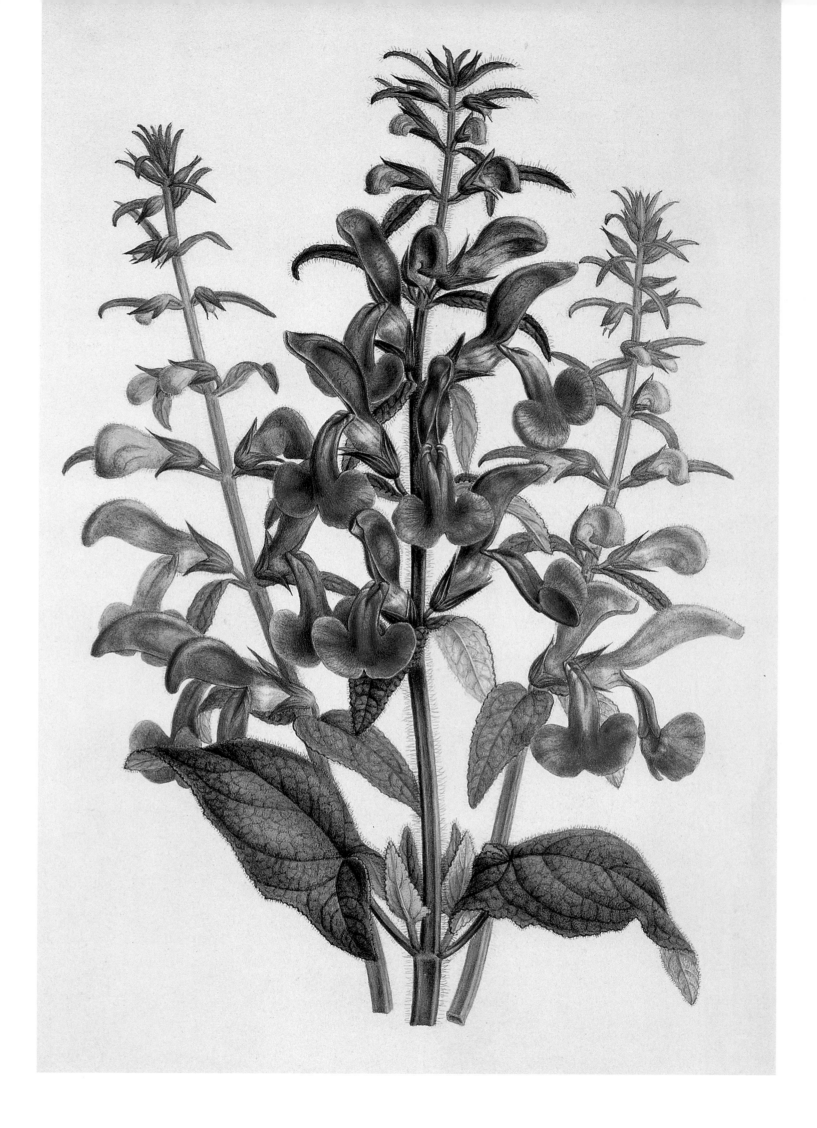

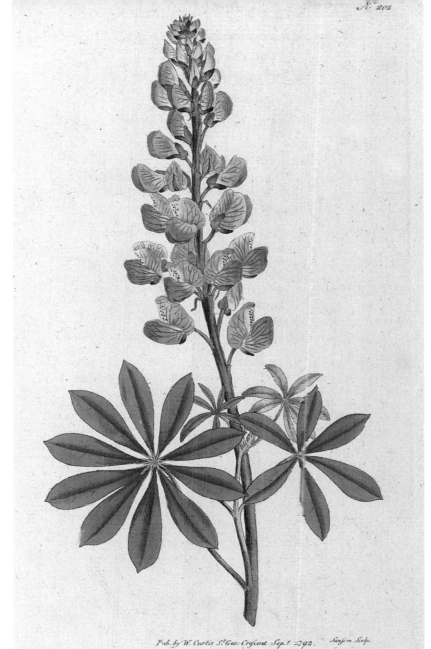

Pub. by W. Curtis St Geo: Crescent Sep. 1. 1792.

LUPINUS PERENNIS

Lupinus perennis was the first American lupin to be introduced into Europe, possibly by John Tradescant, who certainly listed it in the 1650s. *Lupinus arboreus* emerged from Captain Vancouver's expedition in 1792, and David Douglas introduced *Lupinus polyphyllus* in 1826. By the early twentieth century, nurseries were competing to extend the colour range of lupins, but their cultivars were largely superseded in the 1950s by the dramatic Russells, bred by George Russell.

SALVIA PATENS

Although *Salvia coccinea* had been sent to Europe as early as 1774 by John Bartram, it was the more ornamental *Salvia fulgens* from Mexico, and *Salvia splendens* (1822), that attracted notice and became used as bedding plants. *Salvia patens* was introduced in 1838 as a greenhouse plant. The famous blue bedding forms only emerged in the twentieth century, most notably 'Cambridge Blue', which Thomas Hay used in the 1920s for the central royal parks of England.

\mathcal{T}RADESCANTIA VIRGINIANA

Whether or not John Tradescant introduced the plant named after him, it had entered English gardens by 1629. A very variable species, it came to boast named varieties with white, red, blue, purple, and pink with touches of yellow. E. B. Anderson proposed in the 1930s that the range of variation was a consequence of natural hybridisation, and in his honour the cultivars were grouped together as *Tradescantia × andersoniana*; but later botanists have found no evidence that tradescantias hybridise readily in the wild, and that group name has been discontinued in favour of the more neutral Virginiana hybrids.

a

b

c

i

Ephemerum Virginianū flore purpureo.
Ephemerum Virginianum flore albo.
Ephemerum phalangoides erectum foliis
liliaceis bulbosum, flore florescente. B.

Tab.551.

Helianthus annuus.
Jährige Sonnenblume.
Ok.749.

HELIANTHUS ANNUUS

Nicolas Monardes, who had been the first to describe the passionflower, also first described the sunflower. It quickly reached England, and John Gerard claimed in 1597 that he had grown a specimen to the height of 14 feet; by Parkinson's time, 'everyone [was] nowadays familiar' with it. By the 1730s, Philip Miller, at the Chelsea Physic Garden, claimed to know seven varieties of the giant sunflower, some so common that many people took them for native plants.

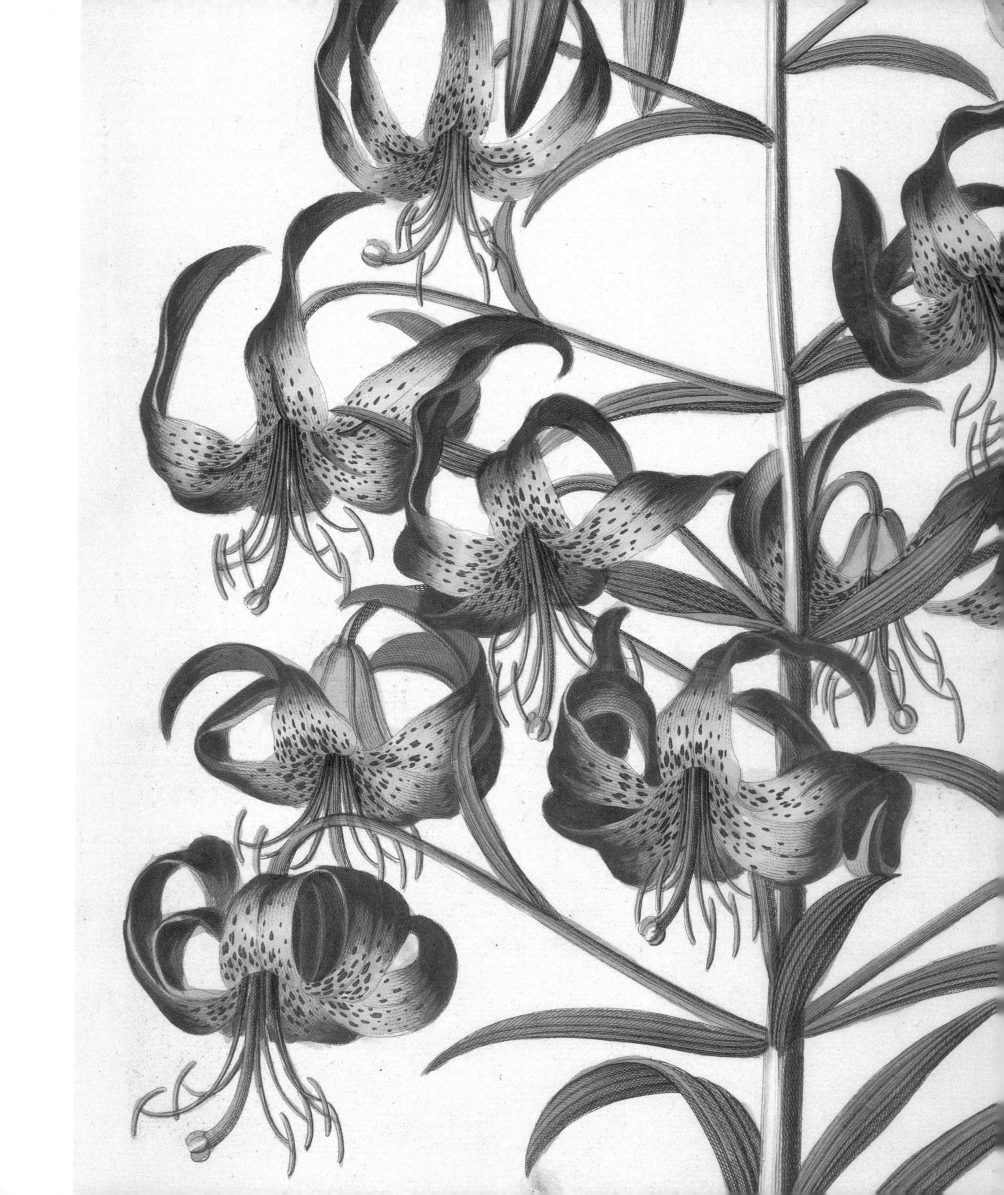

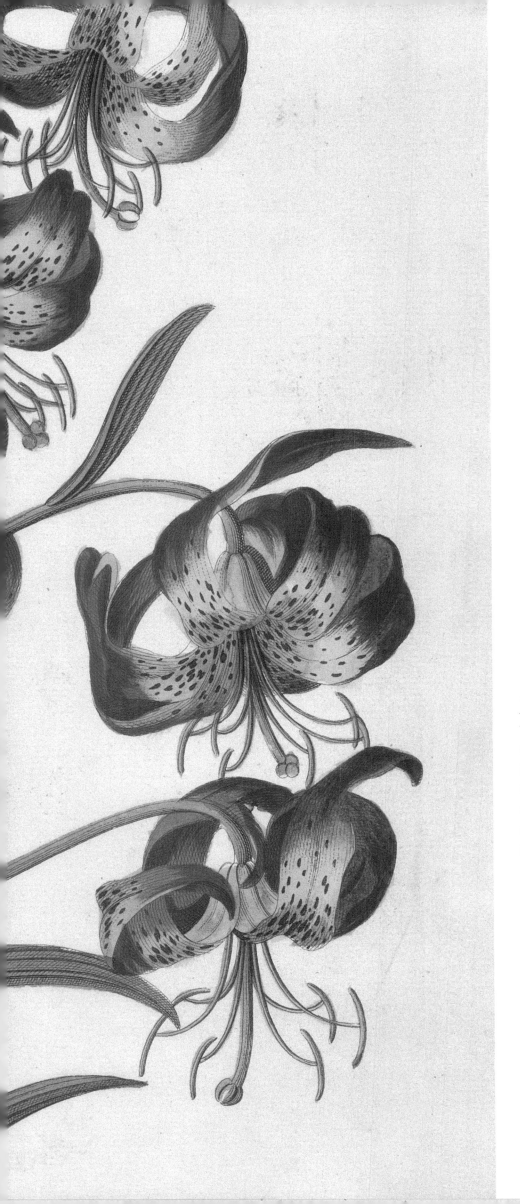

ℒILIUM SUPERBUM

The first American lily of importance, *Lilium superbum* was collected by Mark Catesby in 1738 and distributed in England through Peter Collinson. It may have become known earlier; Thomas Hanmer's reference in the 1650s to a 'Red Virginia spotted with brown spots' may indicate a previous introduction that was subsequently lost. Despite the spectacular introductions from China and Japan in the nineteenth century, this never lost its popularity as a garden plant. This illustration by Georg Dionysius Ehret is from *Plantae Selectae* (1750–1765).

Pl.17.

Rudbeckia velu.

\mathcal{R}UDBECKIA PINNATA & \mathcal{R}UDBECKIA HIRTA

Rudbeckia laciniata was introduced from French Canada in the 1630s, but it was *Rudbeckia hirta* (above), the black-eyed Susan, introduced in 1714, that gave the genus a lasting place in English gardens. This illustration appeared in *L'Art de Peindre les Fleurs à l'Aquarelle* (1834) by Augustine Dufour. Various additional species arrived in the nineteenth century, and were used for hybridising. *Rudbeckia pinnata* (opposite), here from the 1822 volume of the *Botanical Magazine*, was introduced in 1803 but has since moved into the genus *Ratibida*.

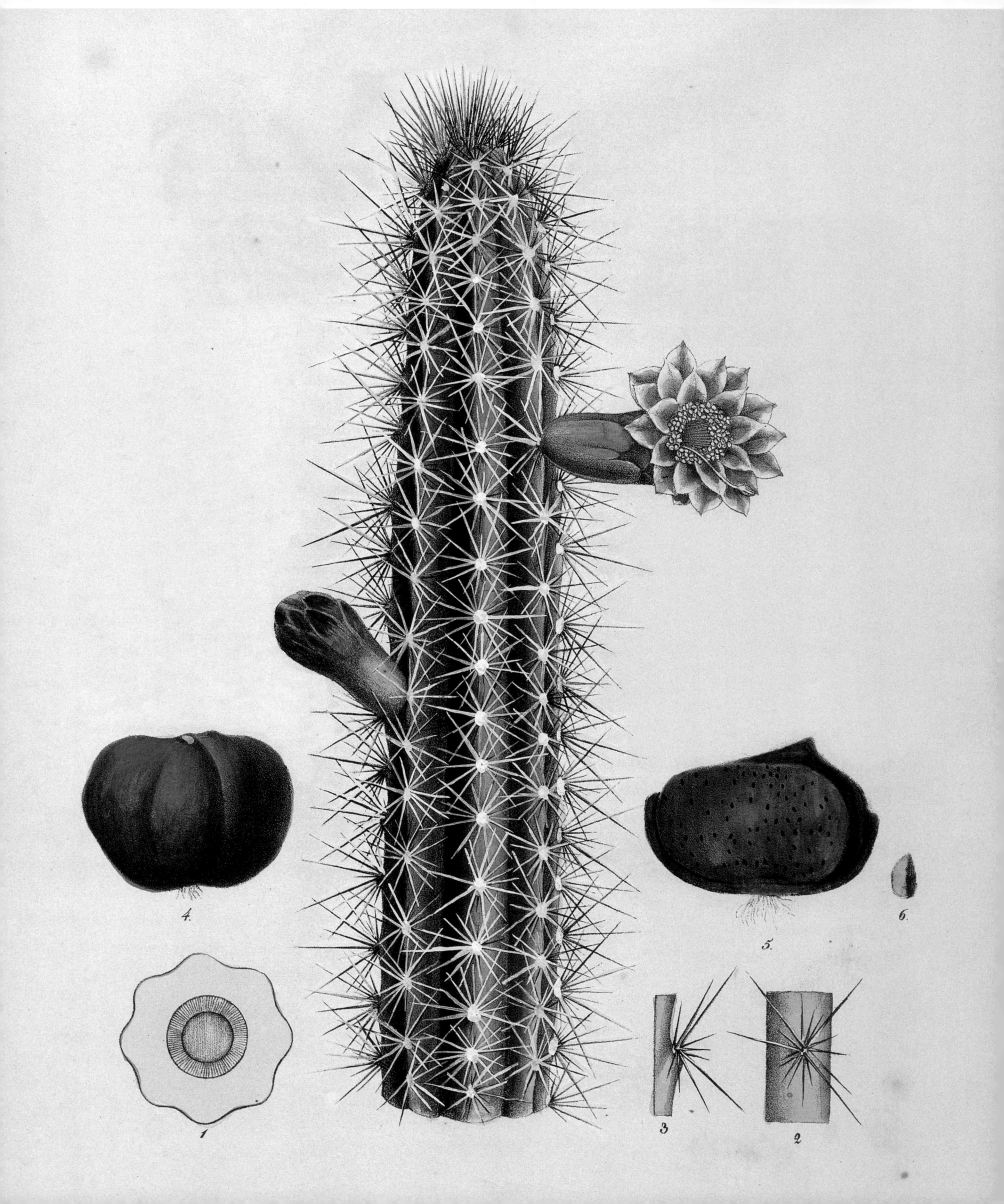

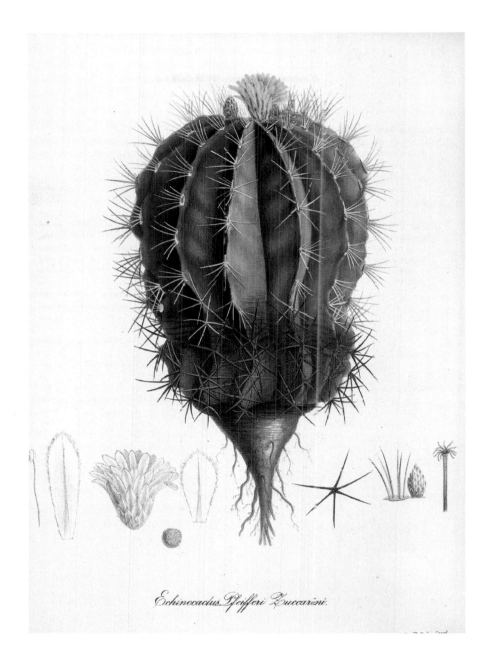

Echinocactus Pfeifferi Zuccarini.

CEREUS CURTISI &
ECHINOCACTUS PFEIFFERI

The cylindrical-stemmed cacti were assigned a separate genus *Cereus*, which has then been further fragmented into *Selenicereus*, *Trichocereus*, etc., but until a thorough revision of the species is made, many of the current names must be considered provisional only. These and other cacti were eagerly collected during the early nineteenth century, and for a while cacti and orchids competed to see which would furnish the greater craze; but after mid-century orchids won out, and collections of greenhouse cacti were more a part of continental, than English, gardens. *Cereus curtisi* (left) and *Echinocactus pfeifferi* (above) were illustrated in *Abbildung und Beschreibung Blühender Cacteen* (1838–1850) by Ludwig G.C. Pfeiffer and Christoph Friedrich Otto.

*D*AHLIA 'THE SOVEREIGN' &
*D*OUBLE DAHLIA

Dahlias were described in the sixteenth century by the botanist Francisco Hernandez, but none reached Europe until the late 1780s, when Antonio José Cavanilles was making great efforts to reinvigorate the Botanical Garden in Madrid. Alexander von Humboldt sent seeds to Berlin in 1804, where two years later fifty-five cultivars flowered. The empress Joséphine collected dahlias at her garden at Malmaison, and they finally reached England after the Napoleonic war ended. Over 100 varieties were available by 1820, and over 2000 by 1840. Dahlia 'The Sovereign' (above) is from a drawing by James Sillett (1764–1840). The double dahlia (right) is from *Choix des Plus Belles Fleurs* (1827) by Redouté.

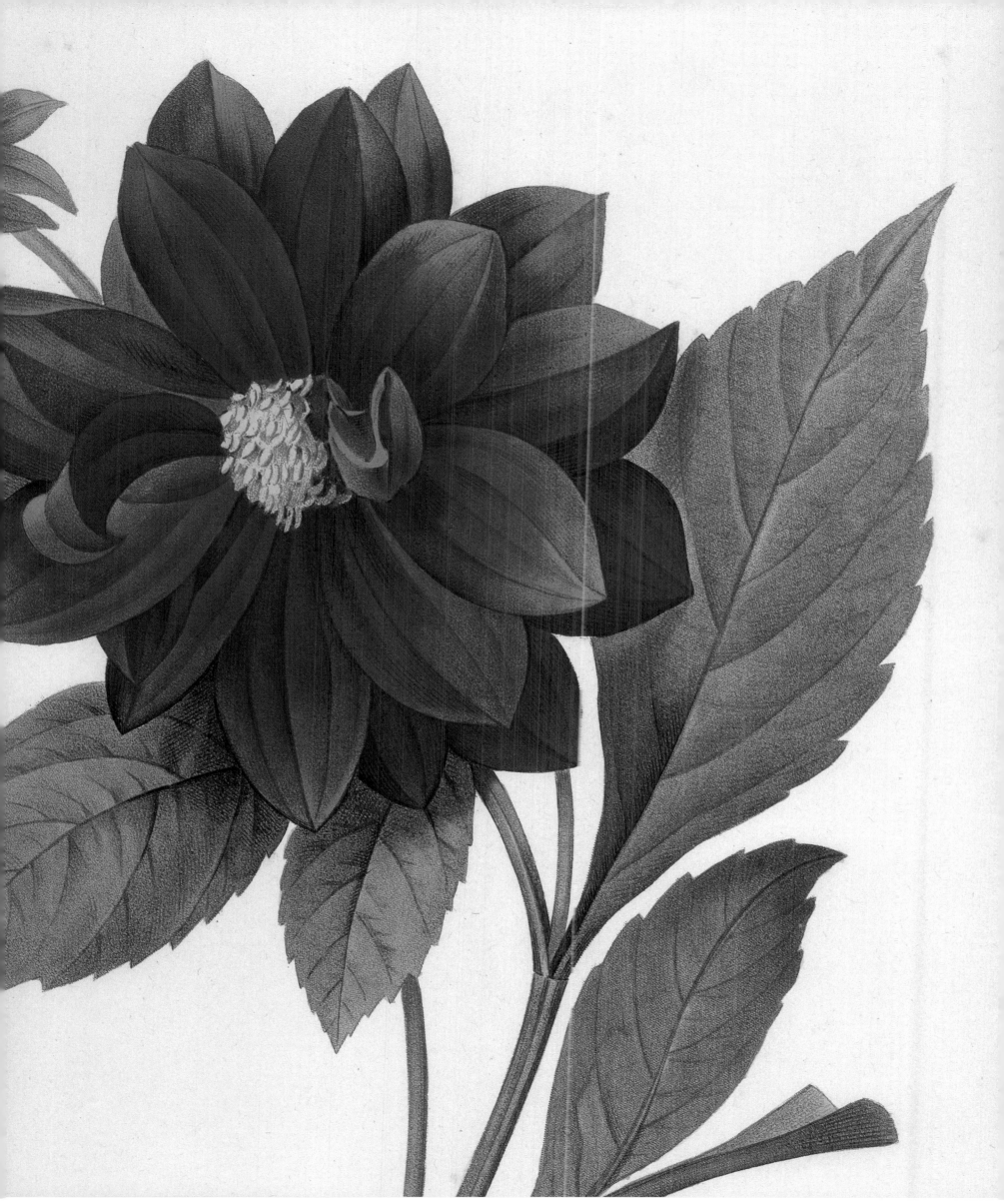

Plate LV.

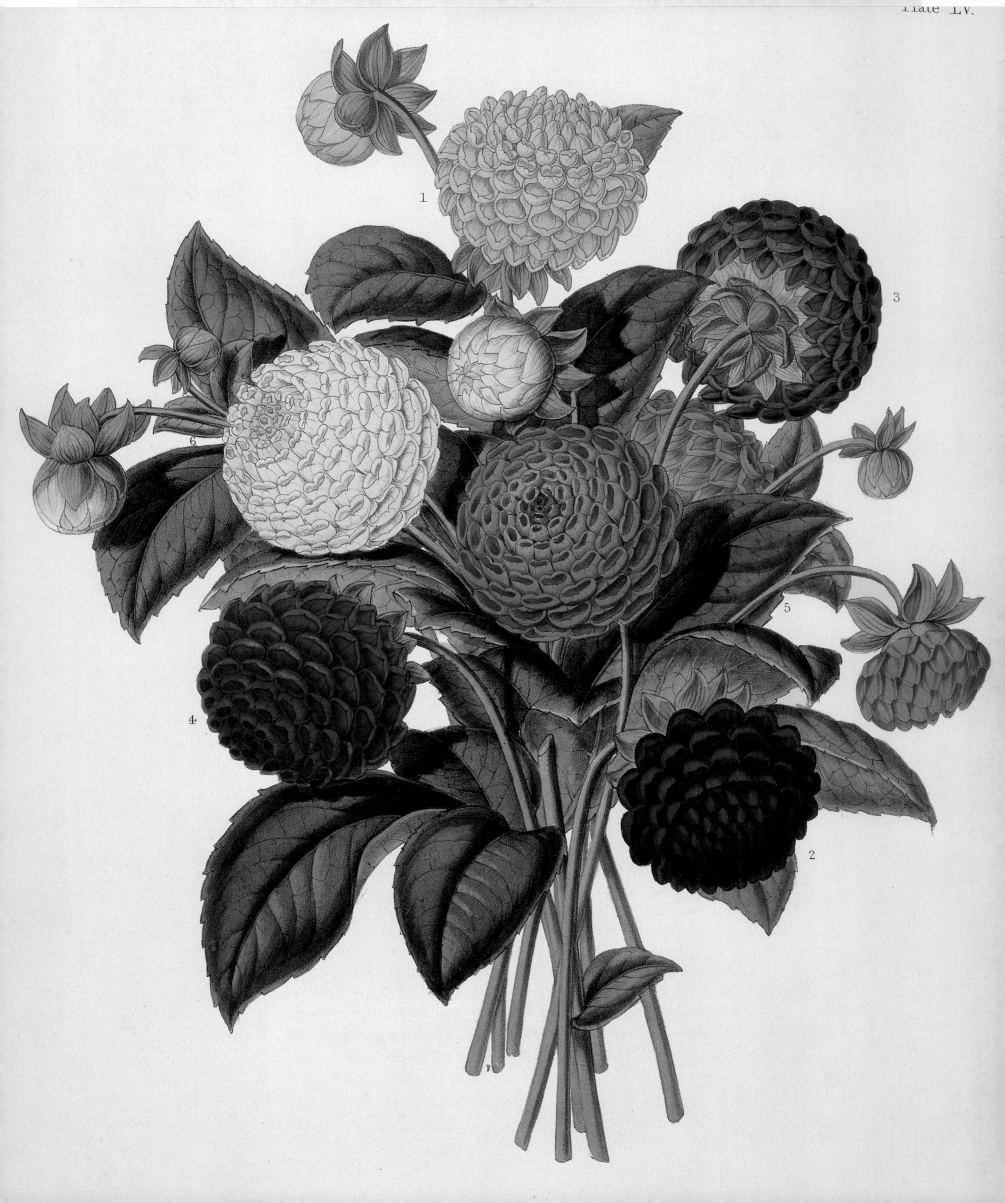

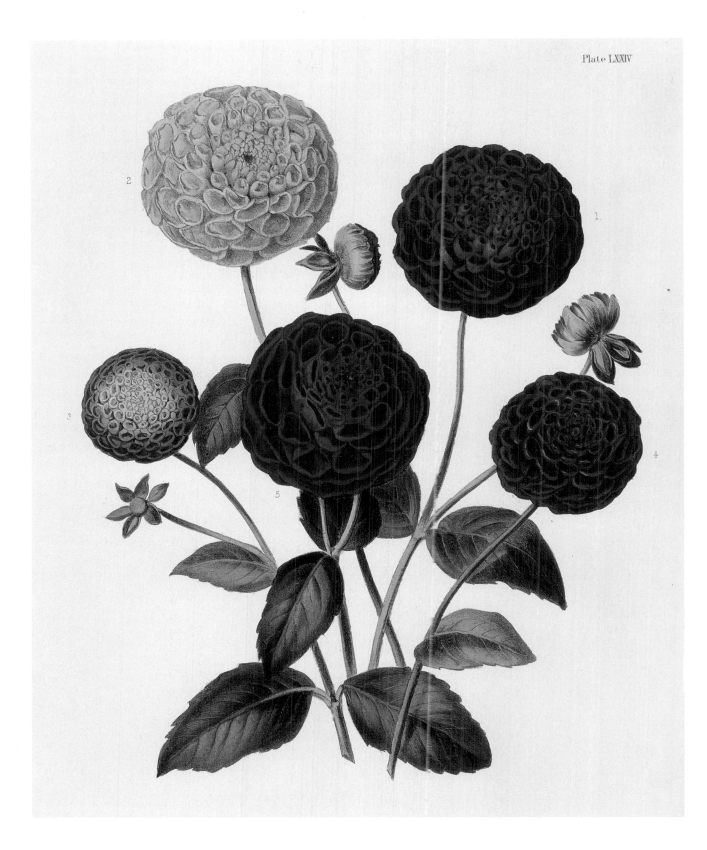

Plate LXXIV

\mathcal{P}OMPON & \mathcal{L}ILLIPUT DAHLIAS

The first dwarf dahlias appeared in 1828; the first anemone-flowered types in
1830; pompons (including the originally distinct lilliputs) in the 1840s.
(Pompon-type flowers were observed as early as 1803 but were not accepted as
a category until the entire plant was bred as dwarf.) Dahlias have gone in and out
of fashion as garden flowers, but have always been popular as exhibition flowers.

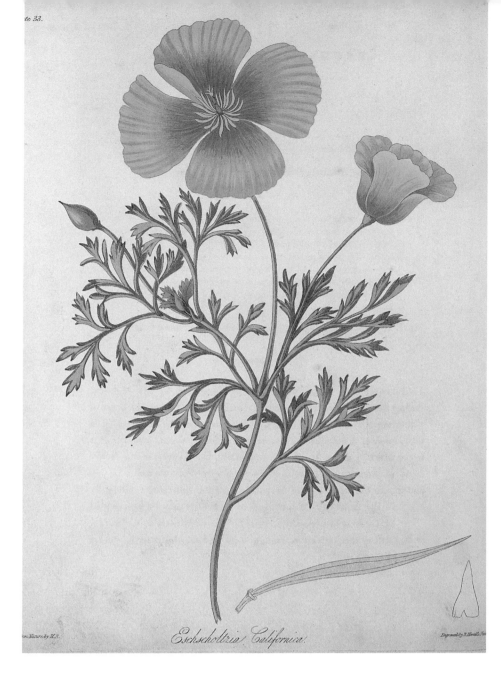

Eschscholtzia Californica.

ESCHSCHOLZIA CALIFORNICA

The Californian poppy was named in 1815 by the German botanist Adalbert von Chamisso, after his friend Eschscholz, the ship's doctor on his expedition. Introduced into Europe by David Douglas, it quickly roused the enthusiasm of gardeners. Donald Beaton, perhaps the most important British gardening journalist at mid-century, wrote of it: 'Who could sleep half the time without a long row of it after once seeing it that way?' The original colour range was yellow to white, but reds appeared in the late nineteenth century, culminating in Luther Burbank's New Crimson California Poppy early in the twentieth century.

GAILLARDIA PICTA

Gaillardia pulchella was introduced as early as 1787 but never became an important garden flower. Other species arrived from the 1810s on, most notably *Gaillardia aristata* and *Gaillardia picta*, the latter found in Louisiana in 1833 and illustrated here from *The British Flower Garden* (1823–1837) by Robert Sweet. These were the ancestors of the later garden hybrids, the most famous of which, *G.* × *grandiflora*, is still available commercially today.

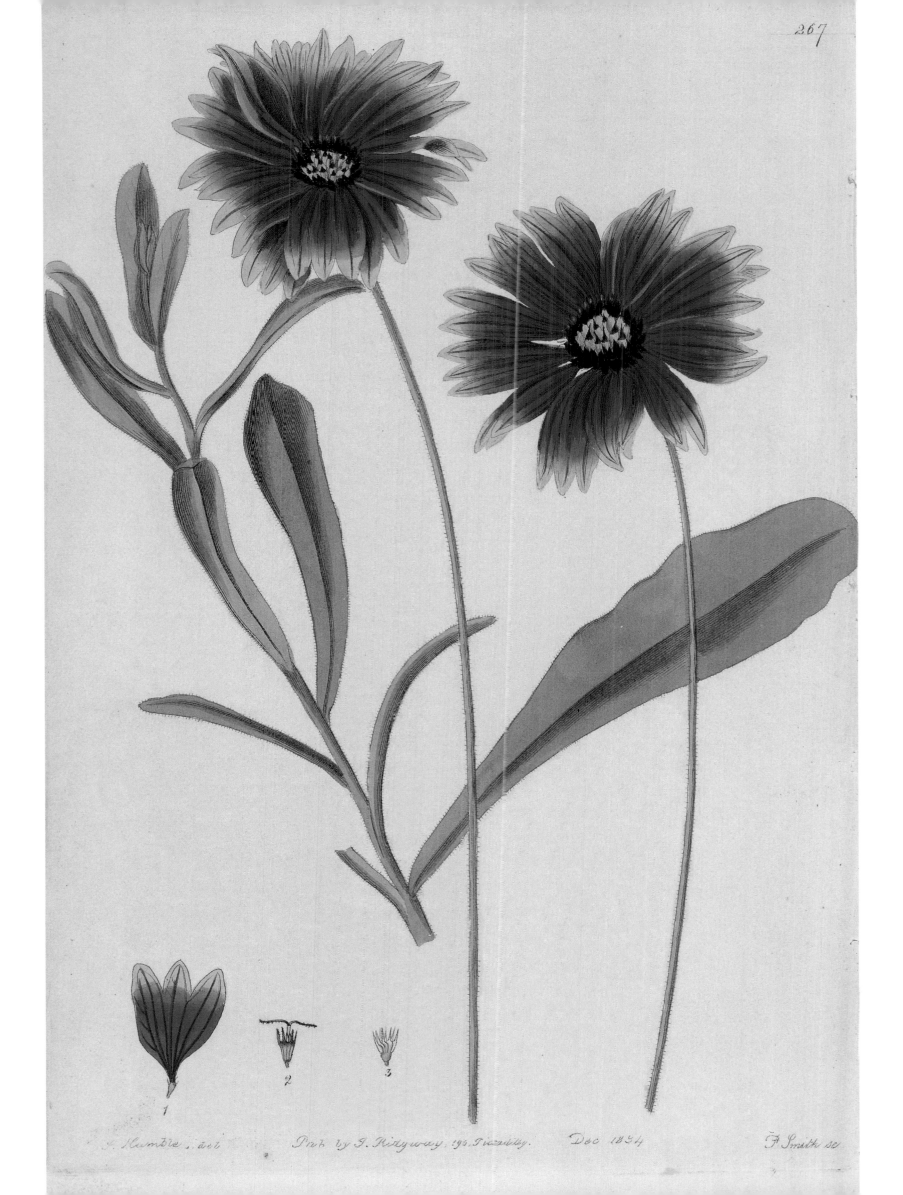

1

2

3

J. Hamble. del. Pub. by J. Ridgway, 195. Piccadilly. Dec 1824. F. Smith sc.

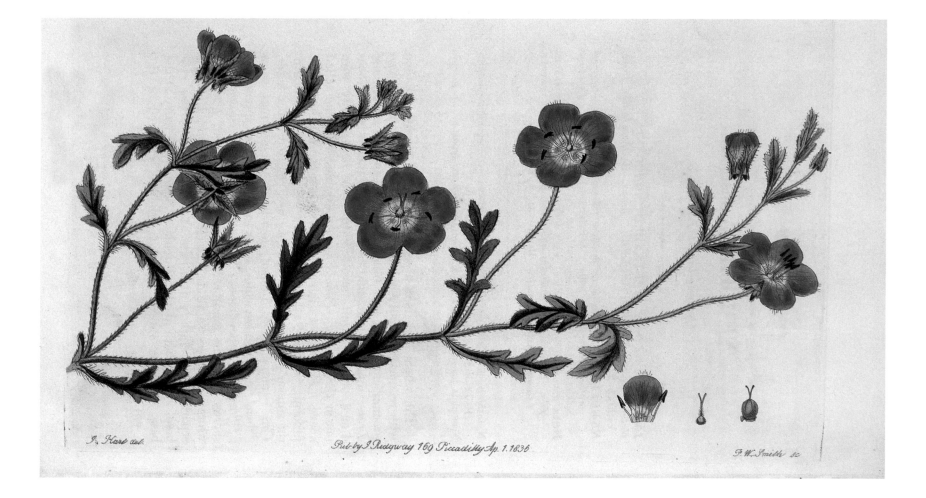

NEMOPHILA INSIGNIS

By the 1840s English gardeners had come to recognise a category of plants called Californian annuals – 'mostly sent home by Douglas', as Mrs Loudon said in her *Ladies' Companion to the Flower Garden*. 'They all bear cold much better than they do heat; and they will live through the British winters in the open air without any protection.' *Nemophila insignis* was one of these, sent to Britain by David Douglas in the 1830s; the colour range was extended in the 1840s with the addition of white-and-black-flowered species.

COREOPSIS GRANDIFLORA

Some species of *Coreopsis* were introduced in the late seventeenth and eighteenth centuries, but it was a series of species discovered in the 1820s and 1830s, most notably *C. grandiflora* (1826), as illustrated here by Margaret Roscoe in 1829, and *C. coronata* (1835), that established the genus in British gardens. Although *Coreopsis* is a perennial, it soon came to be treated for convenience as an annual, and joined the list of 'Californian annuals'.

Coreopsis Grandiflora.

Plate 29.

Penstemon ovatus.

Drawn from Nature by M.R. Engraved by R.Havell Junr.

PENSTEMON OVATUS

Another plant owed to Douglas; though some species had been discovered in the eighteenth century. Douglas introduced fifteen species in the late 1820s and 1830s, and the popularity of the plant dates from that sudden influx. By 1850 there were white, pink, blue, and purple varieties available in England. But the modern cultivars, descended from crosses made between *P. hartwegii* and *P. cobaea*, have been bred primarily in the United States, although there have recently been increased efforts to popularise penstemons in Britain. This illustration comes from *Floral Illustrations of the Seasons* (1829) by Margaret Roscoe.

Ottavi. Mazzi dis. *Gius: Bra incise*

TAGETES ERECTA flore pleno
Puzzole Maggiori doppie.

TAGETES ERECTUS

The so-called African and French marigolds (*Tagetes erectus* and *patula* respectively) are both South American in origin, and derive their names from the routes by which they entered Europe. Both had reached England before the end of the sixteenth century. From the 1860s, bedding varieties were bred in America, but played only a minor role in Britain until the twentieth century, when the garden authority Gertrude Jekyll used them extensively, both in her infrequent bedding schemes and in borders. By mid-century they had become one of the major bedding plants in Britain as well.

CALOCHORTUS MACROCARPUS, CALOCHORTUS ALBUS & CALOCHORTUS PULCHELLUS

Calochortus is a genus of bulbs from the west coast of North America, first discovered by the Lewis and Clark expedition and named in 1814. David Douglas introduced five species in the 1820s and 1830s, among them *C. albus* (above left) and *C. pulchellus* (above right), as illustrated here from drawings made in 1833 by Sarah Ann Drake. *Calochortus* attained its greatest popularity in England in the late nineteenth century, with the advocacy of William Robinson. *C. macrocarpus* is illustrated opposite.

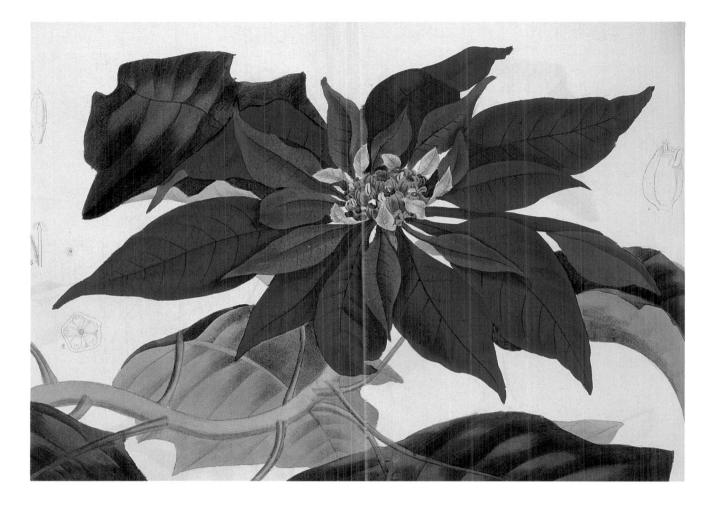

E UPHORBIA PULCHERRIMA

The poinsettia was so named after one of its discoverers, Dr Poinsett. It had already been described as *Euphorbia pulcherrima*, but Americans used the name *Poinsettia* for so long that it became an accepted vernacular name. It was introduced into Europe in the 1830s, and had a long but minor career as a glasshouse plant, before it began being hybridised in America in the 1920s and 1930s and popularised as a Christmas decoration.

N OPALXOCHIA ACKERMANNII

Adrian Hardy Haworth split the Christmas cacti away from the rest of *Cactus*, and gave them their own genus *Epiphyllum*. *Epiphyllum ackermannii* was introduced by the Chelsea nurseryman James Tate in 1829, but was eclipsed at mid-century by other species that began to yield exciting hybrids, of which there are now more than 1000. By the time *E. ackermannii* was reintroduced from the wild in the mid-twentieth century, nomenclatural changes meant that it had become *Nopalxochia ackermannii*, while the Christmas cactus hybrics now fall under *Schlumbergera*. This illustration comes from the *Botanical Register* for 1830.

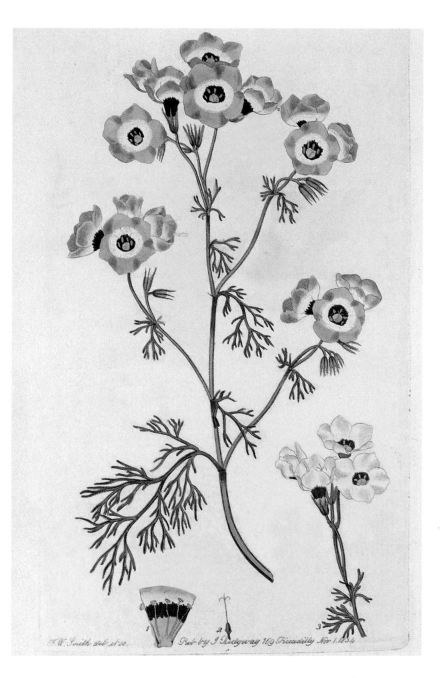

GILIA TRICOLOR

In 1833, David Douglas introduced several species of *Gilia* from western North America into England, where they were distributed through the Horticultural Society. Perhaps the most immediately popular was *Gilia tricolor*, with its distinctive blue and white petals. It eventually gave rise to several different cultivars, with white, pink, and red flowers, which were still popular in the mid-twentieth century but have since faded from cultivation in England.

ZINNIA ELEGANS

Zinnias were grown extensively by the Aztecs before the Spanish conquest of Mexico, and only reached Europe in the eighteenth century. *Zinnia elegans* arrived in the 1790s, but was not as popular as the dahlia. The first double zinnias were raised in France in the 1850s and enjoyed a flurry of interest in the 1860s. The modern large-flowered cultivars began to appear after World War I.

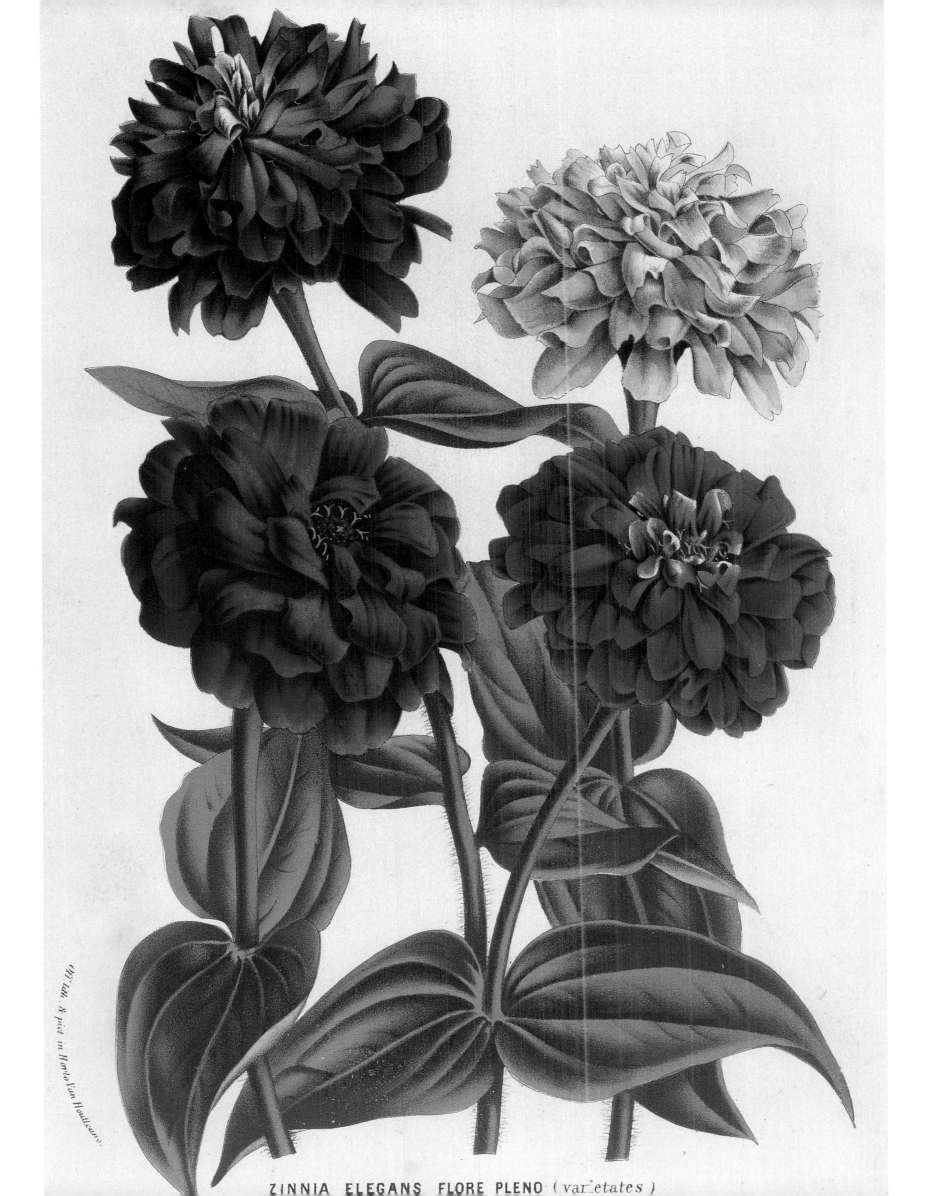

ZINNIA ELEGANS FLORE PLENO (varietates)

TELEIANTHERA FICOIDEA *Moq. Taud.Var.* VERSICOLOR.
(Serre froide & Plein _ air).
A. Verschaffelt, publ.

\mathcal{A}LTERNANTHERA VERSICOLOR & \mathcal{I}RESINE HERBSTII

Carpet bedding – the use of low-growing foliage plants to create patterned beds – was christened in 1868 and was the major horticultural fashion of the 1870s, spreading around the world. The plants used consisted of sedums, dwarf succulents like sempervivums and echeverias, and a group of recently introduced South American foliage plants. Three species of *Alternanthera*, including *Alternanthera versicolor* (above), arrived in the early 1860s. *Iresine herbstii* (opposite) was introduced in 1864 by the Richmond nurseryman Hermann Herbst, formerly the director of the Rio de Janeiro Botanic Garden.

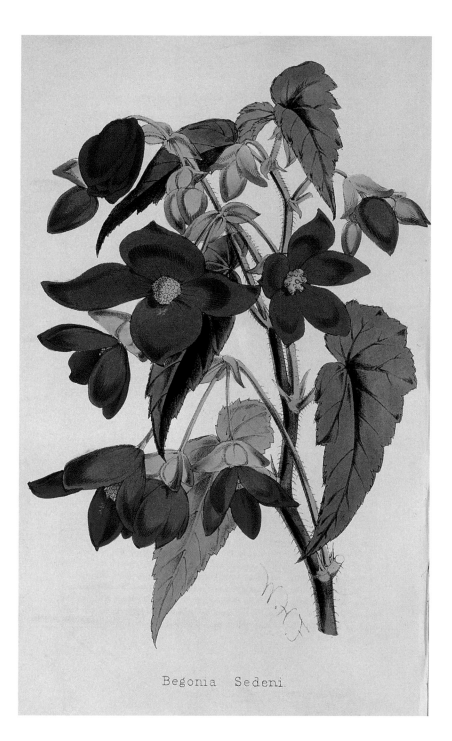

Begonia Sedeni.

ℬEGONIA × SEDENI & ℬEGONIA REX

Tuberous begonias became the major new bedding plants of the late nineteenth century. Their ancestors were collected in South America by Richard Pearce, a collector for the Veitch nurseries in England in the 1860s, and the first hybrid, *Begonia × sedeni* (above), was bred by Veitch's hybridist, John Seden, in 1868. The nurseries of Lemoine in Nancy and Van Houtte in Ghent immediately followed Veitch's example, rivalled from 1875 by John Laing of Forest Hill, who became the major English breeder. *Begonia rex* (opposite) was introduced from India in the late 1850s and was grown primarily as a foliage plant.

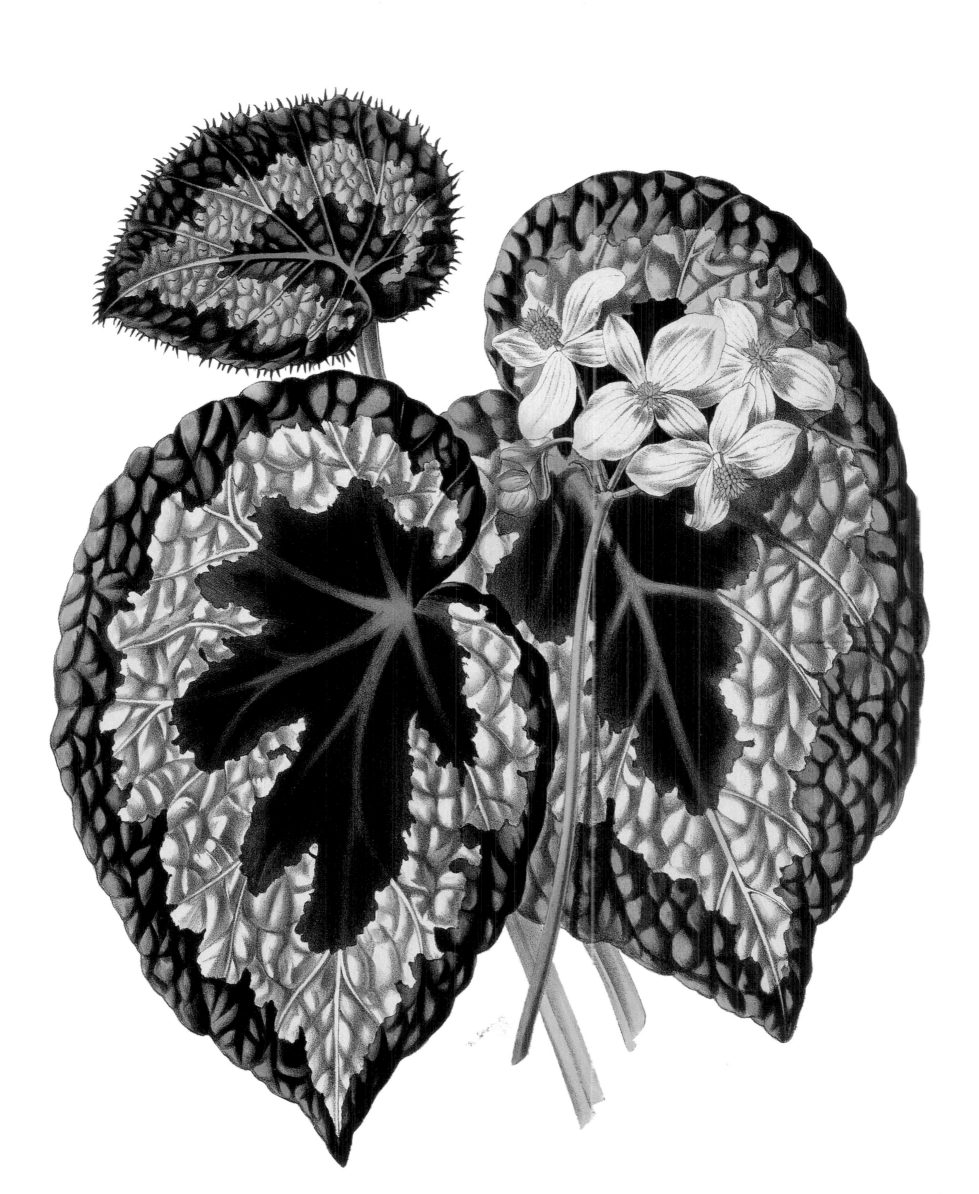

CHAPTER FIVE

NERIUM ODORUM (now a variety of *Nerium oleander*) is a
strongly scented oleander introduced from the Far East in the 1860s.

ℋIBISCUS ROSA-SINENSIS

The name *rosa-sinensis* means 'rose of China', and reflects the fact that the early hibiscus introduced to Europe were garden varieties representing a long history of cultivation in China. The first to become known were double-flowered forms, which reached the Chelsea Physic Garden by the 1730s; singles were not known until species from the Indian Ocean were introduced around the mid-nineteenth century. The hibiscus depicted here is from a drawing by Georg Dionysius Ehret (1708–1770).

Hebiscus chinensis en fleurs a Averloo en 1796 dans mon Jardin
Hibiscus rosa chinensis Flore rubro pleno.

HIBISCUS ROSA-SINENSIS

The first European hybrids of hibiscus were produced by the Veitch nurseries in Chelsea in the 1880s. But it was the United States and Hawaii that saw the greatest interest in breeding varieties; in Hawaii there were reportedly 3000 named varieties already in circulation in the 1920s and 1930s, and the first Hibiscus Society was founded in Hawaii in 1911.

HEMEROCALLIS FLAVA

Two species of daylilies, *Hemerocallis flava* and *H. fulva*, were introduced from China into Europe in the sixteenth century under the name Lilio-asphodelus, possibly in the form of garden varieties rather than wild species. The modern cultivars began to emerge in North America just before World War II, and North American growers have continued to dominate the genus.

Tilo-onapú lav.

63 3 63 ෨ mal.

Tilo

नेलो bram.

غنآپو arab

Impatiens Balsam:

IMPATIENS BALSAMINA

The balsam, the eastern Asian relative of the African busy lizzie, reached Europe in the early sixteenth century. Gerard grew it outdoors in a bed of hot dung; once greenhouses became widespread, it moved indoors. Despite the problems of growing it in the English climate, gardeners persevered in order to get double-flowered and variegated forms with red or purple mixed with white.

Lilium tigrinum flore-pleno.

ℒILIUM LANCIFOLIUM

The tiger lily *Lilium lancifolium* (also called *Lilium tigrinum*) arrived in England in 1804, having been collected in Canton by the Kew collector William Kerr. It quickly became a favourite garden flower. By 1830, Tennyson could list it along with the hollyhock in his poem 'A spirit haunts the year's last hours…', which helped establish the lily as a suitable resident for 'old-fashioned gardens' later in the century.

Tab. 12 .

ℒILIUM SPECIOSUM

In the wake of Chinese came Japanese lilies. *Lilium japonicum* was collected by Thunberg
in the 1770s; Siebold sent *Lilium speciosum* to Germany in 1830, and it reached England two
years later, quickly becoming known as 'Queen of the Lilies'. Its rival for this title,
L. auratum, was introduced by John Gould Veitch in the 1860s.

Tab. 53.

HYDRANGEA *japonica*.

Pöppi del. *Siegrist sc.*

\mathcal{H}YDRANGEA JAPONICA &
\mathcal{H}YDRANGEA MACROPHYLLA 'BELZONII'

The first Asiatic hydrangea to reach England arrived at Kew in 1789, becoming famous because its flowers could change colour from pink to blue. From the 1830s, Philipp Franz von Siebold introduced Japanese garden varieties, which masqueraded in his works as different species.

Tab. 55.

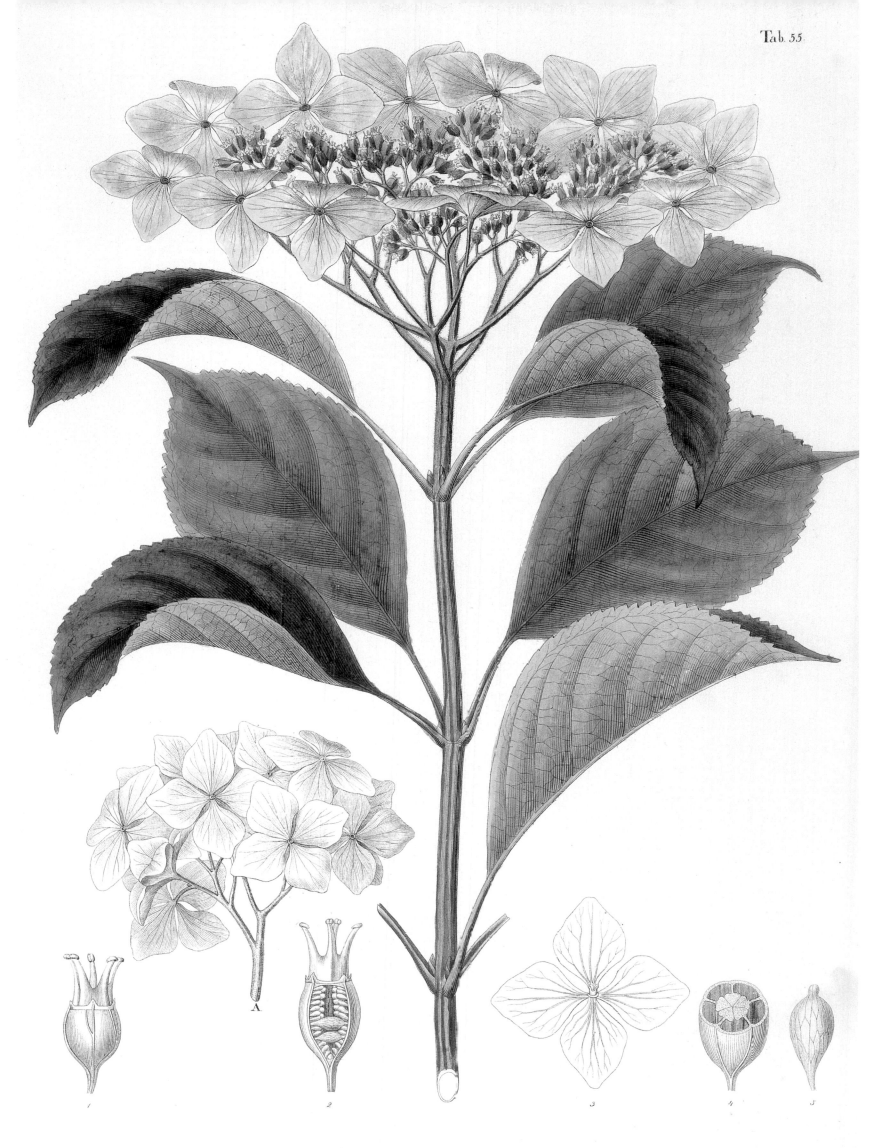

HYDRANGEA Belzonii.

Camellia Japonica 'Variegata' &
Camellia Japonica 'Anemoniflora'

The camellia first impinged on the European consciousness as the source of tea, but for a long time *Thea* was considered a separate genus from the ornamental varieties rumoured to flourish in Oriental gardens. In 1739, at Thornden Hall, Essex, Lord Petre succeeded in flowering the first camellias in Europe; it was widely believed that they died soon after from being kept in his hottest glasshouses. In 1792, John Slater of the East India Company imported two double camellias, white and striped, and the race was on. By 1819, when the first book on the subject appeared (Samuel Curtis's *Monograph on the Genus Camellia*), there were 29 varieties being grown in England. *Camellia japonica* 'Anemoniflora' (left) and *Camellia japonica* 'Variegata' (above) were illustrated by Alfred Chandler in *Illustrations of the Natural Order of ... Camellieae* (1830–1831) by Alfred Chandler and William Beattie Booth.

\mathcal{C}AMELLIA JAPONICA CULTIVARS

About 1830 the nurseryman Alfred Chandler began raising new varieties from seed, among them 'Chandleri Elegans', still grown today. There followed a few decades of enthusiastic camellia breeding, peaking in the 1840s. Their flowers showed the characteristics of the period's florists' flowers: tight, geometrical flowers, preferably with stripes or distinct edges. By the 1880s these camellias followed so many of the older florists' flowers out of fashion.

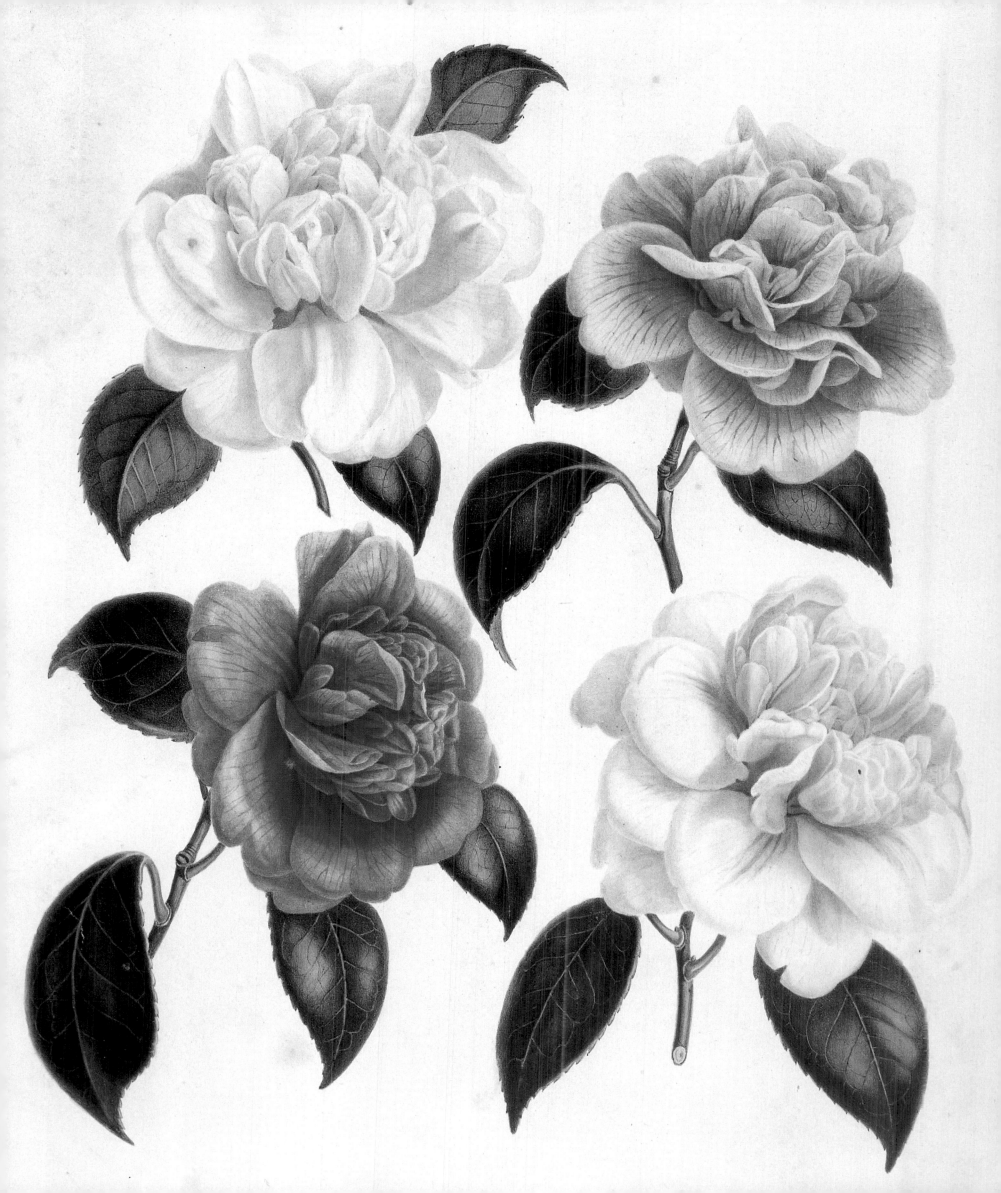

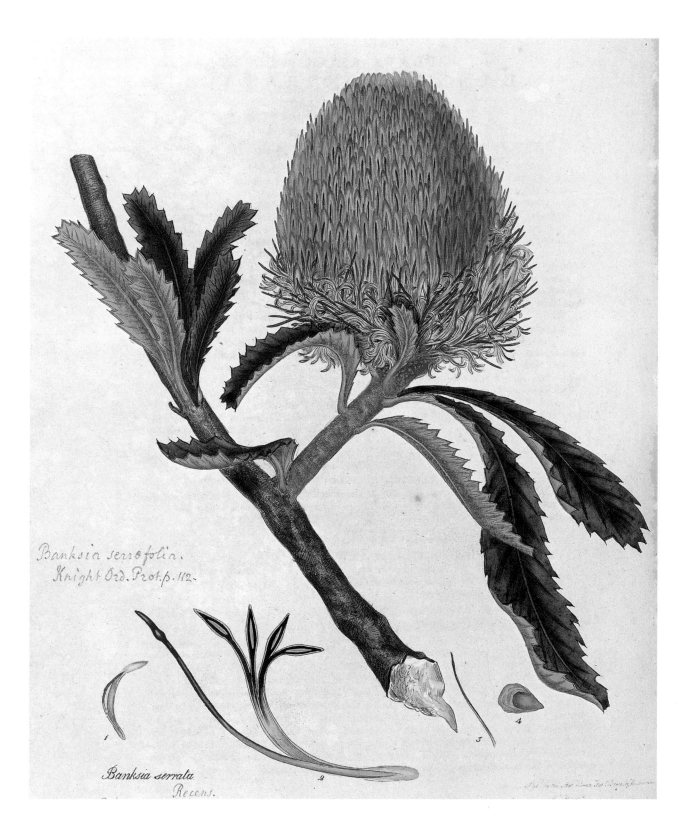

Banksia serrofolia.
Knight Ord. Prot. p. 112.

Banksia serrata
Recens.

ℬANKSIA SERRATA

Banksias were the first Australian plants to attract attention in England. *B. integrifolia* was already available in 1788, and further species were introduced in the 1790s. For a while they were highly popular as greenhouse subjects, but fell rapidly from favour in the 1850s and 1860s. 'It is difficult to understand why they have been allowed to pass so suddenly out of cultivation,' complained the nurseryman B. S. Williams in 1870.

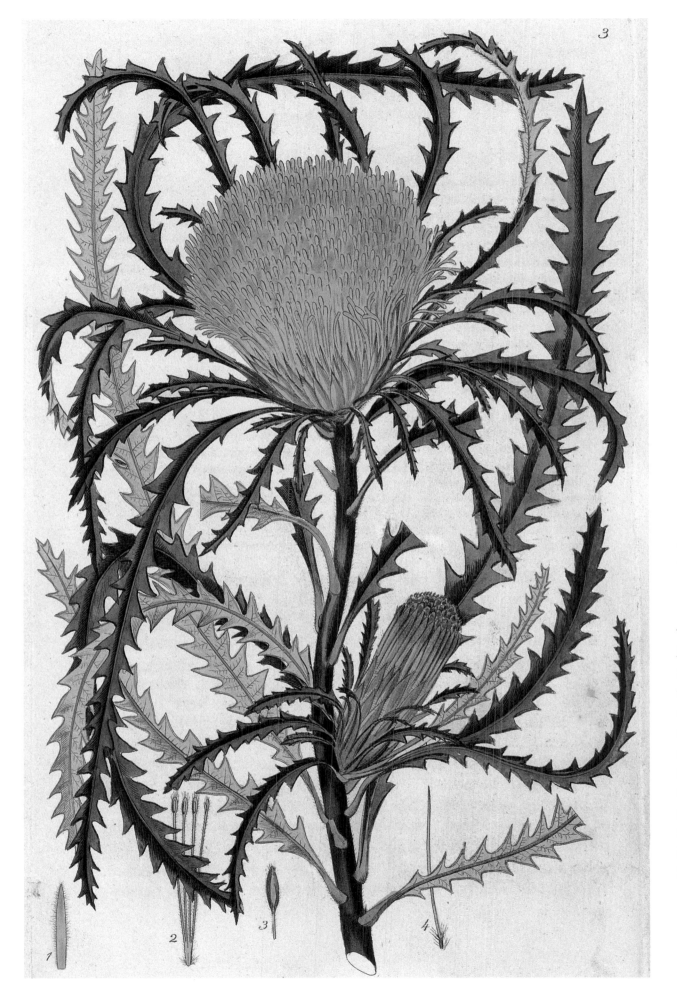

\mathcal{D}RYANDRA

LONGIFOLIA

This was one of a number of *Dryandra* species introduced from 1803–1805; some twenty-six species were grown in England during the early nineteenth century. They shared the fate of banksias later in the century, despite the attempts of people like B. S. Williams to promote them as part of the fashion for foliage plants. Thomas Baines did not even list them in his *Greenhouse and Stove Plants* (1894), where banksias were at least said to be 'rarely met with now'

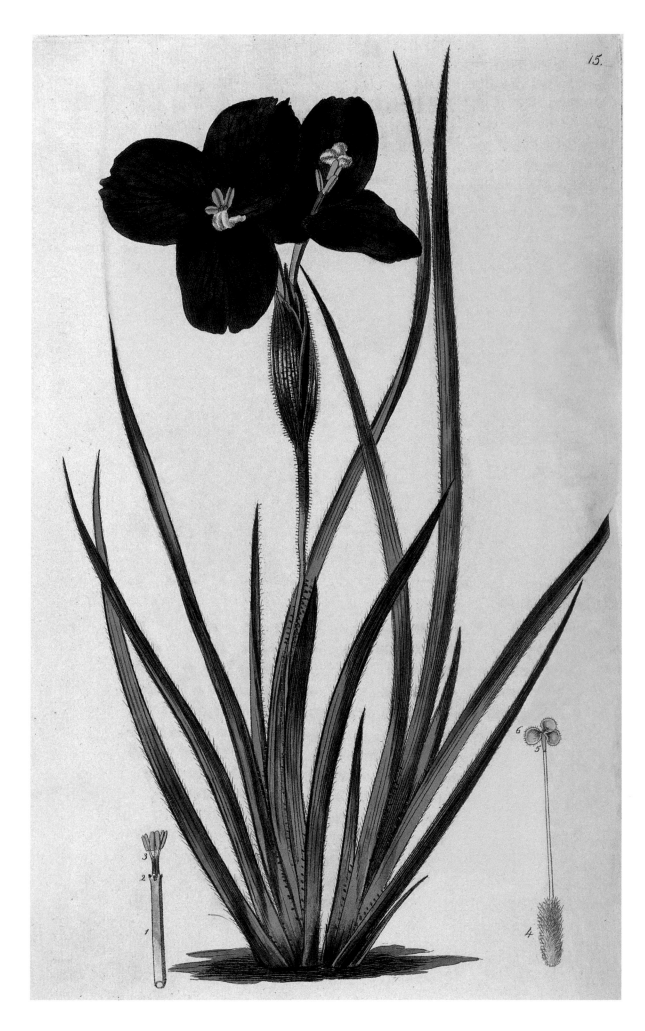

℘ATERSONIA LANATA

From the 1810s to the 1840s, the British magazines depicted and described many Australian plants that disappeared from cultivation within a few years, as even more ornamental sorts were introduced. Already by the 1870s much of the 'New Holland' flora that had been grown in English greenhouses had been lost from cultivation. *Patersonia lanata* was introduced by the Clapton nurseryman John Mackay in 1826, illustrated the following year (as shown here) in *Flora Australasica* (1827–1828) by Robert Sweet, and lost soon after, to be succeeded by other patersonias that lasted little longer.

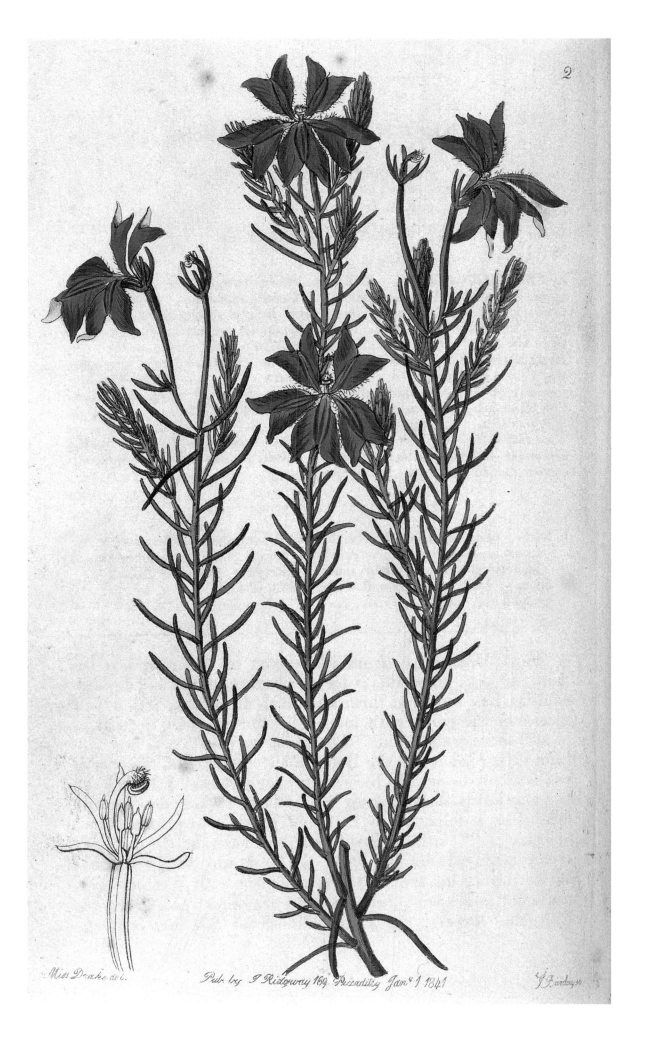

Miss Drake del. Pub by J Ridgway 169 Piccadilly Jan¹ 1 1841 S Pardon so

LESCHENAULTIA

BILOBA

The first species of *Leschenaultia* arrived in England in the 1820s, and *L. biloba* followed in 1840 from the Swan River colony. It remained popular in English greenhouses long after the initial wave of enthusiasm for Australian plants had passed, and in 1894 Thomas Baines could still say that *L. biloba* 'Major' was 'justly esteemed as one of the finest plants in cultivation … It is one of the things the cultivation of which no young plant grower should rest satisfied until he has mastered.'

1

2

3

4

5

GREVILLEA ROSMARINIFLORA

The grevillea was named after Charles Francis Greville, one of the founders of the Horticultural Society. This species was discovered by Allan Cunningham in 1822, and was being grown in England when Robert Sweet published this image in *Flora Australasica* (1827–1828). Grevilleas, in particular *G. rosmariniflora*, were one of the few Australian plants to succeed outside the greenhouse.

HEBE COLENSOI

The most popular British garden plants of New Zealand origin have been hebes, which until 1926 were assimilated into the European genus *Veronica. Hebe speciosa* crept into England in the 1840s, followed gradually by other species, with extensive hybridisation taking place in the twentieth century. This illustration of *Hebe colensoi* by Matilda Smith appeared in Curtis's *Botanical Magazine* for 1893.

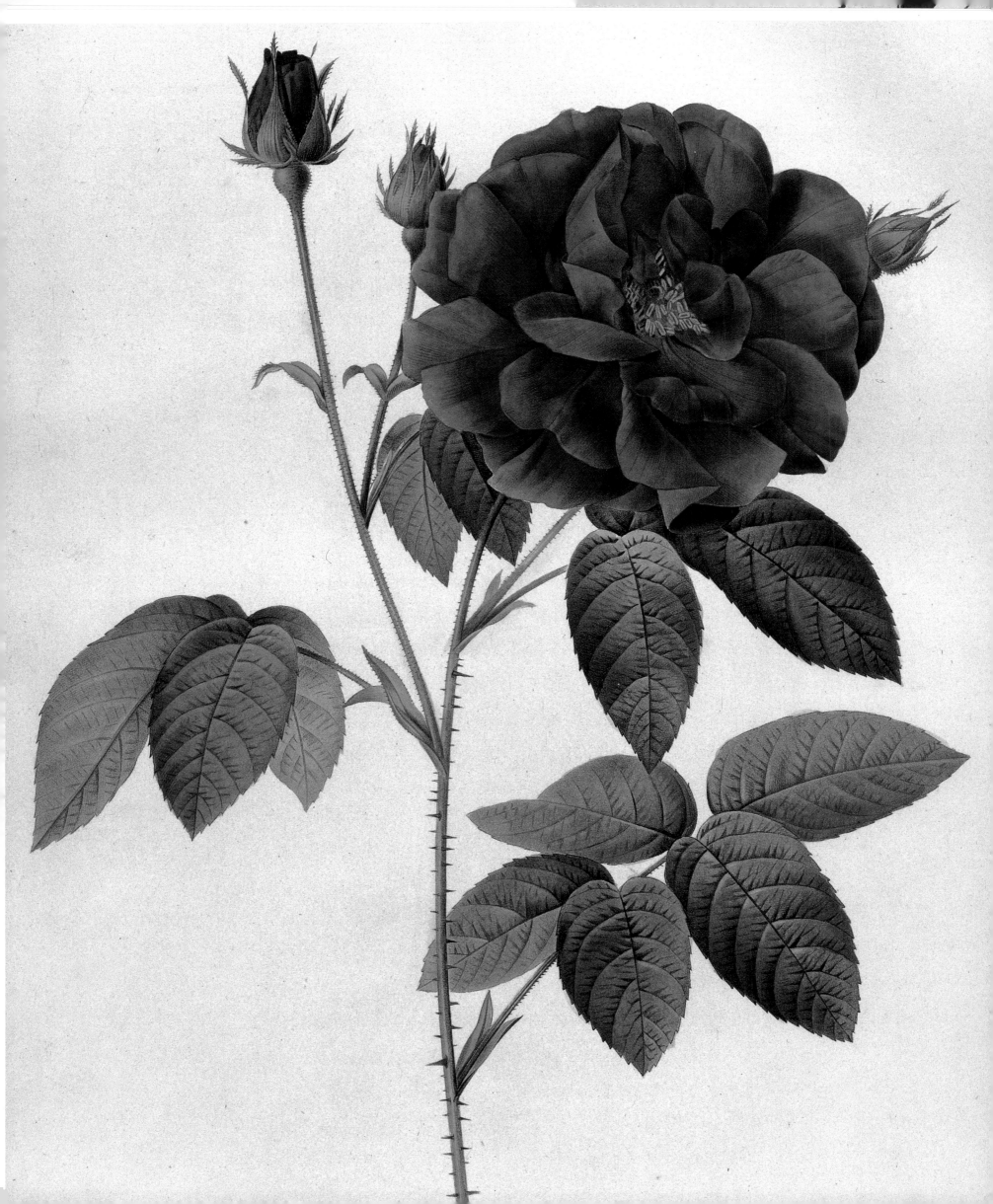

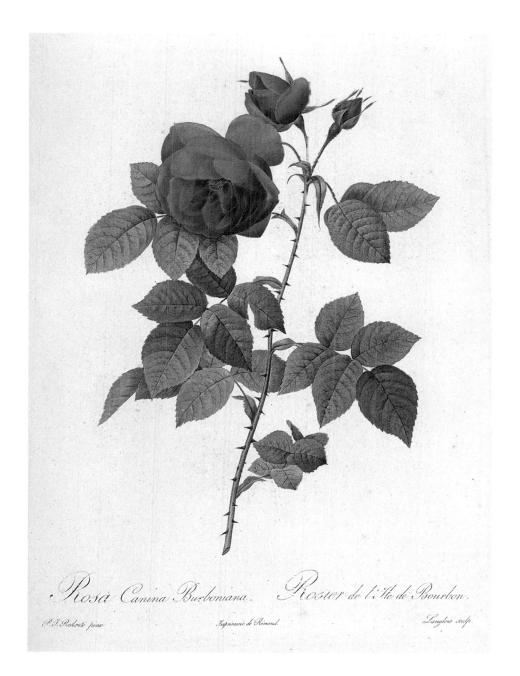

Rosa Canina Burboniana. *Rosier de l'Ile de Bourbon.*

P.J.Redouté pinx. *Imprimerie de Rémond.* *Langlois sculp.*

ROSA × BORBONICA

Chinese roses began to appear in Europe in the late eighteenth century. 'Slater's Crimson China' and 'Parsons' Pink China' both arrived in 1789, and the latter became the ancestor of some of the nineteenth century's first new categories of rose. Crossed with the musk rose, *Rosa moschata*, it produced the Noisettes. Crossed with the autumn damask rose, *Rosa gallica* var. *officinalis*, it produced the Bourbons, the first of which was introduced in 1817.

ROSA GALLICA VAR. OFFICINALIS

Rosa gallica grows naturally in France, southern and central Europe, and was the first rose species to yield an extensive range of cultivars. The variety *officinalis* dates from at least the thirteenth century, when it was grown in France for perfumery.

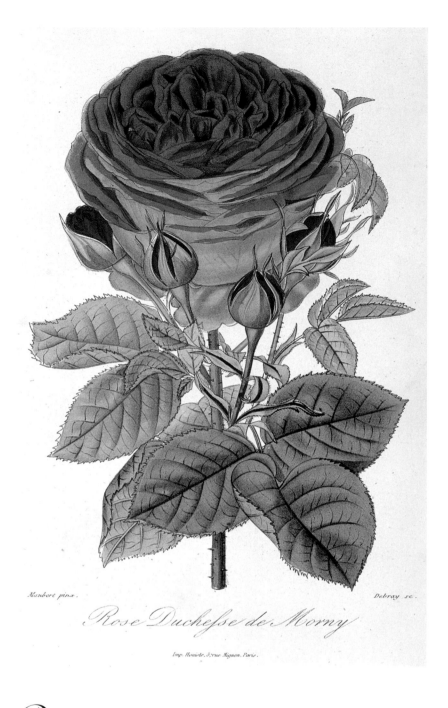

Maubert pinx. *Debray sc.*

Rose Duchesse de Morny

Imp. Rousselot, 3 rue Mignon, Paris.

ROSE 'DUCHESSE DE MORNY' &
ROSA × LHERITIERIANA

In 1808 Sir Abraham Hume received from China the first tea-scented rose, called 'Hume's Blush'. Crossing it with Noisettes and Bourbons produced a new category, called Tea Roses. In 1837 the first Hybrid Perpetual, 'Princesse Hélène', was raised in France, to be followed by some 4000 other cultivars, such as 'Duchesse de Morny' (above), before this category declined in the twentieth century. Crossing Hybrid Perpetuals with Tea Roses produced Hybrid Teas, the first of what became known generally as modern roses, beginning in the 1860s.

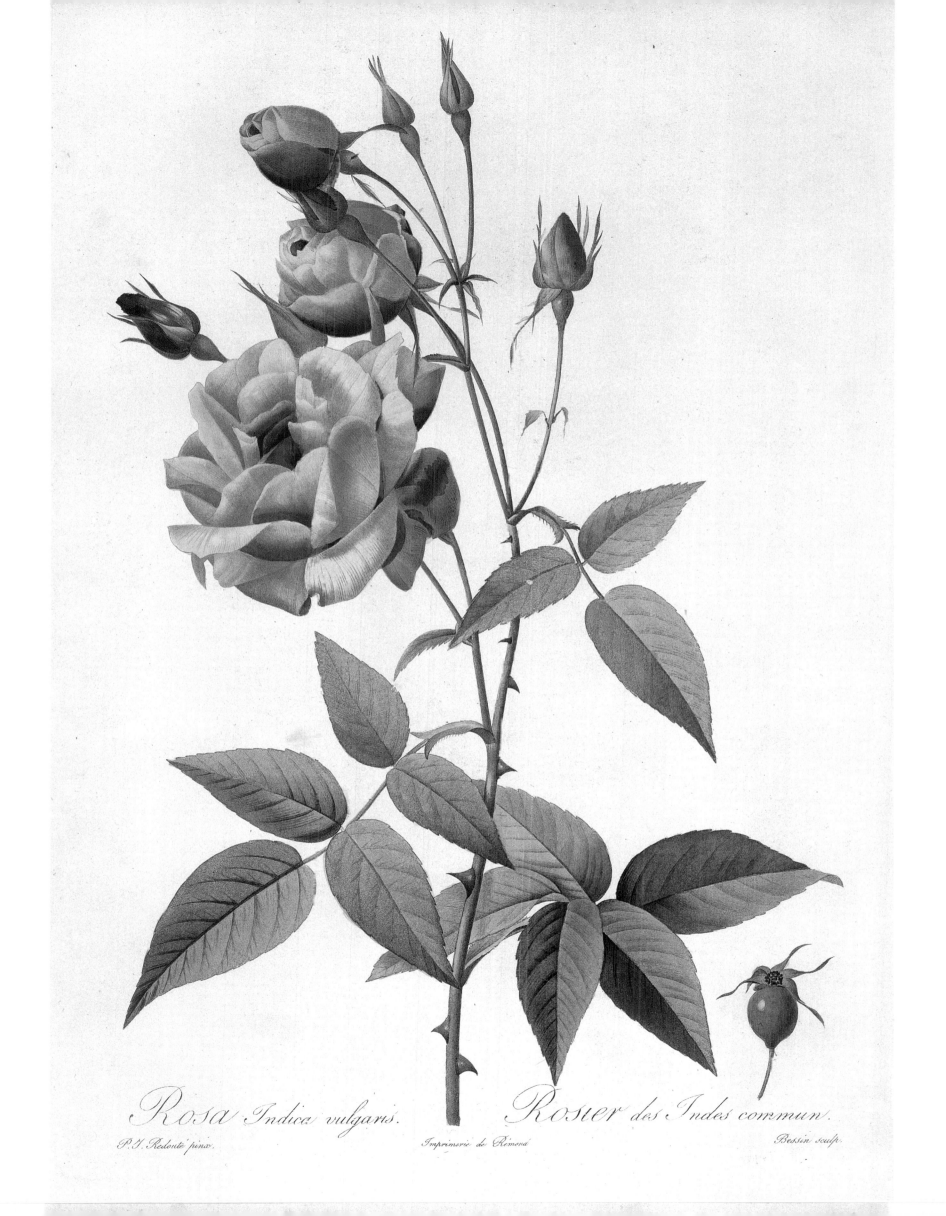

Rosa Indica vulgaris. *Rosier des Indes commun.*

P.J. Redouté pinx. Imprimerie de Rémond Bessin sculp.

Pæonia papaveracea

\mathcal{P}AEONIA SUFFRUTICOSA CULTIVAR

Sir Abraham Hume, who was responsible for introducing tea roses from China, also took a hand in introducing Chinese peonies. The peony shown here, as illustrated for the *Botanist's Repository* (1797–1815), was first described as *Paeonia papaveracea* but was in fact a cultivar of the moutan (*Paeonia suffruticosa*). It first flowered in Hume's garden at Wormleybury, Hertfordshire, in 1808.

\mathcal{I}RIS KAEMPFERI CULTIVARS

The vogue for Japanese-style gardens at the end of the nineteenth century led to a rush of imported Japanese garden varieties suitable for planting near lakes and ponds. The Yokohama Nursery Company, which had offices in London for some years, distributed a catalogue of fifty Kaempferi cultivars in the early 1900s (which included these woodblock prints), and many no doubt found their way into English gardens before hybrids began being produced in England.

Meconopsis Grandis

The blue poppy, *Meconopsis betonicifolia*, was discovered in Yunnan in 1886 by the missionary Père Delavay, and its introduction into Europe thereafter became an explorers' dream until Frank Kingdon-Ward succeeded in 1924. By that time other species of meconopsis had been introduced to good effect: *M. grandis* arrived in the 1890s, and has been used as the parent of many hybrid forms.

Allium Caeruleum

'Not an important garden family', William Robinson said of *Allium* in the late nineteenth century, while acknowledging that some were worth growing by collectors. *Allium caeruleum* was introduced before 1840, and slid gradually into cultivation over the following decades. It was not until the twentieth century that ornamental alliums achieved wide popularity and were hybridised systematically.

Miss Drake del. Pub. by J. Ridgway 169. Piccadilly Sep.r 1840 S. Barclay

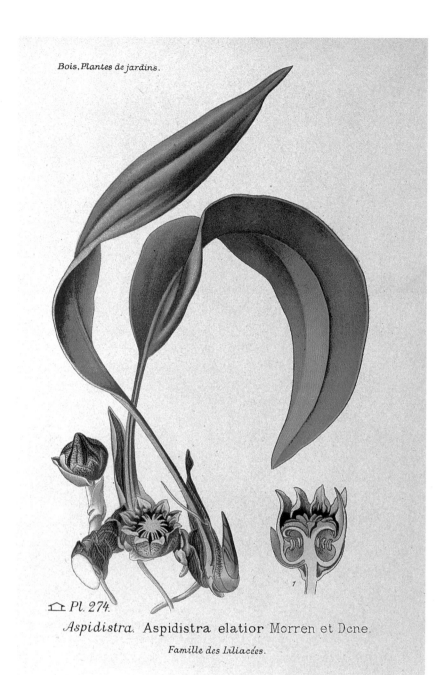

Bois, Plantes de jardins.

⌂ Pl. 274.

Aspidistra. Aspidistra elatior Morren et Dcne.

Famille des Liliacées.

*A*SPIDISTRAS

Aspidistra elatior (above) – sometimes sold as *A. lurida* (opposite), which is a distinct species – was introduced from China in 1824 by the Horticultural Society's collector John Damper Parks. From the 1860s, as the cult of foliage plants grew, it was employed as a house and greenhouse plant. It only really came into its own as other foliage plants such as caladiums and rex begonias fell from fashion. The vogue of the aspidistra was mainly a product of the Edwardian period, and continued through the first half of the twentieth century.

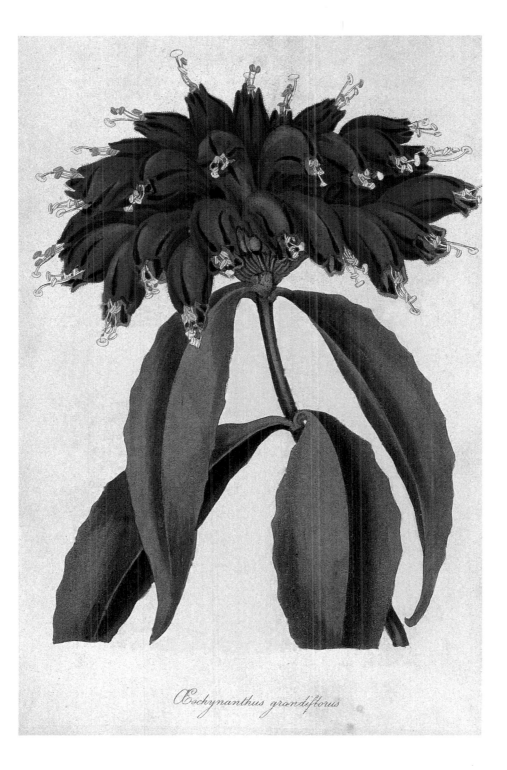

Aeschynanthus grandiflorus

Ꭿ ESCHYNANTHUS GRANDIFLORUS &
Ꭿ ESCHYNANTHUS SPECIOSUS

The improvement of greenhouses in the early nineteenth century coincided with improved plant collecting techniques, and the result was an influx of tropical flowering plants for the hothouse. Among the novelties was *Aeschynanthus grandiflorus* (above), now *parasiticus*, introduced from India in 1838. Crossed with the Javanese *A. speciosus* (left), introduced in 1845, it produced *A. splendidus*, still popular at the beginning of the twentieth century.

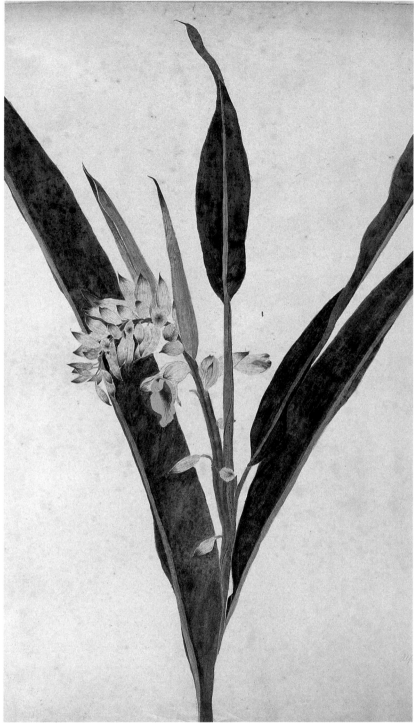

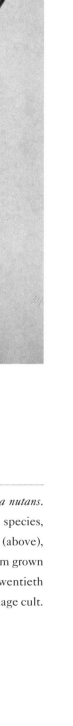

ℛENEALMIA RACEMOSA &
𝒜LPINIA SPECIOSA

Alpinia speciosa (opposite) was introduced from China in 1792 as *Alpinia nutans*. In the 1820s and 1830s, *Alpinia* species, including the tropical American species, which were even then being assigned to the separate genus *Renealmia* (above), were popular as hothouse plants, but later in the century they were seldom grown in Britain. On the continent, their popularity continued into the early twentieth century, and they were used as house plants during the heyday of the foliage cult.

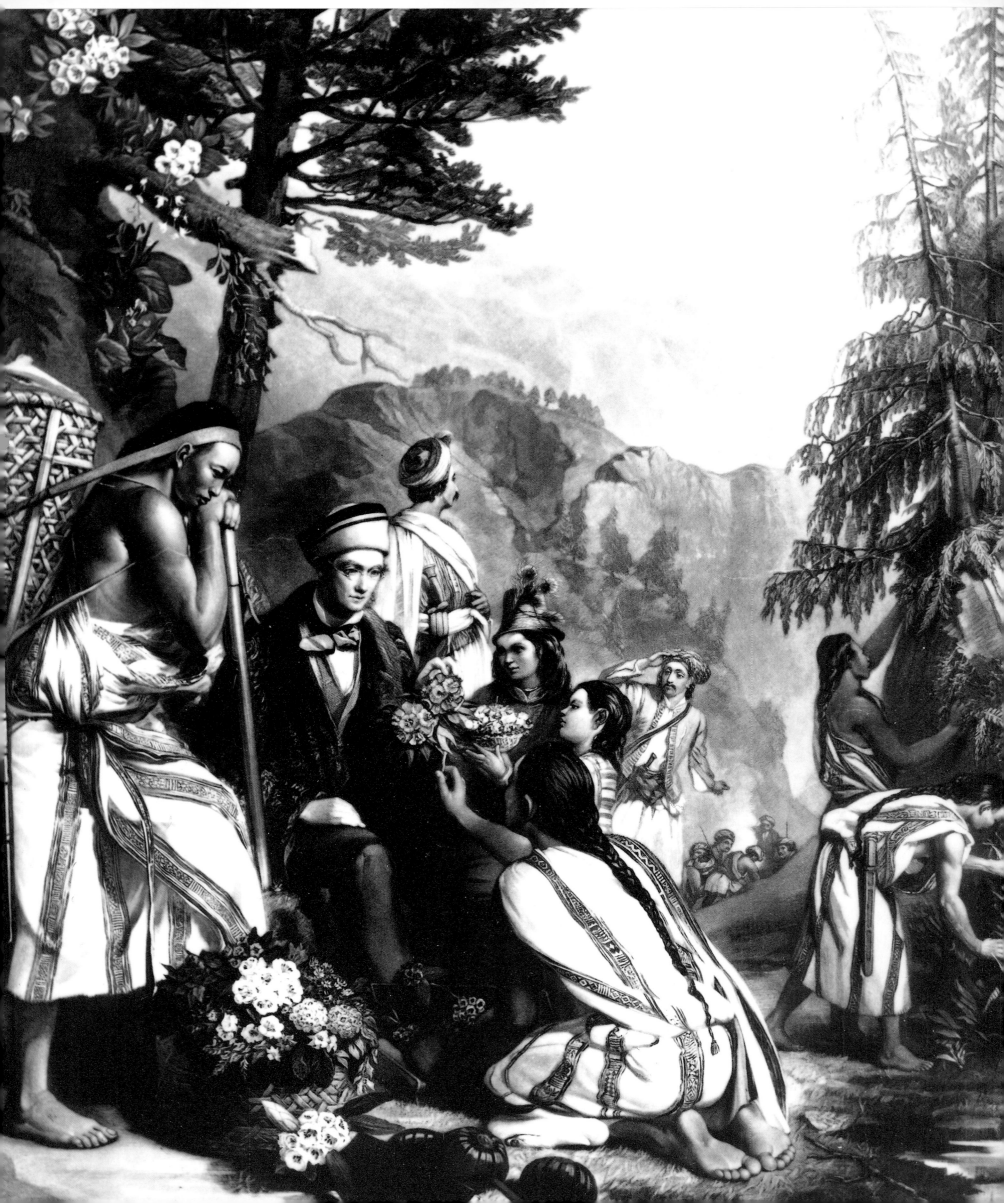

This mezzotint engraving shows Sir Joseph Hooker receiving rhododendrons on his expedition to the Himalayas in 1850. Until this point the rhododendron species grown in Europe had been introduced from America or the Caucasus.

since. It made official the concept of a cultivar, a word which for a long time had separate definitions in Europe and America. In the United States, the great botanist Alfred Rehder had coined the term for a variety raised in cultivation, but Stearn had independently coined it to mean a variety which was either raised or maintained in cultivation. The International Code adopted Stearn's definition, which is gradually ousting Rehder's definition even in its homeland.

Under the Code, a cultivar must be given a name, not in Latin but in a vernacular language (though older cultivars are allowed to retain long-established Latinate names), and this name is distinguished by being printed in Roman rather than italic letters, with single quotation marks; for example, *Iris germanica* 'Nepalensis', *Iris germanica* 'The King', *Ranunculus ficaria* 'Bowles' Double', *Ranunculus ficaria* 'Dusky Maiden'.

Another concept introduced in the Code war is that of the grex, another of W. T. Stearn's coinages. A grex is the name for a group of hybrids of common ancestry yet it is not the name of any individual hybrid. When the Reverend William Wilks bred a group of white-flowered poppies in the 1880s, he called them Shirley poppies, after Shirley in Surrey where he was vicar; there is no variety of poppy called 'Shirley', but a group of poppies which resulted from the same breeding programme. The same is true for Headbourne Hybrid agapanthus, Polar Bear rhododendrons, Barnhaven polyanthus, and many others. A grex should not be confused with an exhibition category, like Parrot tulips, Alpine auriculas, or Split-corona daffodils, where the category may be defined by visual appearance and does not imply common ancestry. The term 'grex' is now gradually being replaced by 'horticultural group'.

SELECTED BIOGRAPHIES

ANDREWS, HENRY CHARLES
(FL. 1790S–1830S)

Andrews was an artist and engraver, and the son-in-law of the Hammersmith nurseryman James Kennedy (see Lee and Kennedy). Beginning in the 1790s, he published a series of works on newly introduced plants, for which he both wrote the text and drew and engraved the plants. They were published on a subscription basis, and for many years five different works ran concurrently: *The Botanist's Repository* (1797–1811), *Coloured Engravings of Heaths* (1794–1830), *The Heathery* (1804–1812), *Geraniums* (1805–1825), and *Roses* (1805–1828). He disappears from view in the 1830s; it is not known when he died.

BARR, PETER (1826–1909)

Born in Scotland, Barr moved to Worcester and then to London, where in 1861 he started a seed and bulb establishment in Covent Garden under the name of Barr and Sugden. Barr became particularly enthusiastic about daffodils, and attempted to find surviving examples of the old varieties listed by Parkinson in the 1620s; as part of this effort, he persuaded the Royal Horticultural Society to publish a checklist of the names of available daffodils – the beginning of modern plant registration. His firm continued as Barr and Sons, until in the 1950s it merged with its old rival, R. Wallace and Co. of Colchester, to become Wallace and Barr.

BURY, MRS EDWARD (FL. 1820S–1860S)

Priscilla Susan Falkner was born in Liverpool in the 1790s; the exact year is not known. She married Edward Bury, a prominent railway engineer, and became a friend of William Roscoe, a wealthy Liverpool patron of the arts. Roscoe, an amateur botanist, published a large work on *Monandrian Plants* in the 1820s; Mrs Bury followed his example and published *A Selection of Hexandrian Plants* in the years 1831–1834, making the drawings for the illustrations herself. She also made illustrations for *The Botanist*, by Benjamin Maund (1836–1841). In her later years she moved to Croydon, Surrey, and died around 1870.

CLUSIUS, CAROLUS
(CHARLES DE L'ESCLUSE, 1526–1609)

L'Escluse was Flemish by birth; he studied at Montpellier, but his family was persecuted and reduced to poverty for Protestantism, and L'Escluse spent years wandering throughout Europe, translating botanical works, collecting plants, and making contacts. Finally, in 1573, the Emperor Maximilian II invited him to Vienna to assist with the imperial gardens; while there he helped introduce plants such as tulips from Constantinople. In 1587 he was made a Professor in Leiden, where he helped to build up the tulip trade. His major publications were *Rariorum Aliquot Stirpium* (1576); *Rariorum Plantarum Historia* (1601); and *Exoticorum* (1605).

COLVILL, JAMES (1777–1832)
See Sweet.

DOUGLAS, DAVID (1799–1834)

Douglas was working at the Glasgow Botanic Garden when the Horticultural Society of London hired him as a plant collector in 1823. His first journey was to eastern North America, where he was asked to bring back fruit varieties. He then made two expeditions to the West Coast of North America, in 1825–1827 and 1830–1834. He introduced over 200 species, most notably the tree which was named after him, the Douglas fir. His last expedition took him to Hawaii, where he died by falling into a pit in which a wild bull was trapped.

EHRET, GEORG DIONYSIUS (1708–1770)
See Weinmann.

FORTUNE, ROBERT (1812–1880)

Fortune was the first prize student of the Horticultural Society's examinations for gardeners. In 1843 the Society sent him to China, where he collected garden varieties of ornamental plants. On his return he became Curator of the Chelsea Physic Garden (1846–1848), and then returned to China on behalf of the East India Company, for which he collected tea plants in order to start up a tea industry in India. He made several other journeys to China and Japan, privately as well as for institutional clients, and wrote four books about his travels – most famously *Three Years' Wanderings in China* (1847).

GERARD, JOHN (1545–1612)

Gerard was a barber-surgeon, who went on to become curator of the College of Physicians' garden of medicinal plants. He had a garden of his own in Holborn, of which he published a catalogue, which has been credited with being the first complete catalogue of a garden ever published. He was also responsible for Lord Burghley's gardens in the Strand and at Theobalds in Hertfordshire. The Queen's

Printer, John Norton, hired Gerard to write a book on medicinal plants to accompany illustrations he had rented from Germany; the result was Gerard's *Herbali* (1597), the most famous English book on the subject. After Gerard's death it was revised by Thomas Johnston (1633 and 1636 editions).

GILBERT, SAMUEL (FL. 1690s)
See Rea, John.

HANMER, SIR THOMAS (1612–1678)
Sir Thomas Hanmer fought on the royalist side in the English Civil War, and spent the rest of his life in retirement at his house at Bettisfield in Wales. A friend of John Rea (q.v.), who dedicated his book to him, he built up an extensive flower garden. In 1659 he wrote a book about his garden, which he never published; the manuscript was finally edited by Ivy Elstob, and published as *The Garden Book of Sir Thomas Hanmer* in 1933. Today it is regarded as the most important gardening document surviving from the Commonwealth period.

HERBERT, WILLIAM (1778–1847)
Herbert was a clergyman, who spent most of his career (1814–1840) as Rector of Spofforth in Yorkshire, before being made Dean of Manchester, a post he held until his death. From the 1820s on, he experimented with hybridising many different kinds of plants, most notably gladioli and Cape bulbs. His principal publication was *Amaryllidaceae* (1837), but he also wrote important articles, for one of which, on crocuses, he made a series of drawings that survives today in the Lindley Library.

HOOKER, SIR JOSEPH DALTON (1817–1911)
The son of Sir William Jackson Hooker, the first director of the Royal Botanic Gardens, Kew, Joseph was the botanist on the expedition of the Erebus (1839–1843); From 1848 to 1851 he collected plants in the Himalayas, introducing twenty-six species of rhododendrons into England and publishing three major books, *The Rhododendrons of Sikkim-Himalaya* (1849–1851), *Illustrations of Himalayan Plants* (1855), and *Himalayan Journals* (1854). He later collaborated with George Bentham on *Genera Plantarum* (1862–1883), and compiled the massive *Flora of British India* (1872–1897). An early supporter of Darwin, he succeeded his father as Director of Kew (1865–1887).

KELWAY
A family of nurserymen based in Langport, Somerset. James Kelway (1815–1899) established the nursery in 1851, and began breeding delphiniums and gladioli. He was succeeded by his son William (born 1839), who took a similar interest in peonies. By the 1880s, Kelways was one of England's foremost nurseries for hardy perennial plants, a reputation they carried for most of the twentieth century.

KOUWENHOORN, PIETER VAN (FL. 1620s–1630s)
Pieter van Kouwenhoorn (also written Couwenhoorn) was a glass painter, working in the 1620s and 1630s in Haarlem and Leiden; he was best known for his windows in the Annahofje in Leiden. The Lindley Library of the Royal Horticultural Society possesses an album of forty-six coloured drawings which he made, with the manuscript title '*Verzameling van bloemen naar de natuur geteekend door* (Collection of flowers drawn from nature by) *Pieter van Kouwenhoorn*'. It was obviously intended for publication, but never printed at the time.

LEE AND KENNEDY,
A celebrated nursery in Hammersmith, then to the west of London. James Lee (1715–1795) founded the Vineyard Nursery there in 1745; he was the author of *An Introduction to Botany* (1760 and later editions). In the later eighteenth century the firm introduced many exotic plants, including the first fuchsias and the first Australian plants. Lee's partner Lewis Kennedy (c1721–1782) was also a garden designer, with several gardens in Northumberland to his credit; his son John Kennedy (1759–1842) advised the empress Josephine on her garden at Malmaison, and was issued with a special passport so that the Napoleonic Wars did not interrupt the supply of plants sent from his nursery.

LINDLEY, JOHN (1799–1865)
John Lindley was the son of a Norfolk nurseryman, whose debts he rashly undertook to pay off as a young man, and never succeeded in doing, despite holding down three simultaneous full-time jobs for much of his career: as Professor of Botany at University College, London, as editor of the gardening newspaper *The Gardeners' Chronicle*; and as Assistant Secretary of the Horticultural Society, in which capacity he identified plants brought back by the Society's collectors, ran flower shows, edited the Society's publications, and much else. His personal library, bought by the Society after his death, formed the nucleus of the present-day Lindley Library.

LOUDON, JOHN CLAUDIUS (1783–1843) AND JANE WELLS (1807–1858)

Born in Scotland, John Claudius Loudon came to England at the beginning of the nineteenth century as an agricultural reformer and landscape gardener. He founded England's first gardening and architectural magazines; published a massive *Encyclopaedia of Gardening* (1822 and later editions), the standard work of its period; and invented a wrought-iron glazing bar that made it possible to build glasshouses with iron frames. Becoming enthusiastic about a science-fiction novel called *The Mummy* (1827), he arranged to meet the author. She turned out to be a young woman named Jane Wells Webb, whom Loudon married. Wells was also the author of several noted gardening books, such as *Gardening for Ladies* (1840), *The Ladies' Companion to the Flower Garden* (1841), and *The Ladies' Flower Garden* (four volumes, on annuals, perennials, and greenhouse plants, 1840–1848).

MASSON, FRANCIS (1741–1805)

Masson was a gardener at the Royal Gardens at Kew, and became the first collector sent from Kew to discover new plants abroad. His first expedition, in 1772–1773, was to the Cape of Good Hope, where he again collected plants between 1786 and 1795, having also travelled in the Canary Islands, West Indies, and Spain. On his return to England, he was accused of illicitly providing plants for the nursery of Lee and Kennedy (q.v.), but exonerated. He was given a year's leave to write his book *Stapeliae Novae* (1796–1797), and then sent to collect plants in Canada, where he died.

PARKINSON, JOHN (1567–1650)

Parkinson served as Apothecary and Herbarist to King James I. His plans for publishing a herbal to replace the older work of John Gerard (q.v.) were frustrated when a new edition of Gerard's book was produced in 1633. Parkinson's eventual herbal, *Theatrum Botanicum*, was published in 1640, but it was never reprinted. He enjoyed much greater success with a book on ornamental garden plants which he published in 1629: *Paradisi in Sole Paradisus Terrestris*. (The title is a pun: it means 'The earthly paradise of Park-in-Sun'.) Parkinson had a garden in Long Acre, near Covent Garden in London, and the book, which was brought out in a second, posthumous edition in 1656, was based on his practical experience of gardening.

PAXTON, SIR JOSEPH (1803–1865)

Paxton, the son of a Bedfordshire farmer, began his career in 1823 as a gardener at the Horticultural Society's garden at Chiswick. In 1826 the Duke of Devonshire appointed him head gardener at Chatsworth, Derbyshire, where he redesigned parts of the garden and built pioneering glasshouses. By the 1840s he was designing parks, gardens, and glasshouses on a wide scale; he was knighted for his achievement in building the Crystal Palace to house the Great Exhibition of 1851. He edited two gardening magazines, the *Horticultural Register* (1831–1834) and *Paxton's Magazine of Botany* (1834–1849), as well as founding *The Gardeners' Chronicle* (1841 –) with John Lindley (q.v.). His only books were *A Practical Treatise on the Cultivation of the Dahlia* (1838), and *A Pocket Botanical Dictionary* (1840).

REA, JOHN (FL. 1620S–1677)

John Rea was a nurseryman in Shropshire, and the author of Restoration England's principal book on ornamental plants: *Flora, seu de Florum Cultura* (1665; second edition, 1676). Rea designed a garden for Baroness Gerard at Gerard's Bromley in Staffordshire. Lady Gerard's chaplain, Samuel Gilbert, who eventually became Rector of Quatt in Shropshire, married Rea's daughter Minerva, and inherited Rea's plant collection. Gilbert went on to write the major gardening manual of the next generation: *The Florist's Vade-Mecum* (1682, and four subsequent editions).

REDOUTÉ, PIERRE-JOSEPH (1759–1840)

Redouté began his career as a botanical artist working for botanists like L'Héritier de Brutelle and Augustin Pyramus de Candolle, before he found a prominent patron in the empress Josephine, for whom he illustrated two books on the rare plants in her garden. As his fame grew, he was able to act as his own publisher for grandiose projects in which his name appeared on the title page, instead of the botanists he hired to write the texts. His three major works were *Les Liliacées* (1802–1816), an eight-volume work on bulbs; the three-volume *Les Roses* (1817–1824); and *Choix des Plus Belles Fleurs* (1827). These are some of the world's finest examples of colour-printing, but the process was so expensive that Redouté never made a great profit from them.

ROBINSON, WILLIAM (1838–1935).

Born in Ireland, Robinson trained as a gardener before becoming the horticultural correspondent for *The Times*, covering the Great Exhibition in Paris in

Opposite (left to right):

Peter Barr, John Gerard, John Lindley, Sir Joseph Paxton, James Veitch.

1867. His first two books were based on his French observations. In 1871 he founded a weekly magazine, *The Garden*, and in 1879 another, *Gardening Illustrated*. His books included *The Wild Garden* (1870), *Alpine Flowers for English Gardens* (1871), and *The English Flower Garden* (1833 and fourteen later editions). By the beginning of the twentieth century he had become England's major gardening writer.

ROLLISSON, WILLIAM (c1765–1842).
William Rollisson founded the Springfield Nursery at Tooting, then south of London, in the 1790s. He collected Cape heaths in South Africa, and began the first deliberate programme of plant hybridising, breeding hundreds of Cape heath varieties by the 1820s. Thereafter he turned his attention to orchids, which became a mainstay of the firm under his son, also William, who died in 1875. The nursery was closed in 1879, shortly before the death of George Rollisson, the last partner, who had spent his last fourteen years paralysed.

SWEET, ROBERT (1782–1835)
Sweet worked in his brother's Bristol nursery before moving to a series of similar jobs in London. From 1815 to 1819 he was foreman for Reginald Whitley (c.1754–1835), who introduced white Chinese peonies to England, and then from 1819 to 1826 for James Colvill (1777–1832), a specialist in Cape bulbs. While working for Colvill he began publishing works on newly introduced plants, following the model of H. C. Andrews (q.v.), but hiring professional artists: *Geraniaceae* (1820–1830); *Flora Australasica* (1827–1828); *Cistineae* (1825–1830); and *The British*

Flower Garden (1823–1837). In 1826 he was charged with receiving plants stolen from Kew, but acquitted; in his later years he became mentally unstable.

TOURNEFORT, JOSEPH PITTON DE (1656–1708)
Tournefort studied botany and medicine in Montpellier, taking his degree in 1682. The following year he took up a post at the *Jardin de Roi* in Paris, where he was to rise to the rank of Professor of Botany. He travelled throughout Europe collecting plants in the 1680s and 1690s, including a journey to Spain and Portugal in 1688–1689, but his major expedition was to the Near East in 1700–1702. His account of the journey was translated into English in 1718 as *A Voyage into the Levant*. Two years before he died he was made a Professor at the College Royal. His *Institutiones Rei Botanicae* (1700) outlined the first widely accepted system of classification for plants.

TRADESCANT, JOHN, THE ELDER (c.1570–1638) & YOUNGER (1608–1662)
The elder Tradescant was gardener to the Earl of Salisbury, both at Hatfield House, Hertfordshire, and in London; he also designed and maintained gardens for Sir Edward Wotton, the Duke of Buckingham, and others. He made two plant-collecting expeditions, to Russia in 1618, and to North Africa in 1620. In 1630 Charles I made him responsible for the royal garden at Oatlands, Surrey, and in this role he was succeeded in 1638 by his son, also named John. The younger John made three journeys to 'Virginia', i.e. the British colonies in North America, in 1637, 1642, and 1654, and helped to introduce many American plants. In 1658 he published *Musaeum*

Tradescantianum, an account of the rarities in his personal museum; after his death this collection was acquired by Elias Ashmole to form the basis of what is now the Ashmolean Museum in Oxford.

VEITCH
A family of nurserymen. James Veitch (1792–1863) left the family nursery in Devon and bought the already famous nursery of Knight and Perry in Chelsea in 1853. The firm soon became perhaps the world's most famous nursery for plant introductions and breeding. It was at the Veitch nursery in Chelsea that the first hybrid orchid was bred in the 1850s by John Dominy; John Seden raised the first hybrid tuberous begonia there. Veitch employed such famous collectors as William and Thomas Lobb and Charles Maries. James's son John Gould Veitch (1839–1870) collected plants in China and Japan in the 1860s, as did his son James Herbert Veitch (1868–1907). The last director, Sir Harry James Veitch (1840–1924), closed the nursery in 1914.

WEINMANN, JOHANN WILHELM (1683–1741).
Weinmann was a wealthy apothecary in Regensburg, Germany. He built up a collection of botanical drawings; among the artists he hired was the young Georg Dionysius Ehret (1708–1770), later to become the most famous botanical artist of the eighteenth century. In 1734 he began to publish an immense illustrated work on cultivated plants entitled *Phytanthoza*, hiring the botanist J. G. N. Diderichs to write the text. Frustratingly, none of the illustrations are attributed to their artists. Weinmann died before the book was completed in 1747.

LIST OF ILLUSTRATIONS

All images sourced from the Lindley Library of the Royal Horticultural Society.

Please note that some of the images appearing in this book are details from the existing artworks.

LIST OF ILLUSTRATIONS

186 *Nemesia strumosa* from the *Botanical Magazine* (1893), illust. by Matilda Smith.
187 *Crocosmia aurea* from *Flore des Serres et des Jardins d'Europe* for 1850–1851.
188 *Freesia* cultivars from the *Revue Horticole* for the year 1907.
189 *Saintpaulia* cultivars from the *Revue Horticole* for the year 1901.
190–191 *Aloe variegata* and *A. saponaria* from *Phytanthoza* (1734–1747) by Johann Wilhelm Weinmann (artist unknown).
192–193 *Helianthus annuus* from Crispijn van de Passe, *Hortus Floridus* (1614).
196 *Canna indica*, from the *Herbarium Amboinense* (1741–1750) of Rumphius (Georg Eberhard Rumpf).
199 Passionflower, from *Jardin d'Hyver* (1616) by Jean Franeau.
200 *Passiflora × caeruleo-racemosa*, from the *Transactions of the Horticultural Society* for 1830 (artist unidentified).
201 *Passiflora caerulea*, from the *Traité des Arbres et Arbustes* (1801–1825) by Duhamel du Monceau, revised by J. H. Jaume Saint-Hilaire et al., illust. by Pierre-Joseph Redouté.
202–203 *Hippeastrum striatum* from Priscilla Susan Bury, *A Selection of Hexandrian Plants* (1831–1834).
204–205 *Hippeastrum aulicum* (left) and *H. psittacinum* (above), from Priscilla Susan Bury, *A Selection of Hexandrian Plants* (1831–1834).
206 *Fuchsia magellanica* from the *Traité des Arbres et Arbustes* (1801–1825) by Duhamel du Monceau, revised by Jaume Saint-Hilaire et al., illust. by Pierre-Joseph Redouté.
207 Fuchsias, from *Les Promenades de Paris* (1867–1873) by Adolphe Alphand, illust. by P. Lambotte.
208–211 *Victoria amazonica*, from Sir William Jackson Hooker, *Victoria Regia* (1851).
212 *Buddleja globosa* from the *Botanical Magazine* for 1791, illust. by Sydenham Teast Edwards.

213 Calceolarias, raised by Mr Green, head gardener to Sir Edmund Antrobus at Cheam, Surrey, from the *Florist's Journal* for 1841.
214–215 *Calceolaria* cultivars (above) from *The Illustrated Bouquet* (1857–1864), edited by E. G. and A. Henderson, illust. by Charlotte Caroline Sowerby, and (right) from *Flore des Serres et des Jardins d'Europe* for 1847.
216 Two petunia cultivars, with an achimenes, from *The Illustrated Bouquet* (1857–1864), edited by E. G. and A. Henderson, and illust. by Charlotte Caroline Sowerby.
217 Verbena cultivars from *The Illustrated Bouquet* (1857–1864), edited by E. G. and A. Henderson, and illust. by James Andrews.
218 The Duke of Devonshire's hybrid *Nymphaea*, from the *Botanical Magazine* (1852), illust. by Walter Hood Fitch.
219 *Canna indica*, from an anonymous nineteenth-century drawing.
220–221 *Gunnera scabra* from *Flore des Serres et des Jardins d'Europe* for 1869–1870.
222 *Polianthes tuberosa* from *Choix des Plus Belles Fleurs* (1827) illust. by Pierre-Joseph Redouté.
223 *Tropaeolum majus* from *Medical Botany* (1790) by William Woodville, illust. by James Sowerby.
224 *Salvia patens* from the *Transactions of the Horticultural Society* for 1842, illust. by Sarah Ann Drake.
225 *Lupinus perennis* from the *Botanical Magazine* for 1793, illust. by Sydenham Teast Edwards.
226–227 *Tradescantia virginiana* and varieties, from drawings by Pieter van Kouwenhoorn (fl. 1630s) in the RHS Lindley Library (left) and from *Phytanthoza* (1734–1747) by Johann Wilhelm Weinmann, right.
228–229 *Helianthus annuus* (left) from *Abbildung aller Oekonomischen Pflanzen* (1786–96), written and illustrated by

Johann Simon Kerner, and (right) from a drawing made in 1816 by James Sowerby (1757–1822).
230–231 *Lilium superbum* from *Plantae Selectae* (1750–1765) by Christoph Jakob Trew, illust. by Georg Dionysius Ehret.
232 *Oenothera biennis*, from volume 23 (1896) of H. G. L. Reichenbach's *Icones Florae Germanicae*, written and illust. by F. G. Kohl.
233 *Aster novae-angliae* from *La Flore et la Pomone Française* (1828–1833), written and illustrated by Jean-Henri Jaume Saint-Hilaire.
234 *Rudbeckia pinnata* from a drawing by James Sowerby (1757–1822), for the 1822 volume of the *Botanical Magazine*.
235 *Rudbeckia hirta* from *L'Art de Peindre les Fleurs à l'Aquarelle* (1834) by Augustine Dufour.
236 *Agave americana* from *Phytanthoza* (1734–1747) by Johann Wilhelm Weinmann.
237 *Cereus eriophorus* from *Abbildung und Beschreibung Blühender Cacteen* (1838–1850) by Ludwig G. C. Pfeiffer and Christoph Friedrich Otto.
238–239 *Cereus curtisi* (left) and *Echinocactus pfeifferi* (right) from *Abbildung und Beschreibung Blühender Cacteen* (1838–1850) by Ludwig G.C. Pfeiffer and Christoph Friedrich Otto.
240 *Dahlia* 'The Sovereign' from a drawing by James Sillett (1764–1840).
241 Double dahlia from *Choix des Plus Belles Fleurs* (1827) illust. by Pierre-Joseph Redouté.
242 *Dahlia* 'The Queen', from *The Parterre* (1842) by James Andrews.
243 *Dahlia* 'Picta Formisissima' from the *Horticultural Journal* for the year 1833, after a drawing by Alfred Chandler.
244–245 Pompon and lilliput dahlias from *The Illustrated Bouquet* (1857–1864), edited by E. G. and A. Henderson, illust. by Augusta Innes Withers (pompon) and

Charlotte Caroline Sowerby (lilliput).
246 *Eschscholzia californica* from *Floral Illustrations of the Seasons* (1829) by Margaret Roscoe.
247 *Gaillardia picta* from *The British Flower Garden* (1823–1838) by Robert Sweet, illust. by S. Humble.
248 *Nemophila insignis* from *The British Flower Garden* (1823–1838) by Robert Sweet, illust. by J. Hart.
249 *Coreopsis grandiflora* from *Floral Illustrations of the Seasons* (1829) by Margaret Roscoe.
250 *Penstemon ovatus* from *Floral Illustrations of the Seasons* (1829), by Margaret Roscoe.
251 *Tagetes erectus* from *Raccolta di Fiori Frutti e Agrumi* (1822–1825), by Antonio Targioni-Tozzetti.
252 *Calochortus macrocarpus*, drawing made for publication in *The New Plantsman* (1994) by Lawrence Greenwood.
253 *Calochortus albus* and *C. pulchellus*, made in 1833 from drawings by Sarah Ann Drake.
254 *Nopalxocia ackermannii* from the *Botanical Register* (1830), illust. by M. Hart.
255 *Euphorbia pulcherrima* from *Paxton's Magazine of Botany* (1838), illust. by Samuel Holden.
256 *Gilia tricolor*, from *The British Flower Garden* (1823–1838) by Robert Sweet, illust. by Frederick W. Smith.
257 *Zinnia elegans* from *Flore des Serres et des Jardins d'Europe* (1858).
258 *Alternanthera versicolor* from *Illustration Horticole* (1865), illust. by P. Stroobant.
259 *Iresine herbstii* from the *Floral Magazine* (1865), illust. by James Andrews.
260 *Begonia × sedeni* from the *Florist and Pomologist* (1869), illust. by Walter Hood Fitch.
261 *Begonia rex* from *The Illustrated Bouquet* (1857–1864), edited by E. G. and A. Henderson, illust.

ℐNDEX

ACKNOWLEDGMENTS

The publisher would like to thank Dr Brent Elliott and the staff of the RHS Lindley Library, most especially Jennifer Vine, the Picture Librarian, and Sally Kington, the Daffodil Registrar. Thanks also to Susanne Mitchell and Sir Simon Hornby for their generous assistance, to photographer Nick Moss from Rodney Todd-White & Son, Dorothy Frame, Nikky Twyman and Karen Watts.

Colour separation by Bright Arts Pty Ltd, Singapore.